Tropical
Renaissance

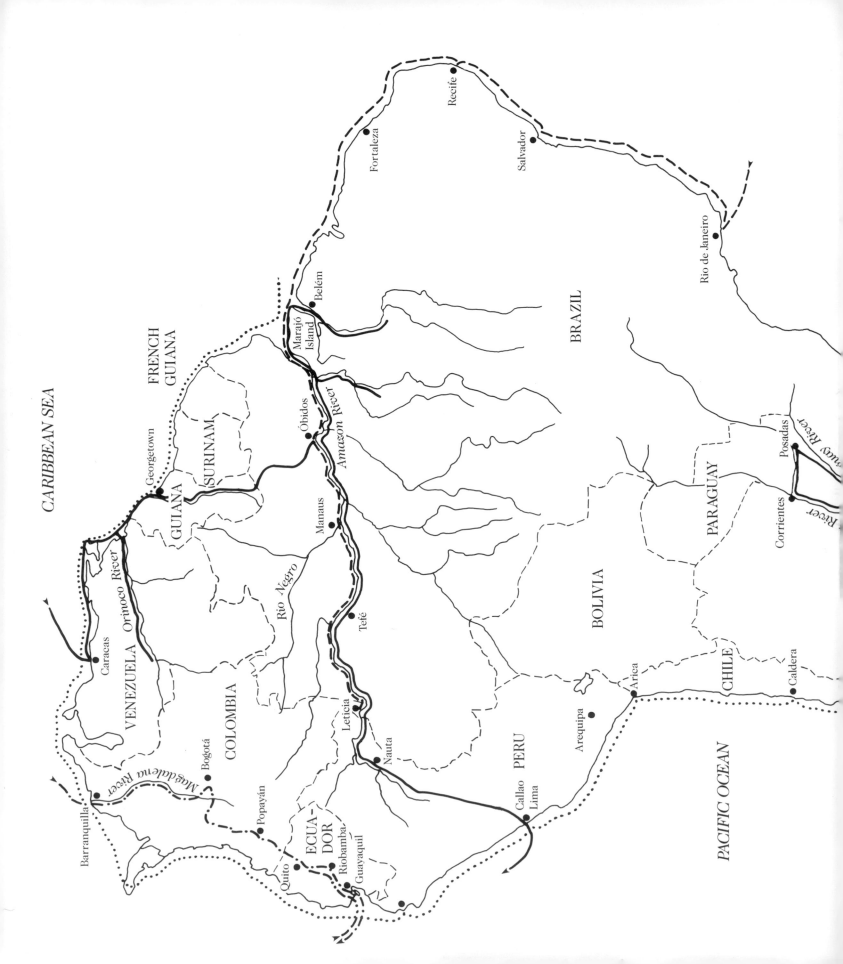

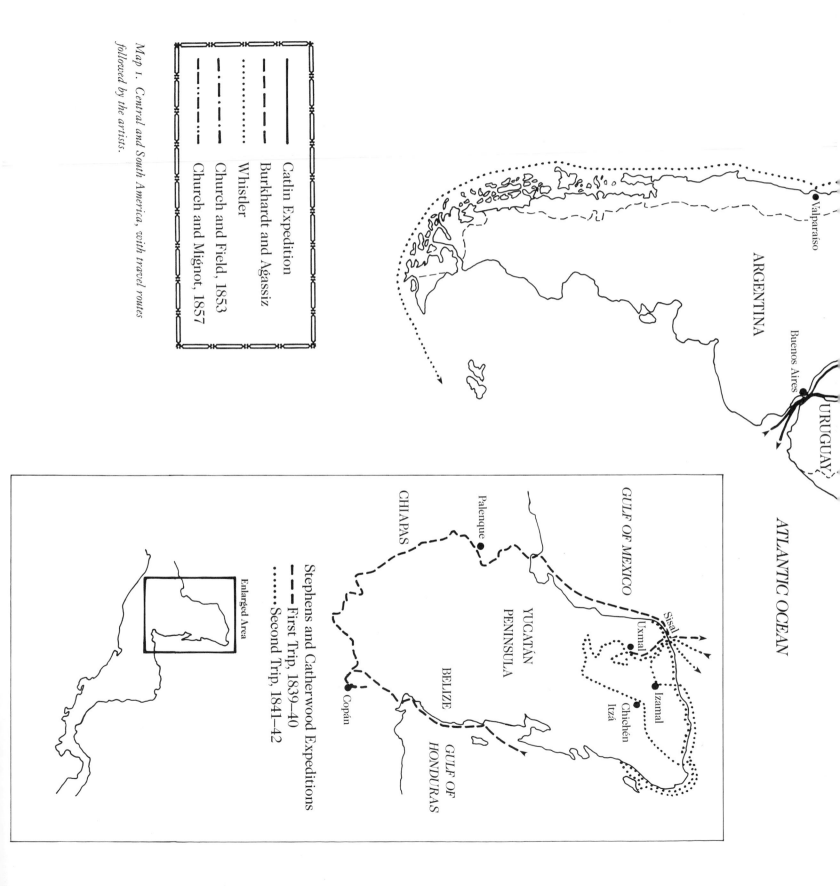

Map 1. Central and South America, with travel routes followed by the artists.

Catlin Expedition
Burkhardt and Agassiz
Whistler
Church and Field, 1853
Church and Mignot, 1857

Stephens and Catherwood Expeditions
First Trip, 1839–40
Second Trip, 1841–42

Enlarged Area

ATLANTIC OCEAN

ARGENTINA

Valparaíso

Buenos Aires

URUGUAY

GULF OF MEXICO

Palenque

CHIAPAS

YUCATÁN PENINSULA

Sisal

Uxmal

Izamal

Chichén Itzá

BELIZE

Copán

GULF OF HONDURAS

Tropical Renaissance

Katherine Emma Manthorne

NEW DIRECTIONS IN AMERICAN ART

North American Artists Exploring Latin America, 1839–1879

Smithsonian Institution Press · Washington and London

Edited by Tom Ireland
Designed by Linda McKnight
Typeset by The TypeWorks, Baltimore
Printed in Hong Kong by South China Printing Company

For permission to reproduce illustrations appearing in this book, please correspond directly with the owners of the works as listed in the individual captions. The Smithsonian Institution Press does not retain reproduction rights for these illustrations or maintain a file of addresses for photo sources.

Library of Congress Cataloguing-in-Publication Data

Manthorne, Katherine
　　Tropical renaissance: North American artists exploring Latin America, 1839–1879 / Katherine Emma Manthorne.
　　　　p. cm. (New directions in American art)
　　Includes index.
　　Bibliography: p.
　　ISBN 0-87474-714-7. ISBN 0-87474-715-5 (pbk.)
　　　1. Latin America in art.　2. Exoticism in art—United States.
3. Art, American.　4. Art, Modern—19th Century—United States.
I. Title.　II. Series.
N8214.5.USM3　1989　　　　89-6199
760'.044998—dc20　　　　　CIP

96　95　94　93　92　91　90　89
　　　　5　4　3　2　1

The paper used in this publication meets the minimum requirements of the American National Standard for Permanence of Paper for Printed Library Materials Z39.48–1984.

Cover: Martin Heade, *Passion Flowers and Hummingbirds*. Museum of Fine Arts, Boston (pl. 6).

Contents

Acknowledgments

This book would not have been possible without the generous assistance of many kind and knowledgeable individuals. Among them I would like to single out Sr. Albornoz, Nancy Anderson, Donald Brewster, Gerald Carr, Juan Castro y Velázquez, Diana Fane, Ella Foshay, Stanley Grant, Jean Hanowell, Raymond Holsclaw, David Huntington, Franklin Kelly, Joseph Ketner II, Andrew Lark, Edward Lurie, Keith McElroy, Col. Merl Moore, Jr., Helina Nelken, Mr. Nissisan, Jean O'Leary, Ramón Osuna, the descendants of Ramón Páez, Edith Pollner, Jules David Prown, Lucille and Walter Rubin, James Ryan, Tirsa Scott, Gerald Silk, Emily Umberger, and Nelson White.

The gathering of materials was greatly facilitated by the staffs of numerous libraries and museums, which I would like to acknowledge: American Philosophical Society; Archives of American Art, where Garnett McCoy and William McNaught have been especially helpful; Art Institute of Chicago, particularly Milo Naeve and Anndora Morganson; Berry-Hill Galleries, with special mention of Frederick Hill; Century Association and Mark Davis; Columbia University Libraries; Cooper-Hewitt Museum, especially Elaine Dee; Detroit Institute of Arts, particularly Nancy Rivard Shaw; Drexel University Museum Collections; George Eastman House; Framingham State College Library; Frick Art Reference Library; Gibbes Art Gallery; Gilcrease Institute of American History and Art; Harvard University's Houghton Library and Museum of Comparative Zoology, where Ann Blum provided valuable assistance; Joseph Henry Papers of the Smithsonian Institution, especially Nathan Reingold and Kathy Waldenfels; Hirschl and Adler Galleries,

particularly Mrs. M. P. Naud; Inventory of American Painting, Smithsonian Institution; Kennedy Galleries; Library of Congress; Massachusetts Historical Society; Metropolitan Museum of Art; Jerry Mallick, Photographic Archives, National Gallery of Art; National Museum of American Art; New-York Historical Society; New York Public Library; Olana State Historic Site; St. Louis Art Museum; and University of Illinois Library.

The research for this study was supported by generous grants from several institutions. A traveling fellowship from Columbia University allowed me to conduct my own exploration of South America. I also received a fellowship from the Smithsonian Institution, which supported a productive year at the National Museum of American Art. There Lois Fink and William Truettner gave generously of their time and knowledge, as did my fellow fellows. Charles Eldredge, then director, offered me the timely opportunity to curate an exhibition of Frederic Church's pictures of Cotopaxi. I also received a summer travel grant from Columbia University to consult resources in Great Britain. A shoestring grant from the University of Illinois helped defray the cost of the photographs. And at a critical stage in the completion of the book manuscript, a research fellowship for recent recipients of the Ph.D. from the American Council of Learned Societies and the National Endowment for the Humanities enabled me to take a semester off from my teaching duties. I would also like to thank the art history department, School of Art and Design, University of Illinois, for a semester's leave only a short time after I arrived there.

In South America I was graciously permitted access to a number of institutions. In Guayaquil, Ecuador: Museo Antropológico del Banco Central del Ecuador and the Museo Municipal. In Quito, Ecuador: Museo del Banco Central del Ecuador, including the Museo del Camilo Egas; Casa de la Cultura Ecuatoriana; Museo Municipal; Museo Aurelio Espinosa Polit; Museo Jacinto Jijon y Caamano, Pontificia Universidad del Ecuador; and the Asociación Humboldt, where Irene Heuer was particularly helpful. In Lima, Peru: Instituto Cultural Peruano-Norteamericano; Museo Nacional de Bellas Artes; Pinacoteca Municipal; Universidad de San Marcos, especially Pablo Macera ; Pontificia Universidad Católica del Perú, particularly Sr. Pease; and the staff of *El Mercurio*. And in Santiago, Chile: Museo Nacional de Bellas Artes; Archivo Nacional; and Biblioteca Nacional.

Although numerous endnotes indicate the importance of monographs to this book, I should like to cite in particular David Huntington's study of Frederic Church, Theodore Stebbins, Jr.'s, work on Martin Heade, William Truettner's on George Catlin, and the catalogue raisonné of James Whistler by Andrew McLaren Young and others. Similarly, Hugh Honour's *New Golden Land*, Bernard Smith's *European Vision and the South Pacific*, Edward Said's *Orientalism*, and Barbara Novak's *Nature and Culture* are models of their kind and have influenced the formulation of the present study.

Since this work represents the extension of my doctoral dissertation at Columbia University, it owes much to colleagues there. Among fellow students I would like to mention Kevin Avery, Fatima Berechte, Annette Blaugrund, Marie Busco, Cheryl Cibulka, Elizabeth Ellis, Maria Fernandez, and Susan Sivard. Faculty members with whom I had the pleasure to work include Richard Brilliant, Howard Davis, the late Howard Hibbard, and Theodore Reff. James Beck and Jack Salzman read the dissertation and offered many suggestions; Linda Ferber proved an intelligent and supportive advisor; Allen Staley, with his insight into the nineteenth century, was indispensable to its fruition. My debt to Barbara Novak, evident throughout these pages, deserves special mention; she has been an unfailing guide and brilliant inspiration in all my art-historical inquiries, and I sincerely thank her. I also want to express my gratitude to Donald Clark for his support over the years. There is no appropriate way to convey my appreciation to my mother; father; Patricia, Mark, and Jay Manthorne; and Michael Gennari, who have relived with me many of these artists' adventures.

Introduction

*W*riting in 1888 of the prospects that awaited the artist in the tropics, Vincent van Gogh predicted, "Surely the future of a great renaissance in painting lies here." He was undoubtedly thinking of the promise it held for European painters; unknowingly he was also speaking of the North American artists who, traveling and painting in Latin America, underwent an unprecedented renewal of their creative energies. The Andean journeys and pictures of Frederic Church have long been known, and their importance acknowledged. What has gone largely unrecognized, however, is that his experience was a single instance of a far more widespread phenomenon: the artist from the United States exploring Central and South America. Along with Church at least thirty other draftsmen and painters headed south in these years, including Martin Heade and James Whistler, Titian

Peale and Norton Bush: the famous and the less well known, the painters who traveled independently and those attached to expeditions. [1]

The great adventure began in earnest in the late 1830s, as Peale and Frederick Catherwood sailed for southern shores. It continued until the late 1870s, when Bush and Henry Ferguson returned home from their journeys, about the time Church put the finishing touches to his *Morning in the Tropics*, and Heade to the finest of his hummingbird and orchid pictures. During the intervening four decades the North American artist's confrontation with the South American landscape gave rise to an extraordinary body of pictorial images. For most it was the decisive moment of their careers, constituting a formative influence or turning point and providing the subjects that played a substantial role in their oeuvres. Their fascination with the luxuriant and

I

terrible beauty of these regions took on the character of a long-standing love affair rather than a brief infatuation, for sustained involvement with Central and South America often required that they remain for long periods of time or make multiple trips. Ferguson, Ward, and George Catlin all traveled there for three to five years. Church and Andrew Warren followed their extensive initial trips with second expeditions that concentrated on smaller, more circumscribed regions, while their fellow artists—Heade, Catherwood, and Bush— each made three or more separate journeys. Both Heade's residence in Florida and Church's winter sojourns in Mexico in the 1880s and 1890s represent their continued desire for contact with tropical nature. Thus they remained faithful to their Latin American mistress, painting and repainting favorite locales long after the physical voyage had ended and their memories had begun to fade.

The large number of artist-travelers who went south of the border, the extent of their involvement with the subject, and the participation of important figures are all indications that Latin America profoundly affected our art. The Andes and the lowland lagoons, the harbors at Valparaíso and Rio de Janeiro, were often rendered by our major painters in canvases that are still regarded as masterpieces of their age. Entry into the unfamiliar terrain of the Andes and the Amazon challenged the precepts of landscape painting held by American artists, and—as Humboldt predicted— "heightened the power of artistic creation." The Latin American experience constituted a major formative influence or a turning point, and it led to such important and influential works as Church's *Heart of the Andes* (pl. 1), Louis Mignot's *Lagoon of the Guayaquil* (pl. 2), Catherwood's renderings of the Maya ruins (pl. 4), Heade's *Passion Flowers and Hummingbirds* (pl. 6), and Whistler's *Nocturne in Blue and Gold: Valparaíso* (pl. 7). They are a measure of the power of the Latin American landscape and the effect it wrought upon the mind of the artist-traveler from the United States.

No contemporary reviewer failed to mention the change that had come about in a painter's work as a result of this seminal encounter. One critic pointed out how much "South America had done for Church." Referring to Mignot, another observed, "The really distinctive quality of his genius appears to us to have been developed by his visit to South America in '58 [actually 1857], which gave rise to some of his finest and most original productions, and seems to have had a permanent influence in defining and developing his style." Whistler's biographers identify his trip to Chile as the decisive moment in his career, and in various ways so do the commentators of almost every artist covered in this study. No other single event in their artistic development had the same impact. Latin America, in short, contributed significantly to the genius of North American landscape art.

A word about terminology is necessary at the outset. Nineteenth-century writers in the United States employed the name *Spanish America* when referring to the region under consideration here; for the reader of today, however, this term carries restrictions. Therefore, *Latin America,* a twentieth-century term, is used throughout these pages as a kind of intellectual shorthand. It refers here to all of the Spanish-speaking republics of the western hemisphere, excluding Mexico and Cuba, and including Portuguese-speaking Brazil. Mexico and Cuba properly fall under this heading but have been omitted from my direct consideration; their close physical proximity to the United States sets them apart in their interrelations. Consequently, factors motivating the potential traveler to Cuba or Mexico were distinct from those of the traveler to the more remote regions of Central and South America, and require a separate study. *Tropics,* another word that appears frequently in this study, requires qualification. In correct geographic terminology, it refers to the region of the earth lying between $23\frac{1}{2}$ degrees north and south latitudes, also called the Torrid Zone. It

therefore connotes regions of Africa and the South Pacific as well as South America. All the world's tropics have certain things in common, including a warm, wet climate and abundant natural vegetation.[2] In nineteenth-century American practice, however, *the Tropics* referred almost exclusively to lands of Central and South America and was therefore often capitalized. The use of this nomenclature to refer to all of Central and South America reflected a myopic view and a prevailing misconception. The tendency was to lump the entire continent under this heading, with little regard for the fact that much of it was not hot, steamy, jungle-covered terrain.

"Go West, young man!" Horace Greeley advised, articulating the national predisposition toward westward movement. So pronounced is the hold of the western frontier on the American imagination that ever since, students of its history, economics, science, literature, and arts have followed the same path. The dominant axis of national interest unquestionably has been the east-west axis; certainly no comparable spokesman of the period ever gave the command to "Go South, America!" Why then should any special attention be paid to this group of artists who go south in the middle decades of the nineteenth century? Just as the country cannot be defined physically by its eastern and western boundaries only, neither can its ambitions, nor its art. We must therefore begin to ask: Why did large numbers of artists from the United States travel in Latin America? How did their experiences affect their art? And to what degree did their travels and paintings reflect larger national attitudes? Or, pared down to the single best-known representative, why did Frederic Church—who has been called America's painter of Manifest Destiny—go to South America in 1853 instead of to the American West, as his rival Albert Bierstadt chose to do six years later?

Attempts to explicate Church's motivation have credited the influence of the great German naturalist Alexander von Humboldt. And rightly so, for Humboldt's writings stirred the outside world to levels of excitement about Latin America unmatched since its discovery and conquest. Besides reporting on the natural history of the Andes and the Orinoco, he also pointed out what a rich yet untapped source of inspiration these regions offered the visual artist. But the explanation that Church read Humboldt's *Cosmos* in about 1850 and set off for Colombia and Ecuador fails to recognize his achievement as part of the collective exploratory phenomenon of 1839 to 1879. Looking back to the early years of the century, we discover a slowly emerging sentiment of pan-Americanism. These vague feelings of hemispheric brotherhood were not long in metamorphosing, in the late 1840s and 1850s, into more aggressive, proprietary attitudes, with which Humboldt's researches conveniently meshed.

During this Age of Expansionism and Manifest Destiny, the national rhetoric began to include such phrases as "our southern continent" and "our own tropical regions." This idea of the western hemisphere, based on its apparent geographical unity on maps, presupposes that North and South America stand in special relation to one another and apart from the rest of the world. While its usual connotation has been politico-economic, my intention is to examine it as a constituent phenomenon of nineteenth-century American art: to explore the implications of the artist's awakening inter-American consciousness, manifested by the critical role the Latin American landscape played in his work. This is not to say that the concept of pan-American unity enjoyed universal acceptance in the United States, for at all times there has been strong dissent from it. But the fact is that from 1839 to 1879 major painters began to define the boundaries of the American landscape not only in national but also in hemispheric terms.

From these observations we might be tempted to draw a direct correspondence between the pictorial fascination with Latin America and territorial expansionism. But further consideration indicates that the interactions are more subtle than they first appear. The

United States regarded itself not as a foreign power in its relations with Latin America. Rather, it was a member of the family—significantly, the most powerful member—and in that capacity it had come to feel increasingly proprietary toward South America. The tropical pictures were interpreted, in part, in this spirit of appropriation. A painting by Church was appreciated because it expressed "the very spirit and splendor of *our* most characteristic scenery as a poem does [emphasis added]." Louis Mignot's pictures of Ecuador were similarly embraced because he "first awoke the attention of a nation to a consciousness of the beauty, glory, and inexhaustible variety of scenery of *this* continent, which had fallen to them as a heritage as no other people had yet acquired [emphasis added]." But before it can be concluded that these Latin American landscape images merely followed the southern path of Manifest Destiny, several important distinctions must be made.

Americans may have made an a priori claim over the entire southern continent; in practice, however, their sphere of power and influence was far more limited in this period. The Monroe Doctrine was invoked in U.S. relations with Mexico and Cuba, in its policy in the Caribbean, and in matters pertaining to the Isthmian canal: those areas, in other words, in close geographic proximity that impinged most directly on its affairs. While some artists depicted those strategic sites, the majority of them discussed in these pages found inspiration in the more distant reaches of the southern continent, where even the most ardent expansionists never seriously contemplated extending the physical domain of the Stars and Stripes. Thus Church's Andean panoramas and Mignot's lush riverscapes, Whistler's nocturnes of the harbor at Valparaíso, and Heade's images of Brazil must be read as something more than the direct visual corollaries to U.S. policies of expansion and economic penetration into the territories of the south. These factors were involved, to be sure, but they do not tell the full story.

The Latin American policy of the United States was taking shape at a time when the country as a whole was concerned primarily with the internal problems and ocean waterways of the continental republic. There was no thought of applying the principles expressed by President Monroe anywhere in Latin America, in fact, until the acquisitions in California and the Southwest made so imperative the strategic control of the Isthmus. But to secure the "rights" of the United States in Mexico and Central America was one thing; to become involved in South America was another matter all together. It is unnecessary here to review the many floutings of the Monroe Doctrine, and other political factors involved; the conclusion is inescapable that at the height of artistic activity in South America, between 1839 and 1879, it was regarded as too far away to be of vital national concern.

Artists took their impetus from the official policy toward Latin America and took advantage of the newly established steamship and railroad lines that took them at least part of the way. But once they touched down in Central America or the Caribbean coast of South America, their optimistic belief in a tropical paradise, their unquenchable zest for adventure, and their bonds to New World nature overrode any narrowly circumscribed arena of political activity. So they penetrated ever southward, this Yankee advance guard, through Ecuador, Peru, Chile, Brazil, Argentina, to the desolate plains at the tip of Patagonia, where the destiny of the United States was far from manifest. Their indomitable spirit helped to expand the boundaries of American landscape art, now redefined not only by its western but also by its southern frontier.

The collective portrait of Latin America created by artists from the North is primarily a landscape image. An occasional artist such as Catlin delineated the native Indians, and the pre-Columbian ruins constituted no small part of the fascination with the place. Nature, however, invariably took precedence over the living inhabitants or their ancestral remains. The natural rather then the social sciences guided these artist-travelers from the United States, who perceived Latin America essentially in terms of *space:* vast, unculti-

1. *Albert Bierstadt*, The Rocky Mountains, Lander's Peak, *1863, oil on canvas, 73 1/4 × 120 3/4 in. (186 × 306.7 cm). The Metropolitan Museum of Art, New York, Rogers Fund, 1907 (07.123).*

vated, primeval. This fact in itself perhaps comes as little surprise; their prevailing view of their own northern continent, after all, exhibited a similar emphasis on nature over culture. But certain factors operated to make the North American pictorial consciousness of Latin America unique. First, there is the subject: a continent of lofty mountains, wide plains, vast rivers, and dense jungles, which, up to that point, had yet to be civilized by pictorial tradition. Then there is the artist himself: the American Adam who, armed with the certitudes of science and his own objective eye, was eminently qualified to respond to the physicality of the continent. And finally, the artist's relation to his subject must be taken into account: Central and South America

were regarded, according to the Monroe Doctrine, as the geographical extension of the United States. Departing for the southern continent, the northern artist expected to locate himself in a landscape he explicitly possessed as spiritual property. Once he arrived on its shores, however, he discovered it to be strange and unfamiliar, difficult to assimilate into his concept of America. In this precarious mix that Latin America presented to him of self and other, familiar and foreign, lies the uniqueness of this encounter.

Comparison of a South American work by Church

(pl. 1) and a view of the Rocky Mountains by Albert Bierstadt (fig. 1) helps to isolate the factors distinguishing the United States pictorial consciousness of Latin America. First, consider the respective subjects. In both cases we have what critics of the day called "continental" subjects, possessing lofty mountains, wide plains, vast rivers, and dense forests, which—up to that point—had yet to be civilized by pictorial convention. Then, there are the artists: the American landscapists who, inspired by the literature of exploration and their own sense of artistic mission, were eminently qualified to respond to the physicality of the land. What ultimately differentiates them, however, is the artist's relation to his subject. Heading west, Bierstadt was part of the largest migration in the history of the nation; his responses to these lands were relatively clear-cut, as were those of his audience. Awe mixed with admiration for divine handiwork and a definite sense of national pride: These were the emotions stirred by a view of his own western United States. This proprietary stance is perceptible even in his compositional handling. He invites the viewer to step into the low-lying foreground, where the vistas are neatly framed; the mountains, although grand in scale, recede properly into the distance, and the figures of the Indians appear domesticated, sheltered in the bosom of nature. Choosing to head south, by contrast, Church located himself in a landscape that aroused more conflicting emotions.

A closer look at Church's *Heart of the Andes* helps to define the artist's complex relation to his subject. The picture was inspired by the landscape of Ecuador, a country within the sphere of influence delineated by Monroe but far removed from the arena of actual political action. The locale therefore occupied an ambiguous status in the national imagination: It was appropriated as part of "our tropical regions" but otherwise was of little immediate consequence. Steeped in the landscape aesthetics of John Ruskin and the scientific explorations of Humboldt, Church was sensitive to Ecuador's unique geological and artistic potential and brought it to the attention of his stay-at-home public. Painting its scenery

amounted to taking artistic possession of it; South America became *his* territory, just as the American West *belonged* for a time to Bierstadt. His achievement was interpreted in just these terms in his own day, when it was said that he made equatorial America "his own." Viewing his canvases, audiences confirmed their assumptions that the Andes he so minutely rendered were a continuation of the Rocky Mountains, and the Magdalena or the Amazon but extensions of the mighty Mississippi.[3]

But has the North American viewer the right to enter the fictive space laid out so invitingly before him? Did the artist intend it to be interpreted as the extension of his own northern forest? The picture's visual ambiguities and spatial tensions leave us in doubt. Significant first is the elevated viewpoint. Related to the popular panoramas of the day, the view from above allows us to delight in the canvas's botanical detail and its mountain grandeur. It has the additional effect of leaving the beholder not within the tropical landscape but at a distance: the expression of a certain physical and psychological detachment. It is, furthermore, difficult to get a foothold. The traditional threshold of the picture—the foreground strip of land extended to the edge of Bierstadt's view of the Rockies—is here replaced with a crashing waterfall and protruding branches. Jungle vegetation presses up against the picture plane; the few paths that invite passage into the distance lead to entanglement a few yards beyond; and the mountain looms too large and too near. In other words, Bierstadt's ability to impose the Claudian formula on his subject signals one thing, while the departures Church made from that convention (or his inability to "tame" it through convention) indicate something else. Telling also is the tree in the lower-left foreground, in which the artist has carved his signature: It is the only specimen amidst this vegetal luxuriance to have withered and died. Taking too strong a hold of tropical nature, the northerner brings about its alteration and death.[4] Thus Church conveys his dilemma over his subject: the collision of beliefs that led him to feel simultaneously pro-

prietary toward South America and tentative about the implications of that assumption once he actually came in contact with its lands.

But what entitles us to make these claims? The painter-explorer arrived at his tropical destination laden down with his mental baggage of the inherited myths and national attitudes about Latin America. While the majority of his countrymen could maintain their proprietary stances toward it in the comfort of home, Church and his fellow artists took it one step further: *They went there*. And that made all the difference. For out of the special bond he enjoyed with the very soil of the New World sprung his unique pictorial image of Latin America.

Church's *Heart of the Andes*, the single most important and influential picture in this study, is the point of departure for the two chapters that make up Part 1. Chapter 1 analyzes this and other contemporary images as reflections of the age-old myths that stimulated interest and exploration in the New World from the time of its discovery. Singled out for close examination are the myths of paradise, El Dorado, and the last frontier. All three took on new meaning in the United States of the mid-nineteenth century, when its proprietary attitudes toward Latin America began to manifest themselves in politics and economics, science and art. Chapter 2 examines the picture's achievement in its historic moment. The year of its completion and triumphant public exhibition, 1859, was the apogee of artistic and scientific awareness of Latin America. The events of that pivotal year are traced back to 1839 and forward to 1879 to better survey the political and cultural circumstances that focused the attention of the nation on Latin America. What emerges is a curious, bipolar distribution of interests: While the country at large focused its attentions on Mexico, Cuba, and those regions of Central America targeted for an interoceanic canal, the painters found their greatest inspiration in those more southerly reaches where the "destiny" of the United States was far less "manifest." What resulted, in other words, was more than a Monroe Doctrine in paint. We

must therefore look beyond political and historical concerns to comprehend the attraction Latin America held for the North American artist.

These artists shared certain historical, political, and philosophical beliefs, which helped shape their conception of Latin America; at the same time, there were differences in the motivation behind and the nature of the travel they undertook. Broadly speaking, they fall into two categories: the purposeful explorer, who was inspired by the natural sciences; and the soulful wanderer, who was influenced by romantic thought.

Part 2 focuses on the explorers. It takes as its premise the idea that the American artist's entry into the Tropics was motivated by the quest for a New World cosmogony. The word *cosmogony*, derived from the Greek *cosmos*, meaning "order of the universe," signifies a theory of the creation of the world. And that was, on its most fundamental level, the object of the North American artist's mutual search: insight into the origins of the earth and, ultimately, of man himself. The successive layerings of the search, for which the painters enlisted the aid of science, defines the organization of part 2. Although each of its three chapters is essentially thematic rather than monographic, each has its "hero": an artist who best embodies that phase of tropical exploration. Thus, chapter 3 analyzes the inquiry into terrestrial origins, assisted by the study of the geological sciences, which led artists and naturalists alike to probe the active volcanoes and quiescent peaks of the Andes. Those efforts are epitomized by Church's series of renderings of the volcano Cotopaxi. Chapter 4 treats the ongoing investigation into the archaeological remains of the Aztec, Inca, and particularly Maya cultures conducted by antiquarians such as John Lloyd Stephens and Frederick Catherwood, whose renderings of the ancient ruins were increasingly thought to hold the key to the long-lost American past. The geological and archaeological approaches to the problem of origins taken by some artists contrast with the biological approach taken more commonly after 1859, when Charles Darwin's *Origin of Species* forced the ultimate question of the origin of life

more insistently into the consciousness of the Western world. Clinging tenaciously to their old cosmology, artists and naturalists began to probe the source of biological life—studying individual species of tortoises and finches, fish and hummingbirds—in an attempt to disprove him. In the battle to counter his challenge, Heade, like his scientific counterpart, Louis Agassiz, produced a remarkable body of work, examined in chapter 5.

Running parallel to and at times merging with the objective, scientific interests was the more subjective, even romantic orientation of the wanderers toward Latin America, the focus of part 3. Inspired by the romantic literary tradition, artists such as Mignot were encouraged to penetrate beneath the outward appearance of tropical nature to seek a deeper and more personal meaning. These dreamy, evocative images by Mignot and others, discussed in chapter 6, provide counterparts to the scientifically informed work and demonstrate that the search for spirit, symbol, and feeling behind the objective data of the external world surfaced with some insistence in the artist's responses to this faraway and exotic locale. This issue of exoticism as a constituent phenomenon of the painter's romance with the Tropics is addressed more fully in the final chapter. There it is argued that a kind of imaginative conflation occurred between the luxuriance of the American Tropics and the splendors of the Orient. This link between the New World and the exotic East dates back to the landing of Columbus, who described all that he saw with reference to Marco Polo's descriptions of the Great Khan's kingdom. In the romantic era this syncretism of South and East received renewed currency, as travelers found the only analogies to the exoticism of Latin America in verbal and visual descriptions of the Orient. These developments are epitomized by Whistler's nocturnes of Valparaíso, in which for the first time he was able to incorporate oriental design into his pictorial structure. Chapter 7 thus brings our inquiries around full circle, to Columbus and the geographical myths that started with the discovery of the New World.

Two appendixes, in addition, supplement the thematic orientation of the text. Appendix 1 provides biographies and itineraries of the individual artist-travelers. And Appendix 2 is a chronological table of political, scientific, cultural, and artistic events from 1839 to 1879, related to the exploration of Latin America.

Church, Catlin, Heade, Whistler, and at least twenty-five other American artists headed for Latin America between 1839 and 1879 because it possessed that delicate balance of familiar and foreign, near and far, self and other they instinctively sought. They brought diverse experiences to bear on their quest; yet each came to define, or reaffirm, his identity as an American artist by going south instead of west. The challenge offered by their twin American continent was taken by many of the finest painters of the age, whose contribution lay not only in the visualization of these little-known lands, but also in the development of a new feeling of Americanism in the hemispheric sense.

Latin America:
Myth and Reality

Myths and Mind Sets

Historical Preconceptions Attracting Travelers to Latin America

> The world was so recent that many things
> lacked names, and in order to indicate them
> it was necessary to point.
> GABRIEL GARCÍA MÁRQUEZ, *One Hundred Years of Solitude*

*T*ravelers usually depart with a clear mental image—no matter how misconceived—of the lands and people they are to encounter. Between 1839 and 1879 a number of North American artists journeyed to Latin America, their expectations of tropical nature at least partially defined by the natural history texts of Alexander von Humboldt. Frederic Church, Louis Mignot, Titian Peale, and George Catlin were among the painters who found in his vivid descriptions of the lofty mountains, mighty rivers, and stately palms the inspiration to go and see them for themselves, and they probably would have concurred with the declaration of a fellow South American explorer, Charles Darwin: "As the force of impressions generally depends on preconceived ideas, I may add, that mine were taken from the vivid descriptions in the Personal Narrative of Humboldt, which far exceeds in merit anything which I have read."[1]

Whether Darwin or the artists were aware of it or not, Humboldt's scientism was not the only factor shaping their attitudes toward Latin America. Almost from the beginning this region was something more than what was empirically known about it. By the time of Humboldt's expedition of 1799–1804, over three centuries of legend had accumulated about the Americas in the collective imagination of the outside world. Following Columbus's discovery of the New World in 1492, the Spanish government restricted travel in this jealously guarded territory, thereby sustaining the air of mystery surrounding it. With information limited, the void of this terra incognita was filled with the early accounts of Spanish conquistadors and missionaries,

which were expanded and augmented until they reached mythical status. Recurring legends of El Dorado, the Enchanted City of Patagonia, the island of the Amazons, and paradise itself gave rise to a continuous tradition, a complex layering of ideas as important in the formation of the written and pictorial descriptions of the Tropics as the newly collected empirical data.[2]

These geographical myths became increasingly pertinent in the middle decades of the nineteenth century, when North Americans were becoming more cognizant of the existence of Latin America but had as yet little firsthand knowledge of it. "The first impression that is made upon the imaginative mind is often one of surprise," one traveler to the Amazon observed in 1849, "that regions so vast and beautiful should exist and yet be so little known save by vague and uncertain rumors to the mass of mankind."[3] The southern continent presented itself as a vast, dark blank, a tabula rasa, onto which were projected the age-old images and fantasies. These geographical myths merged with the inspiration of Humboldtian science and romantic thought to catalyze the Latin American travels of painters.

American artists were not particularly cooperative in recording the whys and wherefores behind their tropical expeditions. Their reasons must be for the most part deduced from oblique references in letters and journals and from their paintings. The remarkable exception is George Catlin. He produced, in addition to a large body of pictorial images, a number of published texts, including *Life amongst the Indians* and *Last Rambles amongst the Indians of the Rocky Mountains and the Andes,* which provide detailed if sometimes contradictory chronicles of his travels from Venezuela to the tip of Patagonia between 1852 and 1857.[4] In his writings Catlin was highly conscious of his audience and spun his own mythologies, and shaped his voice, to suit the expectations of the public. Although his words naturally reveal his personal motivation, they may also be taken as a reflection of the shared outlook of a whole generation of artists who similarly were prompted to explore equatorial America.

The mix of science and romanticism, fact and fiction, that merged in the image of Latin America as a whole can readily be perceived in Catlin's volumes. In touch with Humboldt and other scientific men of his age, Catlin pursued his studies of ethnology, geology, and botany with an objective eye. At the same time, his grounding in romanticism, which inspired and colored his fascination with American Indians and nature, shows through on each page of his books.[5] When the paintings of Church, Mignot, and others are examined against the writings of Catlin, their willing and eloquent expositor, the aims and ambitions of mid-century artist-explorers can be discerned. Three New World romances or myths surface throughout his writings and find parallels in contemporary art and travel literature: South America as paradise, El Dorado, and untried frontier. These three geographical myths, inherited from the age of discovery and given new life during the romantic movement, seemed to propel the artists ever forward in their travels.

The term *geographical myth* here refers to the blend of fact and imaginative conception that fed the artist's interest in the tropical landscape. It does not imply a fictitious or erroneous belief, but rather a collective representation grounded in the reality of South America. The myth of El Dorado, to cite one example, was not pure fantasy but took inspiration from the fact that the continent did possess a wealth of precious metals, which foreign travelers continued to seek out and thereby make their fortunes. "All fables have some real foundation," Humboldt argued. "That of El Dorado resembles those myths of antiquity which, travelling from country to country, have been successively adapted to different localities."[6] Such cultural myths, rooted in man's attempt to come to terms with the luxurious and forbidding environment, possess a continuous tradition of their own. They helped shape the nineteenth century's conception of Latin America, which was given visual form in the painted images.

Latin America as Paradise

The Heart of the Andes (pl. 1), completed and exhibited by Frederic Church in 1859, became the touchstone of

the North American pictorial consciousness of Latin America. On a five-by-ten-foot canvas, Church painted the great peaks of the Andes looming above a foreground of rich, dense vegetation, crashing waterfalls, and colorfully costumed natives by a shrine. The picture carried the authority of the artist's extensive South American expeditions of 1853 and 1857, during which he had sketched the varied scenery of Colombia and Ecuador. Audiences delighted in the details of mountains and vegetation he had transferred to canvas. Beyond the reportage of geological and botanical facts, however, the painting was celebrated by the public because it gave visual form to their idea of tropical America: It represented the long-lost Garden of Eden, a nascent world left untouched since the creation.

The underlying concept as well as the individual features of the canvas was explicated by the artist's trusted friend and spokesman, Theodore Winthrop, in a forty-page pamphlet entitled *A Companion to "The Heart of the Andes."* Winthrop, who had made two extended visits to the Tropics as an agent for the Pacific Mail Steamship Company in 1852 and as a volunteer on the U.S. Exploring Expedition to the Darien Peninsula in 1854, was well qualified to interpret Church's work.[7] Guiding the viewer step by step through the pictured landscape, he arrives at a plain just below the great mountain, a region that more than any other seemed to possess the qualities of life in the terrestrial garden:

When our mortal nature is dazzled and wearied with too long gazing on the golden mount, where silence dwells and glory lingers longer than the day, we may descend to the Arcadian levels of the Llano at the *Heart of the Andes.* . . . On the reaches of this savanna is space and flowery pasturage for flocks and herds. Llamas may feed there undisturbed by anacondas. No serpent hugs; no scorpion nips; never a mosquito hums over all this fair realm. Perpetual spring reigns. . . . Life here may be a sweet idyl.[8]

Conveyed through every aspect of the image—the everlasting blue skies, beautiful singing birds, and eternally green vegetation—is the notion that "we are safe in our Paradise at the Heart of the Andes."[9]

This association of the landscape of the American Tropics with an edenic garden was expressed verbally and visually by nearly every northern artist who traveled there in this period. References to Arcadia, Eden, paradise, Atlantis, Elysium (the vocabulary varied, but the underlying concept remained constant) were unfailingly applied to the entire extent of Central and South America. Sailing along one of the waterways in Honduras, the illustrator A. V. S. Anthony wrote, "Pursuing this little Euphrates through the Garden of Eden, we reached the *Camino Real* to Comayagua."[10] Describing his "Three Weeks in Cuba," another artist felt himself to be side by side with Columbus, seeing the New World for the first time:

Her mountains, rising in queenly magnificence, and crowned with a diadem of brilliant atmosphere, are yet as glorious—and, in her vestments of unequaled verdure, garnished every where with buds and blossoms, and fragrant with the perfumes which Araby could not yield for the garments of Sheba's Queen, she is yet as attractive as on that brilliant October morning, three hundred and sixty years ago, when Columbus, with the Pinzons and their followers anchored in the beautiful Nisse, chanted *Te Deum,* and then reveled in the paradisiacal luxuries of Nature in her plenitude.[11]

Catlin confirmed that at this moment the tropical landscape, more than any other, carried edenic connotations, for he described the scenery of Brazil in just such terms:

If anything on the face of the earth could properly be called a paradise, it was the beautifully rolling prairies, with their copses and bunches of graceful leaning palms and palmettos, encircled with flowers of all colors, spotted here and there with herds of wild cattle and horses, and hedged in a hundred directions with the beautiful foliage bordering the rivulets and rivers wending their serpentine courses through them.[12]

Gazing upon the tropical scenery, whether through the medium of the artist's canvas or firsthand, the viewer felt himself transported in time and place to the biblical garden.

The concept of America as the New Eden that flourished around mid-century can be traced back to the age of discovery and conquest. It was put into historical perspective for the American public by Washington Irving, who published *The Life and Voyages of Christopher Columbus* in 1828. Columbus, as Irving explained to his readers, believed he had found the long-lost terrestrial garden in the West Indies. In the accounts of his discovery he sent back from his first voyage, he had recourse to Ovid's description of the Golden Age. By his fourth voyage, when he reached South America, he became convinced that he had reached paradise. To the recipients of his letters the implications were obvious. Evocations of a "green and beautiful land" recalled the world before the Fall:

> Its lands are lofty and in it there are many sierras and very high mountains. . . . All are most beautiful, of a thousand shapes, and all accessible, and filled with trees of a thousand kinds and tall, and they seem to touch the sky; and I am told that they never lose their foliage, which I can believe, for I saw them as green and beautiful as they are in Spain in May, and some of them were flowering, some with fruit and some in another condition, according to their quality. And there were singing the nightingale and other little birds of a thousand kinds in the month of November. . . . There are palm trees of six or eight kinds, which are a wonder to behold because of their beautiful variety. [13]

Irving defended "the speculations of Columbus on the situation of the terrestrial paradise." He argued that "the world has ever been inquisitive as to the abode of our first parents, described in such engaging colours in holy writ" and observed that in the time of Columbus this notion especially held true. [14] The assumption widespread throughout Christendom was that the original home of Adam and Eve had been a garden from which they were driven. During the Middle Ages the Garden of Eden was believed to have somehow survived the Flood, and in the golden age of discovery in the fifteenth century men were ever hopeful of finding it.

Columbus believed that he had found it, and nineteenth-century Americans, through Irving's account, turned back to Columbus to confirm these cherished beliefs.

That Irving's life of Columbus enjoyed increased readership around 1850, more than twenty years after its initial publication, is evidence of the high premium Americans in this period began to place on accounts of the discovery and exploration of their land. Besides Irving, William H. Prescott, Henry Thoreau, and other well-known writers took up their pens to celebrate the achievements of Raleigh, Cortés, Balboa, and Pizarro. In this time of rapid expansion and increasing concern with national identity, it was not uncommon for Americans to look to their past—to the fifteenth- and sixteenth-century explorers of the New World—for historic precedents. These men, frequently unappreciated or even persecuted in their own times, became the heroes of the era of Manifest Destiny. [15] It is little wonder, then, that Americans referred to Columbus for the historical justification to equate their continent with paradise.

A distinguishing feature of equinoctial America is the type and fecundity of its vegetation. Humboldt described the overwhelming impression made by "that vigour and freshness of vegetable life which characterizes the climate of the tropics":

> When a traveller newly arrived from Europe penetrates for the first time into the forests of South America, he beholds nature under an unexpected aspect. He feels at every step that he is not on the confines but in the centre of the torrid zone; not in one of the West India Islands, but on a vast continent where everything is gigantic,—mountains, rivers, and the mass of vegetation. . . . It might be said that the earth, overloaded with plants, does not allow them space enough to unfold themselves. [16]

This quality, expressed in diverse ways, was emphasized in the painted and verbal descriptions of the Tropics. Whether the trees and plants were described in scien-

tific nomenclature or in the most nonspecific and romantic terms, the overriding impression was of nature at her most plentiful. This distinction was underscored by the Maya explorer John Lloyd Stephens, who compared the scenery of Central America to that of the Near East, which he had previously visited: "The wild defile that leads to the excavated city of Petra is not more noiseless or more extraordinary, but strangely contrasting in its steril [*sic*] desolation, while here all is luxuriant, romantic, and beautiful."[17] The Old World appeared barren in the face of this luxuriance, which was linked with the essence of existence. "Nature in these climes," wrote Humboldt, "appears more active, more fruitful, we may even say more prodigal of life."[18] The fertility of the tropical landscape ultimately identified it with the origins of life.

Increasingly, this concept of the prodigality and fertility of these regions converged in the image of the stately palm. Alfred Russel Wallace called palm trees "true denizens of the tropics, of which they are the most striking and characteristic features."[19] Traversing the continent, travelers saw countless palm varieties, many of which lacked species names, and held them synonymous with the Tropics. The palm became a genius loci of these southern regions; its nearly ubiquitous presence in the painted and verbal imagery indicated transport to the Torrid Zone. Within the flat, open expanses of Louis Mignot's *Lagoon of the Guayaquil* (pl. 2), for example, a single palm is given almost preternatural prominence, extending above the rest of the grove to the top of the canvas. Mignot's tropical pictures derived from one visit to Ecuador with Church in 1857. Although far less familiar to the twentieth century than his traveling companion, in his own day Mignot was considered "one of the most remarkable artists of our country." One critic, writing of the South American artist-travelers, singled out Mignot and Church as the two who had "won their fame by their magnificent paintings of the wild and gorgeous landscape of that, as yet, little known continent."[20] The conspicuous position the palm tree occupies in Mignot's

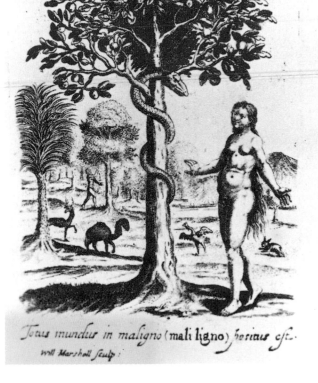

EMBLEMES. Book 1.

2. *Unidentified artist,* Temptation Scene, *from Francis Quarles,* Emblemes.

canvases, frequently at the expense of fidelity to nature, alerts us to its special significance.

Within the larger body of tropical scenes, the palm offers the key to the iconography of the edenic landscape. According to the Book of Genesis, two trees stood in the center of the Garden of Eden—the Tree of Knowledge and the Tree of Life. Although not named specifically in scripture, the Tree of Life became historically identified with the date palm, indigenous to the

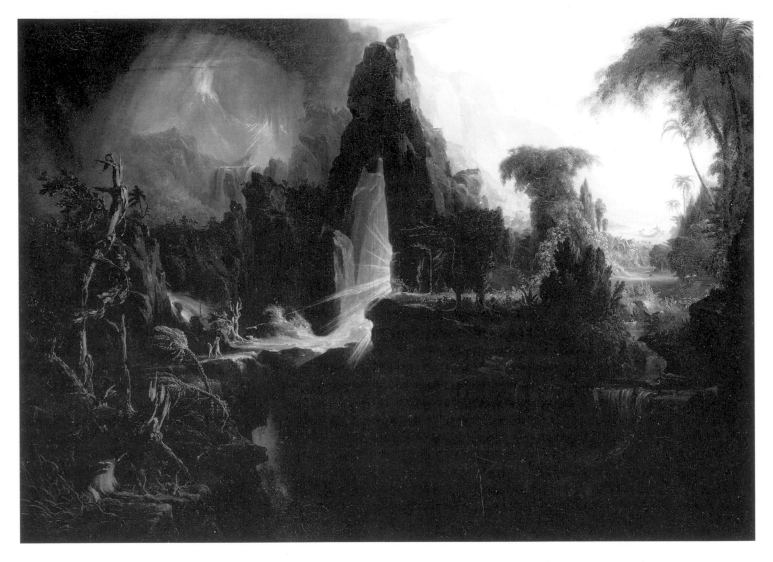

3. *Thomas Cole*, Expulsion from the Garden of Eden, *1828*, *oil on canvas, 39 × 54 in. (99 × 137.2 cm). Museum of Fine Arts, Boston, M. and M. Karolik Collection.*

biblical lands. But as exploration of the American Tropics proceeded from the fifteenth century onward, it began to appear that the coconut palm—which provided all the earthly needs of the native Indians—was more likely to be the tree alluded to in biblical accounts. Humboldt's nineteenth-century observations, echoing those of Sir Walter Raleigh and Columbus, literally interpreted the palm as a tree of life: "It is curious to observe in the lowest degree of human civilization the existence of a whole tribe depending on one single species of palm-tree."[21] A typical illustration of the Fall, which appeared in Francis Quarles's *Emblemes* of 1635 (fig. 2), depicts the Tree of Life, the evergreen palm, to the left of the Tree of Knowledge, whose forbidden fruit tempted Eve. The picture also suggests a mild climate,

in which trees flowered and bore fruit constantly and protective clothing was unnecessary. Other early prints of this subject include the fountain from whose boundary walls issued the four rivers of life: the Euphrates, the Hiddekel or Tigris, the Phison, and the Gihon. These features again find parallel in nineteenth-century descriptions of South America, which sometimes substituted its four great rivers: the Amazon, La Plata, the Orinoco, and the Magdalena. The concepts of perpetual spring and peace with and among the animals, associated with the mythical Golden Age, were also incorporated into pictorial renderings of this type.[22]

John Milton's arcadian Eden, described in *Paradise Lost*, was the primary source of edenic imagery in the post-Renaissance world. Milton's garden is an "enclosure green" with a lake that serves as a "crystal mirror," "lawns" where flocks graze, and "umbrageous grouts and caves of cool recess." Vegetation plays a substantial role in creating the setting. Among the "trees of noblest kind" he numbers "cedar, and pine, and fir, and branching palm." The Tree of Life, although not precisely identified with the palm, is evoked in several passages in terms recalling the lushness of those leafy tropical specimens:

> And all amid them stood the Tree of Life
> High eminent, blooming ambrosial fruit
> Of vegetable gold . . .[23]

The palm tree, echoing Milton's description of the Tree of Life, made an early and important appearance in American allegorical landscape painting in Thomas Cole's *Expulsion from the Garden of Eden* (fig. 3), a significant intersection between the literary and pictorial traditions. This picture, along with is companion, *The Garden of Eden* (now lost), was completed and exhibited in 1828, the year that also witnessed the publication of Irving's life of Columbus. In a letter of 26 November 1827 to his friend and patron Daniel Wadsworth, Cole described his works in progress in vocabulary that points to his direct reliance on Milton:

I am now painting in imagination a scene which I intend embodying on canvass for the next Exhibition. . . . The Garden of Eden is the subject—The scene as it exists in my minds eye is very beautiful. . . . If I had time I should indulge myself in attempting to describe the scene I have imagined: but can now only say that there are in it lofty distant Mountains, a calm expansive lake, wooded bays, rocky promontories—a solitary island, undulating grounds, a meandering river, cascades, gentle lawns, groups of noble trees of various kinds, umbrageous recesses, a crystall rill with bed of brilliant marble, golden sands, pebbles of every dye— banks of beauteous flowers, fruits, harmless and graceful animals & c & c. . . . I *must* say that our first parents shall not be forgotten they are on the flowery threshold of their bower, watching the glorious sun, rise from his eastern couch.[24]

In the finished *Garden of Eden*, the palm tree, whose presence Cole failed to mention in his letter, looms above the figures of Adam and Eve. It appears also in *Expulsion from the Garden of Eden* on the right or "paradisiac" side of the picture, thus reemphasizing its identification for Cole with the biblical Tree of Life.

These features, enumerated by Cole and incorporated into his allegorical pictures, were recognized by travelers in the contours of the Latin American landscape. When Winthrop wrote that perpetual spring reigned and llamas grazed undisturbed at the Heart of the Andes, when Anthony called the Honduran River the Euphrates, and when Catlin glowingly described the flowering plants and palms along the Amazon, they made deliberate reference to the biblical garden with which they increasingly came to identify the neotropical world. Cole perhaps drew on a similar firsthand source for his conception of paradise, his trip to the West Indies in 1820 with a friend whose health required warmer climates. There the scenery of the island of St. Eustatius suggested to Cole an edenic setting: "Fields of flowery luxuriance, groves of dark and glistening green made the spaces between the sea-shore and the distant slopes look to his enamored eyes like Paradise."[25] The

link between the literary Eden and Cole's actual experience of the Tropics is further supported by several passages in his short story "Emma Moreton: A West Indian Tale":

> The sun was just dipping his broad edge into the distant waters, which reflected his golden light, and each object in the Island was clothed in one of the richest tints of heaven—the mountains were bathed in the flood of colour, and the princely cocoanut tree, as it vibrated its plumed head in the breeze, seemed transmuted into gold.[26]

Shortly after writing these words, as he planned his painted image of the biblical Garden, Cole may have supplemented his study of Milton and the scriptures with his recollection of St. Eustatius.

Cole's importance in the development of tropical Paradise imagery in the mid-nineteenth century extends beyond his visualization of the Garden of Eden. As Washington Irving provided historical justification for the association of the New World landscape with paradise in his *Columbus*, Cole gave seminal pictorial form to the myth of America as a rediscovered Eden, where pristine nature antedated the civilized and cultivated landscape of Europe.[27] Writing in 1834 that in America "all nature is new to Art" and that its mountains were hallowed to his soul because "they had been preserved untouched since the creation," he attested to his belief that the American wilderness was a vestige of paradise.[28]

Cole's ideas were passed on to his pupil, Frederic Church. In Church's hands the concept of the New World paradise was given its most complete expression, an achievement built upon Cole's pioneering landscape efforts, accounts of the discovery and conquest by Irving and others, and Humboldt's natural history explorations. Cole died young in 1848; Irving and Humboldt died in 1859, the year Church painted *Heart of the Andes* and Darwin published *Origin of Species:* a chronological intersection that symbolizes the paradoxes of that pivotal moment. In the summer of that year, as *Heart of the Andes* began its extensive exhibition tour, large numbers of American artists traveled to increasingly remote locations on their annual excursions, as a report in the *Cosmopolitan Art Journal* indicates:

> Artists are now scattered, like leaves or thistle blossoms, over the whole face of the country, in pursuit of their annual study of nature and necessary recreation. Some have gone far toward the North Pole, to invade the haunts of the iceberg with their inquisitive and unsparing eye—some have gone to the far West, where Nature plays with the illimitable and grand—some have become tropically mad, and are pursuing a sketch up and down the Cordilleras, through Central America and down the Andes.[29]

They scanned the entire western hemisphere, from the arctic north to Tierra del Fuego, but to what end? Like Cooper's Natty Bumppo, they were after "Creation . . . all creation."[30] And more than any other single locale, the Tropics seemed to possess the secret of life. In the equinoctial lands nature existed not only unspoiled, but also at her most abundant, most fertile. In the very aspect of its incomprehensible vitality, it came to represent renewal, rebirth, the closest one could come to the primal state of the organic world. When artists made their arduous treks up the Andes and down the Amazon, confronting the landscape for themselves, they recognized the biblical garden in the natural facts of the tropical scenery; the signs were unmistakable in its physical contours.[31] They recorded the details in on-the-spot drawings and sketches and returned home to transfer to canvas their visions of a tropical paradise.

Advising painters to make "colored sketches, taken directly from nature," Humboldt had singled out the particular need for "a large number of separate studies of the foliage of trees; of leafy, flowering, or fruit-bearing stems; or prostrate trunks."[32] Among Church's on-the-spot drawings and oil sketches, the palm emerged as a favorite botanical subject.[33] Along with many quick vegetation studies sketched in small pocket notebooks, he made panoramic studies such as *View*

near Cartago (fig. 4), typical of the finished drawings he presumably did in the evening after a day's travel. The over-sized palm, rising above the surrounding deciduous forest, is the hallmark of these recollected compositions, an indication of the dominant place that tree occupied in his conception of the landscape.[34]

The palms that made their way into the finished paintings were, like the overall composition, synthetic. The specimen that appears in Church's *View of Cotopaxi* (see fig. 37) has been identified as a stylization of the genus *Scheelea*, possibly *Scheelea butyraacea*, once abundant in the valley of the Magdalena River, although the stalk of the flower clusters is longer than one would expect in a tree of that variety.[35] Church, it seems, transported to the base of the famous Ecuadorian volcano a palm tree of the type he had seen along the Magdalena in Colombia, further north, and subtly altered its form for pictorial effect. As the artist himself knew, however, palm trees and other verdant specimens did not grow in the relatively desolate region immediately surrounding the volcanic peak. A letter written by Church in 1866 in response to a commission for a palm-tree-laden view of Cotopaxi reveals that he was cognizant of the problems involved in introducing rich vegetation into such a landscape:

> Standing on the Easle [*sic*] is the canvas which I design for your picture. . . . I don't know how I am to get palm trees and other rich vegetation into a picture of Cotopaxi as, from any standpoint where the mountain is most imposing, the elevation is so great as to preclude the growth of palms & —. I have seen palms growing at a much greater elevation than the *Cotopaxi* plains but the big mountain grimly secludes itself in an immense circle of volcanic and comparatively barren country.[36]

In the *View of Cotopaxi* of 1857, Church had tried to partially circumvent this problem by taking a far view of its conical peak, thereby implying that his vantage point was at a substantial distance, where palms and flowering plants might be found in greater profusion. The palm remains, however, in this picture of Cotopaxi,

4. Frederic Church, View near Cartago, *1853, pencil and gouache on paper, 12¹/₄ × 18 in. (31.5 × 45.7 cm). Cooper-Hewitt Museum, Smithsonian Institution, New York (1917-4-75).*

as it does in almost every other tropical composition he painted between 1853 and 1865, including a particularly lush tree in *Cayambe* (pl. 3). In each it appears as one of the dominant features of the scene and competes with the Andean peaks for ascendancy into the heavens.

Why then would Church have omitted this important signpost to paradise from *Heart of the Andes,* his most complete statement of the tropical Eden? The answer lies in the subtle alterations that occurred between the study for the painting, done in 1858 (fig. 5), and the finished work. The palm tree in the study was replaced by a tree fern in the final version. The tree fern, which Heade made the central focus of his *Brazilian Forest,* "surpasses even the palm in refinement of foliage," Winthrop wrote, "and its plumes became the substitute for palms in the elevated zones where the latter would chill and whither."[37] Climatic conditions aside, the substitution of the tree fern for the palm had a significance consistent with an edenic reading of the great masterpiece. The tree fern, Agassiz explained, is a modern representative of a past type, the palm tree of the ancient vegetable world.[38] Gazing upon the tree fern in the right foreground of *Heart of*

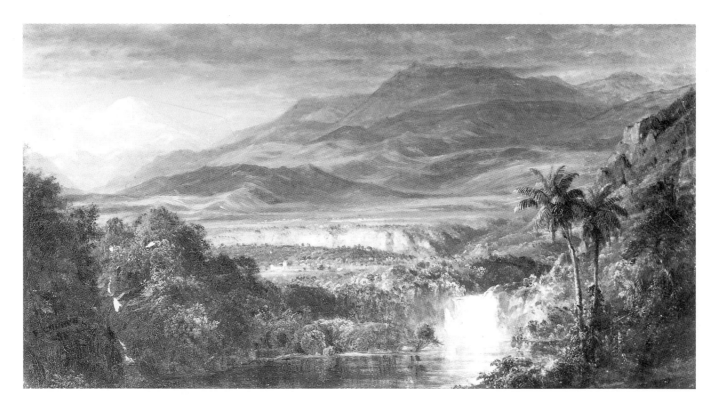

5. Frederic Church, Sketch for "Heart of the Andes," *1858, oil on canvas, 10¹/₄ × 18¹/₄ in. (26 × 46.4 cm). New York State Office of Parks, Recreation, and Historic Preservation, Olana State Historic Site, Taconic Region (OL.1981.47).*

the Andes, audiences felt themselves transported back to the inception of time. "When examining the noble plant one's thoughts go back to the gigantic growth of the pre-Adamic periods," one viewer explained, "and to the times when the foundations of the globe were shaken more terribly by the violence of the earthquake, and the mountains were lifted out of the sea."39

Gradually some of Church's critics began to voice the opinion that some element was missing from his tropical pictures; paradise required not so much scientific illustration as dreamy, poetic evocation. "The Heart of the Andes, as the natural philosopher sees it, is one thing," an observer wrote, "but the poet gets near enough to hear it beat."40 After mid-century many

began to name Louis Mignot as the artist best endowed with the power to portray the sentiment of the tropics. His *Evening in the Tropics* (fig. 6) must have been on critic Henry T. Tuckerman's mind when he wrote, "Quite diverse from the exactitude and vivid forest tints of many of our Eastern painters, are the southern effects so remarkably rendered by Louis R. Mignot, whose nativity, temperament, and taste combine to make him the efficient delineator of tropical atmosphere and vegetation."41

In contrast to Church, who preferred the Andean highlands, Mignot "especially delighted," as his British patron Tom Taylor explained, in depicting "the still lagoons, embosomed in rich tropical vegetation."42 *Lagoon of the Guayaquil* (pl. 2) represents such marshes along the Guayas River on the coast of Ecuador, filled with the melancholy of the evening sky. At this transitory moment, when the still waters reflect sky and merge with darkening earth, the silhouette of the palm

6. S. V. Hunt, engraving after Louis Mignot, Evening in the Tropics, *from Henry Tuckerman,* Book of the Artists.

is the only distinguishable element identifying the locale. In contrast to Church's scientism, Mignot was inclined by virtue of his southern origins and European training toward a more romantic outlook, in which the emblematic took precedence over the botanical significance of the tree. Elongating the trunk so that a single palm towers above the scene, forming a natural canopy to the landscape below, the artist signals to us the otherworldly realm of his canvas. In his picture, the palm rises above the view like Milton's tree in the Garden of Eden, the "highest there that grew."[43]

In the lowlands, where the palms and parasitic vines could be found at their most rank and luxurious, the painter's imagination was given full play. The lagoon possessed a dreamy atmosphere familiar to Mignot from a childhood in South Carolina that nurtured in him, as it had in another native painter, Washington Allston, an appreciation for the wild and the

mysterious. The mood of the lagoons near Guayaquil was not dissimilar to that of their counterparts in the American South, described by T. Addison Richards as "mystic lagunes [*sic*], in whose stately arcades of cypress, fancy floats at will through all the wilds of past and future."[44] In choosing the more magical realm, in catching what Tuckerman called his "vague expression," Mignot invited the viewer to complete in his mind's eye this enchanting vision. Beholding the strange presence of the palm against the twilight sky he may have fancied, as traveler John Esaias Warren did when for the first time he wandered in a tropical forest, that he was "in the midst of a delightful dream, from which he may at any moment be awakened," or that he had been "translated by some magical influence to the far-famed

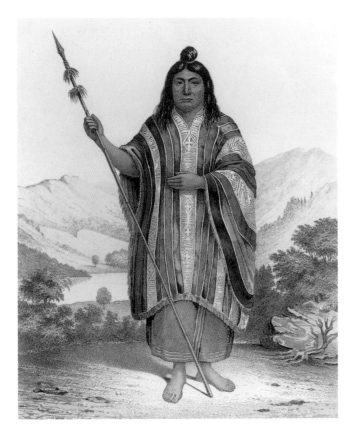

7. *After daguerreotype by Edmond Reuel Smith,* Araucanian Chief, *from James Gilliss,* U.S. Naval Astronomical Expedition to the Southern Hemisphere during the Years 1849–50–51–52.

garden of the Hesperides."[45] Mignot's pictures, often described in analogous terms of dream, myth, and magic, suggest a more imaginative evocation of the edenic local. His palm trees, projecting high into the heavens of his Ecuadorian landscapes, led to reveries of an idyllic world.

That Church's and Mignot's travels should have taken them to Ecuador, of all the countries in South America, is not without significance. This small nation is located on the equator at zero degrees latitude, the line dividing the northern from the southern hemisphere. The Bavarian explorers Spix and Martius referred to it as "the place where heaven and earth were in equilibrium."[46] The timeless quality of nature at the equator, where days are of equal length and the seasons constant, captured the imagination Herman Melville. In his story of the "Encantadas"—the Galápagos Islands off Ecuador—he wrote of their "special curse": "To them change never comes: neither the change of seasons nor of sorrows. Cut by the Equator, they know not autumn, and they know not spring.[47]

Nature seems to be at its most fertile in Ecuador, as the distribution of palms emphasizes. The loftiest and most regal specimens are located directly on the imaginary circle and as they approach the Temperate Zone diminish in height and beauty.[48] Here one could study the question of creation, for "the nearer we approach the equator," Warren noted, "the more prolific do we find the mysterious essence of life."[49] The capital city of Quito, not far from the equatorial line, derived its particular reputation as the terrestrial paradise in part from these associations. The region depicted in *Heart of the Andes* and in Mignot's lagoon scenes took on something of the timelessness and vitalism characteristic of life at the equator, and of Eden itself.

For the majority of artist-travelers, the Latin American landscape was closely linked to the myth of paradise, as revealed in the resultant paintings. Yet the image of the terrestrial garden was not the only mirage shimmering on the southern horizon, nor was Columbus the only explorer to whom North Americans turned for inspiration for their own travels. In this period numerous accounts were mined for the wonders they disclosed, not only of the landscape, but also of the people who inhabited it. Tales of the indomitable Araucanian Indians of southern Chile, told by Alonso de Ercilla in his sixteenth-century epic poem, *La Araucana,* and perpetuated by Voltaire, inspired great curiosity:

> Robust and beardless,
> Bodies rippling and muscular
> Hard limbs, nerves of steel,
> Agile, brazen, cheerful,
> Spirited, valiant, daring,

Toughened by work, patient
Of mortal cold, hunger and heat.⁵⁰

North American draftsman Edmond Reuel Smith was
among those inspired to portray these noble Indians
(fig. 7) and publish his observations in an illustrated
book, *Araucanians; or, Notes of a Tour among the Indian
Tribes of Southern Chili* [*sic*], in 1855.⁵¹ In the same
year an article appeared in *Putnam's Magazine* on "The
Amazons of South America"; it began with Francisco
de Orellana's search for these fantastic women, which
resulted in his discovery of the Amazon River, and
brought it up to the present day, concluding, "Even to a
very recent period, the story of the Amazons was still
current in South America."⁵² His remarks, like those
of Smith on the Araucanians, hint that their hopes for
finding these remarkable creatures had not been totally
extinguished. They knew these people could not exist as
they were described; and yet somehow in the wilds of
South America anything seemed possible, as Catlin's
musings on the legendary Patagonian giants suggest:
" 'Patagonia and the Patagons, of course.' The 'Giants of
Patagonia—ten feet high!' The 'Cannibals!' I did not
believe such things, but would go and look for them
through the centre of Patagonia and Terra [*sic*] del
Fuego."⁵³

Latin America as El Dorado

Of the many myths enticing men to the shores of Latin
America, that of El Dorado has proven historically the
most decisive. El Dorado, literally "the Golden Man,"
was the leader of an Indian tribe somewhere in the
northern territories of South America. Every year, at
the climax of a religious ceremony, he was covered with
gold and in a ritual act of purification submerged in a
lake, to rise again. Stories of these practices reached the
Europeans and seemingly were substantiated by the
gold artifacts traced to those regions. The fabulous
wealth of El Dorado became firmly associated with the
lands of the ancient Americans in the mid-nineteenth-

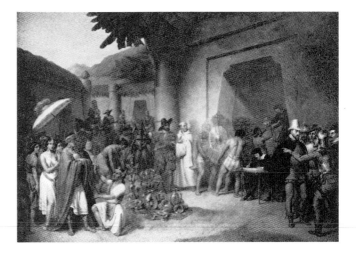

8. *Christian Mayr,* Conquest of Peru: King Atahualpa Filling
a Room with Gold to Purchase His Freedom from Pizarro,
*1849, oil on canvas, 40 × 54 in. (101.6 × 137.2 cm).
Courtesy of Kennedy Galleries, Inc.*

century mind through the writings of William Prescott.
In *History of the Conquest of Mexico* (1843) and *History
of the Conquest of Peru* (1847), the author vividly evoked
the splendid riches of the Aztec and Inca empires.⁵⁴
Church was among the many painters who owned copies
of Prescott's volumes, as did Emanuel Leutze, who
undertook *The Storming of the Teocalli Temple by Cortez
and His Troops* (1849; Wadsworth Athenaeum). This
large canvas depicts the conquistadors attacking the
Aztecs, half naked but for their golden helmets and
chains, much as Prescott had described them.⁵⁵

Christian Mayr's *Conquest of Peru* (fig. 8), exhib-
ited at the National Academy of Design in 1849, dem-
onstrates even more emphatically the link between these
lands and peoples and their purported golden treasure.
From among the many incidents of the Peruvian con-
quest and the numerous achievements of the Incas,
Mayr chose the moment in the historical narrative when
Atahualpa filled a room with gold as a ransom to
Pizarro for his life. The painting features the cloaked
King Atahualpa, supervising the workmen who load the
golden utensils and ornaments into the storeroom, while

Spanish soldiers and a friar look on. Prescott's contemporary text provided the background for the picture as it would have been understood by the general public:

It was not long before Atahuallpa [*sic*] discovered, amidst all the show of religious zeal in his conquerors, a lurking appetite more potent in most of their bosoms than either religion or ambition. This was the love of gold. . . . In the hope, therefore, to effect his purpose by appealing to the avarice of his keepers, he one day told Pizarro, that, if he would set him free, he would engage to cover the floor of the apartment on which they stood with gold. Those present listened with an incredulous smile; and, as the Inca received no answer, he said, with some emphasis, that "he would not merely cover the floor, but would fill the room with gold as high as he could reach. . . ." No sooner was this arrangement made, than the Inca despatched couriers to Cuzco and the other principal places in the kingdom, with orders that the gold ornaments and utensils should be removed from the royal palaces, and from the temples and other public buildings, and transported without loss of time to Caxamalca. . . . The greedy eyes of the Conquerors gloated on the shining heaps of treasure, which were transported on the shoulders of the Indian porters, and, after being carefully registered, were placed in safe deposit under a strong guard.[56]

Thus, the Incas were associated primarily neither with their enlightened ideas of government nor with their advances in astronomy (both of which Prescott discussed at length), but with their riches, that is, with the wealth that was already associated in the popular imagination with Latin America. Tales of the Aztec and Inca gold, mingled with nineteenth-century reports of mines of precious metals and gems, seemed to confirm the myth of El Dorado.[57]

Combining the idea of the wealth of lost empires with the original legend of Indian ritual, El Dorado came to stand for a specific place, although its precise location remained a matter of some debate. Writing in 1810, Humboldt followed the tradition that placed it in the area of Lake Guatavita, some fifty miles northeast of the Colombian capital of Bogotá. He illustrated Lake Guatavita in *Picturesque Atlas* and described its significance within the context of Indian lore:

The lake is situated to the north of Santa Fe de Bogotá . . . in a wild and solitary spot. In the drawing are shown the remains of a flight of steps, serving for the ceremony of ablution; and a cut in the mountains, which was attempted a short time after the conquest, to dry up the lake, and find the treasures, which, according to tradition, the natives had concealed, when Quesada appeared with the cavalry on the plain of New Granada.[58]

The location of this site, by no means as certain as Humboldt might lead us to believe, was the impetus for much exploration over the centuries. Raleigh became convinced that El Dorado was not in Colombia but in Lake Parime, further east in Guiana. Having failed in his attempts to establish a colony in Virginia, he was driven by the reports of the putative riches to explore Guiana in 1595, and although he did not participate personally, to send out additional reconnaissances in 1596 and 1597. Imprisoned in the Tower of London for treason in 1603, he was finally released in 1616 on the condition that he lead a fourth expedition to Guiana to bring back evidence of the gold mines he claimed existed there. Having returned empty handed, the celebrated man was beheaded on 29 October 1618.[59]

Though El Dorado forever eluded Raleigh, the notoriety surrounding his career helped perpetuate his belief that it lay hidden somewhere in Guiana, an idea repeated by Milton in *Paradise Lost:*

> . . . and yet unspoiled
> Guiana, whose great city Geryon's son
> Called El Dorado.[60]

Closely linked with the myth of El Dorado, Raleigh's life and writings were studied in the nineteenth century, when he was held up as one of the exemplars of his age.

Raleigh was Thoreau's favorite character in English history. In the early 1840s he wrote an essay

celebrating his voyages of discovery and colonization in both North and South America. His heroism, Thoreau argued, could be assessed only with respect to America, for none of his achievements "can be duly appreciated if we neglect to consider them in relation to the New World."[61] He defended the explorer's relentless search for riches, arguing, "It is easy to see that he was tempted, not so much by the lustre of gold, as by the splendor of the enterprise itself." Not unlike Irving's defense of Columbus, Thoreau's essay attempted to put Raleigh's pursuit of El Dorado in the context of the beliefs of his age:

> It is not easy for us at this day to realize what extravagant expectations Europe had formed respecting the wealth of the New World. . . . The few travellers who had penetrated into the country of Guiana, whither Raleigh was bound, brought back accounts of noble streams flowing through majestic forests, and a depth and luxuriance of soil which made England seem a barren waste in comparison. Its mineral wealth was reported to be as inexhaustible as the cupidity of its discoverers was unbounded. The very surface of the ground was said to be resplendent with gold. . . . These and even more fanciful accounts had Raleigh heard and pondered, both before and after his first voyage to the country.[62]

Raleigh's own account, to which Thoreau alluded, may have been found in *History of the World*, written during his imprisonment in the Tower of London and read by Thoreau beginning in 1842.[63] More pertinent for South American travelers was Raleigh's report of his expeditions. Entitled *The Discovery of the Large, Rich, and Beautiful Empire of Guiana* (1596), it seems to have made a particular impact on Catlin, one of the few artists of the period to visit the regions of Guiana and northern Brazil described therein. The book was reissued in 1848, edited with an extensive introduction by Robert Schomburgk, a close associate of Catlin's who had himself explored Guiana.[64]

The appearance of the reprinted edition of

Raleigh's book could not have been more timely for Catlin. By the spring of 1852 the artist's debts finally caught up with him; he was thrown in prison and forced to sell his Indian Gallery to Joseph Harrison of Philadelphia.[65] Finding himself in such dire financial circumstances, the artist must have thought only something as fantastic as the treasure of El Dorado could rescue him, and he formulated a plan to go to Guiana. In a chapter of *Last Rambles* entitled "Gold Hunting in the Crystal Mountains," Catlin provided an account of the events leading to his departure:

> My "occupation gone," and with no other means on earth than my hands and my brush, and less than half a life, at best, before me, my thoughts . . . tended towards Dame Fortune, to know if there was there anything yet in store for me. . . . In this state of mind, therefore, into one of the eccentric adventures of my checquered life I was easily led at that time, by the information got by a friend of mine, a reader in the Bibliotheque Imperiale of Paris, from an ancient Spanish work, relative to gold mines and marvellous richness, said to have been worked by Spanish miners some 300 years since, in the Tumucamache [Tumucumaque] (or Crystal) mountains, in the northern part of Brazil. . . . Nuggests of gold of all sizes appeared in my dreams. . . . With such reflections and anticipations I started, in 1852 . . . for the Crystal Mountains, in Brazil.

Once in Brazil, Catlin found in a mountain stream "a cluster of nuggets, from the size of a pin's head to the size of a pea," which convinced him that he and his party had arrived "at or near our 'El Dorado,' " a phrase used with deliberate reference to Raleigh.[66] But the "mother lode," the larger deposit of precious metal further upstream, never materialized. Thwarted in his search for riches once again, Catlin made a series of pictures of the Crystal Mountains. In this effort he repeated the practices of travelers since the sixteenth century, who recorded the appearance of the mountains containing rich metal stores. A woodcut illustration,

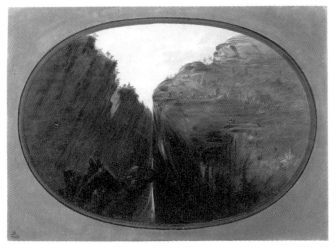

9. *George Catlin*, Rhododendron Mountain, *1852–57, oil on cardboard, 15⁷⁄₈ × 21⁷⁄₈ in. (40.3 × 55.6 cm). National Gallery of Art, Washington, D.C., Paul Mellon Collection (1965.16.273 [2231]).*

10. *George Catlin*, The Beetle Crevice, *1852–57, oil on cardboard, 15³⁄₈ × 21⁷⁄₈ in. oval (39.1 × 55.6 cm). National Gallery of Art, Washington, D.C., Paul Mellon Collection (1965.16.268 [2226]).*

The Silver Mines of Potosí, published in Pedro Cieza de León's *Crónica del Perú* in 1553, documents the topography of the mountain and surrounding town with little hint of the substantial profit it yielded to the Spanish Crown. Catlin's pictures, similarly matter-of-fact, convey the immediacy of his response to the Brazilian landscape. Some images take a distant view of the terrain; others, including *Rhododendron Mountain* (fig. 9) and *The Beetle Crevice* (fig. 10), give close-up views of its rocky masses.

These mountains did not offer up the diamonds and gold they were thought to contain but became instead the subject of some of the most interesting of Catlin's South American landscape studies. His painted and written descriptions of Raleigh's "Mountains of Crystal" represent the specific point of intersection between the sixteenth-century explorers and the American artists who came to identify with them. In the minds of others, however, the myth of El Dorado, independent of Raleigh's adventures and of the restrictions of precise time and place, evolved into an abstraction. The search for the riches of the ancient Indians had

merged with the biblical concept of the Garden of Eden to give rise to a universal tropical utopia. Writing from the vantage point of the last quarter of the twentieth century, V. S. Naipaul summarized these developments: "El Dorado, which had begun as a search for gold, was becoming something more. It was becoming a New World romance, a dream of Shangri-la, the complete, unviolated world."[67]

Latin America as an Untried Frontier

Even as Catlin dreamed of the paradisiac shores of the Amazon and of the gold he would cart away, he was equally stirred by "the stimulus of an unexplored country."[68] In so saying, he pinpointed a prime factor in the American artist's motivation for southbound travel. Of all the points on the globe to which they could have headed, South America was one of the last untried frontiers. "It is probably venturing nothing to say," Rev. J. C. Fletcher observed as late as 1857, "that a very large majority of general readers are better acquainted

11. *John Greenwood*, Sea Captains Carousing in Surinam, *c. 1758, oil on bed ticking, 37³/₄ × 75¹/₄ in. (95.9 × 191.1 cm). St. Louis Art Museum (256.1948).*

with China and India than with Brazil."[69] The desire for adventure, for the excitement of new experiences and challenges, seems to have been inextricably bound up in their fascination with the Tropics.

This zest for adventure and fortune-seeking is typified in John Greenwood's remarkable early genre piece, *Sea Captains Carousing in Surinam* (fig. 11), painted on bed ticking about 1758. A tavern scene of a ship's captain and his crew eating, drinking, and playing cards, it is a combination group portrait and image of collective pleasure. It was based presumably on the firsthand experience of the Boston-born Greenwood, who moved to the Dutch colony of Surinam (present-day Dutch Guiana) in 1752. Most of the characters are identifiable as the artist's friends, mariners from Rhode Island, including the future governor of the colony, the commander of the continental navy, and a signer of the Declaration of Independence. The artist himself also appears, departing the scene with candle in hand. The

freedom with which he painted these men staggering drunkenly and indulging themselves in a manner reminiscent of Hogarth (whose *Midnight Modern Conversation* of 1732–33 may have provided a model) was rarely seen in the art of colonial America. The license Greenwood took in this picture may have stemmed from the mood of his exotic locale, where such behavior, unacceptable at home, was permitted and even condoned. In the wilds of South America, even the most constrained of colonial portraitists felt free to depict the life of adventure as it was lived in this remote outpost.[70]

The love of travel and adventure has historically been regarded as an important characteristic of the American cultural identity. In the nineteenth century it manifested itself in a vogue for travel literature and paintings of exotic places that reached an unprecedented

peak in the 1850s. Writing in 1851, Bayard Taylor, whose incessant wanderings earned him the epithet "the Great American Traveler," summarized the attitude he shared with his painter friends: "There is no use in continually walking in other people's tracks."[71] This need for pioneer experience was fully satisfied in Latin America, where every bend in the river and every mountain pass seemed to bring the northern visitor into terrain never seen by outsiders. Probably little of the territory had not been traversed by missionaries, explorers, or fortune seekers over the centuries, but the frequency with which the nineteenth-century voyagers boasted in their letters and journals that they had gone where no (white) man had ever gone before testifies to the significance they attached to this supposed achievement. "In these little frequented countries," Darwin explained, "there is also joined to it some vanity, that you perhaps are the first man who ever stood on this pinnacle or admired this view."[72] When John Lloyd Stephens declared in Yucatán that "the ground was entirely new," or when Church said that he preferred the mountains of the New World to those of the Old because the Alps lacked "many important features which made the Andes wonderful and exclusive," they implied that tropical America had not been tread by others and was exclusive to them.[73] They had discovered and claimed it for their own.

The frontier quality of tropical America, like its mythical identification with the terrestrial paradise and the land of El Dorado, functioned as a positive point of attraction and beckoned travelers to its shores. At the same time, the dark and unknown aspect of the tropical frontier operated as a factor of negative escapism.[74] This same polarity of motivation lay behind the fictional voyages of Childe Harold as delineated by Byron, who identified first the positive elements:

Where rose the mountains, there to him were friends;
Where roll'd the ocean, thereon was his home;
Where a blue sky, and glowing clime, extends,
He had the passion and the power to roam;

The desert, forest, cavern, breaker's foam,
Were unto him companionship; they spake
A mutual language, clearer than the tome
Of his land's tongue . . .[75]

But Childe Harold, like the American artists who were sometimes directly compared to him, was driven by the need for escape from negative forces in his own life to seek refuge in exotic locales:

Self-exiled Harold wanders forth again,
With nought of hope left, but with less of gloom;
The very knowledge that he lived in vain, . . .
Had made Despair a smilingness assume, which though
'twere wild, . . .
Did yet inspire a cheer, which he forbore to check.[76]

Negative escapism was a significant factor in the tropical adventures of artists as diverse as Catlin, Francis Drexel, and Eadweard Muybridge. These men went into a kind of self-imposed exile in the depths of Latin America, which, with its vast pampas and lawless gauchos, seemed an extension of the Old West. Like the West, it offered a place to hide, to escape from difficulties—legal, financial, or personal—while holding out the promise of exploration and discovery.

This notion of South America as a frontier escape found its most illustrious adherent in the person of Robert Leroy Parker, better known as Butch Cassidy. When Cassidy could no longer evade the Pinkerton men, he set sail for Buenos Aires, where he believed he would be safe from extradition.[77] The underlying reason behind Catlin's departure for South America was not so different. Although he described himself as being down on his luck after losing the Indian Gallery, the circumstances were far more grave than his remarks allow. He was forced to leave England and was in danger of being sent back to debtor's prison should he return there. His five-year stay in South America, it has been suggested, was intended to let the statute of limitations on his debts expire.[78] Drexel hatched a

scheme to go to Ecuador to paint portraits of Simón Bolívar rather suddenly upon the loss of his job and all his portrait commissions, the result of slanderous attacks published against him. After an unsuccessful libel suit he took refuge in South America, where he spent the next four years, from 1826 to 1830, traveling as an itinerant portraitist.[79] But perhaps the most notorious example of an American artist seeking escape in the Tropics is that of Muybridge, who departed secretly for Central America to avoid arrest and imprisonment for murdering his wife's lover and allegedly poisoning his wife.[80]

To each of them Latin America offered a place of refuge, the promise of new beginnings. A letter Butch Cassidy wrote home from Ten Chubut, Argentina, in 1902 speaks for the asylum each of them at least temporarily found:

> It will probably surprise you to hear from me away down in this country but the U.S. was too small for me the last two years I was there. I was restless. I wanted to see more of the world. I had seen all of the U.S. that I thought was good. . . . I visited the best cities and the best parts of South A. till I got here. And this part of the country looked so good that I located, and I think for good, for I like the place better every day. . . . The only industry at present is stockraising (that is in this part) and can't be beat for that purpose, for I have never seen finer grass country, and lots of it hundreds and hundreds of miles that is unsettled and comparatively unknown.[81]

Like him, the painters, draftsmen, and photographers found at least momentary respite in the Tropics. But more importantly, once there they each experienced a resurgence of their artistic powers. Muybridge, once safe in Guatemala, went on to produce an extraordinary series of photographs of coffee plantations and scenery (fig. 12), among the finest of his late works. Drexel painted a number of portraits, which netted him the profits he needed to return home and begin life afresh. And, in spite of advancing age and total deafness, Cat-

12. Photograph of Lake Atitlán, Guatemala, 1875, by Eadweard Muybridge. From Muybridge, The Pacific Coast of Central America and Mexico.

lin added to his gallery of western landscapes and Indian portraits an entirely new body of images, accomplished in a final burst of creative energy that he probably never would have experienced without the stimulus of equinoctial nature.

The Expressive Dilemma and the Failure of the Written Word

No matter how varied the reasons behind the departures of these travelers, they almost universally experienced the same sensation upon their arrival in Latin America: They were struck with wonder at all that surrounded them and at the same time with a feeling of their inadequacy to convey it. This theme recurs in the written accounts from the time of the discovery to the present. Authors invariably expressed their frustration that they felt incapable of conveying the appearance and mood of the tropics. The recent Colombian Nobel laureate, Gabriel García Márquez, acknowledges this dilemma: "One very serious problem that our boundless reality poses for literature is the inadequacy of words." The length and breadth of the Amazon, for example, never seem to have been described adequately despite the repetition of facts and figures. "When we speak of a

river," García Márquez continues, "a European reader is not likely to imagine something larger than the Danube, which is 2,700 kilometers long. It is hard for him to imagine . . . the reality of . . . the Amazon, which is 5,500 kilometers long. At Belén del Para [Belém] the river is wider than the Baltic Sea."[82] After eleven years on those same waterways, the nineteenth-century British naturalist Henry Bates stared with unabashed awe at what he termed "the sea-like expanse of water," where the Madeira—in its two thousand miles the greatest of all tributaries—united with the even greater Amazon. His account testifies to the difficulties of portraying such a sight in words:

> I was hardly prepared for a junction of waters on so vast a scale as this, now nearly 900 miles from the sea. Whilst travelling week after week along the somewhat monotonous stream, often hemmed in between islands, and becoming thoroughly familiar with it, my sense of the magnitude of this vast river system had become gradually deadened; but this noble sight renewed the first feelings of wonder. One is inclined, in such places as these, to think the Paráenses do not exaggerate much when they call the Amazons the Mediterranean of South America.[83]

The reality of the neotropical world proved as fantastic as the myths that had attracted men there.

In agreement on the near impossibility of describing the South American continent, other travelers met the challenge in different ways. Frederic Church, bewildered by the first sight of tropical nature, struggled to express what stood before him. A letter he wrote to his mother just after his arrival on the Caribbean coast of Colombia gives his immediate reaction to the strange, new plant life:

> I have already seen many things that would be the making of a florist. What do you think of hugh cactus overtopping trees and some decayed and fallen like logs, and of monstrous plants resembling in the appearance of the leaves & c. "Life Everlasting" 20 and 30 feet high and covered with highly scented blossoms; large trees without a single green leaf covered entirely twigs and

branches with bright yellow flowers or of huge shapeless stems terminating with magnificent white blossoms. I cannot here attempt to enumerate the great variety of vegetation which I saw even in this barren part of the country but shall keep my eyes open.[84]

His method here, a catalogue of diverse objects, is a commonly employed device. It involves an even more subtle rhetorical principle, what William Faulkner might have called the *reducto parvum:* rendering a few objects in high detail and then indicating the incompleteness of the inventory.[85] Similarly confounded, Catlin threw up his hands in momentary defeat when he came upon the pampas, which "no pencil could portray and no pen could describe."[86]

Humboldt had already addressed the problem of accurately describing tropical nature. His unceasing efforts to record his observations of America were an extension of his lifelong concern with the descriptive potential of language, of the ability (or inability) of words to carry the effect of nature. As an explorer he wished to convey with precision and economy the most distinguishing physical characteristics of a particular geographical region. Yet he recognized that language could give an imprecise notion of the very aspect he was concerned with portraying. In one of the essays in *Views of Nature* entitled "The Nocturnal Life of Animals in the Primeval Forest," he explained:

> If the faculty of appreciating nature, in different races of man, and if the character of the countries they now inhabit, or have traversed in their earlier migrations, have more or less enriched the respective languages by appropriate terms, expressive of the forms of mountains, the state of vegetation, the appearances of the atmosphere, and the contour and grouping of clouds, it must be admitted that by long use and literary caprice many of these designations have been diverted from the sense they originally bore. Words have gradually been regarded as synonyms, which ought to have remained distinct; and languages have thus lost a portion of the expressiveness and force which might else have imparted a physiognomical character to descriptions of natural scenery.[87]

He was concerned that language lacked the power to convey a scene's peculiar "physiognomy," or distinctive topographical character. To reestablish the physiognomy of nature as a subject worthy of description, he published more than thirty volumes, subsequently translated into numerous languages.[88] Yet despite this immense verbal outpouring, his overriding conviction of the inadequacy of words led him to despair of his own verbal efforts: "Notwithstanding all the richness and adaptability of our language, to attempt to designate in words, that which, in fact, appertains only to the imitative art of the painter, is always fraught with difficulty."[89]

Artistic Models

From the moment in 1790 when Humboldt discovered the pictures of exotic scenery by William Hodges in the London collection of Warren Hastings, he realized the value of landscape painting for the dissemination of knowledge of distant terrains.[90] The written word no longer had to bear the total burden of conjuring up the appearance of these far-flung lands; artists could be enlisted to make reliable pictorial records. And so he put forth in *Cosmos* his now well-known call for artists to paint the Tropics. But even if the artist took Humboldt's entreaty to heart, made the difficult journey to South America, recorded his on-the-spot observations in pencil drawings and colored sketches, and survived the trip home, he faced an even more difficult task: adequately transferring the impact of the tropical scenery to the finished painting. If he tried to adapt it to conventional models, he ran the risk of sacrificing its most unusual and distinctive characteristics.

Were there, then, any more appropriate models around with which to formulate his painted image? Humboldt had urged the landscapist to paint the Tropics largely because it was—artistically speaking—virgin territory. Yet he was acutely aware (perhaps as a result of his own efforts at picture making) that some guide was needed. To this end he enumerated for his prospective followers the few instances of painters who

had portrayed exotic landscape. "The merit of the earliest attempts at such a mode of representation," he wrote, "belongs to the Flemish painter Frans Post of Haarlem." Post traveled as Prince Maurits's official artist on his expedition to Pernambuco in 1637 and recorded the countryside of the Brazilian *nordeste*, while his fellow artist Albert Eckhout produced a remarkable series of life-sized portraits of the local natives. Post's style, which combined close attention to detail with the panoramic format of the seventeenth-century Dutch landscape school, was well suited to his task.[91] Works from his hand, including *A Brazilian Landscape* (see fig. 68), inaugurated the tradition of topographical and scientific painting that was to become an important element in the nineteenth-century images of Latin America.

Although he did not visit South America, Hodges made important contributions to the iconography of exotic landscape painting. In the South Pacific with Capt. James Cook's second voyage from 1772 to 1775, Hodges fulfilled the instructions of the British admiralty to "give a more perfect idea [of these regions] . . . than can be formed from written descriptions only."[92] Following his South Seas excursion with a tour of India, Hodges became one of the most widely traveled artists of his day. His *Travels in India during the Years 1780, 1781, 1782, and 1783* recorded these experiences and adapted Sir Joshua Reynolds's three stages of artistic development to the role of the artist-traveler.[93]

Humboldt's survey of prototypes is brought up to the nineteenth century in his *Personal Narrative* by the mention of several German artists: "These examples of delineation of the physiognomy of natural scenery . . . [have] been done, in more recent times, on a far grander scale, and in a masterly manner, by [Moritz] Rugendas, Count Clarac, Ferdinand Bellerman[n], and Edward Hildebrandt; and for the tropical vegetation of America, and many other parts of the earth, and by Heinrich von Kittlitz, the companion of the Russian Admiral Luetke, on his voyage of circumnavigation."[94]

To what extent were these images, which Humboldt failed to illustrate, available to his American readers? Engravings after Post's tropical landscapes

were reproduced in C. van Baerle's history of Prince Maurits's governorship of Dutch Brazil, one of the first scholarly books to be published on South America, and they were widely "borrowed" for subsequent volumes. On occasion his paintings, or at least those attributed to him in the nineteenth century, were acquired by North American collectors and shown in public exhibitions. In 1834, for example, Post's *Bears—Landscape in Surinam* and *Lions* (presently unlocated) were lent to the First Annual Exhibition of Paintings at the Louisville Museum and Gallery of the Fine Arts by one Thomas Hilson.[95] The similarity between Post's placement of his signature on the foreground tree in *Brazilian Landscape* and the "1859 / F. E. Church" carved into the tree spotlighted in the left foreground of *The Heart of the Andes* makes it tempting to assume that Church was familiar with the work of his seventeenth-century predecessor. And living five years at the Hague, where Prince Maurits's collection was housed, Mignot likely encountered Post's art. Similarly, the name of Hodges was not unfamiliar to American artists, some of whom owned illustrated editions of his *Travels in India*. In this book Mignot could have found the inspiration to follow his own trip to South America with another to India.[96] Maybe he and others identified with Hodges in a more general way as well. For the conflict Hodges faced in reconciling European artistic convention with the desire for accurate portrayal of the scenery and people of the South Pacific was not unlike the difficulty his North American counterparts faced in rendering South America almost three-quarters of a century later. And perhaps Humboldt's mention of Rugendas, Bellermann, or Hildebrandt would have stirred curiosity about them. The work of Rugendas, for example, was available in his *Voyage pittoresque dans le Brésil* (1835), which focused on the customs and manners of the local people; images by him and others may have reached the American public in this format.[97] The evidence suggests, however, that the work of these European painters served not so much as models, but rather as challenges to the New World artists. Humboldt's mention of his countrymen may have struck a cord of national pride in select American painters, who became increasingly convinced that the delineation of American territories should be their exclusive province. Thus Church, Catlin, Mignot, Heade, and many other American artists read Humboldt's words and, believing he wrote directly to them, took up his mandate:

> Are we not justified in hoping that landscape painting will flourish with a new and hitherto unknown brilliancy when artists of merit shall more frequently pass the narrow limits of the Mediterranean, and when they shall be enabled, far in the interior of continents, in the humid mountain valleys of the tropical world, to seize, with the genuine freshness of a pure and youthful spirit, on the true image of the varied forms of nature?[98]

Art in the Context of United States-Latin American Relations from the Vantage Point of 1859

The occasion has been judged proper, for asserting, as a principle in which the rights and interests of the United States are involved, that the American continents, by the free and independent condition which they have assumed and maintained, are henceforth not to be considered as subjects for future colonization by any European powers. . . . We should consider any attempt on their part to extend their system to any portion of this hemisphere as dangerous to our peace and safety.

JAMES MONROE, Address to Congress, 1823

*H*umboldt's evocative descriptions of South America and his call for artists to paint its scenery fell on receptive ears in the United States in the 1850s. Coming of age with his election to full membership in the National Academy of Design in 1849, Church was destined to become his foremost artist-disciple. The popular exhibition of his masterpiece *Heart of the Andes* (pl. 1) in 1859 marks the high point of northern interest in the southern continent (and concomitantly, of Humboldt's influence in the country at large). The painting was shown beginning that spring to large crowds in New York, other cities around the country, and London; it created a sensation unmatched in the history of American art. The five-by-ten-foot canvas debuted at the Tenth Street Studio Building on lower Broadway, in an illusionistic frame resembling a window casement.[1] Rumors spread about the number of people viewing the painting and the profit realized on the twenty-five-cent admission charge. John Ferguson Weir later reminisced about seeing the legendary picture of the closing day of the show:

I had gone to the City as a boy to see *The Heart of the Andes* on the last day of its exhibition in the Gallery of

the Tenth Street Studios. . . . I was told by the door-keeper that the paying attendance for that day was more than six thousand visitors. It seemed to me as I approached the Studios at noon that the stream of visitors reached nearly from Sixth Avenue to Broadway and I refer to it as phenomenal in the history of single-picture exhibitions.[2]

Spectators delighted in the picture's minute detail, intended to be studied with opera glasses to get the full effect, for the vegetation, the miniature village on the lakeshore, and the tiny figures by the roadside shrine were all painted with the loving attention that invited closer inspection. Critics embraced *Heart of the Andes* as "a grand and unique work"; others proclaimed it "the complete condensation of South America."[3] It was, in short, a blockbuster success.

The popularity of Church's panoramic landscape accompanied a wave of exploration undertaken by artists, naturalists, and travel writers throughout the decade. About 1852 George Catlin departed for the West Indies and Venezuela and spent the next five years painting the Indians and landscape of South America. In 1853 Norton Bush made the first of three Latin American journeys; the many paintings that resulted from his travels established him as California's premier painter of the Tropics. About the same time Granville Perkins set out in the company of the Ravel circus family in search of exotic scenery for their stage sets. The equinoctial world took such a hold on his imagination that he spent much of the remainder of his career evoking it in panoramas and easel paintings. After completing his duties on the Gilliss Expedition in 1852, the draftsman and writer Edmond Reuel Smith remained in Chile to record his observations of its famed Araucanian Indians, which he published in an illustrated travel account in 1855. Three artists accompanied Ephraim George Squier on his archaeological expeditions to Central America: James McDonough in 1849–50; Wilhelm Heine in 1851; and DeWitt C. Hitchcock in 1853. Joining Church on his return visit to Ecuador in 1857,

Louis Mignot became fascinated with its scenery, which he continued to paint until his untimely death in 1870. Even this brief roster of painters who headed south in the 1850s indicates the mounting artistic interest in tropical America.

Latin American exploration was becoming a recognized component of the North American artist's experience. In 1855 Church completed his first major painting of South America, *The Andes of Ecuador* (see fig. 83); the same year Squier was induced to cast the hero of his travel adventure, *Waikna; or Adventures on the Mosquito Shore*, in the guise of a landscape painter. Loosely based on the travels he made in the company of McDonough, Hitchcock, and especially Heine, *Waikna* tracks the adventures of the hero-narrator, Samuel Bard, as he travels from New York to Jamaica and on to Nicaragua in search of exotic scenery. "Go to the tropics, boy," Bard is advised by a friend, who articulated the expectations of those lands held by many in his day, "the glorious tropics, where the sun is supreme . . . and catch the matchless tints of the skies, the living emerald of the forests, and the light-giving azure of the waters; go where the birds are rainbow-hued, and the very fish are golden; where—Hold; I'll go to the glorious tropics!"[4]

That a Central American travel account of the mid-1850s was told from the viewpoint of a painter signals important developments in American art: first, that the landscape painter had achieved the status of able reporter; and second, that the theater of his activity now unmistakably included the neotropical world. These developments were understood at the time as a direct outgrowth of Humboldt's researches. "Here, at length, is the very painter Humboldt so longs for in his writings, the artist who [studies] not in our little hot-houses, but in Nature's great hothouses bounded by the Tropics," a British critic noted of Church (although his remarks might also apply to his fellow artist-travelers).[5] But why did Humboldt have to wait so long for his painter? The exhibition of Church's masterpiece coincided with the death of the great explorer and marked a

highpoint in these developments, which had begun in 1839 and continued until 1879. The year 1859—the midpoint of the forty years under consideration and the apex of our imaginary time curve—therefore offers the perfect vantage point from which to survey the emerging North American pictorial consciousness of Latin America.

The Year 1859

The study of historical developments from the perspective of a single year was achieved in *The Year One Thousand*, by Henri Focillon, who explained his methodology and intentions:

> We have often thought how useful it would be to historical inquiry, and generally to an understanding of mankind, if we were to take up a position at some fixed moment in time—not merely in order to examine the moment in itself, but so that we might grasp in all their fullness the vistas that spread out around it: in other words, to make a survey of a site, a terrain which could then serve as our point of observation. It seemed both desirable and possible to choose a year, a climactic year, and first to empty it of its own content. The matter is more difficult than might appear at first glance—more suitably entrusted to the labors of a team than to the researches of a single historian. For, even a brief period of historic time comprises many layers or, if you will, stratification.[6]

Such stratigraphic analysis of 1859 reveals that every phase and thread of United States interest in Latin America—scientific and archaeological, political and aesthetic—brought their impact to bear on that pivotal year, which emerges as a chronological focal point in the development of the North American consciousness of Latin America. In that year not only the exhibition of *Heart of the Andes* and the death of Humboldt, but also the appearance of *The Origin of Species* converged to recreate the circumstances in which fifty square feet of canvas covered with minutely detailed tropical vegetation and Andean peaks became the landscape icon of a continent.[7]

In 1859, twenty years after completing *The Voyage of the Beagle*, Darwin published his revolutionary *Origin of Species*. That book and Church's painting, representing two influential attitudes toward nature, developed in direct response to the powerful stimulus of the South American landscape. Church's artistic quest drew him twice to Ecuador in search of the terrestrial paradise; Darwin's observations of the Galápagos Islands off the Ecuadorian coast while sailing on the HMS *Beagle* helped formulate his theory of origins. Both sought, in tropical nature, the secrets of creation. But while Church's artistic conception was based on the tradition of the earthly Garden of Eden, nurtured for centuries and applied with particular fervor to the Latin American landscape in these decades, Darwin's theory challenged and ultimately destroyed the foundations of those cherished beliefs. Its publication set in motion a series of attempts to disprove his ideas, resulting in a final burst of activity in South America between 1865 and 1879.

The year 1859 also witnessed the death of the Boston historian William H. Prescott, who brought to life the ancient civilizations of Latin America. While Church and Darwin concerned themselves with description and classification of tropical nature, setting the stage for the arrival of man, Prescott peopled the landscape with the events of human history. With the publication of his highly influential *History of the Conquest of Mexico* (1843) and *History of the Conquest of Peru* (1847), he brought the achievement of the Aztecs and the Incas to the attention of the Western world. "Mr. Prescott," wrote Rev. J. C. Fletcher, "has, by his graphic pages, given to Peru an interest and a distinction far beyond that conferred by her gigantic mountains and her beautiful flora." Along with Church and Darwin, he was concerned with origins. He opened up, as another reviewer put it, "the great question of the origin of Mexican and Peruvian civilizations," which

34

beckoned them "onwards into the dazzling mirage of antiquarian speculations."[8]

But the achievements of Prescott, like those of Irving, Darwin, Church, and his fellow artists, are inconceivable without the work of Humboldt. He stands in a very real sense as the fountainhead of the nineteenth century's Latin American quest. "No man who had been in the tropics of Central America or the equatorial region of South America, and who has eyes, heart, and mind to feel their charm," wrote the editor of *Harper's* in 1859, "but must be conscious of his great debt to Humboldt who, in a generous sense, was really the discoverer of that region."[9] But why did his explorations, conducted across the breadth of Venezuela, Colombia, Ecuador, Peru, Cuba, and Mexico between 1799 and 1804, become so relevant to North Americans in the 1850s? The accounts of his expeditions, which contained glowing descriptions of the New World, had been available to the general reader since early in the century. *Ansichten der Natur* (1808) was translated into *Aspects of Nature* and *Views of Nature; Vues des Cordilleres* (1810) was translated into English in 1814 as *Researches Concerning the Institutions and Monuments of the Ancient Inhabitants of America* (affectionately known as the *Picturesque Atlas*); and the *Personal Narrative of Travels to the Equinoctial Regions of America during the Years 1799–1804* (part of the *Voyages aux regions equinoxiales*) was available in English beginning in 1814. Yet it was not until the 1850s that these volumes enjoyed their widest readership in the United States, as Humboldt's American biographer Richard Henry Stoddard observed in 1859:

> Nearly fifty years have elapsed since the publication of [Humboldt's] *Voyages;* men and manners have changed, and taste with them . . . similar books have been written, and excellent ones too; yet he still holds his ground with all classes of readers. Nay, he has gained ground, for his book was never so popular as at present.[10]

To put his influence in perspective, we must look back to the events of the early years of the century.

Early Excursions

"America has a hemisphere to itself. It must have its separate system of interest," Thomas Jefferson wrote in 1813.[11] During the decade that followed, this belief in hemispheric unity was strengthened by Latin America's struggle for independence, which gave rise to a new group of states whose political institutions resembled and in many respects were modeled upon the Yankee example. Diplomatic relations between the United States and the new republics date from 1822, when President Monroe's administration acknowledged the governments of Gran Colombia (comprising, until it dissolved in 1830, present-day Colombia, Ecuador, and Venezuela) and Mexico. Buenos Aires and Chile were accorded recognition the following year, as were the empire of Brazil and the United Provinces of Central America in 1824. And Peru, the last stronghold of Spanish power in South America, was acknowledged in 1826.[12] John Neagle's *Portrait of Henry Clay* (fig. 13), in which the great statesman gestures toward South America on a flag-draped globe, emblemizes that recognition and the role Clay played in winning it.[13] Coming into existence at a time when the United States was still shaping its own national identity, the Latin republics offered an alternative to the inevitable comparison with Europe. From that moment forward, the United States gained a certain strength and definition by setting itself off against Latin America, its surrogate or underground self.

On 2 December 1823 President Monroe translated these ideas into concrete terms in his address to Congress. According to his message, which later became known as the Monroe Doctrine, the United States would recognize as an unfriendly act any attempt by a European nation to interfere in the affairs of American countries or increase its possessions on the American continents: "It is impossible that the allied powers should extend their political system to any portion of either continent without endangering our peace and happiness; nor can anyone believe that our southern

13. *John Neagle*, Portrait of Henry Clay, *1843*, *oil on canvas,* *111¹/₄ × 72¹/₂ in. (282.6 × 184.1 cm). The Union League of Philadelphia.*

"period of quiescence," for it was not until the 1840s that the country could back Monroe's words with action. His message did, however, expand the horizons of United States interests and ambitions further southward, as indicated by a report in the *North American Review* in the summer of 1824. It noted that "relations of the most intimate kind are daily gaining strength between the United States and the new republics at the South" and foretold increasing interactions between the United States and those fledgling countries. "These republics are our neighbors," it continues, and "the time may come when they will be our rivals."[15]

In this prevailing climate of ideas John Vanderlyn began to make inquiries into the prospects awaiting the painter in Mexico. On 1 February 1826 he wrote to his friend Mr. Cambreling,

> I feel very desirous of obtaining some information respecting the prospects of a portrait painter in the city of Mexico. Whether the public take any interest in having their likeness taken? . . . In case there should be a good field for the portrait painter, I might be induced to visit Mexico principally for this motive and partially with the intention of obtaining whilst there sketches for a panoramic view of the city—I have not heard of any picture of this kind having yet been made of it.[16]

Although he apparently did not follow up on his plan at the time, Vanderlyn's interest in Latin America did not completely subside. In 1839 on his way to France he stopped in San Salvador, where he made botanical studies for a painting, *The Landing of Columbus* (U.S. Capitol Rotunda, Washington, D.C.).[17]

Around the same time, Francis Drexel began to plan an extensive portrait-painting excursion through South America. The Austrian-born Drexel, who arrived in Philadelphia in 1817 with some training as a portraitist, was among the first to take advantage of the opportunities for travel and patronage in the newly independent countries of South America. Inspired by the news accounts of Simón Bolívar's heroism, Drexel brought with him a number of portrait prints of the

brethren, if left to themselves, would adopt it of their own accord."[14] At the time the United States was fully aware of its limited power, and in the following years it had to endure the intervention of Great Britain and France in Latin America in clear disregard of the principles the president had affirmed. The 1820s and 1830s accordingly have been called the doctrine's

14. Francis Drexel, Portrait of Simón Bolívar, *1824, oil on canvas. Destroyed by fire.*

newspapers his availability to paint portraits and miniatures. The accounts he kept of his activities indicate success in his attempts to attract clients, although at least one sitting came to an abrupt end with the tremors of an earthquake:

> I was painting a lady at the moment she felt it she ran off in the street, and I followed her just as quick with my palette and brushes in my hand. It is certainly very awful to see all the people in the streets on their knees making crosses and praying fervently for forgiveness and mercy, hear dogs bark and the horses refuse to proceed. But the fright is very soon past, since they are so frequent, and two days after all is forgotten.[18]

In 1830 Drexel returned to Philadelphia, but in 1835 he was off on another painting excursion, this time to Mexico. By 1837 he was again at home, where he decided to give up painting for what turned out to be a far more lucrative career in banking. His legacy to Pan-American artistic relations is recorded in his own account book. Although he was unable to realize his scheme for portrait prints of Bolívar, he left at least 116 full-scale portraits and 61 miniatures in the countries he visited and took back several cases of miscellaneous objects, which were shown in Peale's museum in the State House.

Drexel's fellow Philadelphian Titian Ramsay Peale is the earliest forerunner of the artist-naturalists whose tropical expeditions burgeoned in the 1850s. Following his journey to Florida with the entomologist John Say in 1817 and his experiences as assistant naturalist on Stephen Harriman Long's expedition to the Rocky Mountains in 1819, Peale went to South America in 1830. There he studied the topography, flora, and fauna, and returned home in 1832 with colored drawings and specimens for future display in the family museum.

Peale's precocious decision to make this collecting mission to South America must have been inspired in large measure by Humboldt, with whom the entire family enjoyed close ties. Titian's brother Rembrandt

liberator, which he hoped to sell to local patriots. Landing at Guayaquil in October 1826, he was dismayed to learn that the revolt against Bolívar had already begun, rendering the portrait prints unsalable. Nevertheless, Drexel painted his *Portrait of Simón Bolívar* (fig. 14), based on earlier portraits, as he had missed the opportunity to paint his subject in person.

Undaunted, Drexel went on to seek portrait commissions from private citizens and government officials in Guayaquil and other cities on his itinerary, including Lima, Peru; Santiago, Chile; and La Paz, Bolivia. In Lima on 1 March 1827, Drexel advertised in the local

15. *Titian Peale*, Falls of Tequendama, *c. June 1831*, *pencil on paper*, 5³/8 × 9 *in. (13.7 × 22.9 cm). American Philosophical Society, Philadelphia.*

had painted Humboldt's portrait in Paris, and before that their father, Charles Willson Peale, had guided the last leg of his American travels.[19] Stirred by his father's recountings of Humboldt's achievements, Titian planned his own expedition. With the private sponsorship of New York merchant Silas Burrows secured, Titian and his companion, William McGuigan, set off for the same portion of the continent the great naturalist had traversed thirty years before. Landing on the Caribbean coast at Cartagena, they apparently followed Humboldt's route through Colombia and briefly visited Surinam and northern Brazil. They stopped at Turbaco, the site of the curious mud and gas volcanoes featured in Humboldt's *Picturesque Atlas*.[20] From there, they embarked on a steamer excursion four hundred miles up the Magdalena River to Honda and climbed nine thousand feet to reach the great plateau of Bogotá by mid-August 1831.[21] Outside the city they visited the falls of the Tequendama, which Humboldt had praised so highly, and Peale made a pencil sketch of the stupendous cascade (fig. 15). Church followed essentially the

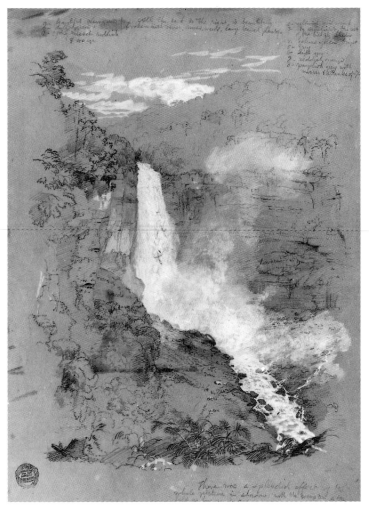

16. *Frederic Church*, Falls of Tequendama, *1853, black crayon, brown, black, and white wash on gray olive paper*, 18¹/4 × 12⁵/8 *in. (46.5 × 32 cm). Cooper-Hewitt Museum, Smithsonian Institution, New York (1917-4-701).*

same route to arrive at the identical spot twenty-two years later. There he made a series of pencil drawings (for example, fig. 16) culminating in the canvas *Falls of the Tequendama near Bogotá, New Granda* (fig. 17), painted for his traveling companion, Cyrus Field, in 1854.[22] Whether Church and Field were aware of Peale's journey is uncertain, but it seems more likely

17 . Frederic Church, Falls of the Tequendama near Bogotá, New Granada, *1854, oil on canvas, 64 × 40 in. (162.6 × 101.6 cm). Cincinnati Art Museum, Edwin and Virginia Irwin Memorial.*

that the similarity of their itineraries was grounded in mutual Humboldtian sources. The occasional tropical expeditions undertaken by Peale and his contemporaries in the 1820s and 1830s represent the early stirrings of what was to become, between 1839 and 1879, a far more widespread phenomenon among artists.

The Events of 1839

The attitudes, institutions, and technological advances requisite for the full flowering of tropical landscape painting were taking seminal form in 1839. In that year Washington Irving, in an essay entitled "National Nomenclature," sought to define the identity of an inhabitant of the United States more specifically within the context of the western hemisphere. "How is a citizen of this hemisphere to designate himself?" he queried. "As an American? There are two Americas, each subdivided into various empires, rapidly rising in importance."[23] His call for a national appellation that would distinguish his compatriots from Latin Americans marked a critical departure from their traditional self-definition as Anglo-Americans. He was also one of the first to emphasize the historical unity between the twin continents, arguing that the same forces that helped shape North America operated equally in South America:

> Two leading objects of commercial gain have given birth to wide and daring enterprise in the early history of the Americas; the precious metals of the South, and the rich peltries of the North. While the fiery and magnificent Spaniard, inflamed with the mania for gold, has extended his discoveries and conquests over those brilliant countries scorched by the ardent sun of the tropics; and the adroit and buoyant Frenchman, and the cool and calculating Briton, have pursued the less splendid, but no less lucrative, traffic in furs amidst the hyperborean regions of Canada, until they have advanced within the Arctic Circle. These two pursuits have thus in manner been the pioneers and precursors of civilization.[24]

Such pronouncements find their analogues in the simultaneous initiation of scientific investigations, the establishment of transit lines, and the development of diplomatic relations across the hemisphere: circumstances that increasingly favored travel between the United States and Latin America.

Titian Peale was again in South America in 1838–39, a member of the United States Exploring Expedition under the command of Charles Wilkes. Circumnavigating the globe between 1838 and 1842, the Wilkes Expedition established a precedent for United

States naval exploration. Numbering Peale as well as draftsmen Alfred Agate and Joseph Drayton among the crew, it demonstrated the value of having trained artists accompany the expeditions. "The number of drawings brought home by the Expedition amounts to two thousand sheets, including those in natural history, scenery, costumes, and individual portraits," one reviewer noted with satisfaction.[25] These images, many of which were illustrated in the widely circulated *Narrative* by Wilkes, became prototypes for subsequent artistic efforts in the Tropics.

The importance of studying the natural history of South America, which figured in the work of Wilkes and his men, impressed itself even more strongly on the public mind with the appearance of Darwin's *Voyage of the Beagle* in 1839. It represents a link between the early expedition of Humboldt, whose descriptive science Darwin praised so highly, and the subsequent developments in which Darwin himself played so conspicuous a role.[26]

That same year witnessed the birth of American archaeology with the departure of Catherwood and Stephens for Mexico and Central America. Their discovery of the long-lost cities of the Mayas was recounted by Stephens in *Incidents of Travel in Central America, Chiapas, Yucatán* (1841) and *Incidents of Travel in Yucatán* (1843). These volumes, greatly enhanced by Catherwood's illustrations, stimulated further inquiry into the mysterious race who had once inhabited the continent.[27]

The invention of the daguerreotype, announced in 1839, affected the work of Catherwood and Stephens, as it did, in one way or another, almost every subsequent exploration of Latin America. The implications of this process, whereby an image could be permanently fixed to a photographic plate, were profound. The promise of numerous and seemingly more faithful representations of these long-unknown lands inspired many to purchase the newly available equipment and head south. The resulting photographs contributed to the North's emerging conception of these regions.[28]

The growth of tropical landscape painting, in Europe or in America, required several conditions. It "could not have gained in diversity and exactness," Humboldt explained, until "the appreciation of the beauty and configuration of vegetable forms, and their arrangement in groups of natural families, became excited." With the rise of interest in natural history and particularly in the botanical sciences, that condition was beginning to be met on American shores by the end of the 1830s. Such a development, Humboldt observed, also had to wait "until the geographical field of view became extended" and "the means of traveling in foreign countries facilitated."[29] Access to Latin America was largely by sea, for difficult terrain and climate made lengthy overland travel a risky business at best. In the eighteenth century trading vessels traveled between New York, Boston, and New Orleans, and the Atlantic ports to Brazil and Surinam, as evidenced by Greenwood's *Sea Captains Carousing in Surinam* (fig. 11). Those Rhode Island mariners had good cause for celebration after disembarking from their slow and cramped sailing vessel, which was in constant danger of being waylaid by storms and pirates.

Travel to Spanish America on any substantial scale also had to await improvements in navigational technology. By 1839, a watershed in the history of shipping, steam had come to stay; following initial experimentation with engines, the development of steam propulsion settled into a period of continuous improvement. For long distance sea voyages, one of the most significant innovations was Samuel Hall's surface condenser in 1834. (Prior to its invention, steamships using ocean salt water had to stop frequently to be desalted; Hall's condenser used fresh water in a closed system, which virtually eliminated these vexing delays.) The missing ingredient then became financial backing, which was soon provided by Great Britain and, subsequently, other countries that granted annual subsidies for the development of steamship lines to carry mail.[30]

The major ports along the Atlantic coast of South America were more accessible to American vessels in

this period than those on the Pacific. Marine views by Gloucester artist Fitz Hugh Lane, including *Surinam Brig in Rough Seas* (c. 1850; Marblehead Historical Society), are reminders of the extensive commerce that went on between Gloucester and Surinam, accounting for many of the early fortunes of the artist's native city.[31] And naval vessels assigned to the West Indies Squadron (established in 1822) or the Brazilian Squadron (established in 1826) protected commerce in these waters and carried out special diplomatic and exploratory missions as well. These circumstances all affected the pictorial delineation of Latin America. While the USS *North Carolina* was off Brazil in 1837, for example, crew member Henry Walke made a sketch of the harbor at Rio de Janeiro, which he later elaborated into an oil painting (fig. 18).[32] By contrast, the independent artists, unattached to navy vessels, found it difficult to reach even some of the relatively close Atlantic ports. Titian Peale's collecting expedition to Colombia in 1830 is a case in point, for it would have been nearly impossible for him to have made it even a few years earlier. The patronage of Silas E. Burrows, who in 1829 organized a line of packet brigs connecting New York with Cartagena and the Isthmus of Panama, made the expedition possible. In anticipation of the traffic his lines would enjoy, Burrows advertised his intention to carry mail to Panama at monthly intervals and establish a line between Panama and the Peruvian port of Callao. Although the line did not survive long after 1835, when Burrows withdrew from the business, his venture reminded the United States of the practical value of an Isthmian route to the Pacific and provided Peale and his companion with a timely opportunity to travel with comparative ease to the region so crucial to the artist-naturalist.[33]

Passage up and down the west coast of South America, prior to 1839, was an even more delay-ridden and difficult affair. The mountainous terrain precluded a coastal road or railroad of any length, and the unpredictable winds and calms of the Pacific made passage in sailing vessels extremely uncertain. The invention of the steamship held out hope, but the fledgling Latin republics had little capital for steamship lines. Enter William Wheelwright, a Massachusetts-born entrepreneur whose experience in Latin America convinced him of the importance of establishing regular steamship service there. (In Guayaquil in 1826, he crossed paths with Francis Drexel, who painted his portrait.)[34] Unable to obtain financial backing in the United States, Wheelwright secured British funds to form the Pacific Steam Navigation Company.[35] The service, initiated in 1840, ran from Valparaíso, Chile, to Callao. By 1846 frequent and dependable steamers were running from Chile, at the southern tip of the continent, all the way to Panama, reducing what had been a journey of twenty days to just two. Thus Wheelwright's efforts greatly facilitated the traffic of goods, mail, and men between the ports of Chile, Peru, Ecuador, Colombia, Panama, and the United States.

Among the artists to take advantage of these improvements was Jacob Ward. He had been recommended by John Trumbull for the position of draftsman on the Wilkes Expedition, but for personal reasons he was forced to withdraw. His continued hopes of neotropical exploration were fulfilled, however, when in 1845 he boarded a steamer bound for South America, where he apparently intended to set up a daguerreotype business with his brother, Charles. He stopped in Brazil on his voyage around Cape Horn to his destination in Chile, where he remained two years. He returned home by the overland route, traveling across the Andes by mule through Peru, Bolivia, Colombia, and Panama, having seen more of South America than probably any other Anglo artist of his day.

A member of New York art circles in the 1830s and 1840s, Ward naturally showed the paintings resulting from his travels at the National Academy of Design, including *Arequipo* [*sic*], *Peru, South America* and *Panama* (both presently unlocated), in the 1849 exhibition. The view of Arequipa, a city in the beautiful valley at the foot of the snow-capped El Misti, perhaps bore some resemblance to his conception of *Muleteers in the*

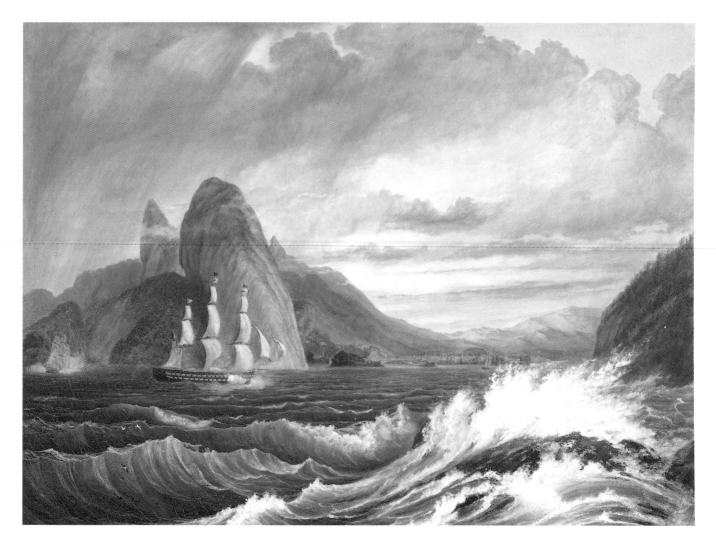

18. Henry Walke, U.S.S. North Carolina Entering the Harbor of Rio de Janeiro, *1848, oil on canvas, 30 × 40 in. (76.2 × 101.6 cm). U.S. Naval Academy Museum, Annapolis, Maryland.*

Aconcagua Valley (fig. 19). His rendering of this valley belongs to the category of the mountain sublime: broad in scale and grand in effect.[36] This approach was entirely appropriate for the subject of the Aconcagua volcano, which the *Beagle* crew determined reached "an elevation greater than Chimborazo," thus usurping the status of the highest mountain on earth, which the great Ecuadorian peak had long enjoyed.[37] Although Ward's South American works seem to have received little notice in the exhibition reviews, they could not have

escaped the attention of Church, whose *West Rock, New Haven* (1849; New Britain Museum of American Art) hung in the same show. Nor could it have been ignored by Field, the owner of the painting, who accompanied Church to Colombia and Ecuador a few years later. But it was the nearly simultaneous events going on in California and Mexico that would direct the interest of their

19. *Attributed to Jacob Ward,* Muleteers in the Aconcagua Valley, *oil on canvas, 26 × 39 in. (66 × 99 cm). Museum of Fine Arts, Santiago, Chile.*

countrymen toward Latin America and to the paintings and photographs thereof.

The Interoceanic Canal, 1849–1859

From 1822 to the late 1840s the policy of the United States toward Latin America was ambiguous at best. Monroe's famous pronouncement had little power to back it, and as a result, the presence of foreign powers (especially Great Britain in Central America) had to be endured. The eyes of the nation looked west, to the Rocky Mountains and the territories beyond, before they looked south. Central and South America were not of primary interest to the nation as a whole because the American frontier—the one that counted—was the westward one. "We all go West, in fancy, if not otherwise," one writer declared in 1855.[38] Mass emigration, economic interests, and land development all took a decidedly westward direction, with the additional incentive of a gateway to the Orient from the Pacific coast. The riches of the East, which prompted Matthew Perry's expedition to Japan, established it as a second focus of national interest by the 1850s.[39] Latin America

took a backseat to interest in the American West and the Orient. There was one point, however, where the east-west axis of interest intersected literally with the north-south axis: at the Isthmus of Darien, the entire body of land between Mexico and South America. By 1850 control of the Isthmus was becoming a national priority. The reasons for this abrupt change in policy were largely external to Latin America, but its effects could nevertheless be felt there.

Two events of the late 1840s—the Mexican War and the California gold rush—signaled an irreversible turn of national interest in Central and South America, which elevated Monroe's message to Congress to the status of a doctrine. According to the Treaty of Guadalupe Hidalgo, signed at the conclusion of the war with Mexico in 1848, the United States acquired the lands now occupied by Colorado, Nevada, Arizona, New Mexico, and California. The discovery of gold in Sutter's field the following year provided additional incentive for many easterners to head to the area. The traveler's choice of routes was threefold: "the plains across, the Horn 'round, or the Isthmus over," as the refrain went during the gold rush years. For many impatient forty-niners, the delays of wagon travel across the entire breadth of the country would have been unendurable. They opted instead for the sea voyage around South America's Cape Horn or, more frequently, for land passage from the Atlantic to the Pacific side of the Isthmus of Panama, where they picked up a steamer bound for San Francisco.

By 1854, therefore, U.S. diplomat Ephraim George Squier could declare that the eyes of the country had indeed begun to look to the Tropics:

> Not among the least of the results which have followed upon the acquisition of California, and the discovery of its golden treasures, is the tropical direction which has incidentally been given to American enterprise. Regions before unknown, or but vaguely known through the wild tales of buccaneers, . . . these strange regions have now become familiar alike to the dwellers on the arid

shores of New England and on the banks of the turbid Mississippi.[40]

In this period the nation's predominant east-west axis began to intersect the north-south axis, for a primary path to its western destination lay through Latin America. As thousands and eventually tens of thousands of Anglos headed west by this southern "detour," the need for a more efficient means of transport became paramount. They therefore revived the age-old notion of a passage to India: a canal from the Atlantic to the Pacific, cut through the isthmus connecting the American continents. Manifest Destiny, it appeared to many, was leading in that direction:

> Since the acquisition of California and New Mexico the impression has become fixed in the mind of the American people, and is deepening every day, that we must have control over the Isthmus. . . . [Transit] considerations, together with the steady extension of our territory southward, are gradually fixing the belief that "manifest destiny" points to our occupation of the entire continent in that direction.[41]

Thus, the desire for an interoceanic canal became a prime catalyst of U.S. interests in Latin America.

The desire for this gateway to the Pacific had been linked to the American continent from the time of its discovery. When Columbus reached the New World the natives told him of a strait through which he could reach the Indies unhampered. He himself never found such a passage, and later Vasco Núñez de Balboa continued the search. Crossing the Isthmus of Panama in 1513, Balboa discovered the Pacific Ocean but no natural waterway connecting it to the Atlantic. When the elusive channel failed to appear over the centuries, it was decided that one should be built. Little progress was made until after 1850, when the United States began to take a proprietary interest in Isthmian transit. Citing Balboa as their precedent, North Americans attempted to justify an interoceanic canal under their exclusive control.[42] But even after it was decided that a

canal was to be constructed, the problem of its location remained to be resolved.

Panama, where the canal was finally completed in 1914, was one of four sites actively being considered in the nineteenth century (map 2). As Humboldt informed the readers of his *Political Essay on the Kingdom of New Spain*, they were the same four routes proposed by Cortés in the sixteenth century: (1) the path across Mexico via the Isthmus of Tehuantepec, with an Atlantic terminal just south of Vera Cruz; (2) the Darien route, from the Bay of Limón to Caledonia Bay, through one of the most dangerous stretches of jungle in the world; (3) the present-day site at Panama, from Colón to Panama City; and (4) the Nicaraguan route along the San Juan River and through Lake Nicaragua.[43] Discussing the relative merits of each, Humboldt cast his vote for a passage through Nicaragua. The United States, which had favored the Tehuantepec route for its proximity during the Mexican War, subsequently campaigned primarily for what became known as Humboldt's route, through Nicaragua—but not before the U.S. Navy sent an ill-fated expedition to Darien, awakening it to the realities of the Tropics.[44]

THE DARIEN ROUTE

Darien was a region less familiar, and reputed to be far more treacherous, than Nicaragua. Lt. Isaac Strain headed the expedition there, which consisted of twelve naval officers and several volunteers, including Theodore Winthrop (fig. 20) and the draftsman S. H. Kettlewell. They anchored the USS *Cyane* on 17 January 1854 in Caledonia Bay, on the Caribbean side of the Isthmus. Their orders were to head overland to Darien Harbor on the Pacific and determine its suitability as a canal site.[45] Strain's previous adventures in Chile and Argentina hardly prepared him for the difficulties of the jungle terrain and the Cuna Indians they encountered in Darien, and the expedition ended in tragedy. An account of their heroic march appeared in *Harper's*

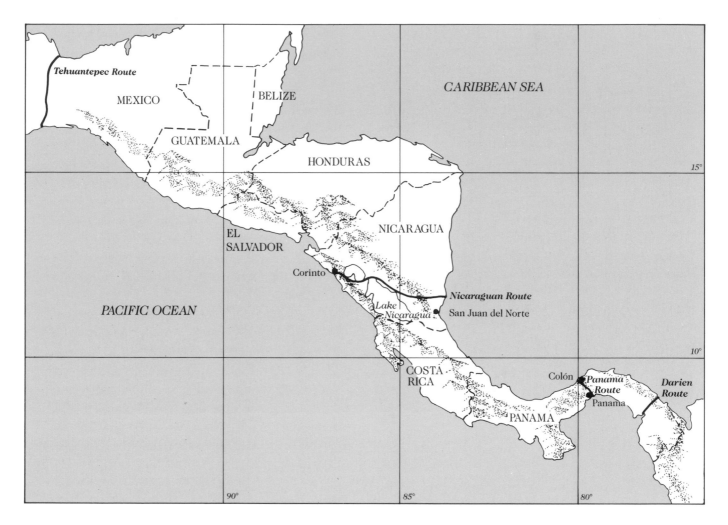

Map 2 . Interoceanic canal routes.

Monthly in 1855, complete with illustrations made from Kettlewell's sketches. It conveyed the horrors the men faced as they hacked their way through thick vegetation, burying their comrades one by one as they succumbed to disease and starvation.[46] Strain's journal recorded:

> Proceeded down stream about a quarter of a mile, when finding a place to camp, built a fire and spread our blankets in the moonlight. We all felt downhearted tonight, being without anything to eat, and not having eaten enough each man for the six or eight days to make one good meal; our clothes all in pieces, and nearly all shoeless and bootless. Having no idea where we are, nor, of course, when we shall reach the Pacific. The sick almost discouraged, and ready to be left in the woods to take their chances.[47]

Strain finally emerged from the jungle forty-nine days later with twenty of his original party, saved by his own discipline and fortitude. He declared Darien an "utterly impracticable" route for a canal. A few years later at Colón, having never fully recovered, he died at age thirty-six. Not until 1870 would the navy send

20. *Photograph of Frederic Church* (seated) *and Theodore Winthrop, c. 1859. Archives of American Art, Smithsonian Institution, Washington, D.C.*

another expedition to this region. In the meantime two of New York's leading capitalists had become involved in alternate routes in Panama and Nicaragua, ventures that measurably increased their own substantial fortunes and greatly stimulated travel to the Pacific coast of South America.

THE PANAMA ROUTE

In 1848 two steamship lines began operating between New York and San Francisco via Panama. George Law and his partners, Marshall O. Roberts and Bowes R. McIlvaine, had control of the Atlantic traffic between

New York, New Orleans, Havana, and the Isthmian port at Chagres. William H. Aspinwall and his associates formed the Pacific Mail Steamship Company to provide passage from Panama to San Francisco.[48] Both lines were in great demand once the gold rush was on; the problem was that the traveler was on his own for the overland crossing between the Atlantic and Pacific terminals. From the mouth of the Chagres River on the Caribbean, where steamers anchored in the early years, to the city of Panama on the Pacific was a journey of about sixty miles. Approximately two-thirds of it could be made by boat along the river. The heat, malaria-carrying mosquitoes, snags in the river, and unfriendly Indians made the crossing of this stretch of terrain an unforgettable experience, though it was only twenty miles long. Having made the journey himself, artist Charles Christian Nahl was familiar with its dangers and discomforts, which he recorded in *Incident on the Chagres River* (fig. 21). Assuming the travelers survived the river crossing, they frequently faced a long wait for the next steamer; many fell ill, ran out of money, and tried to combat the unavoidable ennui.[49] John B. Sing reported in a letter home from Panama on 10 November 1849, "At length I have arrived at this place having successfully crossed the dreaded Isthmus, the tales we read of it are all humbug and can only frighten children." But the statistics of illness and death of those who attempted this route belie the bravura of Sing's remarks.[50]

Sailing from Ecuador in 1853, Frederic Church arrived at Panama and made the crossing to Aspinwall (present-day Colón) to catch a steamer bound for New York. A perusal of his journal between October 5 and 17 provides some idea of the difficulties of life on the Isthmus, waiting for passage out. As the anticipated week of waiting stretched into two, the inconvenience became increasingly vexing:

Anchored off Panama about seven this morning and after a row of a couple of hours put my feet on the shore of Panama. Panama is anything but an inviting looking

21. *Charles Christian Nahl,* Incident on the Chagres River, *1867, oil on canvas, 27 × 37 in. (68.6 × 94 cm). Bancroft Library, Robert B. Honeyman, Jr., Collection, University of California, Berkeley.*

city. I found on my arrival that there will be no steamer from Aspinwall for ten days so that we must content ourselves for a week here. . . . Endured the heat today with considerable patience. The nights are fortunately coolish. . . . Another tedious day gone by and nothing done. Intend to leave here on Tuesday next for Aspinwall. . . . Sent off our luggage this morning by mules for Cruces and expect to follow tomorrow early.

By October 11 they had left Panama and made an intermediate stop at Cruces. "The road was most shocking," Church reported, "although we had the good fortune to

have no rain." By October 12 they reached Aspinwall, where further delays awaited them:

Nothing to break the monotony. No information of steamers either on the Atlantic or Pacific. No steamers as yet but one must certainly arrive tomorrow. Time passes slowly as there is nothing to sketch and little to read; but I am thinking that I enjoy good health in a place which has so bad a reputation.

On October 17 he made the final entry before boarding the homeward-bound steamer:

> Yesterday morning the Falcom from New Orleans arrived and about 10 PM the Ohio from New York crowded with passengers. Today intelligence arrived of the steamer Panama at Panama with only about 230 passengers so that we shall not be inconvenienced with numbers. I hope to sail by tomorrow night.[51]

It is little wonder that the completion in 1855 of the Panama Railroad, which reduced the transit from ocean to ocean to a train ride of a few hours, was greeted with such enthusiasm. It too was built by Aspinwall, who—along with his brother Lloyd and their partners Samuel Comstock, Henry Chauncey, and John Lloyd Stephens (whose archaeological investigations had already familiarized him with the region)—obtained from New Granada the privilege of building a railroad across the Isthmus. Within five years the forty-nine-mile railroad line was completed, carrying passengers between Panama City and its eastern terminal, Aspinwall, named in honor of the man responsible for its success. By 1859 the railroad alone had netted six million dollars, making Aspinwall one of the wealthiest men in New York.[52] Illustrated accounts in *Harper's Monthly* praised the scenery of Panama and the relative ease with which it could now be viewed from the railroad cars—which we can be sure Church took with Mignot on his return trip through Panama in 1857![53]

THE NICARAGUAN ROUTE

At nearly the same time, competing transport lines were being developed by Cornelius Vanderbilt through Nicaragua, where the crossing was longer than at Panama, but which could be made largely by lake and river rather than overland. Prior to Vanderbilt's involvement, travelers from the United States were already passing up the San Juan River and across Lake Nicaragua on their way to San Francisco. In 1848 Gordon's Passenger Line of New York had begun service to San Juan; there, passengers were transferred to large canoes for the 122-mile trip up the San Juan River to Lake Nicaragua. They then sailed across the lake and were conveyed on horses and mules over rough terrain to the Pacific port of Realjó (near present-day Corinto), where they anxiously awaited a vessel to take them on to San Francisco. A refund of seventy-five dollars plus sixty days' provisions was promised to anyone who failed to secure passage to Realjó, an offer that more than one disgruntled traveler tried to collect. Once Vanderbilt's American Atlantic and Pacific Ship Canal Company was granted exclusive rights to transport in the region (pending completion of the ship canal), conditions improved dramatically. New oceangoing passenger steamers were put in service for both the Atlantic and Pacific legs of the journey, special shallow-draft steamers suited to Nicaragua's inland waters were constructed, and the river's rapids were made more passable. As a final improvement, the road from Virgin Bay on the western shore of Lake Nicaragua to the Pacific port of San Juan del Sur was macadamized, taking travelers in carriages of blue and white—the Nicaraguan colors—over the last twelve miles to the sea. When the steamer *Prometheus* sailed from New York with the first load of passengers, including Vanderbilt himself, on 14 July 1851, some problems remained to be ironed out. But by reducing travel time, discomfort, and fare, Vanderbilt quickly garnered much of the traffic and transported large numbers of easterners across the once-unspoiled Nicaraguan countryside.[54]

Vanderbilt's success was greatly facilitated by the ratification on 19 April 1850 of the Clayton-Bulwer Treaty, which stipulated that neither Britain nor the United States would maintain exclusive rights over a Nicaraguan ship canal. And that event, in turn, had been facilitated by the appointment in 1849 of a new chargé d'affaires in Nicaragua, Ephraim George Squier, who was to play a substantial role in the opening up of Central America to the United States. Only twenty-eight years old at the time of his appointment, Squier was an amateur archaeologist, already well

known for his study of the Ohio Mound Builders. His training as a civil engineer probably won him the appointment in Central America, where the government's chief objective was the negotiation of a canal treaty with Nicaragua. Secretary of State John Clayton instructed Squier to use his "personal good offices with the Government of Nicaragua" to aid United States citizens then in the country attempting to obtain a canal contract. The citizens to whom Secretary Clayton referred, of course, were the representatives of Vanderbilt's company. Squier helped them reach a solution with the Nicaraguans, but they also had to contend with competing British factions who laid claim to the Mosquito Coast and the port of San Juan (in effect, the Atlantic coast of the country). To eliminate these obstacles to Vanderbilt's venture, Clayton worked out a resolution with the British envoy, Sir Henry Lytton Bulwer. According to the terms of this treaty, neither Great Britain nor the United States would

> ever obtain or maintain for itself any exclusive control over the said Ship Canal, agreeing, that neither will ever erect or maintain any fortifications commanding the same . . . or occupy, fortify, or colonize, or assume or exercise any dominion over Nicaragua, Costa Rica, the Mosquito Coast, or any part of Central America.[55]

In its efforts to exorcise British presence in Central America, the Clayton-Bulwer Treaty is regarded by many historians as an application of the Monroe Doctrine, and it certainly had the immediate effect of clearing the way for Vanderbilt's transport lines. To express his gratitude, the American capitalist named one of his steamships the *Sir Henry Bulwer.*

Artistic Interest in the Canal Sites

What impact, if any, did these events have on artistic interest in Latin America? To be sure, the construction of a railroad and the establishment of steamship lines greatly facilitated transport to the region. But can more direct corollaries be drawn between the nation's expansionist designs in Central America and possible artistic interest there? The answer is a qualified yes. As it became imperative to have accurate topographical information on these sites, all variety of travelers passing through the area were pressed into providing it.[56] A number of artists, some of them little known in the twentieth century, played an active role in familiarizing their countrymen with this strategic terrain. The group of landscape images of Panama and Nicaragua they produced in these years therefore demands consideration in the context of the ongoing debate over the optimal location for the canal.

The topographical artist James McDonough accompanied Squier on the first of his several trips to Nicaragua, where he delineated the terrain of the proposed canal as well as the antiquarian remains. In a foldout frontispiece to Squier's written account, there appeared two panoramic illustrations of the Atlantic and Pacific terminals of the suggested Nicaraguan route, drawn "from nature by James McDonough 1849" (fig. 22). In his extended views of San Juan de Nicaragua and the entrance to the Bay of Fonseca, McDonough provided widely circulated images that furnished needed information for subsequent survey parties. They also served as prototypes for artists who later visited the region, including Heine, who succeeded McDonough as Squier's draftsman on his return to Nicaragua in 1851. Responses to Heine's Nicaraguan work, exhibited in 1857 in his studio, underscore the distinctive interest such subjects held for the art-going public: "One is a view in the neighborhood of Lake Nicaragua, and the other of a scene upon the Pacific Ocean, near the point where the projected ship canal across the isthmus will terminate—if it should ever be constructed."[57] And when draftsman DeWitt C. Hitchcock went to Central America with Squier in 1853, he was supposed to extend these efforts into San Salvador and Honduras, making landscape views of potentially important interoceanic communication

22. *James McDonough*, San Juan de Nicaragua *and* Entrance to the Bay of Fonseca, from the Island of Tigre, *1849*, *panoramic drawings, frontispiece to Ephraim George Squier*, Nicaragua. *Columbia University Libraries, New York.*

sites.[58] Thus it becomes apparent that part of the appeal of these pictures by Hitchcock, Heine, McDonough, and others went beyond their scenic beauty or topographical truth to encompass issues of national and economic concern.

The possibility also exists that the investors backing these canal and shipping ventures purchased or commissioned pictures of local scenery. William Aspinwall's dual roles as promoter of his steamship lines between the United States and Latin America and connoisseur of the arts (he assembled one of the finest art collections in New York) seems to qualify him as a prime candidate for patron of tropical landscape imagery. Through Theodore Winthrop (whom he employed as a ticket agent in Panama), Aspinwall was likely acquainted with Church, whose *Mount Desert Beacon* he purchased.[59] It seems likely, therefore, that he also acquired South American works from him and others. It is tempting to assume that the large and impressive *View of Panama* (fig. 23)—whose authorship is undocumented—might be traceable to Aspinwall, given that it shows both the port and the ships that greatly

increased his fortune.[60] Marshall O. Roberts, one of Aspinwall's rivals, has assembled an important collection of American art; but there is little indication that his commercial involvement in Latin America had much influence on his picture selection. Similarly, ties between commercial and artistic interests in Nicaragua might be supposed in the case of Cornelius Vanderbilt. So far, however, little direct evidence has come to light. But certainly his enterprise, along with those of Aspinwall and others, enabled artists to transport themselves to Panama, Central America, and regions further south and contributed to a widespread interest in the region.

Filibuster Wars

By the 1850s filibusters entered into the relations between the United States and Central America. William Walker was the most notorious of the filibusters, private individuals who independently took part in

23. Unidentified artist, View of Panama, *c. 1850, oil on canvas, 36 × 60 in. (91.4 × 152.4 cm). Osuna Gallery, Inc.*

fomenting revolutions and insurrections in Latin American countries with which his own country was at peace. From about 1855 to 1857 Walker succeeded in maintaining his revolutionary government in Nicaragua and planned forcible acquisition of a Central American empire. By 1857 his exploits were sufficiently well known for Winthrop to quip in a letter to Church prior to the artist's departure, "Please ascertain also whether the chances for an individual and gentlemanly filibuster are good in Ecuador and New Granada."[61] Walker justified his actions in the following terms:

> They are but drivellers who speak of establishing fixed relations between the pure white American race, as it

exists in the United States, and the mixed Hispanic-Indian race, as it exists in Mexico and Central America, without the employment of force. The history of the world presents no such Utopian vision as that of an inferior race yielding meekly and peacefully to the controlling influence of a superior people.[62]

Although his activities were officially denounced by Washington, the fact that more than a few Americans (many of them in high positions) unofficially encouraged the filibusters demonstrates the claim that many in

the United States felt they unquestionably had on these lands and their blatant disregard for the rights of the people inhabiting them. With the completion of the Panama Railroad by a United States company and monopolies on steamship lines secured, these proprietary attitudes became increasingly evident.

Commerce

Latin America was never more seductive to the North American imagination than during the middle decades of the nineteenth century. And in this attraction, commerce too played its part. Not so glamorous as the spices and tea that drew adventurers to the Orient was the South American guano, or bird droppings, which had been accumulating for centuries on the isolated islands off Peru. The agricultural value of guano had been recognized by the Incas, but not until the late 1830s, when instructive pamphlets such as *Hints to Farmers on the Nature of Guano* went through numerous British and American editions, did the demand for this highly concentrated nitrous fertilizer rise. By the 1850s the Peruvian islands of Ballestas, Lobos, Guañape, and Chincha had become a major focus of international trade. This commodity became so important that the period from 1839 to 1879 became known in Peruvian history as "the Age of Guano." As one British observer explained in 1881,

> Whether it be true, or only a poetical way of putting it, that Yarmouth was built on red herring, Manchester on cotton, Birmingham on brass, Middlesborough on pigs of iron . . . it is true that the Government of Peru has for more than a generation subsisted on guano, and the foundations of its greatness have been the foundations of the same; the ordure of birds.[63]

Numerous artists recorded the appearance of the Chincha Islands at the height of their activity: a task best suited to the panoramic format. A three-foot-long, narrow panel (fig. 24), for example, outlines the buildings and equipment that handled the excavation and loading of guano against the profiles of the islands. Although the identity of the artist remains uncertain, he was perhaps a crewman who passed his time sketching during the weeks and even months his ship was in dock. Photographer Henry DeWitt Moulton, in a series of three consecutive plates, presented a complete view of the island operations. His *Panorama of the Town, North Island, Chincha Islands, Nos. 1, 2, and 3* together form a continuous image, unified by the railroad track that crosses the foreground of all three photographs. Taken by Moulton on his trip to Peru, where he arrived in 1859, these views were published by Alexander Gardner in an album entitled *Rays of Sunlight from South America* (1865). That Gardner chose to include these rather unattractive industrial subjects alongside the architectural splendors of Lima suggests the interest the guano islands held for the general public at a time when ships from Great Britain, France, Germany, and the United States were lined up at their shores.[64]

During the same period, various people in the United States began to realize the potential for trade not only with Peru, but also with the countries along the Atlantic coast. The influential Matthew Fontaine Maury, who published a series of articles under the signature "Inca," tried to encourage commerce in Brazil, Paraguay, and its neighbors. Particularly frustrated by Brazil's refusal to allow exploration of the Amazon, Maury pleaded that it must be opened up—as the argument always went—for the good of North American enterprise:

> For these and other reasons of import, the free navigation of the Amazon, and the settlement of its valley, become matters of deep interest to this country. Therefore it is incumbent upon this country to take the initiative in opening the trade and navigation of that river to the world. The policy of commerce requires it, and the necessities of Christendom demand it.[65]

Maury's words had particular impact in his native Virginia and throughout much of the South.

24. *Unidentified artist*, Chincha Islands off Peru, *c. 1845, oil on canvas, 17¹/₄ × 37¹/₂ in. (43.8 × 95.2 cm). Peabody Museum, Salem, Massachusetts (M3384).*

The Manifest Destiny of the South

Manifest Destiny was of primary importance in the matter of an Isthmian canal. It was significant also for U.S. relations with Mexico, the Caribbean, and Cuba. In 1853, fifty years after the Louisiana Purchase, the Gadsden Treaty added forty-five thousand square miles of Mexican territory to the United States in exchange for ten million dollars. The Ostend Manifesto of 1854 was an attempt to coerce Spain into selling Cuba. "Manifest Destiny . . . became, in the fifties, Caribbeanized," as Frederick Merk put it.[66] As for the southern continent proper, the designs were far more nebulous; southern South America was still too far away to be of vital interest. The single exception was the American South, where extravagant projects for expansion into South America were advocated. Mexico and Cuba were attractive to them, as they had been to their northern brethren, albeit for different reasons. And the Amazon Valley, particularly Brazil, became another of their objectives.

As early as 1845, Rev. Daniel P. Kidder published his popular *Sketches of Residence and Travels in Brazil*, which found a place in many southern libraries. After 1850 Maury began promoting Brazil in the pages of *DeBow's Review* and elsewhere, for he cherished as a pet project the opening up of the Amazon Valley. The most important and frequently expressed idea behind this goal was that the region of the Amazon offered a rich field for development by American (and especially southern) commercial enterprise; the second was that the Amazon Valley could provide what Maury termed a "safety valve" for the increasing southern slave population. "Is the time yet to come when the United States are to be over-peopled with the black race?" Maury asked in a memorial to the secretary of the navy: "And if so where shall an outlet be found for them? In the val-

ley of the Amazon? Will Brazil agree to stop the African slave trade and to depend on the Southern States for a transfer? Would it be wise to transfer the slaves of Mississippi Valley to the Valley of the Amazon?" The free navigation of the Amazon, he confided in a letter to Ann Maury, "is my remedy for preserving the Union."[67] From his position as superintendent of the Naval Observatory from 1844 to 1861, Maury was in a position to put his words into action. "The consequence was," as he phrased it, that "two officers of the Navy were ordered to cross over the Andes from Lima, and descend the Amazon as they might." Those two officers—his brother-in-law, William Herndon, and his fellow officer, Lardner Gibbon—received their orders on 15 February 1851 to explore the Amazon.[68]

Exploration and the Literature of Exploration

Between 1849 and 1853 the navy dispatched three expeditions to South America in an exploratory effort it never again matched in the region. In addition to the Herndon-Gibbon Expedition to the Regions of the Amazon, 1851–52, which explored Brazil, Peru, and Bolivia, there was the U.S. Naval Expedition to the Southern Hemisphere, 1849–52, headed by Lt. James Gilliss and based in Chile; and the Page Expedition, which focused on the southern tip of the continent, navigating the waterways of Argentina and Paraguay between 1853 and 1856. The information and pictorial records they gathered were disseminated in government expedition reports and popular travel accounts to a people hungry for reports of American territories by American explorers.[69] The American Philosophical Society's recommendation on 7 January 1848 in support of the Gilliss Expedition emphasized this nationalist theme, which helped justify much of the exploration done for commercial as well as scientific gain in this period: "As our country had hitherto contributed but little . . . to astronomy and navigation, and as the plan of Lieut. Gilliss is so American, your committee suggest that the

Society should commend it earnestly to the attention and patronage of the Navy Dept."[70]

The plea was apparently successful, for the navy dispatched Gilliss and his crew in 1849 for Santiago, Chile. There he intended to make a series of astronomical measurements which, when compared with measurements simultaneously taken in Washington, D.C., would determine the solar parallax (i.e., the distance between the sun and the earth). In addition to their astronomical duties, conducted in an observatory atop Santa Lucía Hill, the entire staff collected birds, mammals, fish, reptiles, shells, fossils, botanical specimens, and miscellaneous artifacts. The resulting three-volume report, filled with new observations on the Chilean lands and peoples, made its way into many public and private libraries, including that of Church.[71]

In 1851–52 U.S. Navy Lts. William Herndon and Lardner Gibbon descended the Amazon, one by its Peruvian and the other by its Bolivian tributaries. While Herndon's travels through Peru took him through previously charted waters, Gibbon could claim that he was one of the first foreign explorers to descend the Madeira River from its source to the Amazon and to give a comprehensive account of it. According to Van Wyck Brooks, their report, published by the government in 1854–55, was "particularly thrilling to young American readers. They were almost as excited by this pioneer 'opening' of South America as by Commodore Perry's actual 'opening' of Japan." Church also had a copy of their *Exploration of the Valley of the Amazon*, as did Mark Twain, who was sufficiently excited by it to plan his own Amazonian adventure.[72]

La Plata River, which flows through Argentina and Paraguay, was explored by Thomas Jefferson Page and his crew on the paddle-wheel steamer *Waterwitch* from 1853 to 1855. This area had just opened up to commerce and exploration after the overthrow of the Argentine dictator Juan Manuel de Rosas in 1852. Page and his men spent two years in South America, during which they navigated thirty-six hundred miles of river and trekked more than forty-four hundred miles over-

land; he wrote a day-by-day account of their adventure.[73] The North American public anxiously awaited Page's "most timely" book: "Our present relations with Paraguay, partly growing out of the very explorations referred to, have assumed an importance which renders it necessary that we should possess exact information in respect to that country."[74]

The government expedition report was only one of several types of literature concerned with Latin America on the rise in the 1850s. In 1859 Rev. J. C. Fletcher noted the growing number of travel books on the subject:

> It is not a little remarkable that, until within the last dozen years, scarcely a trustworthy or reliable volume has appeared in the English tongue concerning the territory extending from the Isthmus of Panama to the Straits of Magellan. But within the time referred to, the press, both in Europe and America, has been prolific in works of great value in regard to South America.

Fletcher himself was part of this trend, for he along with Reverend Kidder wrote the travel account *Brazil and the Brazilians* (1857), based on observations made while doing missionary work in that country. The book itself took its place on the library shelves alongside Thomas Ewbank's *Life in Brazil; or, a Journal of a Visit to the Land of the Cocoa and the Palm* (1856), I. F. Holton's *New Granada: Twenty Months in the Andes* (1857), and John Esaias Warren's *Pará; or, Scenes and Adventures on the Banks of the Amazon* (1851).[75]

The American public, as it became more aware of the political and economic potential of these regions, began to avail itself of this newly published material. Working as a ticket agent for Aspinwall's Pacific Mail Steamship Company in 1853, Winthrop wrote to his mother requesting her to send any volumes that appeared dealing with Latin America:

> Putting in the same parcel whatever books you chose and particularly Tschudi's *Travels in Peru*. I should like

Sir F. Head's "Rough Notes of a Journey Across the Pampas" and any thing there may or have appeared descriptive or historical relating to South or Central America. I should like too Barnard's Book about the Tehuantepec Route (Squier's Nicaragua I have read). I should like too a good book of modern travels in Brazil and the Republics along the Paraguay & c. . . . I have plenty of time in the intervals between our crushes to read and should be glad to inform myself as much as possible the countries of this continent becoming more and more important every day.[76]

The format of the travel book, for the most part rigidly chronological and dutifully linear, made Winthrop despair when he came to write his own tropical travel account, *Isthmiana*, that "*ex post facto* narratives are doubtless unconstitutional in Yankee literature."[77] But the information contained therein was incorporated into the layering of collective knowledge about Latin America.

Illustrations in Expedition and Travel Accounts

Widely circulated by the government printing office as well as commercial publishers, the illustrations accompanying the expedition reports served as early and important pictorial prototypes for subsequent renderings of these little-known regions. The visual material related to Page's exploration of La Plata—one of the few illustrated accounts on Latin America for which the original sketches are known—underwent a progressive transformation.[78] Comparison of the original watercolor drawing of *Attack on the "Waterwitch"* (fig. 25) and the subsequent print reveals that the engraver made several significant alterations, eliminating the foreground plane, enlarging the Indians on horseback, and giving them dark hair flying in the wind to enhance the savage and threatening effect of their advance toward Page's sidewheeler, the *Waterwitch*.[79] This engraving became part of the repertory of Latin American imagery, undergoing further permutations with each appearance.

25. *Edward Kern*, Attack on the "Waterwitch," c. 1857, wash and pencil on paper, 4³/₄ × 8³/₈ in. (12.1 × 21.3 cm). Gilcrease Institute of American History and Art, Tulsa, Oklahoma (0236.737).

26. *After Edward Kern*, Meeting Indians on the Chaco, *illustrated in* La Tour du Monde, *1861*.

Included in the French periodical *La Tour du Monde* a few years later is the same image (fig. 26).⁸⁰ In the hands of the European engravers the landscape scenery, seen in reverse, has become far more overgrown and wild; and the Indians, now conflated with their northern brethren, wear feathered headdresses and carry spears on their charge to the water's edge. More important than these successive alterations of the engraving, however, is the fact that it became the point of departure for subsequent images of similar subjects.

The illustrations in Gilliss's report on Chile had echoes in topographical and high art alike. Among them Smith's panoramic drawing, *View of Santiago from Santa Lucía Hill*, which appeared as a foldout frontispiece to volume one of the report, proved to be the most influential.⁸¹ On his visit to Chile in the early 1870s, Henry Ferguson, who surely had acquainted himself with the work of his predecessors, Gilliss and Smith, climbed the same hill and sketched from the same spot (even including the same rocky platform in the foreground) the contours of the rapidly expanding city (see fig. 32). Native and European artists similarly took Smith's work as their point of departure. His topo-

graphical records, like the others published in this period, became part of the limited currency of Latin American landscape imagery and provided the schema for larger and increasingly more elaborate paintings.

The Influence of Heart of the Andes

Church's canvases became the most authoritative images of South America. And from among his many renderings, *Heart of the Andes* emerges as the single most important and enduring of the Latin American landscapes ever created by a North American artist. The reverberations of its great success could be felt in American art for two decades after its debut in 1859. Widely circulated through William Forrest's engraving of 1862, it was admired, emulated, and at times directly copied by many of Church's fellow artists. The progeny of *Heart of the Andes* includes a large and ambitious scene entitled *A Morning in the Andes* (fig. 27), painted in 1870 by Andrew Melrose, who seems never actually to have made an Andean journey. Similarly, A. F. Loe-

27. *Andrew Melrose*, A Morning in the Andes, *1870*, *oil on canvas, 37 × 72 in. (94 × 182.9 cm). Collection of the Newark Museum, New Jersey.*

mans, in his large-scale work *Chimborazo, Queen of the Andes* (fig. 28), appears to have been inspired by Church's imagery rather than firsthand experience. Granville Perkins organized his empirical observations according to Church's composition in *Tropical Night* (Oakland Museum). Landscapes of imaginary scenes by Robert Duncanson such as *Land of the Lotus-Eaters* (1861; Collection, His Royal Majesty, the King of Sweden) were inspired by it.[82] The western panoramas of Albert Bierstadt and Thomas Moran followed the lead of Church's picture.[83] And even native artists seem to have looked to Church's engraving as a compositional model for their own images of the Ecuadorian landscape.[84]

More important than these direct borrowings is the inspiration it provided for other artists to take up the neotropical world as an acceptable subject for high art. Although other artists had visited Central and

South America earlier in the century, their efforts were eclipsed by Church's achievement. A *Crayon* reviewer declared that one of his tropical pictures would "be found interesting from its fidelity to a field which he has entered alone." But even though Church was neither the first nor the only artist to treat this subject matter, he was certainly the most influential delineator of the Tropics. Another critic, looking back on the 1850s, recalled, "People did not then know much about the land of the Amazon and the Andes, and Church succeeded in greatly interesting them in it, showing them the most surprising features of a very wonderful region."[85] With *Heart of the Andes* he legitimized and popularized an entire field of imagery previously considered the domain of scientific illustration and theatrical curiosity.

28. *A. F. Loemans*, Chimborazo, Queen of the Andes, *oil on canvas, 43 × 60 in. (109.2 × 152.4 cm). Private collection.*

Although artists began to join the ranks of South American explorers, appreciation of their tropically exotic pictures had been slow in coming. In 1855, the year Church first submitted an Andean scene to the National Academy of Design, the majority of landscapes shown were domestic subjects, interspersed with European views. The taste for classical landscapes, which adapted the scenery of New England and the Hudson River to the compositions of Claude Lorrain, prevailed. The sampling of works on the walls of the academy reflected the philosophy of its president, Asher B.

Durand, who in his "Letters on Landscape Painting" of 1855 cautioned his imaginary student, "Go *not* abroad then in search of material for the exercise of your pencil, while the charms of your native land have claims on your deepest affections." The search for the far-off and the unusual had not yet become part of American landscape aesthetics, codified at that moment in Durand's "Letters." For him, as for many others, exoticism led to a less noble form of expression: "Many are the flowers

in our untrodden winds that have blushed too long unseen," he continued, "and their original freshness will reward your research with a higher and purer satisfaction than appertains to the display of the most brilliant exotic."[86] The same year that Durand wrote his "Letters," Squier published his travel account *Waikna,* based on the adventures of an artist-hero roaming the tropics. But it was clear that such subjects had not yet been assimilated into mainstream American artistic theory and practice and that Squier's book was a bit premature. It remained for Church, with a second South American reconnaissance and a series of increasingly masterful paintings, to earn a place within the national art for tropical landscape. The unprecedented acclaim with which *Heart of the Andes* was received in 1859 signaled the attainment of that status.

The completion and exhibition of the great canvas coincided with a widespread fascination with the natural sciences. But its success depended equally upon several conditions more specific to the painter, the picture, and the art-going public of 1859. Church emerges as one of the principal heroes of this Latin American adventure in part because he spoke with the loudest public voice. His reputation as of 1859 contributed substantially to the triumph of his work that year. The son of a wealthy New England businessman and the star pupil of Thomas Cole, he was, as T. Worthington Whittredge put it, "fortune's favorite from the beginning."[87] These advantages, combined with his extraordinary artistic ability and ceaselessly inquisitive nature, made him "a watched painter."[88] He was always "Mr. Church" to his public; an artist, as one observer phrased it in 1856, "from whom much has been expected and from whom much is in fact due."[89]

By the following year Church seemed to have fulfilled these expectations. In 1857 *Niagara* (Corcoran Gallery of Art) was unveiled in New York and shown subsequently in London, Glasgow, Manchester, and Liverpool, thereby winning the acclaim of the British art world.[90] Church became, in consequence, the first American painter since Washington Allston to establish an international reputation. This enhanced critical standing outside the United States substantially elevated his status at home, for artistic taste in the United States, as John Durand observed, "had developed unconsciously through the experiences and fame of American artists outside their country, the same as its literary taste has improved through foreign admiration of Irving and Cooper."[91] Church's recently earned international attention endowed his next major landscape with added prestige. *Heart of the Andes* did not burst upon a startled public as the product of an unknown hand; it was, instead, the latest major product from the easel of one of the finest and most respected artists of the day.[92] Even those who may have been unreceptive to the introduction of tropical exoticism into American art were more favorably disposed to it because it was his work.

The artist's reputation was not the only mitigating factor in the painting's favor. The sheer efforts behind his repeated explorations and preparations for *Heart of the Andes* were not to be denied by even the most unfriendly critic, as a British reviewer admitted:

Considering the place it represents, the enterprise of the painter in repeating visits to so distant and semi-barbarous a region for the sake of producing a faithful picture, the size of the work, and the care spent upon its execution, and considering further that it is the work of a painter unacquainted with European studies and academic traditions, it would claim respectful consideration even if it failed to satisfy the requirements of the Art critic.

"But," as he hastened to add, "it stands in no need of allowance on any of these points."[93] On American shores Church's reputation was unrivaled in 1859, and his production, if for this reason alone, could not possibly be ignored.

Southern Interest in South America after the Civil War

The war years, between 1861 and 1865, marked a hiatus in American exploration of Latin America, the West, and elsewhere. But in the aftermath of the Civil War, southerners in particular took an increased interest in the southern continent. Following the surrender at Appomattox Courthouse, the Confederate States of America were in effect a conquered nation. The guidelines for regaining citizenship remained blurred, and the wholesale destruction of lives and property meant the continuation of severe financial hardship. In reaction to these economic and political pressures, many southerners decided to leave the United States for another country. England, Canada, Mexico, Cuba, and Honduras were all discussed for their potential merits. But the most frequently considered sanctuary was Brazil, where slavery was legal, land was inexpensive, and southern emigrants were sought and courted.

Beginning in 1865, all over the South, plans were being drawn up for settlement in Brazil. In Chester County, South Carolina, Joseph Abney was elected president of the newly formed Southern Emigration Society. Lansford Warren Hastings, a pioneer in Oregon and California, made plans for a colony on the Amazon River. Alabama's George Grandioson Gunter determined to lead a flock to a home on the Doce River in Espíritu Santo Province. James McFadden Gaston, a South Carolina physician, made an extended survey of southern Brazil, then wrote a lengthy guide called *Hunting a Home in Brazil*, which became an important reference for potential émigrés. Rev. Ballard S. Dunn, an Episcopal minister from New Orleans, acquired a tract of land near Iguape, São Paulo Province, which he declared a refuge for the South's oppressed. And Frank McMullan guided 154 Texans in the most significant Confederate emigration to Brazil.[94] These developments greatly facilitated the opening up of the country and its waterways to the United States. Louis Agassiz,

although not himself a southerner, was among those to benefit from the open arms Brazil had begun to extend to visitors and potential settlers from the United States in the aftermath of the Civil War.

The Last Conquistadores: 1863–1879

During this period Spain and those who have been called "the last conquistadores" were also attempting to exert their power in Latin America once more. Motivated by the hope of reviving its severely ailing economy, Spain made a final attempt to regain control of its former Latin American colonies, and particularly the valuable guano deposits. The assault on Peru, which began in 1863 and lasted until 1866, was justified on the grounds that the Crown had never recognized that country's independence. The United States, at that moment in the throes of civil war, was unable to take action; but Chile joined forces with its neighbor and declared war against Spain. Open hostilities consisted of the capture of a Spanish gunboat by a Chilean steamer in 1865; the three-hour bombardment of Valparaíso on 31 March 1866; and the battle of Callao in May 1866, when both sides declared victory. Direct confrontation ceased, but negotiations dragged on, and the treaty was not signed until 1879.[95] This conflict aroused deep sympathies around the world and aroused many to come to the aid of the Chileans, among them James Whistler.

A Counterfeit Paradise: 1859–1879

These developments, which had reached a peak in 1859, ran their course until about 1879. Artists pursued their travels and paintings in Central and South America with renewed energy in the 1860s and 1870s. Within six years Heade made three tropical sojourns: to Brazil in 1863–64; to Nicaragua and Colombia in 1866; and to Colombia, Panama, and Jamaica in 1870.

LOCOMOTION IN SOUTH AMERICA.

What the country people would do down there, if the jackasses were only long enough.
—What they *do* do, is but slightly caricatured by Our Artist.

29. *George Washington Carleton,* Locomotion in South America, *from* Our Artist in Peru.

George Washington Carleton visited Peru in 1866, culminating in an illustrated account, *Our Artist in Peru* (fig. 29). Cleveland Rockwell participated in the Magdalena River survey in Colombia. Jacques Burkhardt was involved with Agassiz's expedition to Brazil (see fig. 63), and Andrew Warren's "second visit to Central America (Nicaragua) in search of fresh material" was reported by Henry Tuckerman. From about 1870 to 1873 Henry Ferguson explored Ecuador, Peru, and Chile. In 1875 Eadweard Muybridge traveled extensively in Central America, where he made exquisite photographs of the coffee plantations and the surrounding scenery of Guatemala (fig. 12), while his friend Norton Bush made his third and final trip to South America the same year, when he visited Peru.

But these activities, the continuation of events put into motion in 1839, had slowly shifted in character. By the late 1870s a change can be perceived in artistic responses to Latin America. Church's *Morning in the Tropics* (fig. 30) can be interpreted as one sign of this change; for the artist, who had once portrayed in monumental scale the paradisiac heights of the Andes, by 1877 conceived the deepest recesses of the Amazon as mysterious and threatening. Others turned to the depiction of encroaching industry and growing cities as an alternative to the Andean peaks, which they considered redolent of the old sublime. Bush took on a commission from Henry Meiggs to paint his Peruvian railroad enterprise (fig. 31). And Henry Ferguson was said to have attracted the attention of local patrons with his images of the expanding urban sprawl of Santiago de Chile (fig. 32).

Style, as well as subject matter, was changing. The crystalline detail that had once been Church's hallmark gave way to a looser and more "velvety" touch; and Ferguson, who was younger, did a number of smaller pictures of rocks and trees—of the anonymous corners of South American nature rather than its most spectacular landmarks—in a soft, impressionistic stroke. The major transforming influence, the painters who trained in Europe after the Civil War, led to the establishment in 1879 of the Society of American Artists and to a widespread transition in American art in the 1870s.

This metamorphosis, reflected in the pictorial imagery of Latin America, was all but complete by 1879, and it finds echoes in scientific, archaeological, economic, and political developments. Science and archaeology had become more specialized and professional. The end of Humboldt's era had come. Never again would a single man or even a group of men attempt to embrace the totality of a continent. Support for such a plan, in any case, would not have been forthcoming. In 1865 Agassiz had to struggle to find financial backing for his ambitious Brazilian venture: eventually he turned to the private sector in the person of Nathaniel Thayer. Except for its ongoing efforts on the canal project, the U.S. Navy was no longer concerned with South American exploration on a continental scale. Future reconnaissances, such as Theodore Roosevelt's Brazilian sojourn at the end of the century, depended on private institutions for support of far more circumscribed investigation.[96]

A unified pictorial consciousness of Latin America emerged in the United States in the decades around

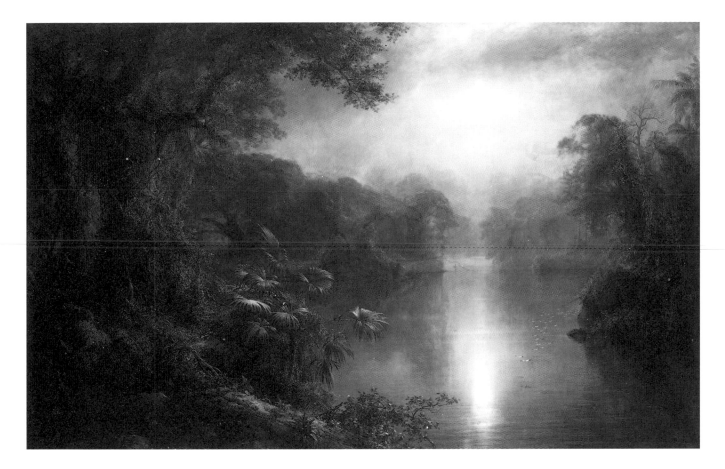

30. *Frederic Church*, Morning in the Tropics, *1877*, *oil on canvas, 54³/₈ × 84¹/₈ in. (138.1 × 213.7 cm). National Gallery of Art, Washington, D.C., gift of the Avalon Foundation, 1965.*

1859 in direct response to a lacuna of knowledge. Its image as a land of scientific wonders, golden riches, and edenic innocence could be maintained only so long as accurate information and direct experience were at a minimum. The age-old myths lingered under these conditions until late in the century. It was only as the peoples of the north learned more of those regions that their cherished preconceptions were shattered.

The renewal of the canal project contributed to an increased scepticism toward inherited myths and finally forced northerners into a more realistic appraisal of the tropics. After 1869, with the completion of the Transcontinental Railroad and the Suez Canal, the one great geographical challenge remaining was the interoceanic

canal, and the eyes of the world focused on that narrow strip of land connecting the Americas. The destiny of the country could "only be attained by the execution of the Darien ship canal," Secretary of State William Seward declared in a speech delivered in New York in 1869. Eleven years later President Hayes noted in his diary that his country would "not consent that any European power shall control the railroad or canal across the Isthmus of Central America . . . the United States will insist that this passageway shall always remain under American control."[97] Their statements

62

31. Photograph after Norton Bush, Mount Meiggs, *by Eadweard Muybridge. Painting unlocated; photograph from a private collection.*

reflected the sentiment of the American public. The implementation of the plan, achieved in 1914 in Panama, ultimately cost 25,000 human lives (500 lives for every mile of the canal) and $639,000,000. In the 1870s, however, the location was still open to debate. Ferdinand de Lesseps and the French canal company broke ground in Panama in 1883, the year Frederic Church painted *Twilight on the Isthmus of Panama* (art market) to hang in the Panama Canal Exhibit. But even that did not sway the United States from its preference for the Nicaraguan site. After the inevitable failure of de Lesseps and his company, the United States resumed its campaign for a Nicaraguan canal, which was maintained until 1902, when the formation of the New Panama Canal Company put the plan to rest for good. Thus until the end of the century U.S. interests in Nicaragua thrived, and its beautiful landscape continued to be the object of much discussion, exploration, and pictorial portrayal.[98]

Lake Nicaragua became an important theme in Bush's art beginning in the 1870s. That freshwater lake, known as the "Gran Lago," is located in the interior of Nicaragua. Squier had described its beauty in *Nicaragua,* a popular travel book first published in

1852, with which Bush was undoubtedly familiar. From the lakeside town of San Carlos, Squier wrote,

> One of the finest views in the world is presented to the traveler. The broad lake spreads like a mirror in front, its opposite shores marked by the regular volcanic peaks of Orosi, Madeira, and Ometepec, capped with clouds, which rise dim and blue in the distance. Nearer lie the fairy-looking islands of La Boqueta, golden under the tropical sun, while in the foreground the emerald shores stretch their wide arms on either side, a fit setting for so gorgeous a picture.[99]

Bush may very well have visited the lake and viewed it from a similar vantage point on each of his three trips to Latin America. *Sunset over Lake Nicaragua* (pl. 8) exemplifies his treatment of that subject. In it the calm waters of the lake, presided over by a smoking but dormant volcano in the middle distance, are viewed through a natural frame of colorful flowers and twisting vines. Other pictures produced over the next several decades—*Lake Nicaragua* (fig. 33), *Volcano and Lake,* and *Tropical Lake*—depict the same location in a similar manner. The number of canvases he painted of this one place suggests that it had a special import for him.[100] Bush was not alone, however, in his preference for this subject. Other artists from the United States drew and painted the Nicaraguan scenery, a fact that underscores the public demand for such imagery.

Martin Heade's interest in Nicaragua, where he visited in 1866, may well have been aroused by the wide publicity it received as a proposed canal site. A group of surviving drawings he did in the region suggest that he closely followed its route. From the Caribbean (i.e., eastern) shore he followed the San Juan between where he penciled at least one sketch. He then would have crossed Lake Nicaragua and landed near Virgin Bay, where he drew the wetlands. He also visited Granada, north of Virgin Bay on the lake, and made several profiles of the coastline, complete with boats and figures (fig. 34). These and other drawings made on that trip must have served as studies for a painting he

32. Henry Ferguson, Santiago de Chile from the Hill of Santa Lucía, *c. 1870–74. Unlocated. Photograph courtesy of Frick Art Reference Library (41198).*

exhibited the following year at the National Academy of Design entitled *Lagoon in Nicaragua.* Although the fate of that painting is uncertain, *Omotepe Volcano, Nicaragua* (see fig. 42) shows the peak's perfectly conical form reflected in the placid waters of Lake Nicaragua. Together these works suggest that Heade's visit to the region was no coincidence but tied to an interest in the canal route he followed. This link seems especially likely considering that besides Heade and Bush, Andrew Warren and others visited Nicaragua during this period, in a burst of attention.[101]

Government exploration of the entire region, including the dread Darien, was escalating once more. Col. Thomas Selfridge commanded the Exploring Expedition to Darien from 1870 to 1874, and the pho-tographer Timothy O'Sullivan was assigned to the first exploring party. But the scenery that awaited them possessed not the idyllic beauty Bush and Heade were able to capture in Nicaragua. O'Sullivan, in fact, had difficulty taking any photographs at all, for the vegetation was so dense it shut out nearly all the sunlight. In addition, the cameras, heavy glass plates, and dark tent he had brought along were nearly useless because of the heat and humidity.[102] The images and reports O'Sullivan, Selfridge, and others sent back from Darien helped convince the general public that the Tropics, far from being a long-lost paradise, were a dark and dangerous realm.

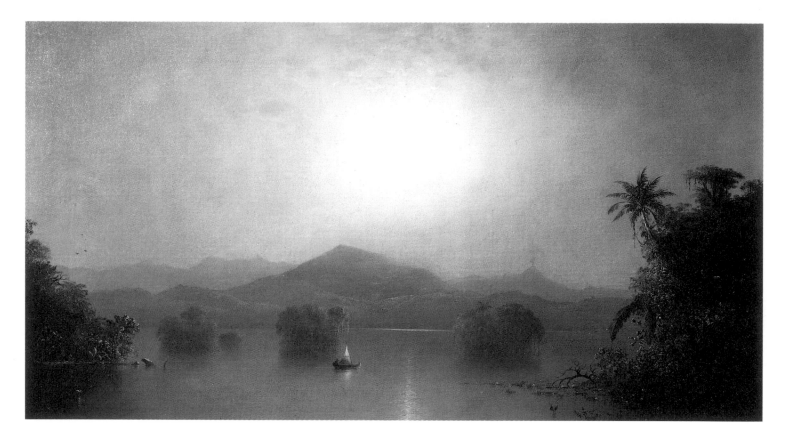

33. Norton Bush, Lake Nicaragua, 1871, oil on canvas, 19¼ × 35 in. (48.9 × 88.9 cm). Hood Museum of Art, Dartmouth College, Hanover, New Hampshire, purchased from the Whittier Fund (P.970.56).

Commercial interests too had shifted. A case in point is the guano trade; Peru's supply of natural fertilizer, a lucrative commodity on the international market in the 1850s, was all but depleted by 1879. The Chincha Islands had been described at mid-century as "bold, brown heads, tall and erect, standing out in the sea." By 1881 ten million tons of guano had been lifted from a single island (a mountain of droppings that required five thousand ships to remove it), and "these same islands looked like creatures whose heads had been cut off, or like vast sarcophagi, like anything in short that reminds one of death and the grave."[103] Once a place of active trade, the ports of Peru were again deserted. Nor did the United States make much effort to stimulate commerce with other South American nations, as one traveler argued in the case of Brazil:

We firmly believe that increased facilities for the United States would be attended by the same good results that have followed the efforts of foreign companies. The fact of the matter is, our countrymen do not appreciate their proximity to the great empire of Brazil, nor make the right efforts to secure its trade.[104]

Travel Conditions

From 1839 to 1879, major improvements took place in transport between the United States and Latin America. It remained, nevertheless, a delay-ridden and difficult

34. Martin Heade, Granada, Nicaragua, *c. 1866, leaf from sketchbook, pencil on paper, 7¹/₄ × 10 in. (18.4 × 25.4 cm). Museum of Fine Arts, Boston (60.1011).*

prospect at best. As late as 1874 a travel writer could still complain that

> the United States have only one line of steamers, making monthly trips between New York and Rio, while Europe sends to the same port eight steamers per month from Liverpool and London, two from Southampton, two from Antwerp, two from Hamburg, two from Bordeaux, one from Lisbon, and one from Genoa![105]

But even after the determined Yankee caught the infrequent steamer and arrived at a coastal port, what then? Transport into the interior of the continent has remained a problem from the time Humboldt and Aimé Bonpland refused the usual means of conveyance—a chair strapped to another man's back—to the present. Railroads offered some hope, but no immediate solution. One of the first railroad lines in South America was completed by William Wheelwright in 1852. It

ran fifty miles from Caldera, the Chilean port he had developed, to the rich copper and silver mines at Copiapó. The short extensions that were soon added brought him only slightly closer to his proposed trans-Andean railroad. Finding little assistance in Chile he began working from the Argentine side, where, as a result of his efforts, the Grand Central Argentine Railway, from Rosario to Córdoba, was opened in 1870. In the meantime, several other national railroads were built. Louis Agassiz reported a ride on a newly constructed stretch of track in Rio in 1865. And Wheelwright's competitor, Henry Meiggs, completed additional lines in Chile and Peru and commissioned the American-born photographer Benjamin Pease and later Norton Bush (fig. 31) to record them for posterity.[106] But in general these railroads tended to service local areas, usually from the coast to substantial mineral deposits in the interior, with no connections between one line and the next. Even Wheelwright's perseverance did not overcome the difficulties, and his dream of a trans-Andean railroad remained unfulfilled until 1910, long after his death.[107] The fact that overland travel was so impossibly difficult helps explain the distribution of North American travelers around the periphery of the continent, while artistically speaking, the forbidding interior remained largely unexplored. It also explains why the written accounts are filled with mixed praise and damnation of travel by burro or champan: that luckless animal (fig. 29) and the curious rivercraft (see fig. 39), which so frequently made their way into the finished paintings, were often the sole means of transport through this vast and difficult terrain.

The fact that travel writers, naturalists, and artists from the United States ever arrived at their South American destinations is a measure of their own motivation, determination, or—in the case of Agassiz, who had steamship lines and the hospitality of the Brazilian emperor at his disposal—their influence. But of course the difficulties in getting there were part of the quest; and in fact Latin America's attraction for them seemed to diminish with increased accessibility. What kind of

an adventure would it have been, after all, if all they had to do was board a luxury liner and be conveyed in safety and comfort to a Hilton at Rio de Janeiro?

The New Pan-Americanism

The end of the 1870s signals also approximately a half century of Latin American independence. Those countries were beginning to experience an increased sense of self-awareness, as demonstrated by the growth of native traditions in science, literature, and an awakening to the fascination of their own landscape. These developments contributed to a distinct change in inter-American relations during the last twenty years of the century.

The Centennial Exposition, held in Philadelphia in 1876, typifies the changes that were occurring across the United States. Its contents and even the format of the opening ceremony suggest, in their new inter-American emphasis, a change in attitude toward Latin America. On a tour of the United States in 1876, Emperor Dom Pedro II of Brazil was on hand in Philadelphia to participate in the opening ceremonies. His presence at the fair and interest in the exhibits, intended to demonstrate the infinite resources and technology of the host country, were strongly applauded in the press.[108] A writer for *The Nation* referred to him as "that gray-bearded and benign steam engine—their ruler—who so recently visited this country, and examined with such eagerness every feature of our industry" and was similarly approving of the exhibition of Brazilian goods in Agriculture Hall:

The Imperial Republic of Brazil, which has been free and independent for only half a century, and which is only beginning to develop the resources of its enormous area, under the control of what is almost the freest government in the world, has attracted here and in Europe little popular attention. A country of almost boundless extent, of great natural fertility of soil, and with every variety of climate that agriculture and forestry can desire, needs only skillful development to make itself felt in the markets of the civilized world. . . . The space set apart for the Brazilian exhibit in Agricultural Hall . . . contains much of instructive interest for the political economist of the United States.[109]

The emperor's efforts to organize this display of his nation's products demonstrate the attempts Latin American rulers were making to promote exchange between their countries and the United States.

This new pan-Americanism extended beyond the confines of agriculture and industry to include art. Among the seventeen nations to participate in the Exhibition of Paintings and Sculpture at the Centennial Exposition, three were Latin American: Brazil, Mexico, and the Argentine Republic. Together they showed eighty-nine paintings in oil, along with miscellaneous watercolors and sculpture.[110] Two Brazilian artists won gold medals: Joaquim Insley Pacheco and Marc Ferrez. The latter, who showed a landscape panorama, had earlier provided Agassiz with scenic photographs of Brazil.[111] And the Mexican painter José María Velasco displayed images of his native scenery. This exposition offered new opportunities to view Latin American art in the United States, and important collections began to be formed.[112] Looking back from the year 1875, a critic for the *Art Journal* reminded his readers that "it was Mr. Church's pencil which first drew attention to the impressive character of the scenery of our tropical regions."[113] But no longer would he, or any other North American painter, bear the full burden of revealing the facts, the beauties, and the promise of the southern continent, for they could now be seen also through indigenous eyes.

Science and the Search for Origins

Cataclysm and Creation

Church and the Question of Terrestrial Origins

> Nothing but pines, fircones, stones, black earth. Yet that earth looked
> parched, those stones, unmistakably, volcanic. Everywhere, quite as
> Prescott informed one, were attestations to Popocatepetl's presence and
> antiquity. And here the damned thing was again! Why were there volcanic
> eruptions? People pretended not to know. Because, they might suggest
> tentatively, under the rocks beneath the surface of the earth, steam, its
> pressure constantly rising, was generated; because the rocks and the water,
> decomposing, formed gases, which combined with the molten material
> from below; because the watery rocks near the surface were unable to
> restrain the growing complex of pressures, and the whole mass exploded;
> the lava flooded out, the gases escaped, and there was your eruption.—But
> not your explanation. No, the whole thing was a complete mystery still.
>
> MALCOLM LOWRY, *Under the Volcano*

*C*otopaxi, the Great Volcano of the Andes, painted by F. E. Church, on Exhibition at Goupils, no. 779 Broadway, from 9 A.M. to 6 P.M., admission 25 cents" read an announcement in the *New York Albion* for 21 March 1863. The exhibition marked the public unveiling of Church's latest and most successful rendering of the Cotopaxi theme, one of his finest achievements (fig. 35). On the four-by-seven-foot canvas he depicted the volcano in "continuous but not violent eruption."[1] Its smouldering cone is illuminated by the light of the morning sun, rising above a still lake. The viewer, suspended above a vast foreground rift, surveys the aftermath of a great natural cataclysm, through which the American continent was created anew.

When *Cotopaxi* "emerged from the collection of Mr. James Lenox to delight a numerous and appreciative company of amateurs" at Goupil's, a comparison

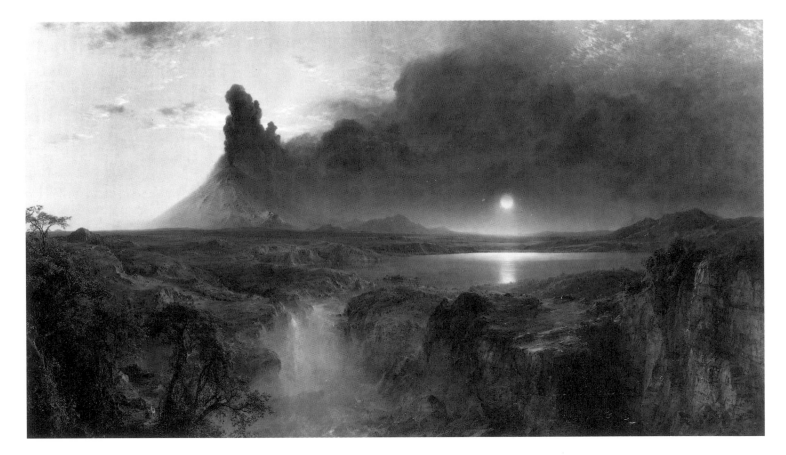

35. Frederic Church, Cotopaxi, *1862, oil on canvas, 48 × 85 in. (121.9 × 215.9 cm). Detroit Institute of Arts, Founders Society Purchase, Robert H. Tannahill Foundation Fund, Gibbs-Williams Fund, Dexter M. Ferry, Jr., Fund, Merrill Fund, Beatrice W. Rogers Fund, and Richard A. Manoogian Fund.*

with its great tropical predecessor, *Heart of the Andes* (pl. 1), was inevitable. Church had moved beyond its portrayal of the peaceful Andes to reveal the primal powers that stirred beneath their surfaces. *Cotopaxi* was immediately appreciated for the further insight it provided into geological process:

> *Cotopaxi* is the *Heart of the Andes*, throbbing with fire and tremulous with life. It is a revelation of the volcanic agencies which made the landscape of Alpine South America what it is. The mountain is breathing; the waters which its central forces, at work far below the smiling plains, unloose and set in motion, are breaking from their gleaming reservoirs in capricious cascades.[2]

The painting represents the apogee of a series of at least

ten finished pictures on the subject. Church first drew its profile in 1853 in the company of Cyrus Field, studied it again on his return in 1857 with Louis Mignot, and continued to essay its perfectly shaped cone for almost two decades. Putting this image to canvas in 1862 fulfilled the purpose of his expedition through South America: a glimpse at terrestrial creation.

South America, to the mid-nineteenth-century North American mind, represented renewal, rebirth, perhaps the closest approximation to the world as it

existed at the beginning of time. The search for origins—a leitmotif of the age—propelled their expanding investigation into its vast rivers and lofty mountains. Coincident with Humboldt's "rediscovery" of Latin America between 1799 and 1804, the study of the earth itself was undergoing profound transformation. Throughout the following century, grand exploratory ambitions merged with the study of the natural sciences. Botany, meteorology, and particularly geology enabled Americans to extend their voyages to events beyond human history, to the earth as it was before the arrival of man. Scanning the continent, Church and his fellow travelers found in the ever-present volcanic craters and cones the most obvious results of recent geological activity and seized upon them for their insights into the workings of the Creator.

Church shared these concerns with Mignot, Heade, and Catlin, who also conducted geological researches during their South American travels. Mignot painted and exhibited, beginning in 1858, his own highly personal views of Cotopaxi and the other great Andean peaks; and Heade studied their counterparts in Central America. Catlin, although he seems to have painted few volcanoes, discussed them and their action at length in his geological treatise, *The Lifted and Subsided Rocks of America*, where he put forth his own theory on the formation of the American continents.[3] Although less well known than Church for their interests in mountains and volcanoes, these artists also pursued the question of terrestrial origins on the southern continent.

Why Paint Cotopaxi? Church's Early Views: 1853–1857

Located among the Andes of Ecuador in the northwest corner of South America, Cotopaxi rises almost twenty thousand feet above sea level (map 3). Through the popular writings of Humboldt, its status as the highest active volcano on earth was well known to the audience gathered at Goupil's. "The form of Cotopaxi is the most

beautiful and regular of the colossal summits of the high Andes," Humboldt had written, but it was "also the most dreadful volcano of the kingdom of Quito," and its explosions were "the most frequent and disastrous."[4] His description of the mountain's exotic beauty and latent powers of destruction proved fascinating to Church, who drew and painted it frequently. His interest in the subject was so closely linked with the great explorer's name that upon the exhibition of *Cotopaxi* in 1863, it was announced that Church had vindicated "his claim to be considered as the artistic Humboldt of the new world."[5]

His early vision of the volcano, quiet and almost pastoral (fig. 36), gives little hint of its potential activity. By 1857 he was putting greater emphasis on the rocky surfaces of the surrounding region, perhaps newly created by an eruption, and on the waterfall that continued to shape it (fig. 37). At this intermediate step he moved closer to his conception of landscape as earthscape, which culminates in the great erupting cataclysm of 1862 (fig. 35). The series documents his developing belief that the dynamic forces and molten lava within the earth's interior had formed and modified its surfaces. These ideas, acquired from his scientific readings (many of the books he consulted are still on the library shelves of Olana, his home in Hudson, New York), were more fully manifested to him by his experiences on the South American continent—itself a living laboratory of natural forces.

This group of paintings, which all take the volcano as their principal subject, includes some of Church's most important and most scientifically informed works. As a related body of images, it has an additional value greater than the sum of its component parts. Artists not infrequently developed their ideas in this way, returning again and again to the same motif. John Constable's paintings of Salisbury Cathedral or, more to the point here, Joseph Wright of Derby's repeated essays on Vesuvius, demonstrate the long-term fascination painters had with their subjects.[6] Church's repeated portrayal of the same theme over this extended

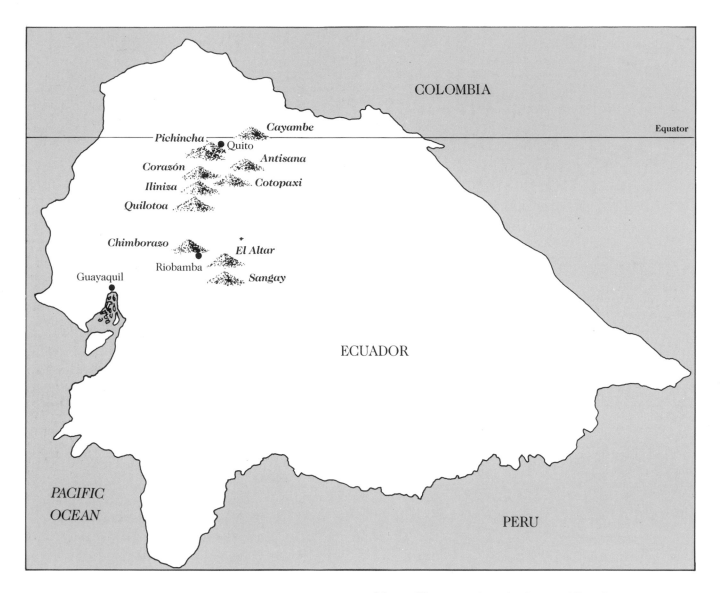

Map 3 . The snowpeaks and volcanoes of Ecuador.

period carries with it similar connotations. George Kubler's analysis of the artistic significance of images in linked sequences sheds light on Church's seriation:

> As the linked solutions accumulate, the contours of a quest . . . are disclosed, a quest in search of forms enlarging the domain of aesthetic discourse. That domain concerns affective states of being, and its true boundaries are rarely if ever disclosed by objects or pic-

tures or buildings taken in isolation. The continuum of connected effort makes the single work more pleasurable and more intelligible than in isolation.[7]

Church had viewed some of the most varied and spectacular scenery in South America, including the Magdalena River and Tequendama Falls, the lagoons of Guayaquil, and mounts Chimborazo, Sangay, and Cay-

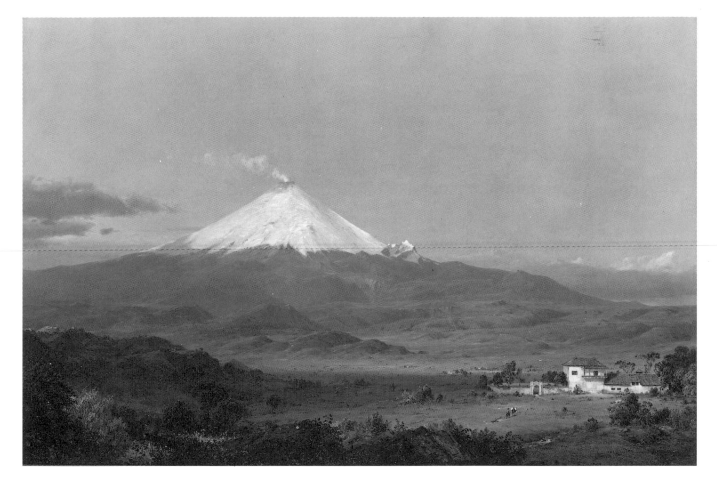

36. *Frederic Church*, Cotopaxi, *1855*, *oil on canvas, 28 ×*
42¹/₈ in. (71.1 × 106.8 cm). National Museum of American
Art, Smithsonian Institution, Washington, D.C., gift of Mrs.
Frank R. McCoy (1965.12).

ambe, sites that he painted only occasionally. Yet he returned again and again to the volcano's perfectly shaped cone because it embodied, more than any other subject, the sought-after vestige of creation.

Cotopaxi, almost universally recognized as one of the finest specimens of Church's skill as a painter, was further appreciated for its handling of the volcanic subject. Examining this aspect of the picture, one critic wrote,

It was a happy thought of the artist to represent, not a fiery eruption—red-hot stones and devouring lava—but the slow-mounting smoke and vapour phase, which suggests all, and gives the god of day a chance to play his role right royally. We have had a surfeit of volcanoes, spitting fire and fury—and convulsions of nature, and paint, and genius. The Cotopaxi is our first true picture of the kind, with power, beauty, and sublimity, and pathos blended in one harmonious whole.[8]

His words imply the public's familiarity with volcanoes and the various phases of their action, based on

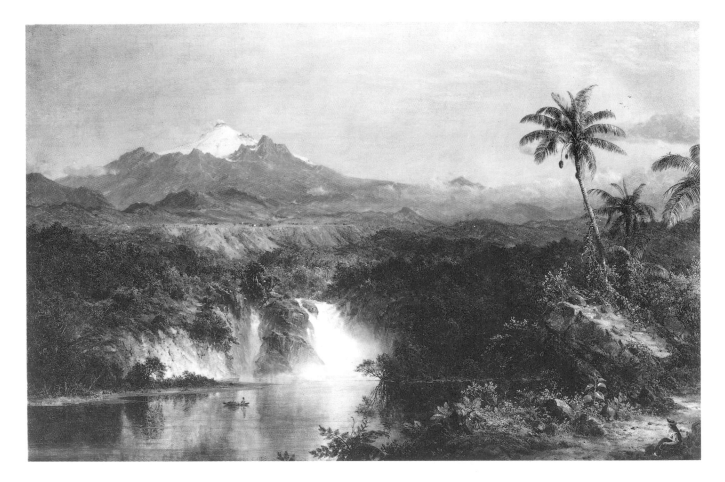

37. Frederic Church, View of Cotopaxi, *1857, oil on canvas, 24¹/₂ × 36¹/₂ in. (62.2 × 91 4 cm). Courtesy of the Art Institute of Chicago, gift of Jennette Hamlin in memory of Mr. and Mrs. Louis Dana Webster (1919.753).*

at least a rudimentary knowledge of geology. That science, dealing with the structure of the earth's crust and the formation of its layers, was especially influential in American thought from the publication of Charles Lyell's *Principles of Geology* (1830), volume four of John Ruskin's *Modern Painters* (1856), and Charles Darwin's *Origin of Species*. Simultaneously, geology had an effect on literature and theology. Lyell's *Principles*, for example, informed James Fenimore Cooper's novel of 1847, *The Crater; or, Vulcan's Peak*, which was set on a newly formed volcanic island.[9] Painters embraced the natural sciences even more enthusiastically in the belief that

such study would help them reveal the handiwork of the Creator in the facts of nature. Catlin, who complemented his portraits of North and South American Indians with landscape views of rivers and mountains, referred to "the sacred science of geology which is all truth."[10] At the same time, Church took up his South American travels armed with geological knowledge. Scanning the continent for evidence of its genesis, he and others focused on mountains, which Winthrop called "the most signal of earthly facts."[11]

How are mountains formed? Do mountains grow? These questions resonated throughout the literature of the period. While today geology has taught us to recognize the results of volcanic forces operating across the entire surface of the globe, in the nineteenth century knowledge of volcanic mechanism was far more limited. These forces were credited with shaping only the isolated oddities of the volcanoes themselves and not, as we now know to be the case, much of the face of the planet. Scientists began, therefore, to seek out the craters and cones for the resolution of their deepest questions. For guidance in their investigations, they naturally turned to the writings of Humboldt, who had visited and described many of the important peaks in Mexico and South America.

Humboldt's consummate appreciation of equinoctial America was intimately linked with its mighty volcanoes, which formed a continuous chain along the Pacific coast of the continent. From the first page of his *Personal Narrative* to the last page of *Cosmos*, volcanoes are an important subtheme in his broad overview of nature. *Personal Narrative* recounted his ascent of Tenerife, prompting Darwin and others to follow suit. But his synthetic treatment of the dynamic activity of volcanoes, incorporated into the grand scheme of *Cosmos*, was most appreciated by his American audience. A dramatic passage on the eruption of a tropical, snow-capped volcano had special appeal for those seeking the key to terrestrial origins:

> A sudden fusion of the snow at its cone of cinders announces the proximity of the eruption. Before the smoke is visible in the rarefied strata of air surrounding the summit and the opening of the crater, the walls of the cone of cinders are sometimes in a state of glowing heat, when the whole mountain presents an appearance of the most fearful and portentous blackness. The crater, which, with very few exceptions, occupies the summit of the volcano, forms a deep cauldron-like valley. . . . Long narrow fissures, from which vapours issue forth, or small roundish hollows filled with molten masses, alternatively open and close in the cauldron-like valley;

the bottom rises and sinks, eminences of scoriae and cones of eruption are formed, rising sometimes far over the wall of the crater, and continuing for years together to impart to the volcano a peculiar character, and then suddenly fall together and disappear during an eruption.

In no other place on earth could these phenomena be studied in greater concentration than among "the mountains of Pichincha, Cotopaxi, Tunguaragua [Tungurahua], and which from their grouping, elevation, and form constitute the grandest and most picturesque spectacle to be found in any volcanic district of an equally limited extent."[12]

Anxious to observe these phenomena for himself, Church departed for the Andes in April 1853. His first important encounter with an active volcano occurred in August near Popayan, Colombia. There he, Field, and "an English gentleman named Gregory" attempted a climb to the summit of Puracé ("Puresé"), which he recorded in several drawings.[13] For the artist the goal of their arduous trek was the crater, what Louis Noble called the "flue or passage for the far-down subterranean fires," which he and his contemporaries had come to regard as a window onto the earth's interior. For even the glimpse it proffered into the mechanism of creation, they willingly endured the hardships of altitude and climate, as Church's account to his sister Charlotte emphasized:

> We left Popayan . . . in the morning and arrived at the village of Puresé in the evening after sunset. . . . The next morning we started for the volcano, although the weather was unfavorable. . . . Thick clouds hung about us and the rain which we had been experiencing for some time changed to hail. . . . One of the horses now gave out and Mr. Gregory who rode it pronounced that it was impossible for him to go afoot the air was so rarefied so he returned. The remainder of us pressed on until all the horses gave out, when we dismounted and continued on foot. You can scarcely imagine the strange effect that so rare an atmosphere has upon the body. Ten

steps will put a strong man out of breath. The guides were obliged to help Mr. Field although we had a fifth of a mile to go to reach the first crater, as it is called.

With the first crater so close at hand, Church pressed on, his curiosity increasing with each new sight he beheld:

> I pushed up to this immediately with one of the guides and found that it was not a crater but a *blowhole* or small opening perhaps a yard in diameter from whence sulphurous steam blew out with tremendous force. The sides of this peak had several cavities from which some issued steam others hot water. Underneath the ashes a few inches was pure sulphur and calcinated stone so hot that a specimen which I picked up dropped from my fingers like a hot iron.[14]

Church's attitude contrasts sharply with Cole's, who had climbed Mount Etna eleven years before to obtain a sunrise view of the surrounding scenery and took only "a hasty glance" into what he called "the gloomy crater of the volcano."[15] Casting aside the dread associations of the sublime held by his teacher, Church was determined to take a look into its hallowed opening for the knowledge he believed it would reveal:

> I was very anxious to go to the crater but the guides were unwilling to undertake it in such bad weather and as the others seemed disposed to return I reluctantly gave it up, but with the intention of returning the next day if the weather was favorable.[16]

He never achieved the summit of Puracé but moved on to Ecuador, where he observed Pichincha and especially Cotopaxi before his departure for home.

Two years after his return Church took up the subject of the volcano, although these early renderings reveal his yet incomplete understanding of its form and mechanism. In the *Cotopaxi* of 1855 (Museum of Fine Arts, Houston) he painted a wisp of smoke emanating from the cone "in order to distinguish," according to Humboldt's advice, "the mountains that are volcanoes still burning from those that have no eruptions," even though smoke was not necessarily visible at the time he made the sketch.[17] Smoke, the main indicator in these initial views that the peak is an active volcano and not a quiescent mountain, appears also in the Washington version (fig. 36) of the same year. But in this picture, which in several respects stands apart as an anomaly in the sequence, the signs of the volcano's might can be read in its external features. Selecting the profile seen from the west, the artist emphasized the irregularity to the right of the main cone. This spur was described and illustrated by Humboldt as the Head of the Inca, believed to have had its origins in a volcanic eruption simultaneous with the Inca conquest on the Cotopaxi plains:

> A popular tradition prevails in the country, that this isolated rock was heretofore a part of the top of Cotopaxi. The Indians relate, that the volcano, at its first eruption, ejected far off a stony mass; which, like the cap of a dome, covered the enormous cavity, that contains the subterraneous fire. Some pretend, that this extraordinary catastrophe took place a short time after the invasion of the kingdom of Quito by the Inca Tupac Yupanqui; and that rock . . . is called the Head of the Inca, because its fall was the ominous presage of the death of the conqueror.[18]

That Church painted this Humboldt-inspired view for Cyrus Field seems entirely appropriate, for his young patron had encouraged and frequently participated in the artist's geologizing from the outset of their friendship in the mid-1840s. Field had acquired Church's major painting of 1849, *West Rock, New Haven* (New Britain Museum of Art, Connecticut), which depicts a curious geological formation of his native Connecticut investigated by Yale geologist Benjamin Silliman. Perhaps acquainted with Silliman through Cole or Winthrop, who studied with him at Yale, Church

undoubtedly appreciated the unusual rock structure for its scientific as well as its pictorial attributes.[19]

This aspect of the subject would not have been lost on its owner, who may even have stimulated the artist's leanings toward natural history. Field's own concern with this science is underscored by his purchase in 1846 of an extensive natural history cabinet, which included about fifteen hundred examples of "fossils of every name and description . . . all geological and mineralogical specimens, scientific books, & &." It was acquired with the recommendation of geologist and paleontologist James Hall, who emphasized the desirability "of making a collection in the department of science which is rapidly becoming absolutely necessary to the study of geology" and described its contents: "many . . . fine and beautiful specimens and some of them unique." In 1851 Field and Church traveled as far west as the Mississippi and south to Virginia, stopping at points of geological interest. Church's *Natural Bridge, Virginia* (c. 1851; University of Virginia Art Museum, Charlottesville), the tangible manifestation of those pursuits, was also added to Field's collection. That trip prepared them well for their more ambitious tropical expedition two years later and set a precedent for the kind of pictorial records the artist made for his patron after the completion of their travels.[20] Although Field's encouragement of Church's art was an outgrowth of their friendship, it also represents the currents of exploratory and scientific interests prevailing in the culture at large.

Volcanoes seemed to have captured the popular imagination in the middle years of the 1850s, with reports of eruptions and earthquakes prominently featured in newspapers and journals. In 1855, perhaps as Church worked on his Cotopaxi pictures, news filtered back to the United States of "the prospect of an eruption of Vesuvius." The regularity with which even art periodicals such as *The Crayon* reported on the activity of the Neapolitan volcano indicates the eagerness of its readers for knowledge of these geological cataclysms.

Less familiar examples were studied with no less excitement. An "Eruption of Mauna Loa, Hawaii" was reported in the pages of *Harper's Monthly*, with all its aspects, including sacrifices to the goddess Pele, described and illustrated by Henry M. Whitney. Ephraim George Squier published a far more extensive treatise in *Harper's Monthly* entitled "The Volcanoes of Central America," including Volcán de Agua, San Miguel, and Omotepe (now known as Volcán de Concepción), later painted by Heade (see fig. 42). Their researches into these and other eruptions were conducted in the belief, voiced in *The Crayon*, that "the floods of molten lava which volcanoes eject are, in truth, nothing less than the remaining portions of what was once the condition of the entire globe." Volcanoes therefore represented a remaining link to the world the nineteenth century most fervently wished to retrieve, "a vestige of the Natural History of Creation."[21]

In this atmosphere, in which such widespread attention was being paid to geological phenomena, Church completed in the early months of 1857 the full-scale *View of Cotopaxi* (fig. 37) and the smaller, related *South American Landscape* (Manufacturers Hanover).[22] The careful delineation of rocks and mountain physiognomy—the most careful to date in the Cotopaxi sequence—indicates that he had begun to make a more systematic study of South American geology, as revealed by the holdings of his library. He must have reread Humboldt's *Aspects of Nature*, *Personal Narrative*, and *Cosmos* to verify observations as he painted his landscapes and perhaps Darwin's *Voyage of the Beagle*, which he owned in an 1852 edition. The first volume of Rev. Edward Polehampton's six-volume compendium, *Gallery of Nature and Art; or, a Tour through Creation and Science*, which contained an extensive explication of American volcanoes, also would have assisted him at that moment. And two reports of the U.S. government expeditions to South America made their timely appearance between 1854 and 1856 and soon took their place on the artist's shelves: William Herndon and Lardner

Gibbon's *Exploration of the Valley of the Amazon* (1854) and James Gilliss's *U.S. Naval Astronomical Expedition to the Southern Hemisphere during the Years 1849–50–51–52* (1855–56). All these references must have stirred his own fading memories of the Andes.

More important, perhaps, for his handling of mountains in the views of Cotopaxi completed in 1857 was the publication of volume four of John Ruskin's *Modern Painters*, subtitled *Of Mountain Beauty*, in London in April 1856. Church was already familiar with Ruskin's previous three volumes and would have eagerly awaited the arrival of the latest book in the series, which he undoubtedly read and absorbed immediately. More concerned with geology than painting, the volume addresses the structure of mountains. Reading Ruskin's distinction between compact crystallines (granites) and slaty crystallines (gneiss), the artist must have searched his memory for the specific appearance of Cotopaxi and rendered it according to his new preoccupation with rock structure. It is even possible to speculate that between painting *South American Landscape* and *View of Cotopaxi*, he had begun to explore the implication of Ruskin's ideas. In the second, larger canvas he viewed the cone from behind the craggy form of Ruminahui, which allowed him to emphasize irregular rock shapes and surfaces. Falling water crashes and mists in a way it had not before on his tropical canvases; the vegetation appears richer and more vibrant. Nature is now rendered with a newly awakened interest in form and texture. The very matrix of Church's art is shifting.

Behind this study of rock structure by artist and critic there was a purpose beyond mere pictorial effect. Discussing what he termed "mountain sculpture," Ruskin posed two questions "of the deepest interest": "From what first created forms were the mountains brought into their present condition? Into what forms will they change in the course of ages?"[23] For Church the answers were written in the peaks of the Andes, to which he perhaps contemplated a return even as he read Ruskin's words. Another look at Cotopaxi promised new insights into his inquiries, for volcanoes generally were

38. Frederic Church, Distant View of Sangay, Ecuador, *1857, oil and pencil on board, 9 × 14³/₈ in. (22.9 × 36.5 cm). Cooper-Hewitt Museum, Smithsonian Institution, New York (1917-4-402).*

thought to reveal the mechanism of mountain formation. Speculating on the question "Do Mountains Grow?" an anonymous writer echoed the widespread faith: "However the Andes, the Cordilleras, the Rocky Mountains, the Alps, the Appennines [*sic*], or the Pyranees [*sic*], the Himalayas, or the Mountains of the Moon . . . may have been caused, certain it is that elevations of considerable height have, in times past, occurred as the direct result of volcanic action."[24] Such ideas inspired a number of explorers to return to a given volcano after an interval of several years to retrace and remeasure its contours. In this way they documented the change and growth they believed would be perceptible. These concepts lay behind the efforts of Charles Wilkes, who instructed his draftsman to make sketches of the Hawaiian volcano Mauna Loa on the outward and the return voyages of the U.S. Exploring Expedition. "These sketches I conceived would enable me to ascertain if any, and what, alterations should take place between our two visits, for I could not but imagine it must be continually undergoing change. For this

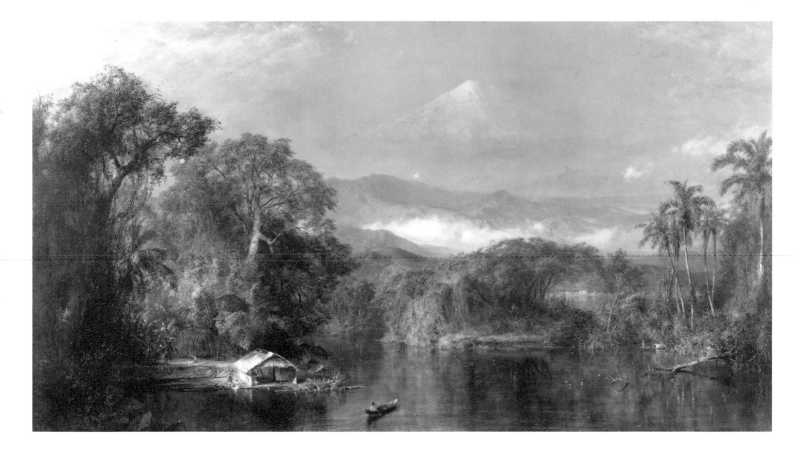

39. Frederic Church, Chimborazo, 1864, oil on canvas, 48 × 82 in. (121.9 × 208.3 cm). Huntington Library and Art Collections, San Marino, California.

purpose we multiplied our camera lucida drawings."[25] Church similarly may have expected to find some measurable difference in the form of Cotopaxi since his 1853 visit. He left New York in the spring of 1857 bound for the corner of South America he knew to be bristling with volcanic cones, for another look at Cotopaxi, and for a glimpse of the dread Sangay.

A Second Look: 1857–1863

Church's return to South America in 1857 reflected his deepening artistic intent and his more scientifically informed outlook. On this second trip he seemed far more certain of what he wanted to see and how he intended to paint it. In May 1857 he and Mignot arrived in Ecuador for a ten-week scrutiny of its rich and varied scenery. The peaks of Cayambe (see fig. 50), Sangay (fig. 38), Chimborazo (fig. 39), and Cotopaxi were now studied more carefully in oil sketches, pencil drawings, and eventually in finished paintings. Not only did mountains become Church's main preoccupation, but his method of recording them also changed significantly. The journal and on-the-spot studies surviving from the reconnaissance of 1857 are noticeably more quantitative and scientific. Instead of viewing the continent with touristlike awe, Church now wears the more focused lenses of a naturalist.

This marked sharpening of Church's powers of observation and description is strikingly apparent in a

comparison between his journal of 1853 and one kept during his four-day expedition to Sangay in 1857. On the earlier visit the daily entries are brief, providing essentially narrative details in short sentences or phrases. Visits to churches, monasteries, and other sites of cultural interest are interspersed with descriptions of mountain scenery and plant life. The visit to Tequendama Falls (figs. 16–17) on the first excursion inspired Church to record his wonder in a profuse verbal outpouring:

> There is another cataract as wonderful as Niagara and if not as imposing yet more beautiful and picturesque and presents a greater variety of imposing phenomena. It is not my province to handle the pen, but if you will excuse the boldness I will grasp it no matter how awkwardly and attempt a simple description of a visit to one of the grandest and most lovely works of nature which I have been fortunate enough to witness. I speak of the Falls of Tequendama near Bogotá in the Republic of New Granada.[26]

The vocabulary—"wonderful," "lovely," "beautiful and picturesque"—belongs to the landscape aesthetic of the late eighteenth century.

The journal of 1857, by contrast, documents the four-day excursion to Sangay with an eye to scientific accuracy. Altitude, temperature, and geological formations are now recorded with some regularity. On 9 July, for example, he wrote,

> Our road today passed through a ["curious" written and crossed out] country curious for the mingling of rich verdure and barren volcanic soil. The ground in many places was cracked in regular pentagonal prisms and the road being trodden hard presented precisely the appearance of a wooden pavement and yet there the ground was turned up and irrigated—luxuriant fields of wheat maize and yerba ["rewarded" written and crossed out] showed vitality and richness in the soil.

His language has changed concomitantly with his focus of interest. Whereas earlier he preferred the broad outlines of a sublime waterfall or mountain panorama, on his second trip he studied the small, anonymous corner of nature for insight into its structure. He recorded observations with botanical and, in his entry for 11 July, mineralogical specifics:

> As the stopping place was close by a river I walked along the bank to examine the bed of the stream. I found a large quantity of quartz and had the curiosity to examine pieces carefully and finally found one which had several minute flakes of gold. The principle sediments of the river was a course [*sic*] black sand.[27]

The character of the travel drawings and sketches demonstrates a similar shift. The earlier trip gave rise to isolated vegetation studies, on the one hand, and composed landscape views, on the other, in a manner reminiscent of Cole. But by 1857 Church was making pictorial records of the processes of terrestrial transformation.[28] The penciled inscriptions indicate these changes. A number of the landscape drawings done in 1853 bear a month and year, but no day, and they were sketched in the evening after a day or more of travel. Rarely do these recollections appear in 1857, when he favored the immediacy of the initial impression, identified by day and often weather conditions. To this end he began a more extensive use of the shorthand numbering system he had been using in North America to record fleeting effects as rapidly and accurately as possible.

The impact this intensive study of the Andes had on Church, and Mignot as well, was profound. The effect of living and traveling in this strange landscape, completely surrounded by the novel results of volcanic action, is perhaps best understood by comparing Humboldt's experiences. The great savant himself underwent a conversion as a result of his extended observations among the Cordilleras. Early in his career he had studied with Abraham Werner, the founder of the Neptunist school of geology. This group contended that the stratification of the earth's crust was caused by the precipitation of layers of rock out of a universal sea, which had

once covered the earth. Under Werner's tutelage, Humboldt saw the earth's surface in terms of its aqueous origins and published his first study on the rock formations of the Rhine Valley in 1790 in direct support of this idea. Close scrutiny of the American volcanoes, however, subsequently convinced him of the dynamic forces operating below the earth's surface. These subterranean powers, he came to believe, continued as active agents in the creation of new land formations. Humboldt's awakening to these notions, the basic premises of vulcanism, occurred as a natural outgrowth of his daily experience in the equatorial landscape.[29] For Church, who traveled in South America fifty years later, the old battle between the Neptunists and the Vulcanists had been laid to rest, and uniformitarianism was assumed. But prolonged exposure to that landscape catalyzed a response no less profound for the painter.

On his second trip Church focused close attention on the region between Quito and Riobamba. There Cotopaxi stood among a number of only slightly less lofty volcanoes, which together formed one of the most impressive sights on the continent. The scenery that confronted the artist was vividly conjured up in the description of Vassar College scientist James Orton, who explored the same region in 1867:

> What an array of snow-clad peaks wall in the narrow Valley of Quito—Nature's Gothic spires to this her glorious temple. If ever there was a time when all these volcanoes were active in concert, this secluded vale must have witnessed the most splendid pyrotechnics conceivable. Imagine fifty mountains as high as Etna, three of them with smoking craters, standing along the road between New York and Washington, and you will have some idea of the ride down this gigantic colonnade from Quito to Riobamba.[30]

Living among these peaks of the principal Andean chain, it is little wonder that Church developed a more profound respect for the forces that had upheaved them. The single-mindedness with which he pursued these volcanoes is emphasized by his insatiable curiosity over Sangay, the volcano that stood isolated in the remote reaches of the eastern Cordillera. On 24 July he reported to his friend Aaron C. Goodman, "In a few days we shall make a visit to Sangay, a terrible volcano about six days journey from here—it is the most terrible volcano in the world."[31] On their trek they did witness the volcano spitting rocks and fire, recorded by the artist in several drawings and oil sketches and in his journal entries.[32] The experience of dwelling among these fiery mountains, witnessing their forces, crystallized Church's new geological awareness and deeply affected his outlook on nature, as revealed in the pictures produced after his expedition of 1857.

The major South American subject commenced upon his return was not a view of Cotopaxi but *Heart of the Andes* (pl. 1), a picture of quiescent mountains in which the intensified scientific observations of his recent expedition are evident. The fruits of his mineralogical investigations, apparent in the Sangay diary, informed the treatment of mountain forms and surfaces on this canvas. Winthrop, who had himself studied geology at Yale, wrote a pamphlet explicating some of these features of the picture to the general public. Interpreting what he called the mountain's "hieroglyphics" according to the classic dictum of uniformitarianism— "the present is the key to the past"—he wrote of the way in which the artist told "the story of the rock's own life" in "crevice, ledge, and mossy cleft." In their "complex action and episode" is proof of the regenerative cycles of nature at work in the Andes. The mountains gave "myriad tokens of primeval convulsions; proofs everywhere of change, building, razing, upheaval, sinking, and deliberate crumbling away, and [of] how new ruin restores the strong lines that old ruin weakened."[33]

In a second explanatory pamphlet on the painting, Rev. Louis Noble similarly interpreted it as a synthesis of artistic practice and geological thought. Writing on the artist's behalf, Noble opened his commentary not with any mention of the painting but rather with an explanation of the natural forces shaping the earth's crust:

The origin of the broken surface of the earth, we learn, is the subterranean power of upheaval. In obedience to that power, inconceivable to the human mind, the outer crust of the globe is lifted into irregularities which we see. Around and upon these are the work and play and battles of the elements. The surf beats at the base, and the storm at the summit of the mountain; along its side sweep the wind and rain; heat and frost dissolve, explode, and crumble. . . . Thus the elements and forces of the earth are forever busy in the apparently infinite task of reducing to a level the primeval erections of violence.[34]

His exegesis signals the artist's awareness of the forces of upheaval and violence that uplifted the continent, but his words contrast sharply with the idyllic calm that pervades *Heart of the Andes*. Not until three years later would Church depict these forces more explicitly.

By 1862 the artist was fully versed in Andean geology. The rock surfaces in *Cotopaxi* (fig. 35) show the signs of the buildup and erosion constantly at work. Compared even with *Heart of the Andes*, in which the mountain forms are still somewhat amorphous and made essentially of paint, the canvas of 1862 incorporates a new petrological awareness. The gully in the immediate foreground reveals the successive striations of matter from which the Andes were built. The broadside accompanying the exhibition, perhaps written by the painter himself, emphasizes the volcano's role as shaper of the surrounding landscape. "The cliffs and plateaus which diversify the surface of the country," it read, "are typical of that portion of the Andes which is modified in appearance and character by volcanic agencies." The rocky foreground and subsidiary peaks on either side of the main cone had, therefore, been given form by its action. Even in the still, reflective waters of the lake (perhaps Quilotoa, an old volcanic crater filled with beautiful emerald waters, slightly transposed for pictorial effect), the signs of its creative power were to be found. The broadside explained this aspect as well: "The lake and its outlet of cascades is also a peculiar feature of the scenery of Ecuador—the former origi-

nating in an eruption—a sudden chasm becoming filled up with water." Every detail of the picture revealed the mechanism of terrestrial formation, "the volcanic agencies which make the landscape of Alpine South America what it is."[35]

Mignot, Heade, and the Power of the Volcano

So powerful was the impression of the South American landscape on the mind of the artist that even those less prone to geological speculations began to probe its volcanoes for insight into their creative capacities. Louis Mignot was attracted less to sublime mountain scenery than to the lowland riverscapes. Yet once among the Andean highlands he too became fascinated by Cotopaxi; he painted and exhibited views of its cone from the first time he saw it in 1857 until his death in 1870. Traveling side by side with Church in Ecuador, he arrived at what contemporary reviewers proclaimed his own vision of the volcano.

Mignot's views of Cotopaxi were among the first paintings he showed upon his return. In an exhibition held at the Maryland Historical Society in 1858 he included two versions, apparently done on the spot: *Landscape—View of the Region near Cotopaxi, South America, from Nature* and *Volcanic Regions near Cotopaxi, South America, from Nature*. The titles suggest his sudden interest in the effects of volcanic action, the result of his travels through Ecuador.[36] After 1862, when Mignot moved permanently to London, the image of the volcano emerged again in his work. The Memorial Exhibition of 1876, put together by his wife primarily from pictures in British collections, included several versions. Alongside *Study of Cotopaxi, with a View of the Falls* was hung *Eruption of Cotopaxi by Night*. Engravings were offered for sale of still another version, perhaps the one singled out by a critic for the *Illustrated London News*:

Among the chief works are . . . the stupendous scene of *Rio-Bamba*, with the mighty Andes looming through

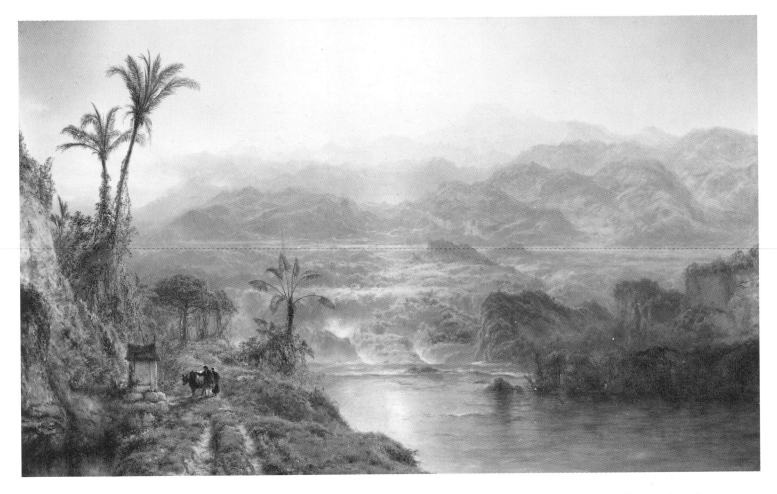

40. Louis Mignot, Lagoon of the Guayaquil River, Ecuador, *1863, oil on canvas, 24¹/₄ × 38 in. (61.6 × 96.5 cm). Detroit Institute of Arts, Founders Society Purchase, Beatrice W. Rogers Bequest Fund, and contributions from Robert H. Tannahill and Al Borman.*

the fiery mists; and *Cotopaxi*, the monarch of volcanoes, rising above perhaps a hundred miles of stratified atmosphere, with fathomless fissures in the foreground created by almost incessant earthquakes.[37]

His language emphasizes not only Mignot's usual concern with atmospheric effects, but also the geological phenomena of fissures and earthquakes that study of the volcanic landscape had so forcibly infused into his art. And although these works remain unlocated, other known canvases, including a scene of the Cordilleras

now in the Detroit Institute of Arts (fig. 40), demonstrate his sensitivity to the geological structure of the high Andes.[38]

Few other North American artists depicted Cotopaxi. It was a subject closely linked with Mignot, Church, and the decade 1855–65. Other painter-explorers, however, as they traveled across the southern continent, were equally impressed by the volcanoes. The tropical expeditions of Heade demonstrate the power of

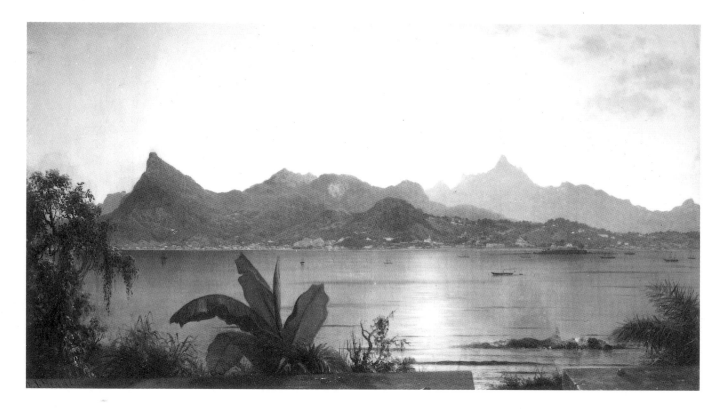

mountains and volcanoes on his imagination. Heade's
natural predilection was for marsh and coastal scenery,
birds, and plants. Among landscapists of the period, in
fact, he stands out for his almost steadfast avoidance of
mountain scenery. Church, frustrated by his friend's
lack of interest in such promising pictorial material,
chided him "for making such a fiasco trying to find
[the] Santa Marta" mountains on his trip to Colombia
in 1870.[39] But in fact he had painted a number of land
scape views of Rio de Janeiro, featuring Corcovado and
the surrounding peaks (fig. 41), which accurately por-
tray the structure of the mountains. And he produced at
least one handsome picture of a volcano he had seen in
Central America in 1866, *Omotepe Volcano, Nicaragua*
(fig. 42), possibly commissioned by Fairman Rogers of
Philadelphia. This mountain enjoyed a substantial repu-
tation of its own, as John Lloyd Stephens had observed:
"The great volcano of Omotepeque [*sic*] reminded me

of Mount Etna, rising, like the pride of Sicily, from the
water's edge, a smooth unbroken cone, to the height of
nearly six thousand feet."[40]

As Heade worked on *Omotepe Volcano, Nicaragua*
in 1867, "a new volcano broke out in Nicaragua, about
eight leagues to the east of the city of Leon, on a
crowded line of volcanoes running through the State,
parallel with the Pacific Ocean"—the region from
which the painter had just returned. The minister to
Nicaragua reported,

The volcano was an active and interesting sight for six-
teen days, and now in its repose affords an ample and
instructive field for the geologist. Indeed, no country in
the world presents a more interesting study than the

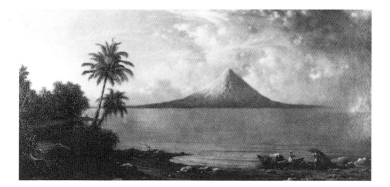

42. *Martin Heade*, Omotepe Volcano, Nicaragua, *1867, oil on canvas, 18¹/₈ × 36¹/₂ in. (46 × 92.7 cm). Photograph courtesy of Christie's, New York.*

plain of Leon. Twenty volcanic cones are seen rising from a single view.[41]

Under the immediate inspiration of his travels, and perhaps with the reminder of such news reports, Heade too probed the secrets of terrestrial creation. The mountain views he produced from each of his three tropical expeditions were painted soon after his return, and as the direct landscape experiences receded further into his memory, he produced his more synthetic works. That the pictures painted closer in time to his contact with the landscape were more geological suggests that the landscape itself inspired, even demanded, attention to its formative processes. Like Mignot, Heade was sufficiently captivated by the volcano to abandon momentarily his usual subject matter in favor of its conical form. They may not have departed with the same degree of scientific interest that Church possessed, but direct observation of the volcano stirred their deepest curiosity into earthly formation.

On the west coast of South America, volcanoes are concentrated most heavily at its intersection with the Pacific Ring of Fire. This region had woven itself into the North American's mental image of the continent, as Winthrop pointed out:

We of the northern hemisphere have a geological belief in the Andes as an unsteady family of mountains in

South America—a continent where earthquakes shake the peaks and revolutions the people, where giant condors soar and swoop, where volcanoes hurl up orbed masses of fiery smoke by day and flare luridly by night.[42]

The northern conception of Latin America was so closely tied to the volcano that its presence in a picture established the locale. In Church's *Century Plant at Cotopaxi, Ecuador* (c. 1864; Century Association, New York) and in Heade's *Hummingbirds near a Volcano* (c. 1863–65; private collection), the tropical habitat of the exotic bird or plant is immediately identified by the distant volcano.

The Perfect Volcanic Cone

The volcano by the late 1850s established the genius loci, the very spirit of tropical America, as the artists wished to evoke it in their paintings. Cotopaxi and Omotepe, however, were not just any volcanoes. Their distinctive cones embodied the object for which these men had searched the continent from 1850 to 1865.

Church's determination to see Sangay despite the hardships of a trek to the distant reaches of the eastern Cordillera is even more remarkable when we realize that Humboldt himself considered it too remote and inaccessible for study. The volcano remained almost completely neglected until 1849, when Sebastian Wisse finally reached it and nearly attained the summit of its precipitous cone.[43] Church's observations of this volcano, to judge from his written accounts, impressed him deeply. Neither Sangay nor Puracé, however, were featured in major pictures. He raised Cotopaxi alone to the status of a landscape icon. And Heade similarly chose from among an entire string of mountains he saw in Nicaragua the peak of Omotepe. The perfect conical form of these particular volcanoes symbolized to North Americans the goal they sought: unmistakable evidence that the hand of God had shaped the Andes.

Volcanic action, as Squier's observations of Central America emphasize, carried with it associations of the deity:

However blind to the suggestions of Divine intelligence and wisdom in the ordinary phenomena of nature, the rising and setting of the sun, the change of seasons, and the budding and blooming of flowers, man·in his lowest estate could hardly fail to recognize the existence of an Almighty Power in the phenomenon of the active volcano; and may we not believe that the undeniable religious tendencies of the aboriginal inhabitants of these regions, as developed in elaborate religious systems, and governments in which a religious element predominated, were in large part due to the influence of these great and demonstrative features of Nature, inspiring reverence and awe equally from their grandeur of form and their manifestation of power?[44]

The perfect symmetry of a Cotopaxi, or an Omotepe, was the visual manifestation of these principles.[45] Artists have frequently been fascinated by the existence in nature of pure geometric forms. Paul Cézanne's remarks on "seeing in nature the cylinder, the sphere, the cone" are not without relevance here; nor is the example of Turner, who often quoted in his lectures lines from Akenside on the discernment "in matter's mouldering structures, the pure forms of Triangle, or Circle, Cube or Cone," and whose conical configurations of light in his paintings and prints certainly had their influence on Church and other American painters.[46]

For the North American artist, the discovery of this platonic geometry in the contours of the tropical volcano connoted divine creation. Reinforcing these associations, Church pulled taut the steep slopes of Cotopaxi and eliminated the slightest irregularity: an effect he studied in at least one oil sketch, in which the volcano's contours appear to have been drafted with a straightedged ruler.[47] Even its angle of inclination has been reduced to less than ninety degrees from its actual, wider, more obtuse angle. The formal purity Church strove for was perceived by the *Albion* reviewer, who resorted to the language of geometry rather than geology when he referred to Cotopaxi's "acute triangular form." Heade demonstrated a similar predilection for

clarity of volcanic shape in his choice, from among the many Nicaraguan specimens, of Omotepe: the one that approaches, according to Squier, "nearer the perfect cone in shape, than any other mountain of the continent, not to say the world."[48] Omotepe held the same status in Central America that Cotopaxi did in South America. In the pure forms of these remarkable volcanoes, proof of divine handiwork was at least glimpsed. God had indeed reigned in this landscape, left untouched since creation.

Catlin's Geology

These developments reached their logical extension in the art and thought of George Catlin. A painter primarily of the Indians of the American West and an expatriate living in London and Paris following his western expedition, Catlin does not immediately spring to mind as Church's closest counterpart. Yet in timing and in character, his South American explorations of 1852–57 exhibit striking parallels to those of Church and others.[49] His departure for Venezuela in 1852 coincided with a wave of interest among American artists, naturalists, and travel writers. His journeys, like theirs, took inspiration from the work of Humboldt, whom Catlin met during the exhibition of his Indian Gallery in 1845 in Paris. His activities, furthermore, were followed in the United States. In 1855, several years before the publication of Catlin's own accounts, *The Crayon* printed a report of his travels in Guiana.[50] He and Church, both from old Hartford, Connecticut, families, shared at least one patron from that city: the Colts. The family, who owned Church's *Vale of St. Thomas, Jamaica* (1867; Wadsworth Athenaeum), commissioned from Catlin a series of lithographs depicting the artist using his Colt rifle, which he affectionately named "Sam," in South America (fig. 43).[51] Catlin's books, published in New York as well as in London, enjoyed substantial readership in the United States. And upon his return, he exhibited in 1871 his entire

Cartoon Collection, including the reconstruction of his familiar North American Indian portraits, the La Salle history paintings, and the new images of South American Indians and landscape views, in New York and Washington.

During his five years of travel across the length and breadth of South America, Catlin became increasingly preoccupied with the question of how the earth came to be as it was and the role volcanoes played in its formation. In this context Cotopaxi became a focus of his interest. In his *Life amongst the Indians* of 1857, he

wrote ironically of the mysterious power of the volcanoes of that country:

What is forged in the mighty furnace underneath us, and how long it has been worked, nobody knows. It formerly threw out its smoke and cinders at the top of Chimborazo, only 19,000 feet high. Chimborazo (Tchimboratho) is "laid up"—the chimney now at work is Cotopaxi (Cotopassi), of equal height; its groanings

and bellowings can only be heard 600 miles, at the utmost! and a block of granite 327 cubic feet it was only able to project a distance of nine miles![52]

Intensive observations on the southern continent had heightened his geological awareness, as they had those of his fellow artist-travelers. His early western pictures and writings already exhibited, to be sure, an ongoing concern with land formations and curious rock structures. On a visit in 1836 to the legendary Pipestone Quarry in Minnesota, Catlin spent several days collecting samples of the red clay from which numerous Indians fashioned their pipes. He speculated at length about the formation of the area and lent his name to what was eventually declared a new mineral compound, catlinite.[53] His discussion of erosion and other forces in *Letters and Notes on the Manners, Customs, and Conditions of the North American Indians* of 1841 demonstrates an intuitive understanding of geology.[54] But during his later southern travels, his landscape inquiries seemed to take on a more systematic and scientific character. By that time he had surveyed the entire hemisphere, providing him with ample opportunity for comparative analysis.

Catlin's tropical works have received far less attention than his western oeuvre, and their details are less well known. The majority of his South American scenes, housed primarily in the National Gallery of Art, are cartoons—colored sketches of native tribes and scenery on small paperboard panels, which were minimally retouched for exhibition. His deepening involvement with geological or, as he preferred to call them, orographical ideas can be detected in these South American landscape cartoons. *Rhododendron Mountain* (fig. 9), for example, preserves the immediacy of his response to the mountain forms of Brazil. And *The Beetle Crevice* (fig. 10) focuses on the fissure between the two rocky masses and invites meditation on the forces that resulted in this unique configuration: a glacier, an earthquake, or perhaps ages of erosion. Such "immense faults," according to his text, "bear incontestable proofs of the subsidence

in which their other halves have gone down to the ocean's bed."[55]

Although Catlin refers in his writing to Cotopaxi and other geological marvels, including the "wonderful 'Silla,' described by Baron de Humboldt," no pictures of these subjects have survived.[56] It is instead in the books that his geological and cosmogonic interests are most completely realized. His writings are the parallel texts not only to his own paintings but also to those of his fellow South American artist-travelers.

Stimulated by volcanoes and other new phenomena witnessed during his travels among the Antilles, the Caribbean islands where he stopped on the first leg of his journey, Catlin no longer confined himself to the isolated observations that characterize his earlier writing. From this point on he began to formulate his own theory on the origin of the American continents. In need of advice on how to proceed with his researches, he went back to Europe to consult with Humboldt and then returned to South America in search of the data and specimens the great savant had encouraged him to find. In a letter of 1855 Humboldt wrote,

> I am more struck with your mode of determining the sinking and rising transits of rocks, and the probable dates and extent of cataclysmic disasters. I believe your tests are reliable, and perfectly justify you for making the contemplated voyage to the lesser Antilles. The subject is one of vast importance to science, and if I were a younger man I would join you in the expedition at once! I believe your discoveries will throw a great deal of light on the important subject of the effect of cataclysms on the distribution of races.[57]

The preliminary observations in *Life amongst the Indians* and *Last Rambles amongst the Indians of the Rocky Mountains and the Andes* culminated in a geological treatise, *The Lifted and Subsided Rocks of America*, published in 1870. Although it contained discussions of the Rocky Mountains based on his earlier western explorations, the raison d'être of this curious book had been his ongoing exposure to the changes the awesome power beneath the

Andes had wrought. Gaining his first view of the Cordilleras in Chile, Darwin had written in his journal, "Who can avoid wondering at the force which upheaved these mountains, and even more so at the countless ages which it must have required, to have broken through, removed, and levelled whole masses of them?"[58] Catlin too, as he viewed and sketched the peaks of the Peruvian Andes from the eastern pampas (pl. 5), contemplated their formation. In this mountain chain that runs down the Pacific coast of the continent he believed he could uncover the past history of the globe:

> He [the observer] will gather evidence enough here, from the fragments of shattered mountains, to account for the powers which have laid low the Antilles, and proofs enough in the glazed crevices of the volcanic beds that are beneath him that he stands over the concentration of volcanic heat of the globe, the thunder and trembling of which are heard and felt to the ends of the continent—the volcanic battery which gives impetus to the Gulf Stream, and the convulsions of which have thrown mountains up, and cast them . . . into the sea; and probably only requires time for a repetition of the awful catastrophes.[59]

A new emphasis on volcanic heat and power, missing from his earlier accounts of North America, is evident. Between his western and tropical travels, he had the opportunity to expand the scientific knowledge acquired during his younger days in Philadelphia. Living in Europe, he met a number of distinguished scientists. From Humboldt, Catlin received a letter of introduction to his old traveling companion, Aimé Bonpland, then living in Uruguay, where he was able to visit him in 1856. And he also mentioned several times in his narratives Sir Robert Schomburgk, well-known explorer of Guiana, who surely must have advised the artist on his own travels in that region. Throughout the pages of *The Lifted and Subsided Rocks of America* occur frequent references to Sir Roderick Murchison, Lyell, and a number of other geologists, both European and American, with whose work Catlin

was entirely conversant.[60] But it was his travels in South America that finally crystallized the data accumulated over a lifetime of travel into a coherent, if incorrect, theory of terrestrial formation.

According to the hypothesis he discussed with Humboldt, Catlin believed that North and South America had been joined by a land mass measuring nearly the breadth of the continents themselves. The great cataclysm that reduced the land bridge to the narrow strip of the Isthmus and gave birth to the Caribbean islands had occurred only a few hundred years earlier. To clarify the points of his theory, Catlin illustrated the pre-cataclysmic and post-cataclysmic states of America (fig. 44) and identified a few strategic locations. Among them were Chimborazo and Cotopaxi, active agents in the transformation. Under the original connecting land mass, he explained, lay huge caverns traversed by salt rivers, one flowing northward under the Andes and the other southward under the Rockies. Through a seismic and volcanic catastrophe of unprecedented might, the Caribbean landmass collapsed into underground vaults or caverns and was swallowed up by the waters:

> It has no doubt been by the never-ending volcanic explosions underneath the Northern Andes, the pulverising of the rocks, and the unceasing removal of their *debris* into the ocean by the currents of the submontagne rivers, that those lofty mountains were undermined and sunk into the ocean, in the cataclysm of the Antilles.[61]

Subsequently, certain areas of Mexico and Central America were lifted up from the sea and the underground rivers united to form the Gulf Stream, leaving the present continental configuration. Thus Catlin explained the origins of the New World according to his pre-Darwinian worldview.

Humboldt had advised Catlin that to prove his theory he would have to demonstrate the essential geological similarity between the Caribbean islands and the

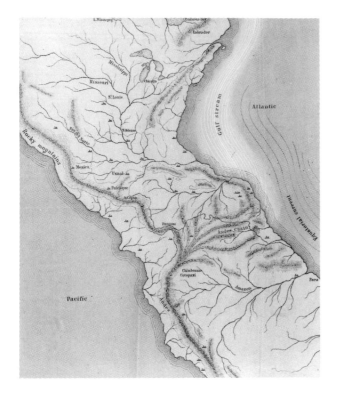 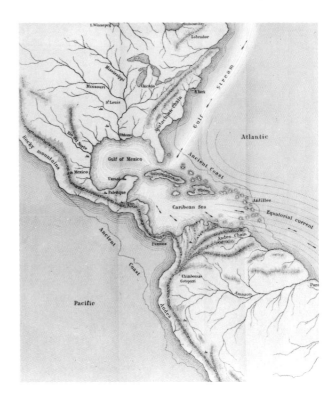

44 . George Catlin, map of the pre- and post-cataclysmic states of the Americas, from his Lifted and Subsided Rocks of America.

northern Andes. To this end he gathered rock and soil samples from two regions:

> In this voyage I was enabled to compare rocks on the coast of Grenada and Venezuela with the summit rocks of such of the lesser Antilles as I visited; and from their unquestionable correspondence as a family group, I gathered the most conclusive and satisfactory evidence of their having been parts of one connected chain, and of one continued elevation and grandeur.[62]

Having found the proof he needed to confirm his suppositions—namely, that the remainder of the continent had subsided to the ocean floor—he left Latin America to complete and exhibit his paintings and to compose his texts.

On Humboldt's recommendation, Catlin sought empirical evidence to verify his theory; yet in his mind the proof already existed in the cataclysmic myths almost universally told by the American Indians. In their ancient racial memory there loomed a massive upheaval that had wiped out the original populations. According to local tradition, at least one tribe of this early culture, known as the Caribe, somehow survived and scattered throughout the Antilles and northern South America. Catlin placed great faith in these legends and singled out for special mention in his text the antiquarian researches of the Abbé Brasseur de Bourbourg, who had recently published several works on Mexican history, including *Quatre lettres sur le Mexique*, "being a complete translation of the 'Teo Amoxtli,' the Toltecan mythological history of the cataclysm of the Antilles."[63] Buttressing his empirical investigations with the legends of the local Indians, Cat-

lin put forth his theory of the great cataclysm that brought about the sinking and raising of continents.

No matter how enthusiastically he expounded on mountains and rocks, his geological studies were part and parcel of his primary concern with his beloved Indians. The many parallels he found in the manners and customs between North and South American Indians led him to ponder the means of their geographical distribution:

> How surprising this fact! that, on the northwest coast of North America and on the southeast coast of South America, almost the exact antipodes of each other, the same peculiar and unaccountable custom should be practiced by Indian tribes, in whose languages there are not two words resembling, and who have no knowledge of each other. Such striking facts should be preserved and not lost, as they may yet have a deserved influence in determining ultimately the migration and distribution of races.[64]

The study of the shifting of continents was therefore conducted for the insight it offered into the patterns of Indian migration and settlement.

Catlin's ideas, it need hardly be said, were inaccurate, even fantastic. Yet as a response to the South American landscape his books belong to the same context as Church's Cotopaxi sequence and the geologically informed paintings of Mignot, Heade, and others: testimony to the primal powers beneath the Andes that had given birth to the American continents. These artists held fast to a pre-Darwinian worldview according to which, in the not-so-distant past, a great volcanic cataclysm had reshaped the surface of the globe. Traveling in the northern Andes almost simultaneously with Church, Mignot, and Heade, Catlin too came to believe he had glimpsed the secrets of earthly creation.

"The Indians, Where From?"

The Archaeological Quest

We call this country the new world. It is old!

. . . but who shall tell its history?

B. M. NORMAN, *Rambles in Yucatán*

*T*he Indians, where from? The Indians, who are they? The Indians, where are they going?" So George Catlin titled the concluding chapters of *Last Rambles amongst the Indians of the Rocky Mountains and the Andes* (1867). His inquiries indicate that the accumulation of geological data—the pursuit of volcanoes on the southern continent as a means of comprehending earthly creation—was subordinate to the larger, nagging problem of the origin of the race who first peopled these lands.[1] For almost a century American anthropology had been impelled by this central historical dilemma, expressed in 1784 by Thomas Jefferson: "Great question has arisen from whence came those aboriginals of America?"[2]

No artist searched longer or harder for the answer than Catlin, who journeyed fourteen years among the Amerindians to record the appearance and manners of what he rightly feared was a vanishing race. Following his exploration through the western United States, he spent five years among the South American tribes,

observing coincidences of physiognomy, language, and custom that stimulated speculation on the race's point of origin and mode of distribution across the continents. The paintings and books Catlin produced after his South American travels raised these questions several decades before Paul Gauguin's Tahitian experiences inspired his masterpiece, *Where Do We Come From? What Are We? Where Are We Going?* (1897; Museum of Fine Arts, Boston). Catlin's pictures and writings, even more than Gauguin's image of luxuriant splendor, bespeak the urgency of his pursuit.[3]

Catlin was one of the few North American artists in this period to study and paint the Indians of Central and South America. (Another of their observers was Edmond Reuel Smith, who toured southern Chile, where the legendary Araucanians lived [fig. 7].) For most travelers the crumbling monuments of the Aztecs, Incas, and Mayas were of greater interest than the living inhabitants. Writers frequently pointed out that ancient ruins "arrest the attention and excite the wonder

of the solitary wanderer in the tropics" as contemporary buildings or people could not.[4]

The ruins provided a pictorial focus to the solitude of the Andean highlands or the forests of Central America. But they also carried with them the implications of the larger philosophical inquiries voiced by Catlin. "It is impossible to survey the monuments now described without feeling some curiosity respecting the people by whom they were built and the state of society which led to their erection," noted Frederick Catherwood.[5] Questions of racial origin were raised not only by observation of the surviving Indians, which had so inspired Catlin, but more frequently by the study of the remains their ancestors had left behind.

Although the civilizations of the Incas of Peru and the Aztecs of Mexico had been known since the arrival of the Spaniards, the majority of the Maya cities stood silent and forgotten in the Meso-American rain forest. Then John Lloyd Stephens and Catherwood rediscovered Copán and Palenque in 1839.[6] Stephens's *Incidents of Travel in Central America, Chiapas, and Yucatán*, illustrated by Catherwood, generated immense excitement, for if two such fabulous cities had remained so long hidden, might there not be others even more magnificent waiting to be found? The two men returned in 1841 to excavate some fifty additional Maya sites reported in the subsequent volume, *Incidents of Travel in Yucatán*. While they were preparing for their departure, several other now little-remembered explorers headed for the region. One, a young Austrian diplomat, Baron Emanuel von Friedrichsthal, produced a handful of daguerreotypes, but no written text to compete with the popular volumes of Stephens.[7] Another traveler, the American B. M. Norman, visited a number of ruined sites including Uxmal and Chichén Itzá between December 1841 and March 1842. He published his own illustrated, highly readable account, *Rambles in Yucatán*, in 1843, which appeared almost simultaneously with Stephens and Catherwood's second book and contributed to the nineteenth century's expanding awareness of the Mayas.[8]

Growing knowledge of that civilization, far more advanced in its artistic style, architecture, and written hieroglyphics than any other race in pre-Hispanic America, made more urgent than ever the question of who these people were and when and how they erected their temples and sculptures. From the rediscovery of the Mayas in 1839 until 1879, by which time antiquarian studies had become more professional, the search for the ruins mounted into an "archaeological epidemic."[9] Painters, draftsmen, and photographers were quick to take up the search. While the natural sciences have rightly been credited as a primary impetus in their tropical explorations, rising curiosity over the ancient monuments was also an important motive. This component of artistic exploration has received little attention, and Catherwood is generally regarded as the only artist who drew and painted the American ruins. But as we shall see, a number of others recorded the appearance of these "idols." Analysis of works by Heine, McDonough, Ferguson, Robinson, and Church, against the undisputed achievement of Catherwood, reveals that the pictorial investigation of the pre-Columbian antiquities was an ongoing concern.

Indeed, it would have been difficult for travelers to Central America, Ecuador, and particularly Peru to have avoided the ruins. Monuments in those regions are ubiquitous, witness to a historied past, the significance of which was not lost on the traveler from the United States. For unlike the history of his own country, which is dominated by a sense of space rather than of time, the history of Latin America is dominated by a complex interweaving of both time and space.[10] The artist-explorers, sensitive to the time-space matrix through which they traveled, included the stone artifacts in their landscape images. Their forms, covered with indecipherable hieroglyphics, offered an opportunity for contemplation of the past, conspicuously absent from northern scenery, and the key to the origin of their makers.

The artists probably consulted available texts on pre-Columbian history and antiquities before leaving. Johann von Tschudi's treatise on Peruvian antiquities, Squier's book on Nicaragua and its monuments, Don Juan de Velasco's *Historia del Reino de Quito*, and Humboldt's *Picturesque Atlas* became treasured volumes in

their libraries.[11] But it was the work of William H. Prescott, perhaps more than that of any other single author, that fired their imaginations about the ancient races and their splendid relics. In his widely read *History of the Conquest of Mexico* of 1843 and *History of the Conquest of Peru* of 1847, he affected a romantic recovery of the pre-Hispanic past, changed for all time with the arrival of the conquistadors.[12] While Catherwood and Stephens helped uncover the structural remains of the cities—the theater of life in ancient America—Prescott peopled the stage. Catherwood supplemented his physical description of a Maya *teocalli* (temple) by quoting Prescott's account of a human sacrifice, typically conducted on the steps of such an edifice:

> On the summit [the victim] was received by six priests, whose long and matted locks flowed disorderly over their sable robes, covered with hieroglyphic scrolls of mystical import. They led him to the sacrificial stone. . . . On this the prisoner was stretched. Five priests secured his head and limbs, while the sixth, clad in a scarlet mantle, emblematic of his bloody office, dexterously opened the breast of the wretched victim with a sharp razor of *itzli*—a volcanic substance, hard as flint—and inserting his hand in the wound, tore out the palpitating heart. The minister of death, first holding this up towards the sun, an object of worship to the Mexicans, cast it at the feet of the deity to whom the temple was devoted, while the multitudes below prostrated themselves in humble adoration.[13]

The lack of such historical associations, however gruesome they may have been, was precisely what American artists lamented in their own country, as articulated by their spokesman, Thomas Cole:

> He who stands on Mont Albano and looks down on ancient Rome, has his mind peopled with the gigantic associations of the storied past; but he who stands on the mounds of the West, the most venerable remains of American antiquity, *may* experience the emotion of the sublime, but it is the sublimity of a shoreless ocean un-islanded by the records of man.[14]

The United States may have lacked monuments with a

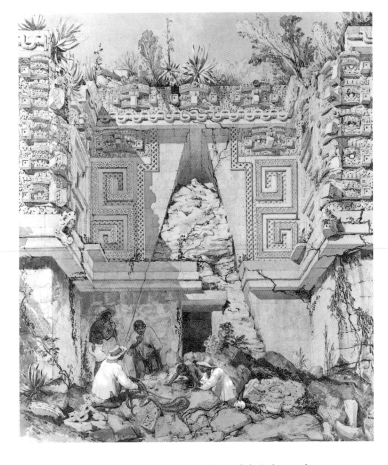

45. *Frederick Catherwood*, Archway, Casa del Gobernador, Uxmal, *1843*, *sepia ink and wash on paper*, *18¹⁄₄ × 14³⁄₄ in. (46.4 × 37.5 cm). The Brooklyn Museum.*

known history, but Prescott demonstrated that the temples and monoliths of Mexico or Peru offered rich opportunities for imaginative contemplation of the American past. Transferring romantic attitudes from the Old to the New World antiquities, he enabled the pre-Columbian ruins to speak to his contemporaries in an increasingly meaningful way.[15]

Drawing a direct parallel between Prescott's descriptions of the Aztec ritual and the Maya structures, Catherwood suggested that they too had witnessed such "dismal rites." The deserted, crumbling edifices in his drawings (fig. 45) and the work of his fellow artists thereby came alive and summoned up visions of a now-vanished race. Once this vision was evoked, how-

ever, the question repeated itself: Where did these people come from? And here Prescott was little help. Fluent in Spanish, he had drawn on eyewitness accounts of the conquistadors, the records of the royal administrators, and the great work of the sixteenth-century Franciscan friar Bernadino de Sahagún.[16] But of life in America far before the arrival of the Spaniards almost nothing was certain. In dealing with the subject Prescott was entering a "shadowy field," he admitted in a letter to Humboldt.[17] The archaeological evidence at his disposal was far too scanty for the task he had set himself: nothing less than the romantic re-creation of the pre-Hispanic world. This he valiantly attempted to do, but he left to his successors the ultimate question: "When this remarkable race came, and what was its early history, are among those mysteries that meet us so frequently in the annals of the New World, and which time and the antiquary have as yet done little to explain."[18]

Prescott's deliberately ambiguous conclusion takes on more meaning in the context of its moment. The prevailing viewpoint, rather skeptical of the advancement of the American race, contended that it was entirely derived from the Old World. Emphasizing the darker side of Indian life, it took as its point of departure the notion of a racial type with fixed limits of achievement. This idea, promoted by the well-known Albert Gallatin, was summarized in his article entitled "Notes on the Semi-Civilized Nations of Mexico, Yucatán, and Central America."[19] He doubted if people he called savage and barbarous would have been capable of producing the art and architecture found in Meso- and Andean America. Instead he subscribed to the idea that the creators of this monumental art had their beginnings in Europe or more likely Asia, from which they had migrated. Gallatin's observations were based not on expeditionary experience but on earlier researches, including those of Edward King, Lord Kingsborough, whose intention it was to prove the then-fashionable theory that the Americas had been peopled by the Lost Tribes of Israel.[20] Armed with such "evidence," the

influential Gallatin propagated a negative view of the pre-Columbian civilizations. By leaving the question open, therefore, Prescott indicated his doubts about the validity of Gallatin's claims.

Stephens and Catherwood took a far more progressive outlook on the ancient Americans. Having surveyed nearly fifty cities once inhabited by the Mayas, they developed a high regard for their carved stelae and architectural complexes (fig. 46). Their firsthand observations led them to conclude that the Mayas were a highly skilled and advanced people who had originated *independently* from Old World civilizations. Arguments both pro and con frequently focused on the visual similarities between the pyramids and other art forms of the two cultures. Having explored Egypt and the Near East before they had set out for Yucatán, Stephens and Catherwood spoke with the authority of experience:

> We have a conclusion far more interesting and wonderful than that of connecting the builders of these cities with the Egyptians or any other people. It is the spectacle of a people skilled in architecture, sculpture, and drawing, and, beyond doubt, other more perishable arts, and possessing the cultivation and refinement attendant upon these, not derived from the Old World, but originating and growing up here, without models or masters, having a distinct, separate, independent existence; like the plants and the fruits of the soil, indigenous.[21]

Debates on these conflicting points of view became so heated that learned societies, including the American Ethnological Society, had to forbid even a mention of the topic.[22] Americans, clearly, were not of one mind on the question of pre-Columbian Indian origins.

Monogenesists and Polygenesists

These issues went deeper than archaeological knowledge or national identity, challenging the most cherished of biblical concepts: the divine creation of Adam and Eve, from whom all people descended. At stake was the va-

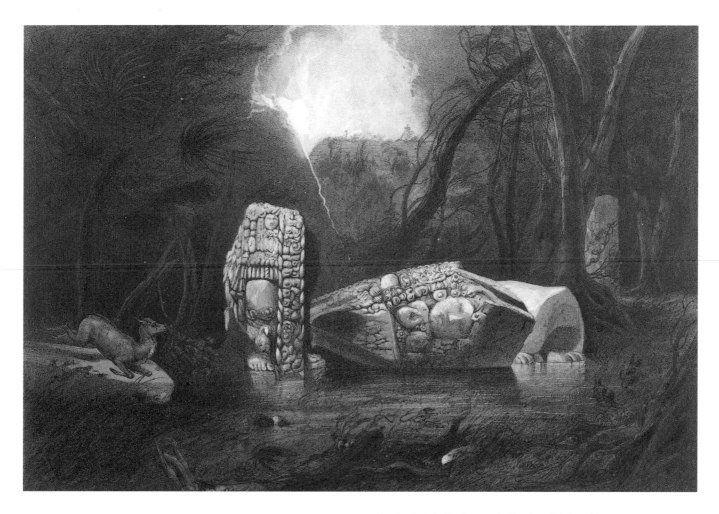

46. Frederick Catherwood, Broken Idol at Copán, *c. 1841, sepia ink on paper, 13³/4 × 19⁷/8 in. (34.9 × 50.4 cm). Yale University Art Gallery, New Haven, Connecticut.*

lidity of monogenesis, the conviction that the human race found unity in a single point of origin. For this reason Gallatin, Lord Kingsborough, and others posited explanations whereby Amerindians could trace their beginnings back to the Eurasian peoples. Then various models had to be conceived to explicate how, when, and where a group of people now inhabiting the New World diffused from the Old. Summarizing the position of the monogenesists, George Bancroft confidently stated that the "indigenous population of America offers no new obstacle to faith in the unity of the human race."[23]

Not everyone considered monogenesis so unshakable. Between 1839 and 1879 a number of investigators

came to believe in an indigenous American civilization, B. M. Norman among them:

We will candidly confess that we could never understand why philosophers have been so predisposed to advocate the theory which peoples America from the Eastern hemisphere. We think the supposition that the Red Man is a primitive type of a family of the human race, originally planted in the Western continent, presents the most natural solution of the problem; and that the researches of physiologists, antiquaries, philologists, and philosophers in general, tend irresistably to this conclu-

sion. The hypothesis of immigration, however inviting
it appear at first to the superficial observer, and however
much he may be struck with certain fancied analogies
between the architectural or astronomical peculiarities of
the American and the Asiatic, is, when followed out,
embarrassed with great difficulties, and leads to a
course of interminable and unsatisfying speculations.[24]

And by 1867 Catlin had joined in the debate. Why, he
asked, should

> a whole continent of human beings, independent, and
> happy in the peculiar modes of life, and never heard of
> or thought of until the fourteenth century . . . be traced
> when discovered, back to the opposite side of the globe,
> because civilization happened to come from there? What
> an ill conceit of civilized man to believe that because
> his ancestors come from the east, all mankind on a new
> continent, a new world, must have come from there
> also! . . . and what proof of it is there? I have said,
> "None whatsoever."[25]

Taken to its logical conclusion, such thinking would
lead to a rejection of the belief in a single origin of man
and in favor of polygenesis. But what, if anything,
would overturn the orthodox view? "We believe the dis-
covery and comparison of these remains to be the surest,
if not the only means, of removing this veil," Stephens
declared.[26] The visual records that Catherwood and
other artist-explorers made of the ruins, along with the
fragments that were occasionally removed, therefore
became primary evidence in the great controversy.

Frederick Catherwood

Catherwood's images of the ruins of Yucatán and Cen-
tral America are masterpieces of their type, created by
an artist ideally suited to the task of recording them.
He was, in the words of Stephens,

> an experienced traveller and personal friend, who had
> passed more than ten years of his life in diligently study-
> ing the antiquities of the Old World; and whom, as one
> familiar with the remains of ancient architectural great-
> ness, I engaged, immediately on receiving my appoint-
> ment, to accompany me in exploring the ruins of
> Central America.[27]

Emphasizing Catherwood's archaeological experience,
Stephens pinpointed a critical factor in their success.
He had worked many years with Robert Hay's team in
Egypt, excavating and drawing the monuments—skills
that he was then able to apply to their investigations in
Yucatán.[28] Along with his exquisite watercolors of the
Maya ruins in situ, he drew maps and groundplans and
took accurate measurements of the monuments and the
site. Such attention to detail could not be taken for
granted at a time when well-intentioned but inexper-
ienced travelers paid little heed to proper field methods.
Yet somehow Catherwood never seems to have received
his full credit. He emerges from Stephens's lively
accounts of their travels as a shadowy figure, working
doggedly, excavating and recording the half-buried
monuments, while Stephens was off on his more flam-
boyant diplomatic missions. Of the two, Catherwood
was the far more accomplished antiquarian, an artist-
archaeologist in the best sense of the term, who had
completely immersed himself in the ancient world.[29]

Catherwood's images of the ruins reached their
largest audience as line engravings in Stephens's vol-
umes. The artist regarded the original drawings, how-
ever, not as mere illustrations but as works of art that
could stand on their own, unaccompanied by text. He
exhibited nine Maya watercolors at the National Acad-
emy of Design in 1845, showed "Portfolio of Central
American Views" at the American Art-Union two years
later, and whenever the opportunity presented itself
hung "specimen drawings" in bookshop windows and
exhibition halls around the country.[30] And although
many of his works have unfortunately been lost, some
idea of them can be gained from the folio of colored
lithographs Catherwood published with his own essay
on antiquities in *Views of Ancient Monuments in Central*

America, Chiapas, and Yucatán in 1844. His widely circulated colored lithographs, line engravings, and original watercolors helped bring the extensive architectural complexes and sculptured stelae of the Mayas to the attention of the outside world. What impression did they convey? And what models did Catherwood have in conceiving them?

Archway, Casa del Gobernador, Uxmal (fig. 45) is characteristic of his approach to the subject.[31] First, he took a frontal view of the building. Orienting the facade parallel to the picture plane gives monumentality to this structure, which stands imposingly before us and occupies the entire pictorial field except for a narrow strip of sky visible at the top. But this orientation also allowed the artist to draw the beautiful stone mosaic and figural detail essentially free of perspectival distortions. Equating building surface very nearly with picture plane, Catherwood rivets attention on the carved ornamentation and allows the viewer to appreciate its unique qualities.

Characteristic of a number of works in the group including *Gateway of the Great Teocallis, Uxmal* and *Las Monjas, Chichén Itzá*, this frontal, highly detailed, and monumental conception visually reinforces the idea that these structures were the product of a technically advanced and civilized people. During his studies from 1815 to 1821 in London and afterward in Rome, Catherwood could have found numerous precedents for such renderings of architectural ruins. Among the most gifted of the eighteenth-century masters of topographical views and ruins was Hubert Robert. His interest in the classical past had earned him the nickname "Robert de Ruines" and the respect of archaeologists excavating Herculaneum and Pompeii. Working with pencil and brush, Robert traveled about his native France as well as Italy, producing images faithful to architectural detail and impressive in their overall effect. These features of Robert's work would have appealed to Catherwood, who may well have studied his example.[32]

But it is to the oeuvre of Giovanni Battista Piranesi, who provided a source of inspiration for Robert, that we must look for the closest parallels to Catherwood's approach to pre-Columbian antiquities. Although at first glance Piranesi's highly dramatic, almost baroque renderings of the crumbling surfaces of Rome appear to defy visual comparison with Catherwood's watercolors, the underlying purposes of their work bear direct analogy. Catherwood's exposure to Piranesi's prints undoubtedly occurred in the lectures of Sir John Soane at the Royal Academy, where he attended the free art classes beginning in 1820.[33] This encounter profoundly affected his vision of the ancient world. Images such as the *Ancient Burial Chamber* (from the *Prima parte di architettura e prospettive*) demonstrated Piranesi's manipulation of scale, light, and perspective to create provocative visions of ruined grandeur. Equally important to Catherwood, the trained architect, was the sensitive treatment of antique masonry techniques and the process of deterioration.

Even more critical, however, was the attitude toward the ruins implicit in the work. Piranesi's interest in the Roman antiquities developed at a time when the art of Rome was considered to be derived from, and inferior to, that of Greece. His stance in favor of the Romans is reflected in his emotionally charged interpretations of the monuments and in the exaggerated expression given to major feats of engineering, including roads and bridges—for example, in *Ponte d'Elio*.[34] Catherwood similarly created dramatic scenes of the Meso-American ruins. For his interior views he deliberately selected a vantage point that showed to optimal effect the corbeled vaults (fig. 47), which distinguished the Mayas from other peoples of the pre-Columbian world, who used only a post-and-lintel support system. Similarly, he created a cavernous image, *Well at Bolonchen*. By depicting a structure that enabled the Mayas to irrigate their land during the dry season, he argued his point about their capabilities as builders. Just as Piranesi's etchings became an important weapon in the Greco-Roman controversy, so Catherwood's pictures, highlighting the skill and originality of the Mayas, argued for an advanced, indigenous race.

47. *After Frederick Catherwood,* Interior of the Principal Building at Kabah, Yucatán, *lithograph by Andrew Picken from Catherwood's* Views of Ancient Monuments in Central America, Chiapas, and Yucatán, *pl. 17. Yale University Art Gallery, New Haven, Connecticut.*

Catherwood's involvement with these polemics was nurtured by a romantic temperament, his passion to recover the long-lost American past from the oblivion into which it had sunk. These feelings are given full play in his romanticized, moonlit views, sometimes inhabited by figures. In his *Colossal Head at Izamal* (pl. 4), for example, he depicted the plunging perspective of a stone wall into which a mysterious face has been carved. Guided by the light of the moon, an Indian assistant and Dr. Cabot (Stephens and Catherwood's companion on the second expedition) come upon the colossal head and stare upon it in mute fear and wonder. In other works, such as *Broken Idol at Copán* (fig. 46), a stela covered with pictographs stands in the

tropical forest, a silent witness of ancient Maya life. These images inspired in other artists a fascination with, and a profound respect for, the pre-Columbian antiquities.

Squier and His Artists in Nicaragua

Among the followers of Catherwood and Stephens can be numbered the French antiquarian Désiré Charnay, whose photographs of Meso-American ruins taken in the 1850s and 1860s strongly reflect the influence of Catherwood's images.[35] But their more immediate American successor was the diplomat and antiquarian Ephraim George Squier, who, as a result of a coincidence of political and archaeological circumstances, was able to take up the much-neglected subject of the Nicaraguan antiquities on three separate expeditions between 1849 and 1853. Endorsed for a diplomatic post by William Prescott, Squier received from President Zachary Taylor the appointment of chargé d'affaires in Central America. As Stephens before him, he was therefore able to combine his archaeological explorations with his diplomatic responsibilities.[36] His investigations there were part of his lifelong fascination with the American past. By 1849 he had already surveyed and classified the Indian Mounds of the Mississippi Valley and the aboriginal monuments of New York State.[37] In the 1860s his work extended to Peru. The fact that he turned his attention at this time to Central America may have been partly due to the influence of Stephens and Catherwood.[38]

Their success also led Squier to realize the importance of making accurate visual records of the ruins he explored. To this end, on each of his three expeditions, he secured the services of an artist. In 1849 he departed with James McDonough, in 1851 with Wilhelm Heine, and in 1853 with DeWitt C. Hitchcock.[39] Modern studies have taken little notice of the existence, much less the antiquarian achievements, of these artists. In *The Painter and the New World,* for example, it states

that "Catherwood was the sole person with an archae-ological interest." Thomas Tax, in his study of the development of American archaeology, asserts that aside from Catherwood's oeuvre, "little art work seems to have been done on American antiquities"; and even specialized studies of Squier's Latin American career do not mention the artists who traveled with him.[40]

Squier's decision to enlist the aid of draftsmen may have been made partly at the urging of his friend John Russell Bartlett, who emphasized the need for drawings as well as antiquarian treasures to be brought back to the shores of the United States to promote public support of antiquarian research. Squier was not as fortunate as Stephens in his associations with artists; he had to employ a different artist on each of his three separate missions, and he referred to those who subsequently engraved his illustrations as "costly assasin(s) [sic] of all life and truth in a picture." Yet he obtained from them a rich variety of visual material that greatly enhanced his publications of popular and scholarly books and articles.[41]

James McDonough, who accompanied the first reconnaissance, is occasionally referred to in Squier's *Nicaragua*, but only as "M." During their travels he produced studies of individual monuments found buried deep in the forests and panoramic drawings of the coastal scenery. Some, such as *San Juan de Nicaragua* and *Entrace to the Bay of Fonseca* (fig. 22), subsequently appeared as illustrations in Squier's texts, while others became the basis for oil paintings submitted to the annual exhibitions of the National Academy of Design and elsewhere.[42] A letter Francis Parkman wrote shortly after he had heard the news of Squier's premature return from Nicaragua in 1850 affords a glimpse into the conditions under which McDonough had to work:

> Four years among Greasers and Indians with a touch of snakes, Alligators and El Vomito [i.e., *il vómito*, the local dialect for yellow fever], would be unpalatable to the best stomached antiquarian. I don't wonder your Artist grew homesick, more especially as I fancy he

hadn't much leisure time given him to swallow quinine and colomel.[43]

This explains why they had cut short their intended four-year tour and why Squier returned to New York to hire another artist before returning to Central America.

Wilhelm Heine replaced McDonough on the second expedition. Parkman's well-wishes, sent to Squier on the eve of the departure in September 1851, expressed the hope that both he and Heine must have felt: "You would be off again this Fall and no mistake for Central America, accompanied by an artist whom I hope will serve you better than the last."[44] Heine, as it turned out, was ideally suited to the life of an artist-traveler; upon the completion of his work with Squier he signed on as artist with Perry's expedition to Japan. He so impressed Squier that he used him as the model for the artist-hero of his adventure tale *Waikna*, where he must have been immediately identified by New York readers.[45] Heine himself took up the pen to describe the ruins to the American Art-Union, which published his letter in its bulletin. "Without offering any theories," he wrote, "I shall content myself with simply stating my own observations, and the circumstances under which I found these antiquities." The temptation for speculation, however, was too great, and in closing he postulated on the origin of the sculptures: "The type of face [found in Nicaragua] greatly resembles those which cover the walls of Palenque, and perhaps this monument was sculpted by some Mexican artist sent to this remote province of the Aztec Empire."[46] His drawings, which illustrated his own article and Squier's books (fig. 48), also became the basis for exhibition pictures, all of which helped foster great interest in these curious objects.[47]

The work of Squier's artists kept before the eyes of the American public an image of what he considered a skilled and independent race of Amerindians. His first intention was to demonstrate that the Central American ruins were equal or even superior to those of the Egyptians. The pictorial records, he hoped, would

48. *Wilhelm Heine*, Nicaraguan Antiquities, *from* Bulletin of the American Art-Union, *1851*.

M. Lewis Clark, written in 1848, reflect Squier's own sentiments in this regard:

> I cannot have a doubt, are not our mounds, the North American "Pyramids"? and may not their contents here-after prove analogous to and perhaps identify with those of Mexico and Central America? from their remains perhaps some American "Rosetta Stone" may yet be exhumed to discover to the astonished savants of the Old Continent that on our side of the "great Water," nations of civilized human beings with Arts, Sciences, and religion have existed in the valleys, and peopled the banks of the American "Nile" thousands of years gone by; and probably prior to the "Nilotic" events themselves.[49]

The researches of Squier and his artists, like those of Stephens and Catherwood, were tied to their moment. As one observer declared, a "general interest is felt in everything related to the aboriginal race of America."[50] But as Stephens willingly acknowledged, "the first new light thrown upon this subject as regards Mexico was by the great Humboldt," to whom they all owed a special debt.[51]

The Influence of Humboldt's Picturesque Atlas

Humboldt had provided the Dresden-born Heine, according to their mutual friend Bayard Taylor, with two items of importance for his life in the New World: letters of official recognition authorized by the King of Prussia and his "own copy (the original edition) of his *Vues des Cordilleres* containing some marginal notes."[52] This volume, known in its English translation as the *Picturesque Atlas*, constituted one of the earliest and most influential attempts to systematize the study of pre-Columbian artifacts and stimulated the antiquarian interests not only of Heine, who joined up with Squier's expedition soon after his arrival in the United States, but also of Gallatin, Prescott, Stephens, and many others.[53] "I have collected, in the following work, what-

demonstrate their differences rather than their correspondences. His extensive investigations in the American West, furthermore, prompted him—as they had Catlin—to speculate on the distribution of races across the American continents. "In respect to the monuments which I have described," he wrote in *Nicaragua*, "there is no good reason for supposing that they were not made by the nations found in possession of that country."[48] Comparative data also suggested that the people who had built these pyramids and painted the rock pictures he found in Central America were related to the Mound Builders of North America. His belief that the New World races shared a point of origin independent from developments in the Old World constituted for him a source of national pride. The words of his friend

ever relates to the origin and first progress of the arts among the natives of America," Humboldt explained in the introduction.[54] The illustrations and descriptions of the codices and pyramid mounds were included with an eye to resolving the question of their origins, and by extension, the origin of their makers. Even the format of the book, which interspersed essays on pre-Hispanic artifacts with others on Cotopaxi, Tequendama Falls, and other natural history sites, was prompted by his idea that "an accurate knowledge of the origin of the arts can be acquired only from studying the nature of the site where they arose."[55] Effectively, then, this book symbolized Humboldt's belief in the unity of nature and art, which characterized all his Latin American explorations. What otherwise might have remained for some time the concern of a small, specialized circle of antiquarians became part of a larger awareness of the tropical landscape as a result of its wide readership.

Church's *Cayambe* (pl. 3) demonstrates how antiquarian concerns permeated a landscape painter's study of tropical nature through the influence of Humboldt's volume. The canvas depicts the Ecuadorian mountain Cayambe and a carved stone monument prominently situated in the lower-left foreground. It was "painted to order" for Robert L. Stuart, a businessman whose widespread interests led him to assemble an important collection of American art and serve as the president of the American Museum of Natural History from 1871 to 1882.[56] A photograph of the interior of Stuart's home (fig. 49) shows the picture hanging with the rest of his art collection above his natural history cabinets, an arrangement dictated by his belief in the unity of art and science. These interests were also reflected in the holdings of his library, which included a rare folio edition of Humboldt's *Picturesque Atlas*. In it Cayambe was praised as "the most beautiful as well as the most majestic" snowpeak in the vicinity of Quito and illustrated in a full-page colorplate.[57] It can well be imagined that artist and patron looked over this volume together to decide on a suitable subject for the commission, probably worked out first in a smaller-scale paint-

49. Photograph of the home of Robert L. Stuart, New York. Rare Book and Manuscript Division, New York Public Library.

ing (fig. 50) showing the peak from a slightly different angle and without the stela. The final painting included this small ruin, which relates to the local tradition that "it was on the heights of the mountains about Cayambe, that the Incas of old built their palaces and temples of freestone."[58] It also indicates a close reading of Humboldt, who pointed out that the colossal mountain was directly on the equator, and therefore "one of these eternal monuments by which nature has marked the great division of the terrestrial globe." This fact had particular appeal for Stuart, who later emphasized that Cayambe was "on the line of the Equator, about 20,000 feet high."[59]

On his second visit to Ecuador, Church seemed more aware of the pre-Columbian past. Several letters sent from Quito in 1857 were inscribed "City of the Incas," a reference to the fact that it had been the second capital of the Inca Empire, after Cuzco. He felt the ancient presence everywhere, even in the music he

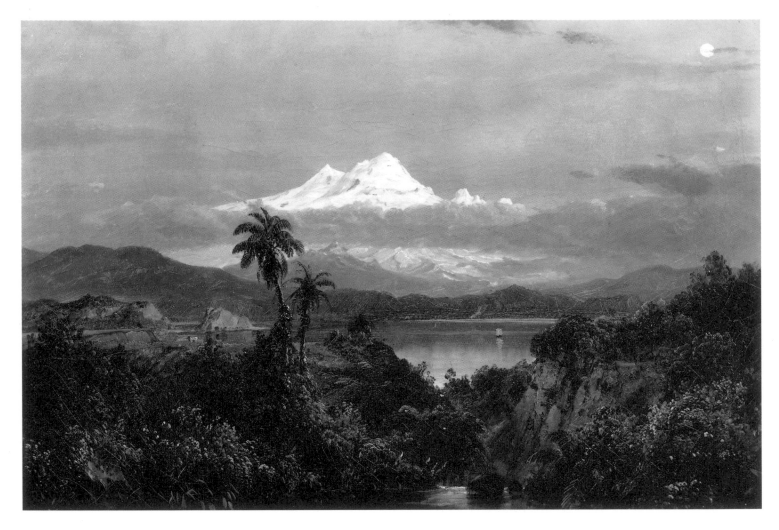

50. *Frederic Church*, Cayambe, *1853 or 1858, oil on canvas, 12 × 18 in. (30.5 × 45.7 cm). Museum of Fine Arts, Boston (47.1237).*

heard. For as he wrote to the composer George Warren, "The Natives have some peculiar music and instruments. The Music is handed down from the Incas." He also mentioned a proposed visit to "some fine ruins."[60] Is the ruin in *Cayambe* one such example? It is a four-sided stone column or plinth, perhaps three feet high, topped by an orb. The low-relief carving resembles a human head with what looks like plant forms, perhaps the visualization of wind or sound, emanating from its lips. The motif echoes the Aztec figures with scrolls protruding from their mouths (in the manner of

present-day cartoons) to indicate speech; images of this sort appeared in the manuscript pages featured in Humboldt's atlas. Stylistically, however, the carving bears a stronger resemblance to decorative sculptural reliefs from the sixteenth-century colonial period, and still found in Ecuador, of lions or especially wild men with leaves coming out of their mouths.[61] Working when little was known of the chronology of Latin American art, Church may well have encountered such a ruin and,

assuming it was the work of the Incas, included it as a reference to their ancient past. The strange illumination of the canvas and placement of the moon just above the stone remains suggest the artist's fascination with the ruin's mysteries. He shared this fascination with his patron, whose extensive library holdings in archaeology included "the stately work of Lord Kingsborough on Mexican hieroglyphics in nine folio volumes."[62] Thus Stuart would have found particular significance in Church's placement of the sculpted ruin at the foot of the Ecuadorian peak. For as Humboldt asserted, the art born of the high Andes was superior to any other: "The only American tribes, among whom we find remarkable monuments are the inhabitants of mountains. . . . their productions bear the stamp of the savage nature of the Cordilleras."[63] Thus *Cayambe* emphasizes the association between this noble scenery and the unique and indigenous art to which it gave rise.

So the ruin—originally a requisite prop, an element of picturesque convention—acquired a deeper meaning as it made its way into Latin American landscape imagery. It never lost the moral associations of the memento mori, a reminder of "the instability of all human possessions and the vanity of all earthly grandeur and magnificence."[64] The sculpted monolith at the base of Mount Cayambe or in the depths of the jungle also provided visual entry into the long-lost American past. Just as mountains and volcanoes raised questions about the origins of the earth, so these ruins raised questions about the ancient race who had inhabited the continent. Painted in 1858, *Cayambe* (pl. 3) falls midway between Peale's renderings of the Peruvian antiquities in the 1830s and images of the Central American ruins artists such as Charles Dorman Robinson continued to do into the 1870s.

Like Church, Peale and Robinson were amateurs in the field of antiquarian studies, but their Latin American travels led them to an awareness of the intimate relation between its nature and art. During his tour of duty on the Wilkes Expedition, Peale occasionally turned his attention from the flora and fauna to

51. Titian Peale, Ancient Mounds near Lima, Peru, *c. 1838, oil on panel, 10 × 12¹/₄ in. (25.4 × 31.1 cm). American Philosophical Society, Philadelphia.*

the ancient remains they came across during brief onshore visits. The small oil painting *Ancient Mounds near Lima, Peru* (fig. 51) and the related pencil drawings are important early indications of the way in which these antiquarian concerns were related to, and inseparable from, natural history investigations. Peale made his sketches in the valley of Almancaes, about three miles north of the city, where the expedition staff attended a festival. The gaily clad figures on horseback who appear in the foreground of Peale's image may be a reference to that event. Strangely, although Wilkes's *Narrative* described the festival, complete with illustrations by draftsman Joseph Drayton, there was no hint of the existence of the mounds that so fascinated Peale.[65]

Peale's interest in these curious structures probably derived from his association with the Philadelphia-based American Philosophical Society, which considered the study of the pre-Columbian ruins one of its primary objectives. In 1798 Thomas Jefferson, then president of the organization, appointed Titian's father, Charles Willson Peale, to a committee to collect material relevant to the subject.[66] Serving as a clearing house for

antiquarian knowledge, the society made a particular effort to acquire publications by Latin Americans, including the purchase in 1803 of "numerous works on Mexican antiquities" for their library.[67] This background, transmitted in part through his father, fostered Titian's precocious interest in the remains he saw in South America.

The vicinity of Lima boasts a number of impressive ruins, including the Temple of the Sun at Pachacamac, enthusiastically described by Wilkes; the fact that Peale singled out these rather prosaic mounds, therefore, is telling. The Peruvian structures bear a close resemblance to the Indian Mounds of the Mississippi Valley, the subject of ongoing controversy within the society.[68] Seeing them in the desert plains outside Lima, Peale must have been curious about their age and the identity of their builders. Recording them for future consideration, he may even have speculated about the possibility that Mound Builders had migrated between North and South America.

The pictorial depiction of American antiquities continued into the late 1870s. New England-born Charles Dorman Robinson migrated to the West Coast with his family during the gold rush. Living in California, he made trips through Mexico and Central America in the 1860s and 1870s. There he was able to observe crumbling pre-Hispanic monuments, which gave rise to paintings such as *Ruins in Central America* (fig. 52).[69] His concentration on the stela recalls Catherwood's earlier approach; but while Catherwood worked primarily in watercolor on paper, the preferred medium of antiquarian studies in the early days, Robinson made the ruin the subject of a full-scale oil painting. An address given at the American Antiquarian Society in 1877, about the same time Robinson painted his picture, helps explain the change that had come about in forty-odd years. In it the speaker emphasized that ideas about the indigenous origin of American Indian art, once considered fanciful, were then "beginning to be repeated with greater boldness and an air of more substantial authority." Given the "prevalence of an

52. *Charles Dorman Robinson*, Ruins in Central America, *1870s, oil on canvas, 30 × 50 in. (76.2 × 127 cm). Private collection.*

archaeological epidemic throughout the scientific world," he argued that it was "a favorable time . . . to have all such questions ventilated."[70] This growing interest was reflected not only in learned circles but also among artists, who lifted the ruin out of its specialized realm and into the domain of landscape painting. To date, only a few images of the ruins by Robinson, Church, Peale, and others have been found. That they appear even sporadically in the work of so varied a group of artists over four decades, however, indicates that the monuments—and the questions they raised—were part of their fascination with Latin America.

The Dream of a National Museum of American Antiquities

Explorers thought that no matter how good a drawing or painting was, it could not replace the real thing. They contrived schemes to remove the ruins from their remote settings and carry them back home with them. "To buy Copán," Stephens had mused, "remove the monuments of a by-gone people from the desolate region in which they are buried, set them up in the 'great commercial emporium,' and found an institution to be the nucleus of a great national museum of American antiq-

uities!" Stephens was eventually able to pull off the deal for the sum of fifty dollars, an incident he recounted in amusing detail.[71] And although frustrated in his attempts to take the monuments back to New York, he continued to negotiate for the purchase of others. Eventually he managed to remove a group of sculptures and other objects from Yucatán, some of which were exhibited with Catherwood's panorama until fire destroyed the building and many of the artifacts. Others were stored elsewhere and later found a home in the American Museum of Natural History, partially fulfilling Stephens's cherished dream of a public collection of American antiquities.

Squier also went to some effort to remove samples of the stone sculptures from Nicaragua and send them back to the United States.[72] But where would they be kept and exhibited? Some were deposited in the Smithsonian Institution, where they apparently created quite a stir. "I hear frequent mention of the idols, extremely curious and unspeakably ugly, which you have sent to Washington," Squier's friend Parkman reported to him, "and I hope some day to see the originals of those whose portraits figure in a late number of the Literary World." Others were sent to the New-York Historical Society.[73] Their presence in the States attracted considerable attention and pointed out the need for a permanent display of the antiquities in a home of their own.

Frederic Church shared that hope. His purchase and subsequent gift to the Metropolitan Museum in 1893 of two pre-Columbian carved limestone slabs (fig. 53) were part of the ongoing efforts to possess and thereby understand the secrets of the ancient Americans. On his winter sojourns to Mexico in the 1880s and 1890s he visited a number of important archaeological sites, as he reported to Heade: "I had a delightful trip to Mitla—where, as you know, are some of the most remarkable pre-Hispanic ruins in the country."[74] On these excursions he occasionally acquired local artifacts such as the slabs, which he then offered to museum director Luigi de Cesnola:

53. Eagles Devouring a Human Heart, *one of two limestone relief slabs, 27¹/₂ × 29¹/₂ in. (68.9 × 74.9 cm), said to be from Veracruz near Tampico. The Metropolitan Museum of Art, New York, gift of Frederic E. Church, 1893 (93.27.1).*

I have two earthen ware tiles or slabs—Aztec works— which were found near Tampico, Mexico, in the vicinity of extensive ruins. . . . They are about 2¹/₂ feet square and I think very interesting. Believing that they would make a desirable addition to the collection of Mexican antiquities now in the Metropolitan Museum I write to say that I will be happy to present them to that Institution and will do so if the gift is acceptable.

A trustee of the museum from 1870 to 1887, Church donated these works in the hope that "the pair will add something to the meagre collection of the Ancient Art of the New World in our Museum and I will be alert to capture other examples of merit." His words echo those of Stephens a half century before.[75]

Attending the occasional public exhibitions of these objects, nineteenth-century observers usually

could not bring themselves to acknowledge the expressive strength of Amerindian art. It fell outside the realm of beauty defined by the Greco-Roman tradition, the supposed supremacy of which had been established by Johann Joachim Winckelmann.[76] Thus, while Stephens could find himself "arrested by the beauty of the sculpture" at Copán, the majority of his countrymen would have concurred with Parkman's assessment of the idols Squier brought back—that they were "extremely curious and unspeakably ugly."[77] Neither did they seem to meet the requirements of faithful representation, the touchstone of aesthetic value in the mid-1800s,[78] as demonstrated by Church's failure to identify the subject of his reliefs.[79] Perhaps the one thing all could admire ungrudgingly was the quality of the workmanship, and it was frequently noted that even with modern instruments it would be difficult to cut stones more perfectly. The craftsmanship, technical knowhow, and engineering feats of the ancient people were the qualities the nineteenth century could best appreciate.

The Inca roads, therefore, came to be among the most admired objects in ancient America. The ruins of this once extensive highway system were thought to enhance the Andean scenery, as Humboldt noted:

> The solemn impression which is felt on beholding the deserts of the Cordilleras, is increased in a remarkable and unexpected manner by circumstances that in these very regions there still exist wonderful remains of the great road of the Incas, that stupendous work by means of which, communication was maintained among all the provinces of the empire along an extent of upwards of 1000 geographical miles.[80]

Similarly, Prescott found that among the many "memorials of the past" the traveler met in the Peruvian highlands, "the most remarkable are the great roads, the broken remains of which are still in sufficient preservation to attest to their former magnificence."[81] Tschudi's praise was stronger still: "The great high road of the Incas, which led from Cuzco to Quito, stretching through the whole extent of Peru . . . was the grandest

work that America possessed before European civilization found its way to that quarter of the world."[82] Comparisons between the Inca and Roman roads were inevitable; for Humboldt the Inca system was equal—and given the altitude at which it was constructed, superior—to that of Rome:

> Whilst we journeyed onward for a distance of about four miles, our eyes were continually rivitted [sic] on the grand remains of the Inca Road, upwards of 20 feet in breadth. This road had a deep under-structure, and was paved with well-hewn blocks of black trap porphyry. None of the Roman roads which I have seen in Italy, the south of France and in Spain appeared to me more imposing than this work of the ancient Peruvians; and the Inca road is the more extraordinary, since, according to my barometrical calculations, it is situated at an elevation of 13,258 feet above the level of the sea.

As masterpieces of "aboriginal engineering," they were admired by technically minded North Americans.

Here indeed were New World antiquities that could compete with the great monuments of Italy. Inspired by such glowing recommendations, American artists sought out and painted portions of the great Inca road.[83] Ferguson, who traveled in the Andean countries of Peru, Chile, and Ecuador in the early 1870s, painted at least one view of the subject, entitled *Natural Bridge, on the Great Inca Highway* (unlocated). A description of the picture mentioned that "several horsemen are crossing a rocky bridge under which rushes a torrent from the range of the snow-capped Chilean Andes," evidence that travelers still followed the old highway.[84] The Ecuadorian painter Luis Martínez demonstrated his interest in the old stonework in his *Camino del Inca* (Collection of the Ministry of External Relations, Quito). Martínez focused on the zigzag path of the road, leading the eye higher and higher toward the heavens.[85] Abruptly terminating the road at the edge of the mountain precipice, Martínez's canvas conveys romantic and even tragic overtones, perhaps suggestive of the sudden end of the Inca Empire with the arrival of

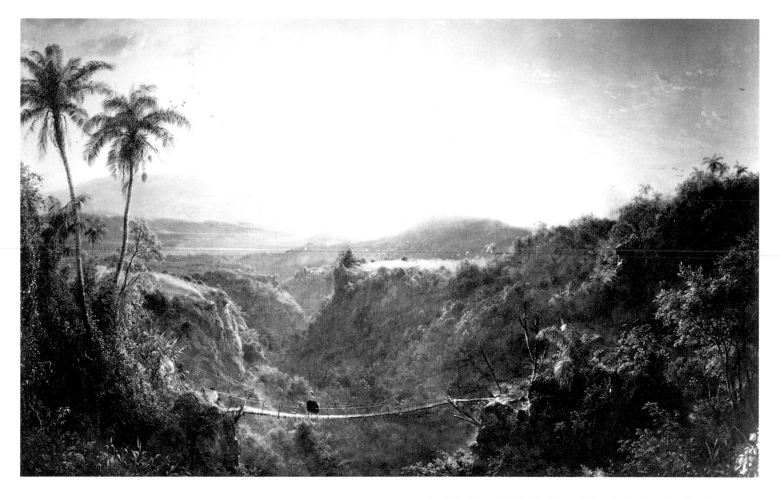

54. *Frederic Church*, The Bridge of San Luis Rey, the Andes, *c. 1855–65, oil on canvas, 31 × 48 in. (78.4 × 121.9 cm). Photograph courtesy Kennedy Galleries, Inc.*

the Spaniards. This element seems to be absent from the work of the North American artists, who focused more closely on the structure and, by extension, the engineering prowess of the Incas.

While the stone roadwork was included in the tropical landscapes of some artists, others seemed intrigued by the famed Inca suspension bridges. Perhaps following Humboldt's lead, Church made a number of pencil drawings of such bridges and included a prominent example in at least one painting (fig. 54).[86] And Granville Perkins made a rather careful study of their technical refinements for his *Swinging Bridge in Peru* (fig. 55). His detailed treatment of the massive

stone pylons on either side of the ravine, from which the fiber ropes are suspended, inspired admiration for the race who erected such structures without the benefit of modern mechanics. And by selecting a vantage point over the deep chasm spanned by the river, he dramatized the experience of the travelers who braved the crossing. This picture may in fact represent the 220-foot bridge suspended 118 feet above Peru's Apurímac River, the most famous of all Inca suspension bridges. Photographed by Squier before it was replaced in 1880, the bridge later became a symbol of fate in Thornton

55. Granville Perkins, Swinging Bridge in Peru, *c. 1870s, oil on canvas, 29¹⁄₂ × 47¹⁄₂ in. (74.9 × 120.6 cm). Courtesy of Sotheby's Inc., New York.*

Wilder's *Bridge of San Luis Rey*.⁸⁷ Whatever its precise identity, as the principal subject of Perkins's landscape the bridge testified to the high degree of technical acumen possessed by the Incas. Furthermore, Humboldt insisted that the rope bridge was a native architectural form "of which the people of South America made long use before the arrival of Europeans."⁸⁸

The Hieroglyphic Inscriptions

The rediscovered roads, temples, and stelae testified to the presence of an advanced civilization in the New World. But no amount of analysis of these monumental forms revealed the answer to the most fundamental question: Who made them? Frustration over the lack

of any written text recording this information was expressed by a number of authors. "Here is one half of the planet without a page of written record, without legends or traditions," Thomas Ewbank despaired. "It presents to the historian, instead of a chronicle of dynasties, of stirring actions and mighty events, a huge and silent blank—not the name of an individual, nor the sound of a foot-fall preserved."⁸⁹

Others came to realize, however, that the story might be contained in the hieroglyphs sometimes inscribed on the ruins. The recording system that evolved in pre-Columbian America varied with region and civilization. "These ancient Peruvians had no manuscript characters for simple sounds; but they had a

method by which they composed words and incorporated ideas," Tschudi explained to his readers. "This method consisted in the dextrous intertwining of knots on strings, so as to render them auxiliaries to the memory." These *quipu*, as they were called, were mnemonic devices to those entrusted with the history of their people. Nineteenth-century explorers longed to decipher their messages, but those who had known how to read the *quipu* had vanished, and with them, the history of their race. As a result, Tschudi lamented, "we are left in complete ignorance of the origin of these nations."[90]

More could be gleaned of the Aztecs, who had formulated a sign system or pictographic form of rebus writing. Devoting a large part of his *Picturesque Atlas* to this subject, Humboldt reproduced a number of examples of "hieroglyphic painting" from the Aztec codices preserved in European collections. His observations constitute some of the most sophisticated speculations on the subject up to that time:

> When we compare the Mexican paintings with the hieroglyphics, that decorated the temples, the obelisks, and perhaps even the pyramids of Egypt; and reflect on the progressive steps, which the human mind appears to have followed in the invention of graphic means fitted to express ideas; we see, that the nations of America were very distant from that perfection which the Egyptians had obtained. The Aztecks [*sic*] were indeed but little acquainted with simple hieroglyphics; they could represent the elements, and the relations of time and place; but it is only by a great number of these characters, susceptible of being employed separately, that the painting of ideas became easy, and approximates writing.[91]

The discovery of the Mayas provided new evidence in the assessment of New World cultures, for they had formulated a writing system vastly more complex than any other in America. At one time there were perhaps thousands of books, which must have recorded the full extent of their ritual and learning, although only a few survived until modern times.[92] It was not the books so

much as the glyphs etched into the stone monuments, standing mute in their overgrown landscape settings, that most fascinated northern artists. Little remained of whatever pictographs the Aztecs had made in stone, a circumstance that had led Prescott to grumble that the hieroglyphs were "too few on American buildings" in Central Mexico.[93] But in picture symbols and numerical signs preserved on the Maya monuments and sculptures they found the New World equivalent to the hieroglyphs of Egypt. The sight of these cryptic signs tantalized the nineteenth-century viewer with the secrets they held to the identity of their creators.

Much of the impetus for discovering the meaning of these carved signs came from the Old World, from the nascent field of Egyptology. It is perhaps no accident that American antiquarian investigations were linked almost from their inception with the study of Egyptian monuments. Coinciding with Napoleon's invasion of Egypt in 1798—scientific and archaeological as well as military—was Humboldt's New World reconnaissance.[94] And awareness of the American antiquities continued to grow along with knowledge of ancient Egypt. The discovery of the Rosetta Stone and the efforts of French scholar Jean-François Champollion to decipher the hieroglyphs with the multilingual tablet were landmarks in both fields. Referred to as "one of those strange accidents which suddenly pour a flood of light on the darkness of ages," the famed stone captured the American imagination and suggested the possibility that the code of the incomprehensible Maya symbols might also one day be broken.[95] Stephens was therefore one of many who called for another Champollion to interpret the message left by the ancient Americans:

> In regard to the age of this desolate city I shall not at present offer any conjecture. . . . Nor shall I at this moment offer any conjecture in regard to the people who built it. . . . One thing I believe, that its history is graven on its monuments. No Champollion has yet brought to them the energies of his inquiring mind. Who shall read them?[96]

The discovery of Bishop Diego de Landa's *Historia de las cosas Yucatán,* written about 1566 and published by Brasseur de Bourbourg in 1865, provided a piece to the puzzle. While it did not prove to be another Rosetta Stone, it assisted Ernst Foerstemann at the turn of the century in partially deciphering Maya writing. Efforts continue to the present day, but during the period under discussion, no Champollion stepped forward.[97]

From the moment in 1839 when Stephens and Catherwood came upon the ruins, they sensed that their carved insignias conveyed some higher meaning. Stephens declared that the monuments were covered "with hieroglyphics explaining all but perfectly unintelligible." Catherwood was equally convinced of their significance and copied each one so faithfully that, incomprehensible as they were to him, they are recognizable to modern students of archaeology.[98] *The Altar of the Temple of the Sun* (fig. 56) epitomizes this effort. It depicts the symbol for the Sun Face in the center, flanked by two life-sized figures and rows of glyphs coursing the sides. The artist's main intent here was to point up the carved inscriptions on the face of the stone, which he painstakingly copied. Just as he had oriented the facade of the governor's house (fig. 45), so he displayed the surface of this stone mural, like the page of a text, for reading and contemplation.

Similar ideas inspired James McDonough's sketches of the Piedras Pintadas (fig. 57), of which he and Squier had heard so much in Nicaragua: "Upon the vertical face of the cliff were painted, in bright red, a great variety of figures." Illustrated in color in Squier's book to indicate the traces of original red, blue, and yellow still faintly visible, McDonough's rendering of the coiled serpent particularly seemed to beg for interpretation. "Amongst the semi-civilized nations of America, from Mexico southward," the text read, "the serpent was a prominent religious symbol, beneath which was concealed the profoundest significance." Isolating the spiral configuration against the rock ground, the sketch emphasizes the skillful conflation by the aboriginal artist of the serpent form with the figure of

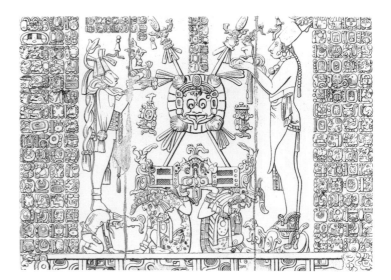

56. *After Frederick Catherwood*, The Altar of the Temple of the Sun (Tablet on the Back Wall of the Altar, Casa No. 3), *engraved by A. L. Dick. Frontispiece from John Lloyd Stephens*, Incidents of Travel in Central America, Chiapas, and Yucatán, *vol. 2.*

the sun—what artist and antiquarian assumed to be the pictorial manifestation of the age-old beliefs of the Indians.[99] The signs and symbols that appear in the images of Heine, Church, Peale, Robinson, and others similarly invite, even demand, reading. Catlin, who had visited at least one Maya site at Uxmal, speculated that the answers to his questions on Indian origins might lie in the glyphs:

> How astonishing that such stupendous ruins are actually there, and were built there, and left there, without a living soul to tell their history, or who built them, and covered them with inscriptions and hieroglyphics, no doubt telling their own history if they could be read.[100]

He and the other artists would undoubtedly have agreed with Stephens: their power was so intense that "often the imagination was pained in gazing at them."[101] Language, never translated, became the ultimate symbol of

57. *James McDonough*, Painted Rocks of Managua. *From Ephraim George Squier*, Nicaragua.

the origins of the American Indians. The carved stelae and buildings that appear wedded to the landscape in the tropical pictures reflect their ongoing archaeological inquiries. Each one, in his own way, pursued the questions articulated by Catlin: Who were these people who had built the first cities in the Americas; where did they come from; and where had they gone? The silent stones prompted the questions, but they did not readily divulge the answers. In recording the ruins, North American painters and draftsmen stated that America too had its ancient antiquities and preserved a link to the unknown race who had inhabited their continent.

The Organic World

Agassiz, Heade, and Darwin's Challenge

The origin of life is the great question of the day.
LOUIS AND ELIZABETH AGASSIZ, *A Journey in Brazil*

The publication of Charles Darwin's *Origin of Species by Means of Natural Selection or the Preservation of Favoured Races in the Struggle for Life* in 1859 changed for all time man's outlook on the world in general and on the neotropical world in particular. The argument put forth that species derived from other species by a gradual evolutionary process and that the average level of each species was heightened by the "survival of the fittest" revolutionized the course of science—but not before it had shaken the foundation of orthodox religion and stirred popular debate to a fever pitch. Scientists, clergy, and people in the street were polarized into one of two camps: the positivists and the creationists. Among the positivists, who limited scientific knowledge to the laws of nature, the theory of evolution won increasing acceptance. But for the creationists, who clung to the belief that God in some way *directly* intervened in the order of nature to create each new species, Darwin's ideas amounted to blasphemy. Someone of this persuasion was incapable of separating science from theology and, in seeking to explain the origin of the world, tended to be an "idealist."[1] In America, where creationism persisted longer than elsewhere, Darwin's ideas met widespread resistance, for they negated the concept of divine creation and, it was feared, ultimately eliminated God from the universe.[2] Louis Agassiz was in the forefront of those to oppose *The Origin of Species*, and he chose Latin America as the "laboratory" where he would conduct the investigations he believed would disprove it. His tropical explorations, along with those of Martin Heade, must therefore be seen as direct responses to Darwin's challenge.

Some have argued that Americans did not turn their full attention to Darwin's theories until after the Civil War, and in the main this generalization holds true. For those interested in the exploration of South America, however, it would have been unthinkable to put off a consideration of his new work. To them Darwin had been first and foremost a fellow tropical adventurer. He was respected in America throughout the 1840s and 1850s as the author of *The Voyage of the Beagle* (1839), which Church and other artists included in their libraries. The Vassar naturalist James Orton dedicated his own book of Andean travel to Darwin, who

"has so pleasantly associated his name with our southern continent."3 They would certainly have been interested in its "sequel," *The Origin of Species*, if only because it was based, as Darwin explained in the opening sentence, on the observations he had made in South America:

> When on board H.M.S. *Beagle*, as naturalist, I was much struck with certain facts in the distribution of the organic beings inhabiting South America, and in the geological relations of the present to the past inhabitants of that continent. These facts, as will be seen in the latter chapters of this volume, seemed to throw some light on the origin of species—that mystery of mysteries, as it has been called by one of our greatest philosophers.4

Whether Heade, Church, and their fellow artists actually read *The Origin of Species* immediately upon its publication is yet uncertain, but it would have been impossible for them to have avoided the resulting controversy, debated in periodical literature throughout 1860 between Agassiz and Asa Gray.

Louis Agassiz and His Expedition to Brazil

Until 1859 Agassiz's supremacy in America had been unrivaled. In June of that year construction began on Harvard's Museum of Comparative Zoology, what became known as the Agassiz Museum, an institution that he intended to stand as a monument to his vision of natural history. The country embraced the Swiss-born naturalist, and he, in turn, pledged his new loyalty: "I feel that the task allotted to me is the development of the Natural History of this continent. . . . Both as to the object and the mode of its performance I am satisfied that America, and not Europe, is my field and my home."5 Upon Humboldt's death in 1859 the mantle of the great universal scientist passed to Agassiz. "With Humboldt terminated an important period in the history of science," one observer noted, "Owen, Liebig, Geoffroy St. Hilaire, and Agassiz constitute the master

spirits of another epoch whose cycle has not yet been completed. . . . Of these, one of the most industrious as well as one of the most successful prosecutors of original scientific researches is Agassiz."6

At the peak of his reputation and powers that fateful summer of 1859, with the cornerstone of the museum in place, Agassiz made his first and last return visit to Europe. By November he was in England, where his stay was disturbed by the appearance in the bookshops of *The Origin of Species*. Its publication had particularly disastrous consequences for the Harvard naturalist, whose inability to assess objectively the new ideas severely undermined his scientific credibility. He received a copy of the book with a note from Darwin asking him to at least give him credit for having "earnestly endeavored to arrive at the truth." But Agassiz's predictions that no purely physical explanation of speciation would ever be found, that no transitional fossils would ever be discovered, that nothing but divine handiwork could explain the existence of the organic world (which had won him great popularity in the United States) were in direct conflict with Darwin's theory. If Darwin were right then Agassiz was wrong, and "the Professor" struggled until the end of his days against that conclusion.

Agassiz was therefore forced to take a stand against the philosophy of evolution, which was entirely alien to his metaphysics. *The Origin of Species* was "poor, very poor" he told the botanist Asa Gray, his colleague at Harvard. Gray, who had been immediately struck by the "great ability of the book," became its greatest champion on American shores.7 The lines were drawn. Agassiz and Gray, friends for years, now barely spoke and conducted their heated debate in the pages of the popular and scientific press. Gray published his essay "Natural Selection Not Inconsistent with Natural Theology" in a series of articles in the *Atlantic Monthly* in 1860, while Agassiz outlined his objections in Benjamin Silliman's widely circulating *American Journal of Science and Art* the same year and continued in his anti-evolutionary crusade throughout the decade.8 A long-

delayed plan to take a trip for his health therefore became a scientific expedition to survey the fish populations of the Amazon, which he believed would provide him with the necessary evidence to counter the claims of the evolutionists. Thus while Darwin, two years Agassiz's junior, remained at home in his English country house, his exploring days over, Agassiz departed for Brazil on one of the most fantastic adventures of his already remarkable career.

His decision to pursue these inquiries in South America was related, of course, to his need to return to the part of the world in which Darwin's own conclusions had been reached. But it was also the fulfillment of a lifelong goal. His scientific training at Munich had been greatly influenced by Johann Baptist von Spix and Karl Friedrich Philipp von Martius, the two Bavarian scientists whose *Travels in Brazil in the Years 1817–1820* increased outside awareness of that country. With the death of Spix, his associate, in 1826, Martius had been in need of someone to take up his unfinished project and recognized in the young Agassiz the very person to complete *The Fishes of Brazil* (1829).[9] "From that time," Agassiz recalled, "the wish to study this fauna in the regions where it belongs had been an ever-recurring thought with me; a scheme deferred for want of opportunity, but never quite forgotten."[10] Lacking the immediate resources for Brazilian travel, the young scientist pursued his chosen organism in fossil form, which he published in *Recherches sur les poissons fossiles* (1833–43). Documenting more than seventeen hundred species of ancient fish, the book's emphasis on comparative anatomy for a comprehension of geology and paleontology demonstrated the author's links to Georges Cuvier; but in its effort to bring wide-ranging concerns to bear on his topic, he revealed himself to be a true heir of Humboldt, to whom he dedicated the volumes. This remarkable contribution to natural history inspired future investigations into the question of organic creation, including those of Agassiz himself, and he became increasingly determined to resolve that question on the great southern continent.[11]

In 1865 and again in 1871 Agassiz and his wife, Elizabeth, left Cambridge with loyal bands of followers headed for South America. The Hassler Expedition of 1871 made a grand sweep of the southern continent along the Atlantic coast, through the Strait of Magellan, and up the coast of Chile, Peru, and Ecuador, where it made a special stop at the Galápagos Islands.[12] The expedition was essentially oceanographic in nature and concerns us less here than the Brazilian exploration of 1865, which was undertaken with the expressed purpose of disclaiming Darwin:

> I am often asked, what is my chief aim in this expedition to South America? No doubt in a general way it is to collect materials for future study. But the conviction which draws me irresistibly, is that the combination of animals on this continent, where the faunae are so characteristic and so distinct from all others, will give me the means of showing that the transmutation theory is wholly without foundation in facts.[13]

History has judged Agassiz harshly on his opposition to the doctrine of evolution. But his quarrel with Darwin and the work of the Brazilian expedition, which it prompted, were rooted in a fundamental idealism. An anecdote later told by William James, one of the young assistants on the expedition, underscores the hopeful enthusiasm with which Agassiz departed for South America. In his hammock on the deck of the Brazil-bound steamer one night, next to James, Agassiz lay sleepless. "James, are you awake?" he whispered. "I cannot sleep; I am too happy; I keep thinking of all those glorious plans."[14]

Louis and Elizabeth Agassiz and their party of twelve assistants (fig. 58) departed on 1 April 1865 under the sponsorship of Nathaniel Thayer, who underwrote all the expenses.[15] It was yet another manifestation of what James called "the Agassiz legend," which enabled him to conceive and execute his grand Brazilian project with no government support and only a handful of fledgling explorers. Agassiz "made an impression that was unrivalled," James recalled in 1896. "He left a

58. Photograph of the members of the Thayer Expedition, 1865–66. Left to right, William James, Mr. Bourget, Walter Hunnewell, Stephen V. R. Thayer, Jacques Burkhardt, Major Coutinho, Newton Dexter. Collection of Museum of Comparative Zoology, Harvard University, Cambridge, Massachusetts.

sort of popular myth—the Agassiz legend, one might say—behind him and in the air about us."[16] So profound was his impact on those around him that he convinced James and five other Harvard students to pay their own way on the expedition. Along with James and Edward Copeland there was Tom Ward, son of Samuel Gray Ward (a financier of the Pacific Mail Steamship Company), who provided the party with free passage on the steamer *Colorado*.[17] James found him "active and tough and a most pleasant companion," while he pronounced Newton Dexter a "sun-burnt, big-jawed devil . . . from Providence, who is a crack shot and has hunted all over the U.S." His expertise proved useful in the field: "When he has brought down his bird, [he] understands how to strip and mount the specimen with rare skill." The Agassizes felt understandably protective toward Nathaniel Thayer's son, "Ren," who was "a very amiable boy and always most kind and attentive"; his lack of interest in scientific study seems to have been

patiently overlooked. Walter Hunnewell, according to Elizabeth Agassiz, was "rather heavy, but he is kindly and good-headed and I feel as if we should be quite fond of him." Although she did not think he would "add much scientific weight to the party," the photographic equipment with which his father had outfitted him proved useful.[18] To this miscellaneous array of volunteer talent was added the paid scientific staff. To facilitate his collecting objectives, Agassiz had selected one representative from each department of his museum: John G. Anthony, conchologist; John A. Allen, ornithologist; George Sceva, preparator; and geologists Orestes St. John and Charles Frederick Hartt, who returned on several occasions to continue his exploration of the region.[19] Agassiz's son, Alexander, remained in Cambridge to take care of the museum during his father's absence.

All that was missing was an artist. Agassiz had invited Ernest Wadsworth Longfellow to fill the position, but his poet father, Henry, did not allow him to participate, as he later explained:

> One of the great regrets of my life is that my father would not let me go with Agassiz on his expedition to Brazil and his exploration of the Amazon. Agassiz had offered me the post of artist to the expedition and I had been wild to go, but I was not yet of age, and my father very much opposed to it, fearing I could not stand the climate, so reluctantly I gave it up. It was certainly one of the lost chances of my life.[20]

Instead, the aged Jacques Burkhardt, who had worked faithfully as Agassiz's draftsman since the Neuchâtel days, was once more pressed into service. Elizabeth Agassiz acted as expedition historian, recording its daily activities, which she subsequently published as *A Journey in Brazil* (1868). All were essentially novices at fieldwork, but, like Nathaniel Thayer, they had the utmost confidence that under Agassiz's direction they would carry out the plan successfully.

The party landed in Rio de Janeiro, where their three-month stay included a number of meetings with

Emperor Dom Pedro II. The young emperor extended them every hospitality, including the use of a steamer for their Amazon voyage and the assistance of a native engineer, Major Coutinho, whom Agassiz called "my good genius."[21] To accomplish their mission in the seventeen allotted months, the work was divided into two phases: the study of individual biological species inhabiting the Brazilian forests and rivers, especially the fish population; and documentation of glaciation along the banks of the Amazon. The work load proposed by Agassiz for his small crew understandably gave rise to the protests James confided to his mother in his first letter home: "The Professor has just been expatiating over the map of South America and making projects as if he had Sherman's army at his disposal instead of the ten novices he really has."[22] To maximize the territory they could cover, they divided into smaller parties and headed for the various tributaries of the vast Amazonian system leading into the interior of the continent.

Agassiz instructed his men to scan the river banks and "examine the loose materials in every river" for traces of glacial action.[23] This search was motivated by the idea that a recent glacier, a monumental geological catastrophe, would have interrupted the spans of time needed according to Darwin's theory for one species to be transformed into another or for the development of lower into higher forms. To this end he sought, and believed he had found, signs that the Amazon Valley in all its tropical splendor had not long ago been covered completely by great masses of ice. "I have found traces of glaciers under this burning sky," he wrote to his mother from Brazil, "a proof that our earth has undergone changes of temperature more considerable than even our most advanced glacialists have dared to suggest."[24] His creationist preconceptions convinced him he had found evidence of glaciers where Alfred Russel Wallace, Henry Bates, and other explorers who had spent many years on the Amazon (to Agassiz's one) had found none. His pronouncements of Amazonian glaciation on the basis of little or no verifiable evidence

astounded the scientific community and prompted his friend Charles Lyell to exclaim, "Agassiz . . . has gone wild about glaciers."[25]

In this hunt for evidence of a recent geological upheaval, Agassiz's Brazilian exploration finds confluences in some of Church's approximately contemporary South American landscapes. By painting Cotopaxi in an erupting state in 1862 (fig. 35), Church may also have been responding, however unconsciously, to the Darwinian controversy. The masterpiece was conceived through his expanding knowledge of geology and his deepening concern with terrestrial formation.[26] But why, five years after returning from Ecuador and several years after painting the quiescent *Heart of the Andes* (pl. 1), did he take up the subject of the volcano again, revealing the cataclysmic forces only hinted at in earlier canvases? The painting can be interpreted, as David Huntington has suggested, as an artistic statement on the Civil War, the nineteenth-century analogue to Picasso's *Guernica*.[27] Within the context of the national and philosophical crisis precipitated by the war, the painting could also be seen as an artistic manifesto of the Old World cosmology, to which the majority of American landscapists of Church's generation so wholeheartedly subscribed.

But in terms of the prevailing scientific debate in 1862, the subject of the volcano fulfilled the same need for Church that the glacier had for Agassiz: refutation of Darwin through evidence of a great natural cataclysm. *Cotopaxi* depicts the aftermath of a great volcanic eruption, one that would have broken the uninterrupted span of epochs required by Darwin's evolutionary chain of life. Employing a South American subject in this polemic against evolution, Church returned—as Agassiz did—to the continent that had given rise to Darwin's theory. *Cotopaxi* was an emphatic assertion of the pre-Darwinian world, a world in which the might of a volcano was thought to have created the American continent anew. Seen against the background of this crisis of thought, Church's masterpiece represents his

desire to maintain the old order in the midst of the chaos that threatened to engulf them.

Church cast his responses to Darwin in the form of the mountains and volcancoes he had been painting since his first visit to South America in 1853. Artists such as Heade, who first traveled there in the 1860s, were more likely to respond to its vital flora and fauna than to the rocky earth they inhabited. There can be detected, in other words, a shift in pictorial means from the inorganic to the organic, typified by a comparison of Church's *Cotopaxi* and Heade's *Cattleya Orchid and Three Brazilian Hummingbirds* (see fig. 61). Turning to biological life, artists were consciously or unconsciously paralleling the work of Darwin, who studied the Galápagos finches, tortoises, and other species for the keys to existence. Agassiz, similarly, intended to focus on individual species of fauna and instructed his party in Brazil to collect at least one specimen of every type of fish living in the Amazonian waterways: "4,00000000000 new species of fish," Agassiz proudly proclaimed in the caricature by William James.[28] The gentle fun James and others poked at Agassiz's boastful reports did not change the fact that his ultimate goal was nothing less than the documentation of the entire population of the River Amazon.

In his *Essay on Classification* of 1857 Agassiz had already called for the study of specialized species within narrow geographic ranges. Presumably based on the assumption that these species were less likely to have been modified by limited environmental adaptation, such investigation would help to illuminate the "conditions under which animals have been created."[29] With Darwin's challenge now squarely before him, Agassiz had ample reason to undertake the study of Amazonian fish, a group of geographically circumscribed organisms with which he already had some familiarity from his Munich days and which would serve nicely, he thought, to demonstrate the fixity of species. During his shipboard lectures delivered before his assistants on the way to Brazil, he summarized the problem and the proposed method of solving it:

The origin of life is the great question of the day. How did the organic world come to be as it is? It must be our aim to throw some light on this subject on our present journey. How did Brazil come to be inhabited by the animals and plants now living there? Who were its inhabitants in past times? What reason is there to believe that the present condition of things in this country is in any sense derived from the past? The first step in this investigation must be to ascertain the geographical distribution of the present animals and plants.[30]

Martin Heade and the Study of the Organic World

When Agassiz advised his students to look for "the fundamental relations among animals . . . relations to each other and the physical conditions under which they live," he might have given Heade's marvelous pictures of hummingbirds as examples, so closely did the artist's renderings of these tiny birds against the background of their forest habitat fulfill his objectives.[31] Significantly, the two men decided to visit Brazil about the same time: Heade traveled there in 1863–64, and Agassiz went in 1865–66. And both returned to Latin America: Agassiz in 1871, and the artist in 1866 and 1870. Heade's conception of the hummingbird images changed over the course of these journeys. The early small-scale views of birds hovering near the nest (fig. 59) underwent variations in the late 1860s (fig. 60), until he arrived at the combining of birds and orchids, or occasionally passion flowers, after his Jamaican sojourn of 1870 (fig. 61).[32]

The network of connections between Agassiz and Heade regarding Brazil and the hummingbirds is illuminating. Agassiz had helped to complete the publication of Spix and Martius's findings on Brazilian fish; and Heade's hummingbird mania must surely have led him to consult Spix's *Avium species novae, quas in itinere per Brazilian annis 1817–1820*, one of the few books available at the time exclusively devoted to the birds of Brazil.[33] Heade and Agassiz both knew Rev. J. C. Fletcher, who did missionary work in that country and

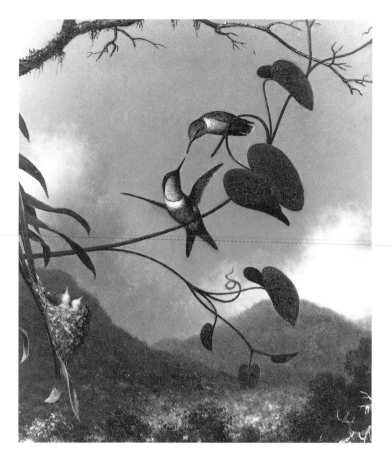

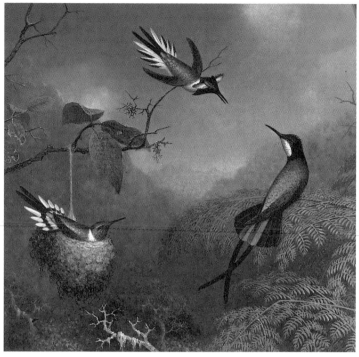

60. *Martin Heade*, Hummingbirds: Two "Sun-Gems" and a "Crimson Topaz," *1866, oil on canvas, 14 × 13 in. (35.6 × 33 cm). Shelburne Museum, Vermont.*

59. *Martin Heade*, Amethyst, *1864–65, oil on canvas, 11³/₄ × 10 in. (29.8 × 25.4 cm). Private collection.*

recorded his observations in *Brazil and the Brazilians* (1857). Fletcher undoubtedly played some role in stimulating Heade's Brazilian interests[34] and made some preliminary acquisitions and inquiries for Agassiz.[35] Agassiz, for his part, apparently had some familiarity with Heade's paintings, as Henry Tuckerman suggested:

> Several fine pictures of tropical scenery have attracted much attention; one in particular, rich with South American vegetation, and singularly true to nature in atmosphere and general effect, was the subject of high encomium on the part of the returned Amazon explorers—Agassiz included.[36]

And to judge from Heade's later statement, they were personally acquainted: "When I was about starting on one of my visits to South America, Prof. Agassiz requested me to procure for him from 50 to 100 eggs of hummingbirds, to be used for scientific purposes." He was unable to fulfill the request, for Agassiz was "apparently ignorant of the fact that one of their nests is seldom found, even in South America where they are most numerous."[37]

Fletcher, Agassiz, and Heade all enjoyed the hospitality of Dom Pedro II, who reigned as emperor of Brazil from 1841 until the country became a republic in 1889. Dom Pedro II hoped that through literary, scientific, and artistic efforts Brazil would become better known to the outside world. Besides welcoming diverse investigators to his country, he also conducted geo-

61. Martin Heade, Cattleya Orchid and Three Brazilian Hummingbirds, *1871, oil on wood, 13³/₄ × 18 in. (34.8 × 45.6 cm). National Gallery of Art, Washington, D.C., gift of the Morris and Gwendolyn Cafritz Foundation.*

graphical researches of his own. In recognition of his efforts he was made an honorary correspondent of the American Geographical Society, an organization that, from its founding in 1852, helped foster geographical knowledge of Latin America.[38] The group, which included the tropical explorers Cyrus Field and Ephraim George Squier, must have been delighted when the emperor appeared at one of its meetings in New York during his tour of the United States in

1876.[39] Bayard Taylor, never at a loss for words, greeted the emperor with a poem and asserted that "no distinguished stranger ever came among us who, at the end of three months, seemed so little of a stranger and so much of a friend to the whole American people as Dom Pedro II of Brazil."[40]

The emperor seemed thrilled with everyone and everything he saw in the United States. He helped open the Centennial Exposition at Philadelphia, took the Transcontinental Railroad to California, and in Boston dined with Henry Wadsworth Longfellow, whose work he had translated into Portuguese, and with his distinguished guests, Emerson, Holmes, and others. By that time his old friend Agassiz was dead, but Elizabeth Agassiz received him warmly and reminisced about their visit to Brazil. Whether he and Heade renewed their acquaintance is uncertain, but the artist could not have been unaware of the emperor's activities, which were extensively covered in the American press. Certainly he must have remembered fondly the emperor's conference upon him of the Order of the Rose, in recognition of Heade's work on the Brazilian humming-birds, for that was one of the few occasions in his long career when he received official honors.[41]

In planning their exploration of Brazil, Heade and Agassiz could have referred to a number of sources. A fairly steady stream of travelers had toured the Andean region from the time of Humboldt's visit in 1799 onward, but excluding the ships of many nations that stopped in the port of Rio de Janeiro, foreign exploration of Brazil did not begin in earnest until the mid-1840s. From the visit of the French geographer Charles Marie de la Condamine in the mid-eighteenth century until the 1840s, Brazil was host to only one major expedition: that of Spix and Martius, from 1817 to 1820. The arrival of Prince Adalbert of Prussia on Brazilian shores in 1842, signaling a surge of renewed interest, preceded a number of expeditions conducted by Germans, British, and North Americans. In 1846 W. H. Edwards left the United States for Brazil, where he made an important early collecting trip up the main river from Pará to Manaus. His *Voyage up the River Amazon, Including a Residence at Pará*, published the following year, informed Agassiz's ascent of the same stretch of river twenty years later; but it had a more immediate impact on Bates and Wallace, who left England for Brazil shortly after reading it in 1848.

Although Bates did not publish his *Naturalist on the River Amazons* until 1863, four years after his return, Wallace made his findings known in several early works such as *Narrative of Travels on the Amazon and Rio Negro* (1853).[42] And Herndon and Gibbon's *Exploration of the Valley of the Amazon* was one of a series of accounts by North Americans published in the 1850s.[43] All of them focused less on the geological than on the botanical and zoological interest of Brazil, serving to promote it as a natural laboratory for the study of plant and animal life.

The collective image of Brazil in these publications was of a region teeming with life. Descriptions of riverways and jungles alike emphasized the luxuriance, the bounty, and the vitality of the species that thrived there. In contrast to the northwestern portion of the continent, which took its character from the Andes Mountains, Brazil was characterized by its flora and fauna. The interest of the region derived not from its inorganic understructure but from the contents of its living, organic world. It is little wonder that after 1859, as artists and naturalists struggled with the question of the origin of species, they cast their glance to Brazil.

Agassiz's Artist, Burkhardt

So Agassiz headed for the Amazon, directing Burkhardt to sketch the hundreds and eventually thousands of fish specimens that were collected. The French-Swiss Burkhardt had worked with Agassiz for most of his professional life; they first met at Neuchâtel and, by a strange set of coincidences, both arrived about 1846 in the United States. There they resumed their old association, and Burkhardt even became a live-in member of Agassiz's Cambridge household. His primary task was to supply the illustrations for Agassiz's lectures and publications. In preparation for volume two of *Contributions to the Natural History of the United States*, for example, Burkhardt drew hundreds of turtles.[44] The original colored drawings, in the collection at Harvard,

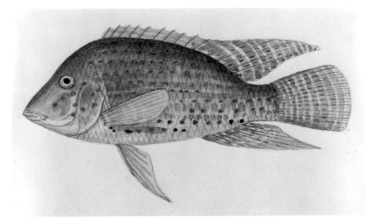

62. *Jacques Burkhardt*, Fish, Belém, *1865–66*, *pencil and watercolor on paper*, *6³⁄₄ × 10 in. (17.1 × 25.4). Collection of Museum of Comparative Zoology, Harvard University, Cambridge, Massachusetts.*

possess a lively quality that recalls the studies of tortoises Albert Eckhout did in Brazil with Prince Maurits in 1637–44, with which he may have been familiar.[45] His expertise in depicting living specimens at the museum and at Agassiz's summer laboratory on the Massachusetts shore at Nahant prepared him well for the intense work of the Thayer Expedition. In Rio de Janeiro, he worked under less than optimum conditions: "Mr. Burkhardt has his little table, where he is making colored drawings of the fish as they are brought in fresh from the fishing boats." In Manaus, at the junction of the Rio Negro and the Amazon, Agassiz recounted, "I had already collected more than three hundred species of fishes, half of which have been painted from life, that is, from the fish swimming in a large glass tank before my artist." Sometimes Burkhardt made "not less than twenty colored sketches of fishes in one day." The specimen drawings (fig. 62) produced under these rudimentary field conditions were left in various states of completion. According to one tally, he "made more than eight hundred paintings of fishes, more or less finished."[46] Unfortunately, illness forced

him to leave Brazil prematurely. He died not long after his return to Cambridge, and he was never able to work up these on-the-spot sketches into finished illustrations of the exquisite detail that characterizes the rest of his oeuvre.[47]

A group of watercolors at the Museum of Comparative Zoology suggests that at least occasionally Burkhardt managed to free himself from the fish to sketch the Brazilian scenery. Most document the coffee plantations, farmhouses, and civic architecture in a straightforward, topographical style. But a few, including *View of the Amazon* (fig. 63), possess a special luminist quality linking them with some of the finest landscape painting of the period. They offer visual corollaries to the written descriptions of the "profound solitude" that reigned on the river, of the "repose and silence" that "peculiarly affect the mind of the man of sensibility."[48] This quiescence is conveyed also in his *Fishing among the Rocks* (fig. 64), a view of the coast at Rio de Janeiro that falls into the luminist canon in composition and mood. A small preparatory outline drawing indicates that as Burkhardt worked from pencil drawing to watercolor he regularized the contours of the prominent shoreline rocks, added a foreground strip of land, and pulled the birds and boat on the water into taut alignment with the tide line.[49] This tightly controlled grid provides a foil to the hazy, almost palpable atmosphere that surrounds the forms, not unlike treatments of the northern coasts by Fitz Hugh Lane or Heade. A photograph of the same place, attributed to the Brazilian Marc Ferrez and dated about 1865, seems to have informed Burkhardt's alterations. The photograph, *Pedra de Itapuca, Flechas Beach, Niterói* (fig. 65), cuts off the rocks that frame the view at right and left and includes a wedge of land in the right foreground in a manner that precisely parallels their appearance in Burkhardt's finished picture. One can imagine the beleaguered draftsman, with only time enough to make a hasty sketch of the coastal scenery on the spot, relying on a locally acquired photograph to put the finishing touches on his watercolor when time permitted.

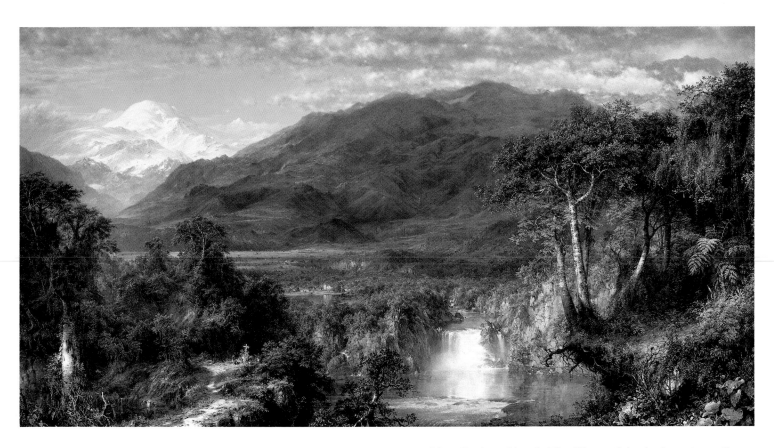

Pl. 1. Frederic Church, The Heart of the Andes, *1859, oil on canvas, 66¹/₈ × 119¹/₄ in. (168 × 302.9 cm). The Metropolitan Museum of Art, New York, bequest of Margaret E. Dows, 1909 (09.95).*

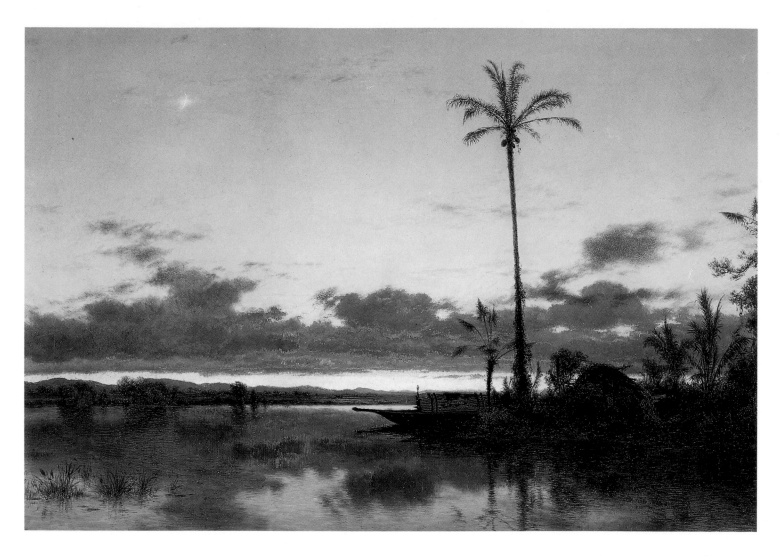

Pl. 2. Louis Mignot, Lagoon of the Guayaquil, *c. 1857–63, oil on canvas, 17 × 25⅛ in. (43.2 × 63.8 cm). Courtesy of Richard York Gallery.*

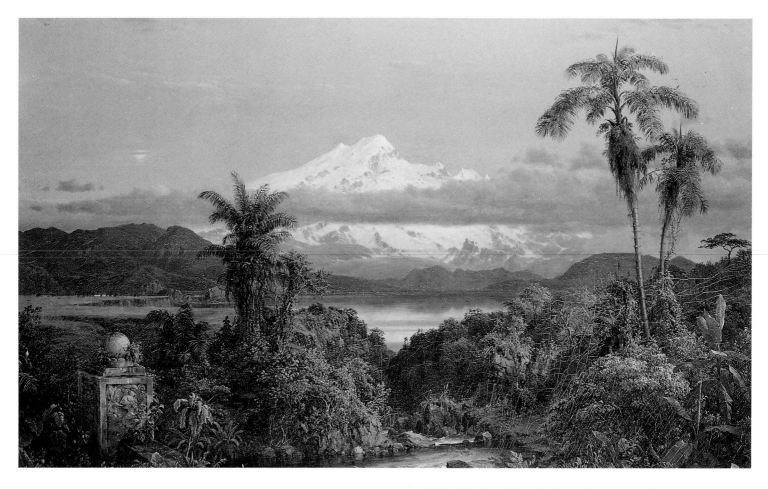

Pl. 3. Frederic Church, Cayambe, *1858, oil on canvas, 30 ×
48 in. (76.2 × 121.9 cm). New York Public Library, Robert
L. Stuart Collection, on permanent loan to the New-York Histor-
ical Society.*

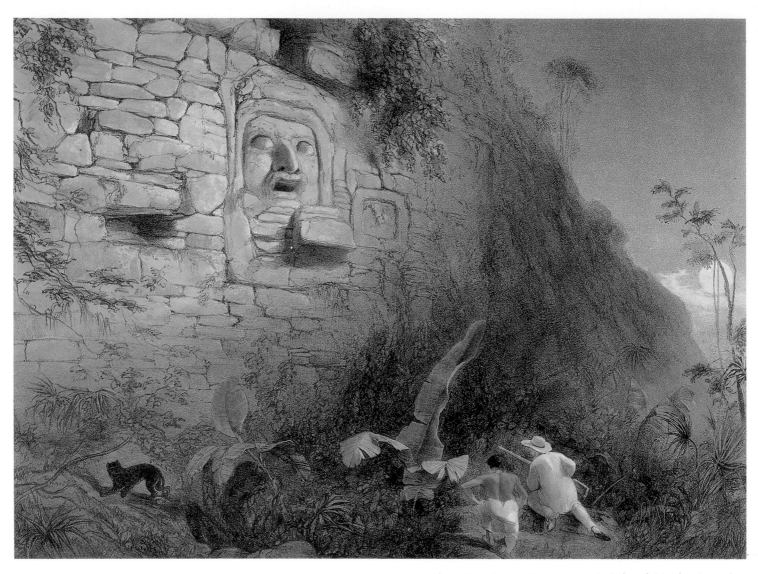

Pl. 4. After Frederick Catherwood, Colossal Head at Izamal, *lithograph by Henry Warren from Catherwood's* Views of Ancient Monuments in Central America, Chiapas, and Yucatán, *pl. 25. Yale University Art Gallery, New Haven, Connecticut.*

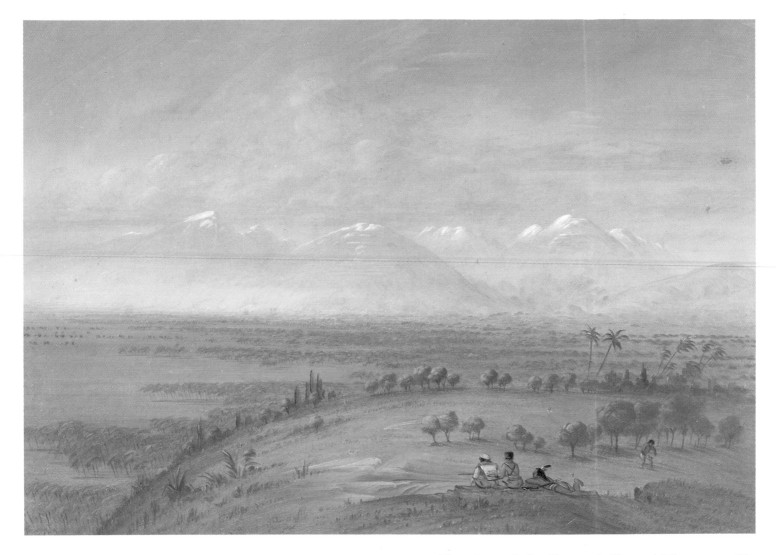

Pl. 5. George Catlin, View on the Pampa del Sacramento: The Author Halting to Make a Sketch, near the Eastern Sierra of the Andes, *1852–57, oil on board, 18 × 24⁵/₈ in (45.7 × 62.5 cm). National Gallery of Art, Washington, D.C. (498).*

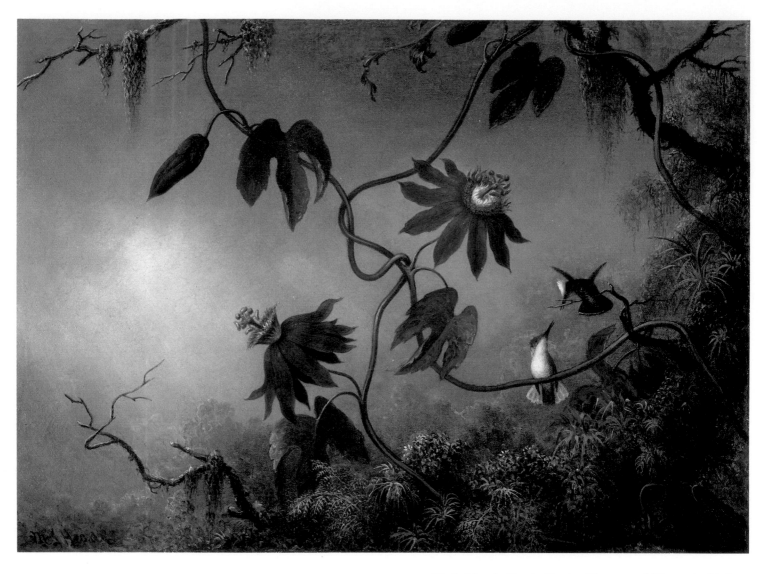

Pl. 6. Martin Heade, Passion Flowers and Hummingbirds, *c. 1875–85, oil on canvas, 15 1/2 × 21 1/2 in. (39.4 × 54.6 cm). Museum of Fine Arts, Boston, M. and M. Karolik Collection.*

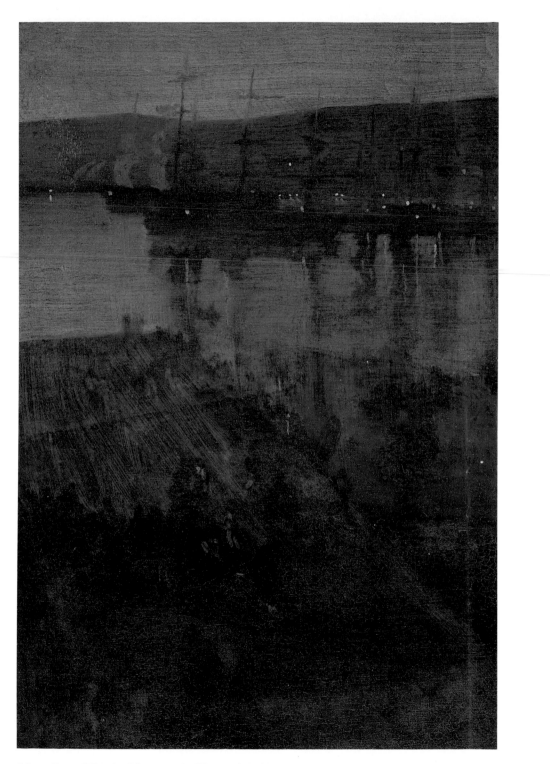

Pl. 7. James Whistler, Nocturne in Blue and Gold: Valparaíso, *1866, oil on canvas,*
29³/₄ × 19³/₄ in. (75.6 × 50.2 cm). Freer Gallery of Art, Smithsonian Institution, Washington, D.C.

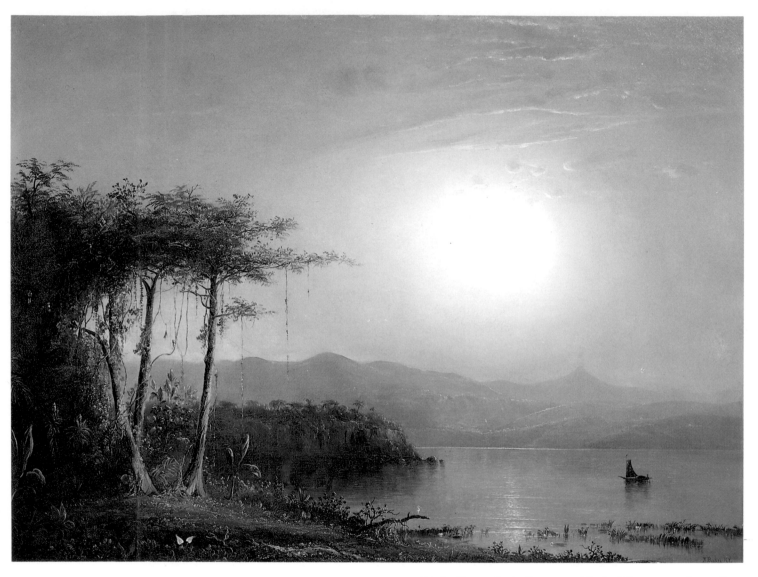

Pl. 8. Norton Bush, Sunset over Lake Nicaragua, *1873, oil on
canvas, 36 × 48 in. (91.4 × 121.9 cm). Private collection.
Photograph courtesy of Cooley Gallery, Old Lyme, Connecticut.*

63. *Jacques Burkhardt*, View of the Amazon, *1865–66, water-color on paper, 6¹/₄ × 9¹/₄ in. (15.9 × 23.5 cm). Collection of Museum of Comparative Zoology, Harvard University, Cambridge, Massachusetts.*

The Role of Photography in Agassiz's Expedition

Agassiz and his team seemed well aware of the potential value of photography for their work and endeavored to obtain prints of the flora, fauna, native peoples, and landscape from a variety of sources. Walter Hunnewell, one of the Harvard student volunteers, had outfitted himself with all the latest equipment and attempted—albeit not always successfully—to document their work. "Mr. Hunnewell is studying at a photographic establishment," Elizabeth Agassiz reported just after their arrival at Rio de Janeiro, "fitting himself to assist Mr. Agassiz in this way when we are beyond the reach of professional artists." The scientific publication that

would have included Hunnewell's images was never realized;[50] but *A Journey in Brazil* does feature a number of woodcuts based on photographs acquired from local commercial firms, suggesting that expedition members had close contact with native professionals. An illustration of a coffee plantation in Minas Gerais was based on a photograph supplied by Sr. Machadeo, whom Agassiz acknowledged "for a valuable series of photographs and stereoscopic views of this region, begun on this excursion and completed during our absence in the North of Brazil."[51] But most of the woodcuts were based on photographs identified as

64. *Jacques Burkhardt,* Fishing among the Rocks, *1865–66, watercolor on paper, 7¹/₂ × 11¹/₄ in. (19 × 28.6 cm). Collection of Museum of Comparative Zoology, Harvard University, Cambridge, Massachusetts.*

the work of "G. Leuzinger," undoubtedly the George Leuzinger who ran an establishment in Rio de Janeiro specializing in photographs of local scenery taken by his staff and sold in albums to foreign visitors. "Leuzinger's admirable photographs of the scenery about the Corcovado, as well as from Petropolis, the Organ Mountains, and the neighborhood of Rio generally, may now be had in the print-shops of Boston and New York. I am the more desirous to make this fact known," Agassiz explained to his readers, "as I am indebted to Mr. Leuzinger for very generous assistance in the illustration of scientific objects."⁵²

Marc Ferrez was among the young photographers apprenticed to Leuzinger, from whom Burkhardt must

have obtained *Pedra de Itapuca*. Ferrez went on to become one of the pioneer practitioners of Brazilian photography, and his impact on Burkhardt's watercolor and other images to come out of the expedition is not insignificant. Much remains to be learned about the development of the native South American landscape tradition in photographs and paintings and about the interactions between South American and visiting North American artists. Burkhardt's *Fishing among the Rocks*, which appeared as an illustration in Charles Frederick Hartt's *Geology and Physical Geography of*

65. *Photograph of Pedra de Itapuca, Flechas Beach, Niterói, Rio de Janeiro, c. 1865, attributed to Marc Ferrez. Private collection.*

Brazil, provides a starting point for the study of such contacts.[53]

Heade's Hummingbirds

Heade, like Burkhardt (whom he may have met during their annual summer wanderings on the north shore of Massachusetts), did landscape views of Rio de Janeiro and the surrounding area (fig. 41). But it is his images of hummingbirds that represent the closest link to the work of Burkhardt and Agassiz's Brazilian expedition. From about 1871 until shortly before his death in 1904, Heade created a series of paintings of hummingbirds and orchids that rank among the most original responses to the Tropics. Until the 1970s they were regarded as the studies of a naturalist or as straightforward still lifes, but recent interpretations have treated them primarily in the context of American flower painting, with the result that important new insights have been gained into their meaning.[54] This imagery represents a synthesis of the orchids that so inspired him on

his visit to Jamaica in 1870 and his observations of hummingbirds in Brazil in 1863–64.

Heade's fascination with hummingbirds is a key to his pictorial consciousness of Latin America. "A few years after my appearance in this breathing world," he wrote, "I was attacked by the all-absorbing hummingbird craze and it has never left me since."[55] As long as he remained in the United States, however, he would have been able to observe only a single indigenous species: the rubythroat. To see most of the family's approximately 320 members one has to travel to equinoctial America, where they make their home. It was not unusual for naturalists and amateurs alike to undertake South American travel with the intention of studying hummingbirds and other native bird populations. Naturalist James Orton reported on the hummingbird during his expedition among the Andes. And William H. Hudson roamed Patagonia and La Plata on birdwatching expeditions, experiences he recorded in *Idle Days in Patagonia* and *The Naturalist in La Plata*.[56] With his decision to travel to Brazil to prepare an illustrated book on hummingbirds, Heade led their ranks.

The idea for such a book could have come from a variety of sources, but Heade probably received encouragement from his friend John Russell Bartlett. Bartlett participated in the Mexican Boundary Survey in 1850 and had a penchant for foreign and rare volumes of science and exploration. His book dealership and publishing firm in New York City, Bartlett and Welford, was a favorite among leading artists, writers, and explorers of the day. There he brought Stephens's attention to the illustrated accounts of Copán by Waldeck, which led him to undertake his own Maya explorations; and he is credited also with sparking Squier's interest in Central America. Bartlett became a patron of Heade's beginning in the late 1850s, when he commissioned a series of portraits of Rhode Island notables, and they continued to be in contact during the mid-1860s, when the artist was working on his hummingbird book. In London in 1865 trying to arrange for its publication, Heade was in touch with Bartlett, and in a letter of

1866 to his Boston dealer, Vose and Co., he mentioned the bookdealer as the agent in a transaction involving the hummingbird lithographs: "When Mr. Miller brings you the Birds, give him an order to get the amt. ($5 a pair) from Mr. Jn. R. Bartlett." One can imagine Heade in Bartlett's bookshop a few years earlier, thumbing through expensive volumes he scarcely would have been able to afford such as William Swainson's *Selection of Birds of Brazil and Mexico* (1841) or John Gould's *Monograph of the "Trochilidae"* and receiving encouragement from the proprietor to produce a book of his own.[57]

Heade unfortunately was never able to complete his proposed volume, *The Gems of Brazil*. Apparently, twenty chromolithograph plates, each depicting an individual species of hummingbird in pairs, were to have been accompanied by the artist's introduction. He completed at least twelve small oil paintings (each approximately twelve by ten inches) while he was still in Brazil, where he exhibited them to an appreciative local audience. He then went to London to arrange for them to be lithographed and somewhere along the way began work on his introduction. A draft of this introductory essay and several chromolithograph impressions have long been known, and several small paintings have been tentatively identified with the project; but the recent rediscovery of sixteen of the twenty original paintings provides a more comprehensive view of *The Gems of Brazil*. The illustrations were intended to record the physical appearance of the birds, especially their extraordinary brilliant and varied plumage. This end Heade achieved admirably, depicting a variety of species in such works as *Snow Cap*, *Stripe-Bellied Star Throat*, and *Amethyst* (fig. 59) against the background of tropical vegetation. The vibrant palette he employed for the plumage of the males is stunning and corresponds to contemporary reports of these jewellike creatures—in this case, as they came to bathe in a small pool:

> The commonest was the *Thalurania venusta* (Gould), the male of which is a most beautiful bird,—the front of the head and shoulders glistening purple, the throat brilliant

light green, shining in particular lights like polished metal, the breast blue, and the back dark green. It was a beautiful sight to see this bird hovering over the pool, turning from side to side by quick jerks of its tail, now showing its throat a gleaming emerald, now its shoulders a glistening amethyst, then darting beneath the water, and rising instantly, throw off a shower of spray from its quivering wings.[58]

But Heade's volume was conceived as something more than a series of discrete pictorial records of individual species of birds; rather, text and images were united by their common emphasis on the hummingbird's life processes.[59]

In each panel the male and female appear together, and in more than half of them they are shown in juxtaposition with the nest. Some images reveal the minute eggs inside, while others show the scrawny heads of the newborn birds peeking out. The artist's special fascination with the nesting behavior of the hummers is reflected in a passage that appears in his introduction, quoted from a book of travel by Lady Emmeline Stuart-Wortley:

> One of these charming feathered jewels had built its delicate nest close to one of the walks of the garden belonging to the house where we were staying. The branches, indeed, of the beautiful shrub on which this fairy nest was suspended almost intruded into the walk, & every time we sauntered by there was much danger of sweeping against this protecting branch with its precious charge, & doing it some injury, as very little would have demolished the exquisite fabric. In the process of time three lovely, pearl like eggs had appeared, & while we were there we had the great pleasure of seeing the minute, living gems themselves appear, looking like two [*sic*] very small bees. The mother bird allowed us to look closely at her nest, & inspect her little nursling when she was flying about near, without appearing in the least degree disconcerted or alarmed.[60]

Heade's images convey the same wonder with the birth and growth of these minute creatures. In this they are aligned with the Brazilian studies of Agassiz, who,

after collecting specimens of mature fish, advised his expedition members, "Our next aim, and with the same object, namely, its bearing upon the question of origin, will be the study of the young, the collecting of eggs and embryos."[61]

Besides the presence of eggs or newborn in the nest, the pairing of the male and female underscores Heade's deep concerns with the bird's reproductive processes. For as the artist himself observed, "The only time when one will tolerate the presence of another is at the mating season, and even then they are seldom seen together except at the nest."[62] Correspondingly, the images focus on variations in the hummer's elaborate mating rituals. Several images, for example, portray the male with his tail feathers fully extended, in an attitude exclusive to courtship, as a contemporary observer described:

> When catching the ephemeridae that play above the water, the tail is not expanded: it is reserved for times of courtship. I have seen the female sitting quietly on a branch, and two males displaying their charms in front of her. One would shoot up like a rocket, then suddenly expanding the snow-white tail like an inverted parachute, slowly descend in front of her, turning around gradually to show off both back and front. The effect was heightened by the wings being invisible from a distance of a few yards, both from their great velocity of movement and from not having the metallic lustre of the rest of the body. The expanded white tail covered more space than all the rest of the bird, and was evidently the grand feature in the performance.[63]

Every aspect of these images demonstrates Heade's preoccupation with the life cycles of the hummingbirds, and therefore with the origin of their species.

Heade's conception of the hummingbirds continued to evolve from this early format to one in which the birds often appeared with orchids growing on vines. In the intervening years he made two return trips to Latin America. Theodore Stebbins, Jr., has demonstrated that the orchids were integrated into these pictures after

his visit to Jamaica in 1870. But to date the artist's Nicaraguan sojourn of 1867 has been omitted from discussions of the hummingbird series. It seems probable, however, that observations of the species made there encouraged him to keep painting hummingbirds after the failure of *The Gems of Brazil*. It was estimated that in central Nicaragua, through which Heade passed, the number of hummingbirds equaled, if it did not greatly exceed, that of all the rest of the birds together. Aside from sheer quantity, Nicaragua possessed some exquisite specimens, the sight of which may have restored the artist's enthusiasm. Canvases such as *Hummingbirds: Two "Sun-Gems" and a "Crimson Topaz"* (fig. 60), dated 1866, and *Hummingbirds near a Volcano* (private collection) may be the product of this trip, intermediate between *Gems of Brazil* (fig. 59) and the mature works of the 1870s.[64]

After 1870 the hummers no longer appear as isolated specimens; rather, they are part of a larger system, interacting not only with one another, but also with their forest habitat. In the work of the 1860s (fig. 59) the birds appear stiff, frozen in a foreground plane that seems hermetically isolated from the forest backdrop. In the later picture (fig. 61), by contrast, the birds appear in the midst of the tropical vegetation and in close proximity to a voluptuous orchid in a manner that immediately suggests a direct association between them. In the same period Darwin's work on orchids, *On the Various Contrivances by Which British and Foreign Orchids Are Fertilized by Insects* (1862), postulated the role that insects and birds play in their pollination, and it is difficult to avoid thinking about Heade's work in these terms. The changes that occurred in his hummingbird pictures over the decade closely parallel the direction of Darwin's researches, which were replacing a static view of nature with a perception of the organic world as a dynamic and interrelated system. Ella Foshay, who first put forth this convincing interpretation, points out that "when Heade selected the subject of the orchid growing in its native environment . . . he was selecting *the* plant specimen Darwin used to demonstrate his evolutionary

view of nature." The artist came to emphasize the hummingbird's role in pollinating the orchid through his pictorial format, in which both principles are presented as vital and active organisms responding to and evolving in nature according to modern scientific thought.[65]

The relationship of these pictures to the biological sciences was appreciated by contemporary observers. "As an accurate and graceful illustrator of natural history, Heade attained a special reputation," Tuckerman wrote; "his delineation of birds and flowers is remarkable for the most faithful drawing and exquisite color."[66] The artist himself was quick to point out, however, that he never assumed for his illustrated hummingbird monograph "the importance of a scientific character." The project, and indeed his lifelong fascination with these mysterious creatures, represents a mix of natural history with more than a dose of popular and romantic thought. He refers to the birds as "Amethyst" or "Ruby Throat" in the layman's manner of identifying them by the male's jewel-colored throat patches and not in formal scientific nomenclature. According to his own statement, he consulted the "works of various Trochiledists [*sic*]," including the authoritative work of John Gould and the texts of Alexander Wilson and John James Audubon. But the drafted essay scarcely mentions the research of these renowned ornithologists (who, as he was quick to point out, had "never set foot on South American soil, the habitat of this large family of birds.")[67] It does, however, quote extensively from the popular and anecdotal accounts by Lady Emmeline Stuart-Wortley and others. Thus his hummingbird pictures also demand examination in an extrascientific context, taking into account the legends and romances surrounding Latin America.

Heade's desire to travel in Central and South America was inextricably linked to his hummingbird mania and through it to his search for a New World cosmogony. His repeated return to the hummingbird theme is as telling of his involvement with the Tropics as Church's fascination with the volcanoes or Catherwood's with the ruins. It was first of all an indigenous

66. Huitzilopochtli (Hummingbird God), *from a Mexican codex. Courtesy of University of Oklahoma Press, Norman.*

American subject, for as the artist noted, this family of birds "is confined exclusively to the New World and its adjacent islands." And in spite of the coaxings of Church and others to paint the spectacular Andean scenery, Heade remained fixated on the hummingbird. It became the primary object of his Latin American quest, and the symbol of the essence of tropical life.

Heade's art finds parallels in the mythology of the ancient Americans, who held the bird and its brilliantly colored plumage sacred. The Aztecs had a hieroglyph for the bird and gave Huitzilopochtli, the hummingbird god (fig. 66), a prominent role in their cosmology. According to their traditional history, it was a stone image of the hummingbird god who spoke to the early tribesmen and directed them to the valley of Mexico, where they eventually established a great empire:

The Mexica . . . paid homage to a tribal deity whom they called Huitzilopochtli, or Southern Hummingbird. We do not know precisely how or when this god was acquired by the wandering Mexica. . . . Brilliant plumage of exotic birds served as symbol and motif of deity everywhere in Mesoamerica—and still does . . . the Tarascans of Michoacán, among whom the Mexica lived for a time, were religiously enamored of a tiny green hummingbird that flourished in the vicinity of Tzintzuntzan, their capital city. The very name Tzintzuntzan is derived from *tzintzuni*, the Tarascan word for hummingbird. . . . Perhaps most significant is the fact that through their entire course of empire the Mexica adorned Huitzilopochtli with green hummingbird crests.[68]

Along with the god of war and the sun and the chief god of Tenochtitlán, Huitzilopochtli became one of the three most powerful and complex gods in the supernatural world of the Aztecs.

Whether or not Heade was aware of these traditions, his selection of the hummingbird as his private symbol of the Tropics likely derived from a fascination with its ability to enter a state of torpor and then revive itself, which prompted one of its Aztec names, *vitzitzili* (or *tzintzuni*), "the reviving one." Because these birds have an extremely rapid metabolic rate, they are in constant need of food, and even brief periods of sleep would be impossible without some means of halting their constant energy demands. So they go into a state of torpidity—a kind of nightly hibernation—in which their metabolic rates drop precipitously, only to be revived from their trance by the warmth of day. Surely there could be no greater confirmation that the continent possessed the secret of life than these tiny birds, who seemed to be awakened from the dead by the rays of the tropical sun. This characteristic of the hummingbird may have appealed to Heade above all others, for it epitomized the creative powers that were so much a part of his absorption with tropical nature. The scant personal writings that have come down to us make little mention of this torpidity. But the Philadelphia ornitho-

logist Wilson had described his observations of a hummingbird that "came back to life" in his hand. It seems unlikely that Heade, who claimed "there is probably very little regarding their habits that I do not know," had not had a similar experience.[69] Every aspect of his pictures—the hovering birds themselves, the profusion of tropical vines, and the overripe orchid blossoms—conveys the vitality he sensed in these unique creatures and in their Brazilian forest habitat. They represent the artist's meditations on the question of the origin of life.

The point of departure for Heade's tropical imagery is distinct from that of his fellow artists. The tallest mountain, the most active volcano, the mightiest river: this repertoire of the old sublime was sought by the artists who traveled in Central and South America before the Civil War. Heade, by contrast, pursued the hummingbird, which numbers in its family the smallest birds on the continent. Taking as his subject these tiny, incessantly moving birds in their forest setting, he crossed the accepted limits of landscape painting. The flora and fauna that are miniaturized in the crowded foregrounds of his contemporaries' pictures (compare, for example, the quetzl birds at the threshold of Church's *Heart of the Andes*) became in Heade's hands the subject of a painting. Microcosm becomes macrocosm. Birds in some cases no bigger than a human thumb (the bee hummingbird, or *Mellisuga helenae*, of Cuba is only $2^1/_4$ inches long) are blown up against their landscape background in a manner as unsettling as the depictions of plant life in the work of Phillip Otto Runge, and equally suggestive of psychological or philosophical disturbance.

There was nothing unusual in Heade's depiction of the bird within a forest setting; natural history draftsmen similarly tried to indicate a creature's natural habitat. But, unlike them, Heade omitted the reference points that would have allowed the viewer to determine scale precisely. Gould, for example, showed the hummingbird larger than actual size, but always against a leaf or some other form that functioned as a measuring gauge. In Heade's work, the hummer can loom as large

as a nearby palm tree. This enlargement offers a key to the expressive potential of these pictures, which should be seen against the northern romantic mode of flower painting in situ, in the tradition of Runge or van Gogh. These parallels become even more evident as Heade's series progressed toward an image in which the birds and flowers were seen in sharp focus against an increasingly atmospheric distance. Near is telescoped into far; the imminent is sharply contrasted with the distant; the abrupt jump from the limited sphere of the hummingbirds and their nest in the foreground to the mountains and waterfall behind creates a visual tension that leaves the viewer feeling vaguely uneasy. The aggrandized birds with their accompanying blossoms hover before the viewer, their ceaselessly beating wings now still. There is a visionary aura about these pictures, reversed in scale and locked in time, that suggests the almost Gothic anxiety the artist felt in the face of the crisis precipitated by Darwin. The pictures he continued to essay on this theme, including a work completed just two years before his death in 1902 (Thyssen-Bornemisza Collection, Lugano), serve as a poignant reminder of his inability to lay the issue to rest.

Resolution to these questions similarly escaped Agassiz. Unable to assess rationally the data of the Thayer Expedition, he never published any quantitative report of his findings and left many of the specimens he sent back from Brazil in their casks (where some of them remained until the 1970s). The sole account of the expedition to appear in print was *A Journey in Brazil*, largely written by his wife, which was "a disappointment to the public in general," according to Agassiz's early biographer, Jules Marcou, "and more especially to the naturalists and personal friends of Agassiz."[70] Perhaps it suffered by comparison with H. W. Bates's brilliant book, *The Naturalist on the Amazons*. Marred by its insistence on special creationism, Agassiz's volume received little attention from professional scientists; and even his good friend Emerson could manage to say only that it was "a very cheerful book to read."[71]

Agassiz's failure to acknowledge Darwinian principles of change and adaptation had resulted in his being dismissed as an anachronism. But while it can hardly be claimed that he approached the question of evolution with a completely open mind, neither can it be said that he closed *The Origin of Species* and put it away on the shelf for good after his initial reading. His efforts as an organizer and promoter of the natural sciences—his primary role during his American years—had left little time for evaluation of the data and specimens he amassed at his museum or for reflection upon new theories. It was partially in an effort to "catch up," then, that he left Boston harbor on 4 December 1871 on board the USS *Hassler* for a year-long oceanographic survey of the South American coast. The *Hassler* expedition had all the outward characteristics of one of Agassiz's typically grand and ambitious adventures. Supported by private subscriptions of twenty thousand dollars, he and his fifty followers traveled on a ship outfitted with the most modern equipment the U.S. Coast Survey could provide, with the intention of dredging the "deepest abysses of the sea" for knowledge of the earth and its inhabitants. For evolutionists and antievolutionists alike turned to the sea for the key to the origin of life. But the expedition was also something of a private crusade. Agassiz had taken Darwin's books as his only reading material, as he explained to his German zoologist friend Karl Gegenbauer, just after a visit to the Galápagos Islands: "I wanted to study the whole Darwin theory free from all external influences and former surroundings. It was on a similar voyage that his present conceptions awakened in Darwin!"[72]

The hopes of the *Hassler* expedition remained largely unfulfilled.[73] Although the ship completed its intended continental circumnavigation, the exploration was greatly hampered by insufficient planning, inadequate leadership, and faulty technology. Constant failures of the engines and the dredging equipment thwarted Agassiz's dream to plumb the depths of the sea for the secret of life. Perhaps he was similarly unsuited

to the task he had set for himself, for as he confided to Gegenbauer, "I no longer leap in with the fiery enthusiasm I would have some thirty years ago, but I examine step by step, and I must admit that up to now I have not made great progress in my conversion to the growing doctrine [of evolution]."[74] The lack of tangible oceanographic results from the expedition probably added to Agassiz's determination to make a summary appraisal of organic evolution. To this end he planned a series of articles for the *Atlantic Monthly*, the first—and as it turned out, the last—of which appeared in January 1874, one month after Agassiz's death.

In this article he attempted to review *The Origin of Species* as well as the works that followed it: *The Variation of Animals and Plants under Domestication*, *The Descent of Man*, and *The Expression of Emotions in Man and Animals*. The conclusions he reached differed little from his pronouncements of a decade earlier: "The world has arisen in some way or other. How it originated is the great question, and Darwin's theory, like all other attempts to explain the origin of life, is thus far merely conjectural. I believe he has not even made the best conjecture possible in the present state of our knowledge."[75] One cannot help wondering, however, if his public and private voices were at odds here. In these final years, a public expression of doubt, renouncing the earlier stance that had won him such popularity in America, was perhaps no longer possible. But his undertaking of a major oceanographic expedition when suffering from physical and emotional fatigue and the mental voyage he made through the evolutionary theories, evident from marginal notes made in his copies of Darwin's texts, indicate his desire to face the challenge squarely—and on the same South American ground.

*R*omanticism and the
*E*xotic *S*outh

Louis Mignot and the Romance
of the Tropics

Know'st thou the land where the citron grows,
Where midst its dark foliage the golden orange glows?
Thither, thither let us go.

GOETHE

*T*he infinite variety of South America was equaled only by the diverse eyes and minds that saw and portrayed it. The dominant tendency around mid-century had been to view it through scientific lenses.[1] Tropical nature had another appeal, however, as travel writer John Esaias Warren pointed out: "If you are a *naturalist,* your reveries will be of birds and plants and flowers, of strange animals and curious shells; if a *poet,* your soul will expand with delight in contemplation of the beauties of nature around you . . . where all is poetry, and beauty, and love."[2]

For other artists, the painter-poets, the Tropics were a land of dreams; their paintings gave poetic expression to the charms and tempers of the landscape. Louis Mignot is a paradigm of the painter-poet. "The best of his works combine in an unusual degree a feeling for the poetic aspect of landscape with a conscientious effort after truthfulness of representation; a

combination not very common," one British commentator noted.[3] Among the works he probably had in mind was *Lagoon of the Guayaquil* (pl. 2). It is the antithesis of Church's scientific, full-length landscapes, typified by *Heart of the Andes* (pl. 1) in subject and painterly treatment as well as intent.

The two works depict widely different types of landscapes. While Church was drawn to the mountain peaks of the high Andes, Mignot preferred the flat marshes along the Guayas River, down near sea level. Mignot, to be sure, essayed some fine Andean subjects (fig. 40). But as a contemporary reviewer pointed out, the scenery in which he "especially delighted" was that of "the still lagoons, embosomed in rich tropical vegetation" on the coast of the Gulf of Guayaquil and represented by pictures such as *Dolce Farniente, on the Guayaquil, Moonlight in Ecuador,* and *Sunrise in Ecuador,* as well as *Lagoon of the Guayaquil.*[4] This choice of scenery provided little in terms of structural composition.

While most of the upper half of Church's canvas was occupied by the massive mountain forms, the lagoon dictated a low horizon and wide, empty expanses. Within these minimal landscape contours, the interaction of light and shadow, color and atmosphere, became the focus. *Lagoon of the Guayaquil* plays on the moment of twilight, when still water reflects both earth and sky, merging them into one indistinguishable whole. In the dimming light shapes are vague, mysterious, and we strain to make them out. Our glance is directed along the horizon line to a jetty of earth to the right of center, where objects gradually become recognizable: a champan on the water, a rude hut amidst the vegetation, the trunk of a palm tree. Almost involuntarily the eye is drawn up the length of the tree to the crown, where it is arrested by the poignancy of the evening sky. The image conveys primarily a mood of romantic melancholy, and only secondarily any notion of Ecuador's topography or natural history.

Church's reporting of the geological and botanical facts signals his efforts to take possession of the landscape by the sheer act of accumulating its knowledge. He strove to inform his audiences, who looked at his paintings in just these terms; teachers conducted geography lessons before them. Mignot's pictures would not lend themselves to such a public purpose. For him, no intimate acquaintance with the scientific details of the landscapes was necessary or even desirable. He regarded its mysteries, left undisturbed, as pleasures in themselves; he sought not to instruct but to excite the imagination and lead to reverie. Here, as in all Mignot's finest work, he achieved a synthesis of fact and feeling that meets these ends and adds another dimension to the nineteenth century's pictorial conception of Latin America.

Wanderers and Explorers

The words *travel, adventure, exploration, discovery, journeying,* and *wandering* are often employed casually as synonyms to describe the movement of individuals from one place to another less well known. For our purposes, however, they signal discrete enterprises with vastly different implications. Although the artist-travelers covered in this study shared a common destination, Latin America, important distinctions can be made between them. Mignot and other artist-poets engaged in a particular kind of travel that entitles us to describe them as *wanderers*. Their endeavors differ markedly from those of the artists who have occupied our attention up to now, including Peale, Smith, Catherwood, Catlin, and Church, who are more properly categorized as *explorers*.

Not surprisingly, Church offers the best foil to Mignot and the others, for he was the exemplar of the explorer. He systematically surveyed Latin America, the frozen North, and the Near East throughout his active years. On each of these undertakings he planned his scientifically informed reconnaissance, executed it more or less on schedule, and returned home, his mission fulfilled, to compose his finished paintings. Although he explored more unusual and varied countries than most of his contemporaries, he always returned to the same home base. That fact, I believe, is critical to his character as an explorer. Even as a young man Church had a clear sense of his own identity, related to the strong ties he always maintained with his family and to the bonds they had forged with the country their ancestors had helped to settle. Unlike Mignot, Heade, or Whistler, Church did not roam the globe in search of some spot where he might feel at home. Rather, he surveyed the far reaches of the earth as one entirely certain of his place on it. The artist-wanderer's travels, on the other hand, were dictated by his sense of himself. This mode of travel affected the way he viewed distant landscapes and the degree to which the artistic self was projected onto those landscapes.

Mignot's expedition to Ecuador was one episode in a life of wandering. As a young man he left his native Charleston, South Carolina, to pursue artistic studies at the Hague. In 1855, his training complete, he returned to the United States and settled not in his familial sur-

roundings, but in New York, where he won almost immediate acceptance among fellow artists and patrons alike. He appeared, in short, to have found a home for himself in the city. This respite from his travels was interrupted by the outbreak of the Civil War in 1861. His Confederate sympathies seem to have made it impossible for him to remain in the North; yet he could no longer return to the South. Like many other displaced southerners, Mignot fled to Britain and took up residence in London, where his art again received favorable notice. But the old wanderlust did not abate; he continued to move about, to France and Switzerland, and to plan his long-awaited trip to India and the Himalayas. That trip never materialized, for he died at the age of thirty-nine, his lifelong wandering at an end.[5]

Whistler was also a wanderer. Like Mignot, he lived most of his life an expatriate. Born in Massachusetts, he was taken at the age of nine to Russia, where he received his early training in art. From there he moved to England and then on to the United States to attend the U.S. Military Academy at West Point. But the life of the military and his native country proved uncongenial to him, and he left its shores, never to return. Arriving back in London, he visited France, Holland, and the Mediterranean before he departed for Chile in 1866. Within a year he returned to London, which he made his residence until his death, but he continued to seek refuge elsewhere, especially in Italy, until he was no longer physically able to do so. He felt himself an outsider, as his biographers consistently point out—an American who could not give up his citizenship but who found it equally impossible to return to his homeland.[6]

Heade does not fall clearly into one category or the other, and for this reason, perhaps, is especially intriguing. On the one hand, he led a peripatetic life. He moved about so frequently that it is difficult to pinpoint his exact whereabouts at any given moment from 1850 through 1870, during which time he made his three trips to Latin America. "He had seen and experienced

much in these restless, productive years, at home and in foreign lands," observed his biographer, Robert McIntyre. "Never staying long in any one place, he had covered thousands upon thousands of miles in his nervous, almost ceaseless wanderings."[7] Yet unlike Mignot and Whistler, he was never driven to abandon his native country permanently for the life of an expatriate, and in his later years, he did seem to find contentment. More importantly, perhaps, his fascination with his beloved hummingbirds gave him a sense of purpose.

The disengaged lives of the wanderers, their feelings of rootlessness and alienation, impelled them on their travels with a tremendous sense of personal urgency. This sense of longing saturates romanticism and identifies them with it. Many explicit formulas express it, such as Friedrich von Schlegel's "Sehnsucht nach dem Unendlichen" ("longing for the infinite") and Friedrich Schleiermacher's "Gefühl einer unbefriedigten Sehnsucht" ("feeling of an unsatisfied longing"). And there are many symbols for that which is longed for: Peter Brown's "country that is always distant" and Goethe's "Land wo die Zitronen blühn" ("the land where the citron grows").[8] This land could be removed in time, as with the romantic preoccupation with the medieval; or it could be removed in space, as with their fascination with the East. And finally, it could be removed in reality: a dreamland, approached through a journey of the imagination. In the 1850s and 1860s several American artists at least momentarily came to feel that the land where the lemon trees bloom was somehow congruent with their conceptions of South America, and they set sail in its pursuit. Although it is perhaps a foregone conclusion that their quest remained unsatisfied, the paintings they produced are important manifestations of this alternative vision of the Tropics. Contact with tropical nature stimulated them to gaze inward as well as outward—to convert the canvas from a window onto the tropical world to a mirror that superimposed their own inner sensations on the reflection of that world. Out of this introspection they created not landscapes of facts, but landscapes of mood or of con-

sciousness. The painter-poet searched beyond the data of geological, archaeological, or botanical origins to find that primordial state at the inception of time when he was one with the cosmos. These less usual but no less significant instances, when the tropical landscapes became the point of departure for the North American painter to delve into the inner realm of thoughts and emotions, are the concern of this chapter. Running parallel to and at times merging with scientifically informed interests, this more subjective involvement with the southern continent gave rise to the romance of the Tropics.

Romanticism and Romance

To invoke the word *romantic* in attempting to characterize this alternate response is to employ one of the most overworked terms in the study of nineteenth-century arts and letters. It is therefore important to clarify its application to these Latin American landscape images. Romanticism, in the main, signifies a search for spirit, feeling, and symbol behind the objective data of the material realm. It departs from the rational analysis of the world associated with the Enlightenment and aims to penetrate beneath the surface appearances of nature to achieve a more subjective interpretation. The use of this label to describe the endeavors of American artists demands further qualifications, for this mode of thought never enjoyed the support and the vogue of a movement on these shores, as it did in Europe. For American painters, complete departure from the external world was rarely possible. Few among them were willing, or able, to create images derived from imagination, untempered by direct confrontation with reality. In any case there was little public sympathy forthcoming for fanciful pictures in a country where the national psyche placed so much importance on utility and on the moral value of knowledge. Since the American painter only rarely was able to transcend this sacred regard for fact, the occasional emergence of this romantic impulse

in the tropical landscape imagery is all the more significant. It suggests that artists at least occasionally found in those faraway and exotic locales the impetus to imaginative contemplation and reverie rarely possible elsewhere. It suggests, in other words, that the place itself elicited a romantic response from the painter: an idea that finds support in the work of contemporary American writers or, as they called themselves, "romancers."

"I have long thought," Herman Melville wrote to his editor John Murray in 1848, "that Polynisia [*sic*] furnished a great deal of rich poetical material that has never been employed hitherto in works of fancy." Thus, his decision "to out with [i.e., reveal] the Romance" in his novel *Mardi*.[9] By ascribing the romantic attributes of the subjective imagination to reality itself, he was in essence bridging the gap between fact and fiction. When Rev. J. C. Fletcher stated that "a charm of romance invests everything connected with South America," he similarly implied that the place itself inherently possessed this quality. By the very act of choosing such a subject, the artist, whether writer or painter, was assured of creating a work imbued with romance. This apparent reconciliation of reality and fancy would best be achieved in connection with a subject removed from the nineteenth-century American parlor, both in time and place; hence Melville's selection of the South Seas as the setting for his novels and the American painter's fascination with Latin America. The result was not romantic in the sense of being derived primarily from the imagination; rather, it took as its point of departure a place or motif whose reality was by definition poetic or romantic. Attempting to express essentially the same thing, Nathaniel Hawthorne called it "a *neutral territory*, somewhere between the real world and fairy-land, where the Actual and the Imaginary may meet, and each imbue itself with the nature of the other."[10] This notion of the romance, a hybrid offspring of realism and romanticism, offers a useful construct in which to view Latin American landscape imagery.

Mignot's romance of the Tropics was born of his trip to Ecuador with Church in the summer of 1857.

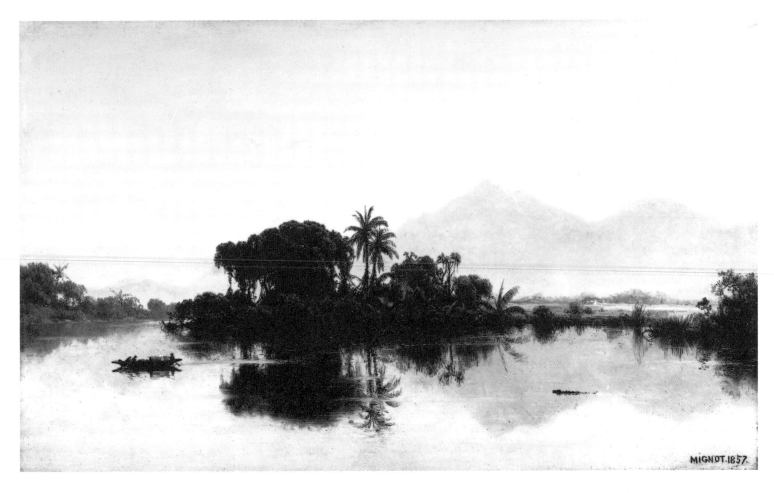

67. *Louis Mignot*, On the Orinoco, Venezuela, *1857*, *oil on canvas. Private collection.*

They set sail from New York bound for Aspinwall (present-day Colón), on the Atlantic coast of Panama. They crossed the Isthmus, most likely by way of the newly constructed Panama Railroad, and caught a steamer at Panama City that landed them in Guayaquil on 23 May. It can be assumed that they began exploring the area immediately; although no sketches made by Mignot during the trip are known, Church recorded the city's typical colonnaded buildings on the day of their arrival. They spent several days in the vicinity before boarding a river craft that took them some distance upstream. Church made pencil sketches of a papaya tree, floating gardens, houses on stilts, and

plantain-laden champans from observations they both made from the boat. By the end of the month they were progressing toward the mountainous interior. Church's drawing inscribed "Guayaquil River May 29, 1857" was one of the last he did on the river.[11] A canvas by Mignot (fig. 67) may have been inspired by this leg of the journey, while they were still traveling upriver, with the Andean highlands coming more clearly into view. By 2 June they were well into the mountainous interior; then they proceeded to Quito, which became their base of operations over the next two months until they

138

descended to the coast and caught a final glimpse of the lagoons before heading home.

This brief rehearsal of their itinerary reminds us that they both were exposed to the entire range of scenery Ecuador and Panama had to offer; but while Church's scientific interests led him to the highest mountain and the most active volcano, Mignot had a romantic fascination with nature's strangest and most unusual aspects. He sought the mysterious lagoons and the transitory moments of light and atmosphere, which lent an otherworldly effect to his scenes. His images, like Church's, derive from direct confrontation with the landscape; but through the *selection* of place, moment of day, and painterly stroke he imparts the quality of dreamlike romance to places perceived in reality. From early on he had what one critic called this "great fancy for Nature's exceptional aspects";[12] he created images that were peculiar, personal. In this way the artist calls attention to himself and invites the viewer to explore the image as a reflection of the mind of its creator.

In the criticism of their own day, such direct analogies between Church and Mignot were rarely made, although the work of Bush, Heade, and other South American artist-travelers was almost invariably measured against Church's standard. Mignot's style and approach were so distinct that they seemed to render the search for direct correspondences pointless. He was regarded as being engaged in a completely disparate enterprise, directed by different philosophical and artistic influences.

Mignot's oeuvre lay outside the "official iconography" of South American landscape painting outlined by Humboldt: one that emphasized sublime subjects rendered in closely observed detail. Generally enthusiastic about all things tropical, the great explorer found the coastal lowland far less inspiring than the Andean peaks; he virtually ignored Guayaquil but for a single plate in his *Picturesque Atlas*, which illustrates a river raft overflowing with local produce. Given this gap in the Humboldtian worldview, what sources were drawn upon in forging the romance of the Tropics?

Southern Ties to the Tropics

Mignot's southern origins nourished his attraction to and romantic vision of the Tropics. His South Carolina heritage was interpreted by Tuckerman as the key to his artistic persona, just as he had claimed that Church exhibited the New England mind pictorially developed. Mignot was "southern . . . in color and subject" as well as in "sympathy." The South had politico-economic bonds with Latin America distinct from those of the North, which, as we have seen, gave rise to a belief in its own unique Manifest Destiny there. More significantly, a romantic legacy can be linked to Mignot's years in the South, where artists and intellectuals generally felt estranged from their own society. Most of the important literary figures of the 1840s and 1850s, including William Gilmore Simms, James Henry Hammond, Edmund Ruffin, Nathaniel Beverly Tucker, and George Frederick Holmes, expressed their sense of isolation within a culture that put little premium on their creative endeavors. These circumstances led them to cultivate, and perhaps overemphasize, the parallels between the experiences of a Byron or a Shelley and their own lives and thought. Their writings are rife with expressions of exaggerated sentiment on the importance of self, loneliness, and exile. They adopted unconditionally the stereotype of the romantic artist, which seemed to explicate their dilemma at the same time it inflamed it.[13]

Immersed in this cultural milieu, Mignot too sought inspiration and solace in the writings of European romantics. His acquaintance particularly with British sources is indicated by the titles of his paintings (the canvases themselves remain, to date, unlocated). Tennyson's *Enoch Arden*, for example, provided the theme for two works, *A Ship-Wrecked Sailor Waiting for a Sail* and *The Glories of the Broad Belt of the World*, which was accompanied by the lines,

> All these he saw; but what he fain had seen
> He could not see—the kindly human face
> Nor ever heard a kindly voice.

Keats's poem inspired a picture called *St. Agnes Eve;* Gray's "Elegy Written in a Country Churchyard," a work entitled *Incense-Breathing Morn;* and Coleridge's "Rime of the Ancient Mariner," one called *A Painted Ship upon a Painted Ocean.* Perhaps most significant of all, given our interest in Mignot's travels, is the inspiration he took from Byron's *Childe Harold* for a watercolor entitled *Childe Harold's Pilgrimage.*[14] His reference to that poem reminds us that the painter differed from his southern literary colleagues in one significant respect: while they remained in the South, deeply embittered by their lack of appreciation, Mignot—like Byron and his fictional hero—embarked upon a life of travel in search of the object of his romantic longings.

Viewed in this light, Whistler's ties to the South might similarly have some bearing here. He identified, throughout his life, with his mother and her Virginia origins: he dropped his own middle name, Abbott, in favor of his mother's family name, McNeill. During the Civil War he sympathized strongly with the Confederates, as did his beloved brother, who served as a surgeon in the Southern army. And during the war, just before his departure, he associated with a group of southerners who had sought refuge in London. Rejecting the Yankee heritage of his birthplace, he instinctively aligned himself with a tradition that was its polar opposite. This background of southern romanticism was not incidental in his relationship to and vision of South America.

Mignot's ability as "the efficient delineator of tropical atmosphere and vegetation" was also interpreted as the direct outgrowth of this background, for the southerner who traveled to the Tropics felt those ties even more strongly.[15] Everywhere, signs of the plantation system, the slave economy, and strong European ties approximated those in his homeland. Even more important for the landscapist, close climatic and topographical similarities provided the basis of familiarity necessary to paint a new subject. The American South with "her broad savannas, calm in the shadow of the palmetto and the magnolia . . . and her mystical lagunes [*sic*]" provided the visual analogue to the lagoons of Guayaquil,

which Mignot subsequently found so captivating.[16] His upbringing along the semitropical swamps of the Carolinas, which he rendered in an early picture, *Santee River* (Gibbes Art Gallery, Charleston), acted as a conditioning—or at least a symptomatic—factor in his subsequent attraction to the tropical lowlands. His lifelong acquaintance with bayou scenery enabled him to approach the Ecuadorian lowlands as familiar territory. Church, less accustomed to it, was unable to assimilate its forms as readily into his pictorial language. He confided to his diary in Guayaquil, "I am sure that if I could spend a month here I should become accustomed to the climate and like it exceedingly."[17] But for the New England artist, his stay was too short to develop the kind of familiarity needed for picture-making; consequently, he seems not to have produced even a single finished painting of the region. Mignot, by contrast, produced numerous renderings of the open marshes along the Guayas and its hot, vaporous atmosphere—his ability to do so dependent, in part, on the affinity he sensed between it and the landscape of his youth. His predilections were also encouraged by the five years he lived and studied at the Hague. Unlike Rotterdam and Amsterdam, which were fast becoming urbanized centers of trade and industry, the Hague retained its semirural character well into the nineteenth century. Sketching among its quiet meadows and waterways, Mignot would have fortified his innate preference for marshy lowlands. His early years in this environment, where he was immersed in the bold horizontality of the polder landscape and surrounded by centuries of pictorial renderings of it, guided him in his conception of the South American landscape.[18]

Artistic life at the Hague differed substantially from that of other European centers. Its academy offered instruction only in draftmanship, mainly from plaster casts; students had to apprentice in the studios of individual masters. Mignot was fortunate in having been placed in the studio of Andreas Schelfhout, whose landscapes demonstrate a mastery over the broad horizontal spaces and luminous atmosphere of Holland,

which he seems to have imparted to his eager American pupil.

Another important component of artistic life in the Netherlands was access to the old masters. Mignot would have concurred with his fellow student Eastman Johnson that he derived "much advantage from studying the splendid works of Rembrandt and a few other of the old Dutch masters," which were "only to be seen in Holland."[19] Pursuit of the old masters undoubtedly led Mignot to the Royal Picture Gallery, or Mauritshuis, at the Hague, where the objects and paintings collected by Prince Maurits during his governorship in Brazil from 1638 to 1642 were housed. For his expedition Prince Maurits assembled a team of explorers, including men trained in natural history and two painters, Albert Eckhout and Frans Post. Their pictorial record of the lands and peoples of Brazil's *nordeste* constituted the most extensive of its kind before the voyages of Captain Cook. It is tempting to speculate that Mignot found inspiration in Post's landscapes (fig. 68), which Humboldt singled out as the "earliest attempt" to "reproduce the individual character of the torrid zone, as impressed upon the artist's mind by actual observation."[20] Certainly there are correspondences between their mutual interest in the coastal lowlands and their conception of the Tropics as a benign realm with happy natives and occasional rustic colonial buildings. In addition, the objects displayed in the museum and the reputation of Prince Maurits in the city where Mignot lived for five years must have helped foster the artist's own taste for the exotic. There was no complete published account of the Dutch enterprise in Brazil to which he could have referred; his interest may have been sufficiently piqued, however, that he would have sought out illustrated volumes of *Picturesque Voyage*, then enjoying popularity in Holland and throughout Europe.

The Picturesque Tour

Motivated by the sheer delight he experienced in viewing the landscape—by the enjoyment, in other words, of picturesque scenery—Mignot participated in the tradition of picturesque travel. Nineteenth-century audiences, in fact, referred to his work in these terms. When a London critic described him as "one of the most enterprising of travellers, his enthusiasm for art as well as his innate spirit of adventure alluring him to the most remote regions in search of the picturesque and the beautiful," he indicated his belief that Mignot was in some way linked to this tradition.[21] But the simultaneous references to adventure and remote places, the beautiful and the picturesque, suggest that by this time the ambitions of exploratory science had impinged sufficiently upon the practices of picturesque travel to blur the old distinctions.

The term *picturesque* itself had been altered over the course of a century. Toward the end of the eighteenth century the picturesque standards by which natural scenery was increasingly being judged were given theoretical justification. The earliest and most conventional formula was put forth by William Gilpin, who defined the picturesque as "that kind of beauty which would look well in a picture." Accordingly, he sought landscape views that resembled the canvases of Claude Lorrain and Salvator Rosa and named them "picturesque beauty" and "picturesque sublimity," respectively. By 1794 Uvedale Price proclaimed the picturesque an aesthetic category distinct from both the sublime and beautiful, distinguished by roughness, sudden variation, and irregularity. For him the "picturesqueness" of the view was an intrinsic property of its individual objects. On this point particularly Richard Payne Knight took exception to Price's definition. Knight too interpreted the picturesque as a system of viewing nature; but as a romantic he believed that the ultimate appeal of the picturesque was rooted in the beholder's innate modes of perception and not in the objects themselves.

In none of these definitions, it should be noted, is unusual, exotic, or tropical detail mentioned as an aspect of picturesque beauty. Yet, the architecture, scenery, and peoples of distant lands, which by any definition fell outside this aesthetic category, were increasingly called

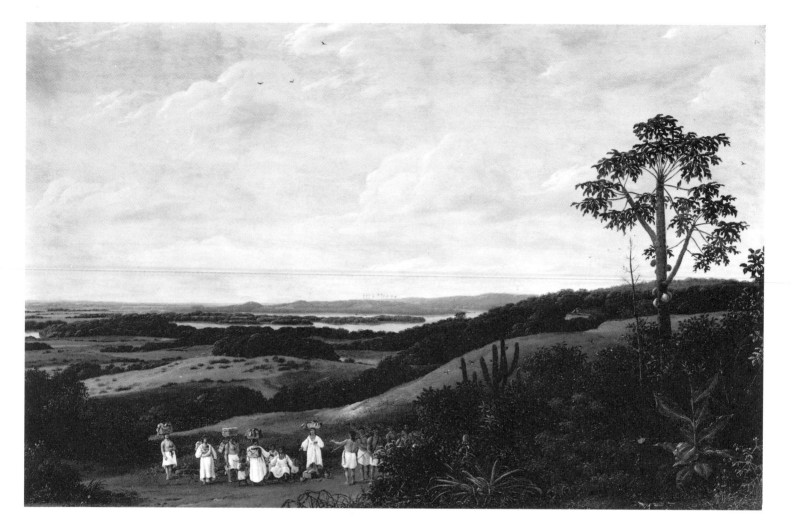

68. *Frans Post*, A Brazilian Landscape, *c. 1660, oil on wood, 24 × 36 in. (61 × 91 4 cm). The Metropolitan Museum of Art, New York, purchase, Rogers Fund, gift of Edna H. Sachs, and other gifts and bequests, by exchange, supplemented by museum purchase funds (1981 .318).*

"picturesque." Exotic elements frequently possessed roughness, sudden variation, and irregularity; but in fact the term was insistently applied to things not intrinsically picturesque according to Price's definition. Beginning in 1827 Johann Moritz Rugendas published his *Voyage pittoresque dans le Brésil,* thus employing the term to encompass one hundred of his Brazilian views with little regard for whether or not they technically fell under that rubric. And similarly Jean Baptiste Debret entitled his work *Voyage pittoresque et historique du Brésil,*

in clear disregard of the fact that Gilpin, Price, and Knight would have found many of the scenes decidedly unpicturesque. In part, they employed the term for the respectability and tradition it lent to their publishing enterprises. More important for our discussion, the limits of the term expanded to accommodate the growing fascination with the exotic.[22]

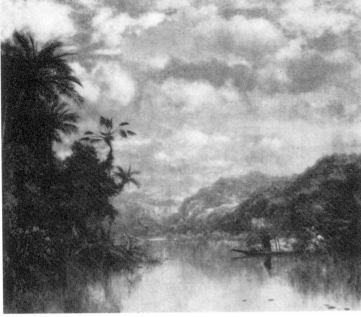

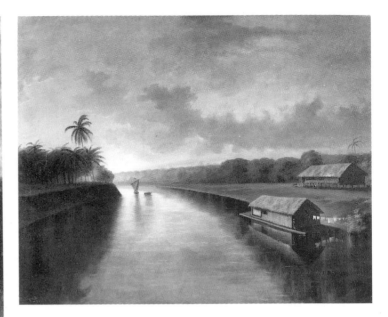

70. *Louis Mignot,* Sunset on the Orinoco, *1861, oil on canvas, 36 × 46 in. (91.4 × 116.8 cm). Collection of the Newark Museum, New Jersey.*

69. *Louis Mignot,* Gathering Plantains on the Guayaquil, *1866, oil on canvas, 21 × 24 in. (53.3 × 61 cm). Location unknown; photograph from the Old Print Shop, New York.*

A number of pictures by Mignot featured the daily activities of people and their relation to the bountiful nature that surrounded them. *Gathering Plantains on the Guayaquil* (fig. 69) of 1866 depicts a group of men picking the fruit to take downriver to market.[23] This was an important aspect of regional life, for the plantain provided the poorer classes with their principal source of food, which they transported up and down the Guayas in primitive river craft. "It is picturesque to see them come with the tide paddled by one or two half-naked mulattoes," U.S. Minister to Ecuador Friedrich Hassaurek had noted, "and generally so well filled that the plantain branches overhang the sides and are dragged along in the waters issuing, as it were, from the very horn of plenty."[24] Focusing on a single champan, Mignot conveyed this picturesqueness against a richly colored sky and a tangle of tropical vegetation. The pic-

ture represents a tropical harvest: nature is so fecund that the natives have no need to plow or sow, but only to pluck from the trees what she so generously provides.

The general public particularly savored such tantalizing glimpses into the existence of these remote peoples. Beneath the palm tree in *Lagoon of the Guayaquil* is the rounded form of a crude mud and straw hut. And *Sunset on the Orinoco* (fig. 70) features a broad expanse of river with several characteristic habitations: a houseboat on the water, complete with the laundry hanging out to dry, and a second building raised on stilts just at the crest of the river bank.[25] Many of Mignot's fellow landscapists frequently repeated the same arrangement of buildings from picture to picture, but Mignot uses such a variety of motifs and individualizes them to such a degree that he earns another reading. His handling of details constitutes a form of romantic primitivism. Critics frequently noted such enhancement, as in the case of a work shown at the National Academy of

71. *Louis Mignot*, Street View in Guayaquil, Ecuador, *1859*, *oil on canvas, 24 × 35 in. (61 × 88.9 cm). New York Public Library, Robert L. Stuart Collection, on permanent loan to the New-York Historical Society.*

Design in 1860 entitled *Lamona* (unlocated), which "shows an inclosure bounded by trees, with pools of water, rank with floral vegetation under a gorgeous sunset effect, its interest heightened by a glimpse of South American life within a tenement peculiar to that country."[26]

The flavor of the bustling port also interested Mignot. *Street View in Guayaquil, Ecuador* (fig. 71) provides an accurate portrayal of its colonnaded wooden architecture, so distinctive from the blocky stone edifices of the highland cities Quito and Riobamba (see fig. 74). Again, Hassaurek was taken by the same features that caught Mignot's attention: "The total absence

of brick and stone buildings is striking," he wrote. 'The houses are two or three stories high, and built in the southern style, with porches or balconies protruding over the sidewalks and resting on wooden pillars, thus forming piazzas, which afford protection against sun and rain."[27] Nor was the architectural interest lost on Church, who made several detailed pencil drawings of these same streets.[28] Church did not find such a scene appropriate subject matter for a full-scale painting, but Mignot was open to the picturesque potential of street scenes (perhaps, in part, because the "southern style" of

the architecture was congenial to him). He was attentive also to the variety of people to be seen in Guayaquil. The padre in his clerical garb strolls along, one woman washes her clothes in the stream, and another carries a heavy parcel strapped to her back in a manner that recalls Debret's scenes of bustling street life.[29]

While Mignot might have been one of the few North American artists attracted to Guayaquil, a fair number of his compatriots (even those ostensibly on scientific expeditions) found themselves captivated by the picturesque potential of other locales, especially the harbor at Rio de Janeiro. "The day one first enters this magnificent harbor may well be regarded as an epoch in his life," one traveler claimed, "for it is without question the finest in the world."[30] And while artist-explorers such as Catlin might argue that Brazil's "grand, and mighty, and impenetrable forests, and rivers, and swamps and mosquitoes, . . . and Indians, that lie west and south of it" were "more exciting and interesting" than its port city, he certainly could not claim that they possessed the same kind of beauty.[31] As its fame grew, it became a requisite stop on the picturesque tour of South America. Those who caught even a fleeting glimpse of that famed harbor seemed to fall under the spell of its charm, sometimes in spite of themselves. For Melville, who traveled along the South American coast on his return from the South Seas, "the bay of all beauties" was a haunting memory. In *White Jacket* he tried to resist describing the contours of the Sugar Loaf and the Corcovado Mountains, clichés of South American travel literature. But eventually he succumbed to the impulse: "I have said that I must pass over Rio without a description; but just now such a flood of scented reminiscences steals over me that I must yield and recant, as I inhale that musky air." His words on the rejuvenating effect of seeing the harbor reflects his own experiences and those of the many travelers whose accounts he had consulted: "How I hung over that main-royal yard in a rapture! High in air, poised over that magnificent bay, a new world to my ravished eyes, I felt like the foremost of a flight of

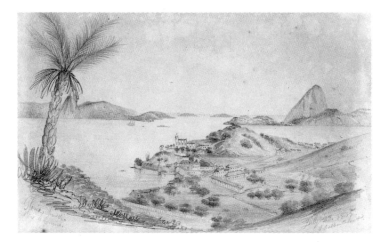

72. *Julius O. Montalant*, Gloria Church, Rio de Janeiro (Brazil), *1845, pencil on paper, 5³⁄₄ × 9 in. (14.6 × 22.9 cm). U.S. Naval Academy Museum, Annapolis, Maryland (57.14.1).*

angels, new-lighted upon the earth, from some star in the Milky Way."[32]

Amateur and professional artists alike attempted to record the visual impact of the scene. Among them many concurred that the best view was to be had from above—if not from the main royal yard, then from the top of the Sugar Loaf. This is the view Julius O. Montalant depicted in his drawing (fig. 72) and the oil painting he presumably did after it.[33] The subject occurred repeatedly among draftsmen aboard various commercial or military vessels that invariably made a stop at this major Brazilian port. U.S. Navy Lt. Henry Walke painted *U.S.S. North Carolina Entering the Harbor of Rio de Janeiro* (fig. 18) in 1848. Its stiff, primitive quality and the swirling pattern of the waves and clouds suggest the Chinese scroll paintings Walke was known to have collected on his tour of duty in the Orient. And at the same time, it conveys the artist's fascination with the unusual configuration of the entrance to the harbor.

Heade seemed to prefer the view across the bay to Niterói, which he rendered in *A View of Rio de Janeiro with the Corcovado Mountains and Hills in the Distance*

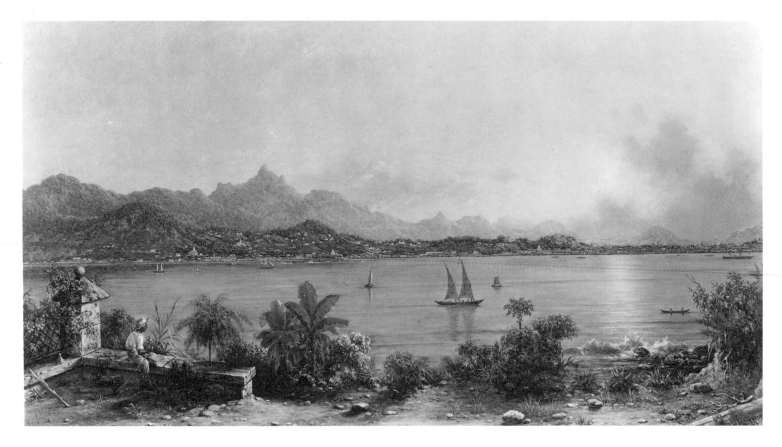

73. *Martin Heade*, Sunset—The Harbor at Rio de Janeiro, *oil on canvas, 18¹/₂ × 33¹/₂ in. (47 × 85.1 cm). Regis Collection, Minneapolis.*

(fig. 41) and *Sunset—The Harbor at Rio de Janeiro* (fig. 73). In the latter he included, somewhat atypically for him, genre details of a black youth lounging on the stone wall at the left and several sailboats on the luminescent waters of the bay. Like similar vignettes in Mignot's pictures, the addition of such glimpses into the appearances and habits of the local folk were appreciated by the public.[34] They offered a point of human contact with these remote people and the opportunity for another level of emotional involvement with the place depicted.

Crosses, Churches, and Holy Light

Vignettes of penitent natives pausing at a wayside cross, and of mission churches, occur frequently in these trop-

ical paintings. They can be appreciated as incidental detail, touches of local color, but they also possess further symbolic meaning. Like the antique monuments—hallowed by association—sought on picturesque tours of Britain or the Continent, these elements functioned as important sources of romantic sentiment. Local churches, recognizable by their domes and steeples, appear in Heade's views of Rio de Janeiro (fig. 73), Ferguson's of Santiago (fig. 32), and Mignot's of Riobamba (fig. 74). These colonial churches were staple subjects of the Latin American topography—established stops on the southern extension of the grand tour. Andrew Warren made a point of sketching "The Old

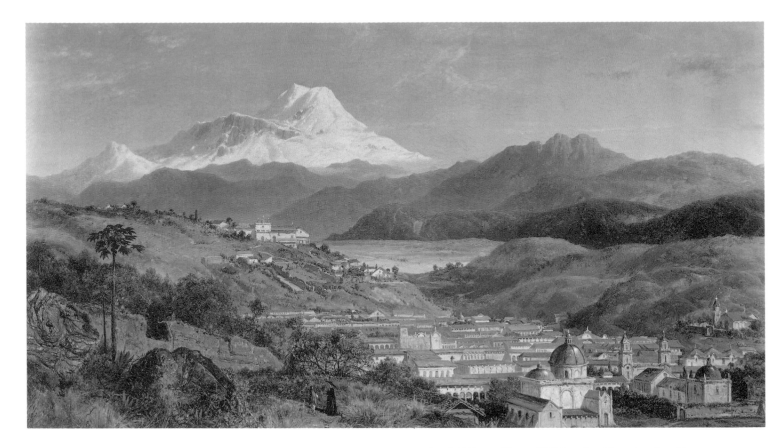

74. *Louis Mignot*, View of Riobamba, Ecuador, Looking
North towards Mt. Chimborazo, *1859, oil on canvas,
17³/₈ × 31¹/₄ in. (44.1 × 79.4 cm). Collection of Hirschl
and Adler Galleries, Inc., New York.*

Cathedral" in Panama (fig. 75). Church, during his
stay in Quito, made mention in his journal of a visit to
the famous Church of San Francisco and—to judge
from his notebook drawings and oil sketches—he made
a point of visiting well-known cathedrals and small par-
ish churches throughout his travels. Occasionally they
became the subjects for finished drawings such as
Ruined Church in the Tropics (fig. 76) or *Church at
Cerrito*, which was illustrated in Holton's travel account
of New Granada.³⁵ More frequently the churches
recorded in these studies were transposed, on a smaller
scale, into panoramic landscape paintings, as were the
wooden crosses frequently encountered in the country-

side. Churches and roadside shrines appear in his work
from the earliest compositions following his return from
South America in 1853 until the late landscapes of rem-
iniscence (fig. 77). Often tiny in relation to their sur-
roundings, they are brought into prominence in a
variety of ways that disallows their dismissal as mere
staffage. They appear atop an isolated hill (fig. 78), in
a lakeshore clearing (fig. 79), or situated so that the sun
spotlights them amid mountains and vegetation. But to
what end?

"Along the roadside we passed many small crosses,"
observed Chilean explorer Edmond Reuel Smith:

76. *Frederic Church*, Ruined Church in the Tropics, *1859, pencil with Chinese white on paper, 6¹⁄₂ × 6 in. (16.5 × 15.2 cm). Walters Art Gallery, Baltimore (37.1534).*

75. *Andrew Warren*, The Old Cathedral, Panama, c. *1866, oil on board, 10¹⁄₂ × 8¹⁄₂ in. (26.7 × 21.6 cm). Courtesy of Kennedy Galleries, Inc.*

On questioning my guide, he informed me that the places so designated, were "paraderos de los defunctos [*difuntos*]" (halting places of the dead). In rural districts, where population is sparse, the parishes are large; the churches are distant from each other, and as the burial-places are always near the parish church, it often becomes necessary to carry the dead a journey of one or two days. . . . On such journeys, wherever the pallbearers stop to rest, they deposit the corpse by the roadside, plant a rude cross of twigs, and repeat a few prayers for the rest of the departed.[36]

Along with their elegiac associations, crosses bore overt religious connotations. "Think what the cross means,"

one commentator admonished viewers of *The Heart of the Andes*. He assumed that they would interpret it as a symbol of the Christian faith as in *Figures in a South American Landscape*, by Granville Perkins (private collection), or canvases by Mignot (fig. 40). Such details reassured the observers that even at the heights of the mountains or in the depths of the jungle, God was not forgotten. In *Heart of the Andes*, "the Artist sets up his own symbol of faith in the church and the foreground cross," Winthrop explained, "and recognizes here [the] religion whose civilization alone makes such a picture as his possible."[37]

But to which religion and whose god did they refer? Neither commentator felt the need to elaborate at any length upon this point; the assured and almost conspiratorial tone they adopted with their readers stemmed from the confidence that they all shared the same outlook, that of Anglo-Saxon Protestantism. Winthrop implied that this was the only religion, the only civilization, that could have produced this great painting.

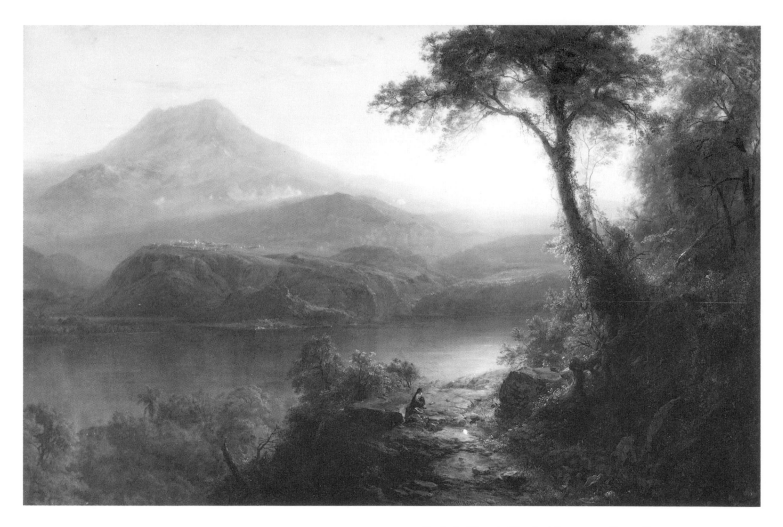

77. *Frederic Church*, Tropical Scenery, *1873, oil on canvas, 39³/₁₆ × 60 in. (99.5 × 152.4 cm). The Brooklyn Museum (63.150).*

What he failed to take into account was the strong Catholic and Indian presence pervading South America, something artists traveling there were unable to ignore. Everywhere they were confronted with the outward manifestations of Latin American religiosity: the priests, shrines, cathedrals, and daily rituals that played a significant, if seldom discussed, role in the travelers' involvement with the country. The introduction of religious emblems into the painted landscapes indicates another level of the artists' response to the mood and spirit of Latin America, and to retrieve something of their original meaning, we must take into account the philosoph-

ical and religious differences between viewer and subject. For surely the sight of these worshiping peons and gilded cathedral domes must have recalled something of their "pagan" Indian and Spanish Catholic origins to Protestant artists and audiences.

All the artists considered here, as far as I have been able to determine, came from Protestant backgrounds. Church was staunchly Calvinistic and even abstained from drawing and sketching on the Sabbath. Mignot

78. Detail of Frederic Church, Tropical Scenery *(fig. 77).*

traced his ancestry to Huguenots, who were forced to flee Catholic France to maintain their Protestant beliefs. Others, although difficult to identify with a particular denomination, likely absorbed the strong religious convictions of family and friends. Catlin, for example, reported that his mother was a devout Methodist and his father "a philosopher, professing no particular faith, but keeping and teaching the commandments."[38] Heade remains allusive in matters of faith, but his close friendship with the Congregationalist missionary Rev. J. C. Fletcher may suggest an affiliation.[39] Common beliefs and attitudes therefore united them not only with one another, but also with naturalists and writers from the United States who went to Latin America.

The practices of Spanish Catholicism were standardly criticized by American travel writers. They unfailingly recounted their distaste and even disgust with holy day celebrations, the materialistic excesses of church decoration, and the licentious behavior of local clergy (no volume was complete, for example, without an anecdote on the priest and his illegitimate offspring). How can these attitudes be reconciled with any positive meaning we try to assign to church and cross motifs? It

must be remembered that the religious and political heritage of Protestant Americans made it difficult for them to comprehend the unquestioning devotion and total religious commitment characteristic of Catholicism, whether practiced in Ecuador, Italy, or elsewhere. They objected to what they perceived as the restraints on intellectual and political liberty imposed by the Church of Rome. They were, therefore, antiauthoritarian and anticlerical before they were anti-Catholic.

Their quarrel with the Catholic church had its foundations not so much in religious doctrine as in temporal policy. The worst fault of Catholicism, as they saw it, was that it was the church of the past and therefore stood in the way of progress. "Many, very many, all too many ways lead to Rome," the historian George Bancroft wrote in a letter that summarizes most of his countrymen's typical objections to Catholicism:

> Idleness leads there; for Rome saves the trouble of independent thought. Dissoluteness leads there, for it impairs mental vigor. Conservatism, foolish conservatism, leads there, in the hope that the conservatism of the oldest abuses will be a shield for all abuses. Sensualism leads there, for it delights in parade and magnificent forms. Materialism leads there, for the superstitious can adore an image and think to become purified by bodily torments, hair-shirts, and fastings, turning all religion into acts of the physical organs.[40]

All of this is to say that travelers from the United States on the whole could not, did not, identify with the institution of the Catholic church, which they believed exerted a pernicious influence on its followers. But this did not prevent many—usually the most religious among them—from developing a sympathy with individual Spanish Americans and finding in their simple, profound faith an additional confirmation of the existence of a divine power.

This may well have been the response of many of the landscapists, as borne out by their handling of cross and church motifs in their South American paintings. The crosses dotting the paths in the tropical pictures,

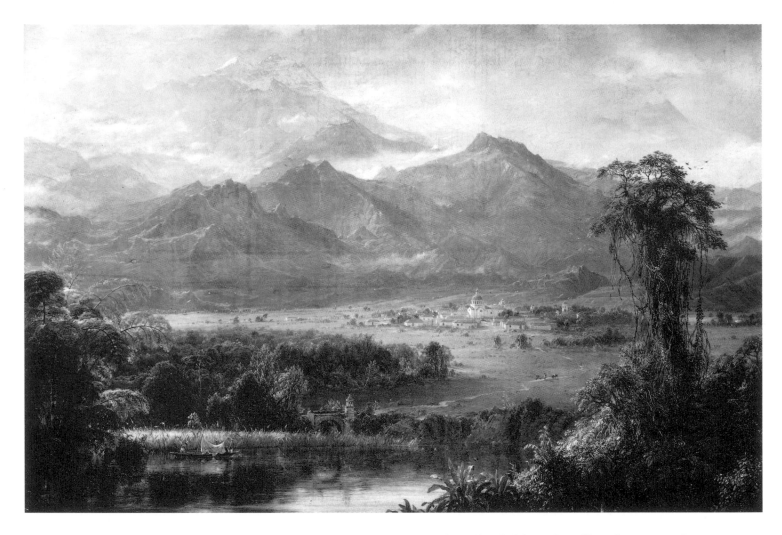

79. *Frederic Church*, Mountains of Ecuador, *1855, oil on canvas, 24³/₁₆ × 36⁵/₁₆ in. (61.4 × 92.2 cm). Courtesy of Wadsworth Atheneum, Hartford, Gould Bequest (1948.177).*

generally attended by several gaily clad natives, rarely stand alone. This constant coupling of cross and faithful suggests that it is the *act* of worship, and not just the shrine itself, that is important. Travelers from the United States were repeatedly struck by the scenes of intense devotion they witnessed. Even the most unsympathetic among them betrayed a tinge of wonder, and even begrudging admiration, at the faith of the local people. The vocally anti-Catholic James Gilliss, for example, wrote with fascination of the "remarkable custom" that accompanied the daily ceremony of the Catho-

lic Mass and the consecration of the host in Santiago de Chile:

> But hark! there are short and rapid strokes from one of the bells of the cathedral; and, with an instant's intermission, from the campanile comes a single solemn vibration through the air. Behold! the life-current is apparently paralyzed. Riders dismount; pedestrians fall to their knees; all bareheaded, bowed, and silent, are motionless as the gravel till the third stroke releases

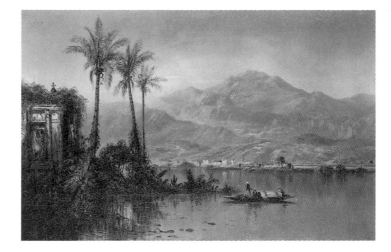

81. Louis Mignot, South American Scene, 1862, oil on canvas, 14³⁄₄ × 22¹⁄₄ in. (37.5 × 56.5 cm). The Art Museum, Princeton University, New Jersey, gift of Mr. and Mrs. Stuart P. Feld (80–83).

80. Signature of letter from Frederic Church to George Warren, 1857. Historical Society of Pennsylvania, Philadelphia.

them from the act of humiliation, and they rise crossing themselves. Probably nothing makes greater impression on arriving in a Catholic country.⁴¹

The Protestant observers cannot fathom the religious fervor behind such a display, and might even be repulsed by its sheer physicality, yet at the same time they are fascinated by the profound spirituality that lay behind it. It was a confirmation of the importance of the religious spirit (and the triumph of Christianity over paganism). Hence the repetition of the motif of the miniaturized cross accompanied by figures in images of Brazil, Ecuador, Peru, and Chile.

The thatch-roofed village chapels and gold-domed cathedrals of the major cities played a similar function and became a stock feature in the panoramic landscapes of a wide range of artists. The particular frequency

with which they appear in Church's pictures invites speculation on their personal and psychological significance. Known for his love of puns, the artist sometimes signed his letters with the picture of a church (fig. 80). This word association may account for the wide variety of such edifices he sought out for study and the painstaking care with which he executed what amounted to small details in his full-length landscapes. Indeed, he may have subconsciously regarded them as projections of himself into the scenes, just as they served as surrogates for his signature in letters to friends.

The use of miniaturized churches as cultural and not just personal symbols is emphasized by the number of other artists who employed them. Mignot painted at least two versions of a river scene featuring a piroque, or native boat, floating on the calm waters (figs. 81–82).⁴² In both versions, a church structure with its distinctive double towers is visible on the far shore. What makes the Christian presence all the more emphatic in these works, however, is the vine-covered structure at the left, what appears to be the remnant of a bell tower,

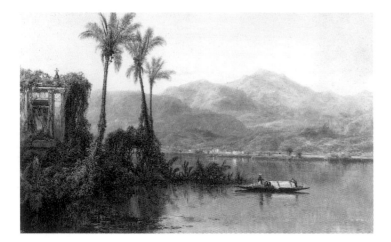

82. *Louis Mignot*, River Scene, Ecuador, *c. 1862, oil on canvas, 13⁵/₈ × 21¹/₈ in. (34.6 × 53.7 cm). Bowdoin College Museum of Art, Brunswick, Maine, Museum purchase, Hamlin Fund.*

with the bells hanging at the side and a crucifix-topped orb perched atop it. The artist purposefully focuses attention on this crucifix, just as he did on the cross above the church in *Evening in the Tropics* (fig. 6), where its meaning is further expanded and refined.

What is significant about *Evening in the Topics* is the manner in which Mignot has amplified this motif as a metaphor for Catholic piety. First, the stylized Spanish colonial church has been enlarged to become the subject of the picture. Its size, position at the edge of the lagoon, and alignment on the central axis of the composition draws the eye toward it and then to the procession of the faithful making its way in to evening services. The cross at the pinnacle of the church facade, flanked by the crown of the palm tree to the left and cruciform star at the right, is the only form to pierce the field of the darkening sky: a sign that God was indeed ever present in this tropical garden. For Tuckerman the church, the cross, and the palm in Mignot's picture called forth a hushed prayer: "His *Evening in the Tropics* represents a chapel on the border of a lake, and worshippers passing in to vespers. The evening star is

shining, and is reflected in the form of a cross on the water. A cocoa-nut palm rises at the left of the picture, and a boat floats in the lake near by, suggesting 'Ave Maria!'" Another salient feature of the picture, which Tuckerman does not mention explicitly, is the oversized sculpture of the Virgin and Child over the central portal. Since the importance accorded to Mary in the Catholic church was in no way matched by Protestants (who regarded it as Mariolatry, bordering on the idolatrous), this detail identifies the scene unmistakably with the Church of Rome.[43]

The artist, then, re-creates a scene of Spanish Catholic ritual and devotion. But the perspective is that of a spectator, not a participant. For Mignot was careful to establish a distance—both spatial and psychic—between viewer and penitent. Against the architectural backdrop, the scene of worship occurs on the far shore of the lake, whose waters extend to the lower edge of the image, setting up a boundary between us and them, between earthly and heavenly realm. Thus Mignot's view of the Spanish colonial church is imbued with transcendental significance.

The cruciform star of *Evening in the Tropics* appears also above the secular realm of the *Lagoon of the Guayaquil*, which falls somewhere between those works laden with overt Christian symbolism and those in which the light of the heavens alone carries connotations of the divine. For the special quality of light attained in many of these images was not purely a response to the physicality of the tropical skies. It represented also an attempt to convey the presence of the divinity, which the artists felt so strongly in the Tropics.

The Andes of Ecuador (fig. 83), painted in 1855, signals Church's first such successful synthesis of light and faith: a fact that has long been recognized by David Huntington and others. What has not been acknowledged, however, is the degree to which the artists's experiences in South America were responsible for this success. For the opportunity to witness not only the light and atmosphere of the equatorial landscape, but also the profound piety of the natives and the most stun-

83. *Frederic Church*, The Andes of Ecuador, *1855*, *oil on canvas, 48 × 78 in. (121.9 × 198.1 cm). Reynolda House, Museum of American Art, Winston-Salem, North Carolina.*

ning examples of Spanish colonial baroque art, helped him make visual this spirituality in a manner he otherwise may never have achieved.

A contemporary reviewer described *The Andes of Ecuador* as "a quivering haze upon the wall," instinctively drawing on language equally suitable to religious visions and landscape art.[44] And indeed this painting represents a significant intersection between the two traditions. Its most striking feature is the dazzling golden light that seems to emanate from the center of the canvas, nearly obscuring the outlines of Cayambe, the twin Illinisas, and Cotopaxi, strung across the middle distance. The composition recapitulates a scene Church

observed many times during his stay in Quito: the Andes of Ecuador spreading out behind the Church of San Francisco, whose glowing golden altar was the spiritual center of the city.

The Church of San Francisco, situated on a steep hill in the oldest section of Quito, boasts a lavishly carved and gilt apse, one of the masterpieces of the Spanish American baroque. Church surveyed its interior on at least one occasion, reporting in his journal on 2 September 1853, "Visited several of the churches this morning, the most interesting of which is the San Fran-

154

cisco." It is difficult to convey the effect of this massive golden altar, shimmering within the dark cavern that houses it. Its dematerialized glow seems to transcend the walls of the church and to unite itself with the sunlight bathing the surrounding Andes. Viewing the spectacle of this altar and then stepping outside to sketch the mountain panorama from the steps of the church helped precipitate a synthesis of light and faith in the artist subsequently carried over into *The Andes of Ecuador* and other mature canvases.

These experiences must be compared to his better-known responses to Italy and the Near East to fully comprehend their significance. Church had little use for baroque Rome. As he put it, "The subject is as thread bare as the priests here."[45] By contrast, he gave himself over completely to the Holy Land. His travels there took on the nature of a pilgrimage, seeking out particular cities and monuments of religious importance. While he identified with the biblical Christianity of the East, he completely disassociated himself from the holy city of Rome. South America occupied a middle ground, and therein perhaps lay its attraction. Its unique mix of Indian and Catholic beliefs invited an artistic melding of primitive and European baroque art. Church was captivated by this blend, and in later years he collected Mexican Churrigueresque artifacts. Just as the colonial style was forged from an amalgam of local Indian and imported Spanish traditions, so did the early morning sky in *The Andes of Ecuador* gain luminosity from his appreciation of this meeting of Catholic spirituality and primitive mysticism.

But here Church and Mignot part company. In Church's hands the Tropics are portrayed only occasionally at dawn, when the awakening sunbeams might be allowed to suggest divine immanence; more often he chose midday, when the details of a scene are most clearly apprehended. For Mignot, light rarely functioned merely as illumination, for he attempted to elicit not so much a rational reaction to form as an emotional response to color.

Color, Atmosphere, and Stroke

Mignot was a master of chromatic effects. He developed a rich and harmonious style of color and atmosphere that was the key to the success of his art. Contemporary critics always emphasized color over subject matter in their analyses of his work. "*Twilight in the Tropics* and *Lamona*," Tuckerman wrote, "giving the brilliant sunset hues and the modified yet radiant light of those regions, and the vital tints of their vegetation are memorable exemplars of local color and tropical nature."[46] Increasingly his subjects came to be identified primarily by their associated color spectra. *Harvest Moon* (1860; New York Public Library, on loan to the New-York Historical Society), a North American scene, was praised as being "rich with the hues of the harvest season." Avoiding a narrative re-creation of the harvest activities, Mignot conveyed the character of the season by way of its typical range of tones. When this northern harvest scene appeared with its tropical pendant, *Lamona* (unlocated), at the National Academy of Design in 1860, it was perceived immediately that Mignot had differentiated the northern picture from its southern twin primarily through a shift in hues: "In *Lamona* . . . we have a brilliant sunset in South America, its coloring revealing the full strength of the palette." *Harvest Moon*, its pendant, was "more subdued."[47]

Repeatedly Mignot associated the Tropics with twilight. This might be regarded as a personal preference for a particular time of day, and left at that. But experience in the region of the world that ostensibly provided him with his subject tells us otherwise. His glowing orange pink sunsets do not stem from on-the-spot observation but rather are the work of the artist's imagination.

This antinaturalistic interpretation of his striking skies is borne out by reference to the geographical locale. Situated directly on the line of the equator, Ecuador does not experience the transitory period between day and night that occurs in the temperate zone. While

occasionally in the Andean highlands there are moments of twilight effect, they are extremely brief and leave one with the impression of watching time-lapse photography, where the event has been sped up enormously. In the Guayas region, near sea level, twilight is a rather dull and almost nonexistent affair, as confirmed by Humboldt's observations: "As there is scarcely any such chromatic display in the tropics, we pass quite suddenly from bright sunlight to darkness."[48] Extending beyond naturalistic illumination, Mignot created a sort of expressionistic twilight, and in so doing conveyed something of his own emotional response to his subject.[49]

To his contemporaries, the pinkish oranges and fiery reds of his Latin American canvases connoted heat. His *Sunset on the Coast of Panama* (unlocated), when shown at the Brooklyn Art Association in 1862, was "much admired" because it conveyed "a great deal of tropical warmth."[50] He gave visual form, as his viewers interpreted it, to the hot, steamy climate northerners always identified with these lands. But there are suggestions that the artist intended more than this. At twilight, day and night are mixed in indistinguishable proportions. Frequent recourse to this transitory moment in his canvases therefore suggests the mixed attitudes—the ambiguities—that he himself felt.[51] For twilight not only confuses day with night, it also obscures the facts of the topography so that the marshy land is indistinguishable from water, and earth from heaven: confusions deliberately exploited in *Lagoon of the Guayaquil* and a number of his other canvases. The last rays of the day's light impart to the scene a sad flush, a romantic melancholy for something lost or perhaps never experienced on the southern continent. These images therefore carry a feeling of incompleteness and yearning, not only in the artist's choice of the twilight theme, but also in his handling of paint.

Mignot's delineation of lush tropical vegetation and equatorial sky demonstrated a breadth of stroke and a willingness to exploit the expressive potential of paint admired by contemporary critics: "His treatment of his subject displays peculiar delicacy of handling, and in his distances the aerial effects are masterly in the extreme; they are soft and melting, if that term may be used, without being marred by unnatural indistinctness or mistiness."[52] Such technique further aligns him with romantic art. The softly blurred edges, the marvelous scumbles of paint seem to tell all, and at the same time, they remain ungraspable. Allowing scientific exactitude to give way to broadly painted foliage and hazy atmosphere, his tropical images hover between fact and suggestion. Perhaps Tuckerman came closest to characterizing the method of his art when he stated that Mignot "seizes upon the latent as well as the prominent effects."[53] The word *latent*—defined in Webster's dictionary as "present but not visible or apparent" and "below the surface, potentially able to achieve expression"—is the key to his artistic sensibility. It describes the way in which the painter created images, suggestive and barely finished, from which the viewer had to retrieve the image that hovered just below the surface. This latent touch alerts us that we are in the presence of an artist whose sense of himself is distinct from that of the majority of artists considered in this study. In Church's work, for example, the artistic ego seemed to disappear so that tropical nature could appear in all its realistic detail (although one could argue that in the virtuoso performance of his minutely painted canvases he called attention to himself in another way). Mignot, by contrast, plays the role of interpreter, not reporter. Creating images that are "vague" and "indistinct," he encouraged and even demanded the participation of the beholder to finish the picture in imagination.

The American artist-wanderers moved away from an exploration of the external world toward an examination of their own minds and souls. Consequently, they projected more of themselves and their feelings onto the contours of the tropical landscape. In this respect they might fruitfully be compared to the French writer Chateaubriand, who offers a more extreme case of a man without a home or the possibility of acquiring one. The

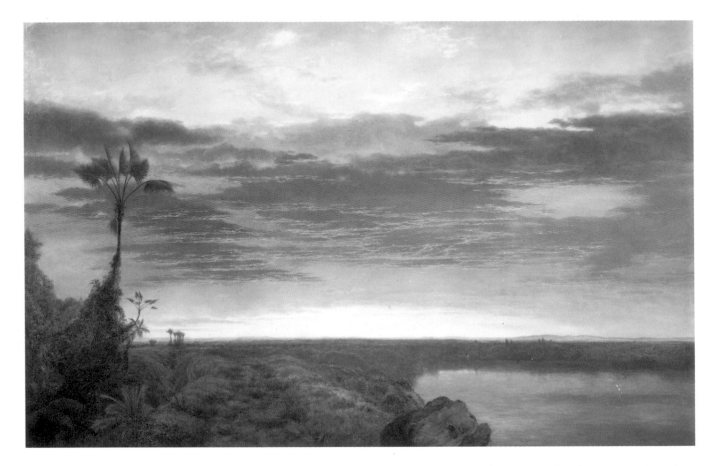

84. *Louis Mignot*, South American Landscape, *c. 1862, oil on canvas, 38 × 59 in. (96.5 × 149.9 cm). Collection of Louis B. Schoen.*

body of writings that resulted from his wide travels, from the Near East to North America, is less a record of the places he visited than it is of his own impressions and being. In search of himself, he found himself everywhere. He created, as did the American wanderers (albeit to a lesser degree), a subjective imagery that took as its subject his longing for, his search for, his own artistic identity.

The Pathos of Emptiness

Toward the end of *The Voyage of the Beagle*, Darwin tried to fathom why the "arid wastes" of the Patagonian desert, at the southernmost tip of the continent, had taken a firmer hold on his imagination than any other aspect of the South American scenery:

In calling up images of the past, I find the plains of Patagonia frequently cross before my eyes; yet these plains are pronounced by all to be most wretched and useless. They are characterized only by negative possessions; without habitations, without water, without trees, without mountains, they can support only a few dwarf plants. Why, then—and the cast is not peculiar to myself—have these arid wastes taken so firm possession of my mind? Why have not the still more level, the

greener and more fertile pampas, which are serviceable to mankind, produced an equal impression?[54]

The source of their fascination, he postulated, lay in their boundlessness, their mystery, their longevity. Such explanations, as he himself was aware, were tentative, inconclusive. But his observations, which stimulated and adumbrated the musings of succeeding generations of South American travelers, hint that even as the most scientifically minded among them collected data on its mountains, flora, and fauna, they were at a loss to explain their emotional reaction to its most remote wastelands.

Darwin's ruminations spurred William H. Hudson's explorations of the Rio Negro in the 1860s and a chapter in *Idle Days in Patagonia*. Hudson concluded that the barren Patagonian landscape brings man back to a moment in time when he was one with nature and allows him to glimpse a state of primeval calm he had never before known. Darwin sensed this but could not express it; Hudson later was able to articulate it for him:

It was elation of this kind, the feeling experienced on going back to a mental condition we had outgrown, which I had in the Patagonian solitude . . . what has truly entered our soul and become psychical is our environment—that wild nature in which and to which we were born at an inconceivably remote period, and which made us what we are.[55]

Few painters visited the distant reaches of Patagonia, but occasionally they found themselves in an empty landscape, devoid of mountains and historic monuments. Most of them considered it an unavoidable inconvenience of travel, to be endured until they could move on to more "interesting" scenery. A rare few among them, however, were willing (or better prepared) to explore these seemingly God-forsaken corners of the globe, allowing them to face not only the enigma of human creation, but also the most impenetrable reaches of the inner self.

Within the damp solitude of the lagoons of coastal Ecuador, Mignot may have experienced this sensation. His *South American Landscape* (fig. 84) suggests that he too had felt the primordial quietude that overtook Darwin and Hudson in the desolate reaches of South America. This canvas, one of the artist's largest, is also one of the most daringly empty. The silhouette of a single elegant palm against the sunset sky protrudes above the horizon. Vacant space, devoid of even a trace of human presence, has become the subject of the picture. No breeze disturbs the tree, no wave ripples the water. The scene is one of utter stillness, and we feel an oppressive loneliness, as before the coming of man. Our intellectual processes are suspended as we stand before it and are reunited with the void that was our beginning.

The Syncretism of South and East

James Whistler in Chile

Ah Genoese thy dream! thy dream!
Centuries after thou art laid in thy grave,
The shore thou foundest verifies thy dream.

WALT WHITMAN, *Passage to India*

James McNeill Whistler sailed for South America on 2 February 1866 and returned ten months later, having completed a series of images of the harbor at Valparaíso, Chile. Some confusion persists concerning the works he created there. It is generally accepted, however, that *Nocturne in Blue and Gold: Valparaíso* (Freer Gallery of Art), the so-called *Sketch for Nocturne in Blue and Gold, Valparaíso Bay* (National Museum of American Art), and *The Morning after the Revolution, Valparaíso* (Hunterian Gallery, Glasgow) belong to this group; all three are vertical canvases measuring approximately thirty by twenty inches. To these can be added several horizontal pictures: *Crepuscule in Flesh Colour and Green: Valparaíso* (Tate Gallery) and *Symphony in Grey and Green: The Ocean* (Frick Collection). *Nocturne: The Solent* (Gilcrease Institute, Tulsa), somewhat less securely identified with the group, is here treated as a work of the South American trip.[1] These pictures marked a turning point in his career and led to the two major break-throughs that constitute his contribution to the history of art: the creation of his first nocturnes and the integration of oriental compositional devices into his canvases. These principles of design and color were refined and elaborated over the next twenty years; it is not insignificant, however, that they made their initial appearance in the canvases that resulted from his trip to South America in 1866.

Why Go to Chile?

The impact the Chilean experience made on Whistler was recognized in the artist's own day. His contemporary biographer, Haldane MacFall, described it as "the splendid moment of his career":

The change of scene . . . seems to have made a marvellous impression on the man. It was in this year that he drew completely away from tradition and the achieve-

ment of his own and former ages—it was in this year
that he found himself. His hand became bolder; his
spirit frees itself from the ages; he rises above the
schooling of tradition; and his confidence is justified
and supreme.[2]

Subsequent writers have continued to make a nodding
acknowledgment to the significance of the trip; for the
most part, however, they follow his progress up to the
time of his departure and then pick it up after his
return, with the result that the intervening year remains
a blank.[3] The artist's chroniclers and friends of later
years, Joseph and Elizabeth Pennell, called the voyage
"the most inexplicable incident of his life." They "were
unable anywhere to find even the suggestion of a special
necessity for him to leave London at this time,"[4] while
his mother assumed the trip was taken just for plea-
sure.[5] With the advantage of hindsight, we can recog-
nize certain factors that would have made a change of
scenery inviting. He may have felt the need for soli-
tude, to resolve the influence of Gustave Courbet and
others to whom he had been exposed in the preceding
years. Several contemporaries mentioned his desire to
escape the domestic conflict between his mother, who
had moved in with him in 1863, and his mistress, Jo
Hiffernan, from whom he parted amicably upon his
return.[6] And acquaintances at the time mentioned that
he exhibited a general restlessness, perhaps exacerbated
by contact with a group of southerners-in-exile in Lon-
don. But none of this explains his specific choice of
destination.

Chile was one of several South American countries
in this period that tried to promote travel, trade, and
emigration. Whistler may well have come across nation-
ally sponsored propaganda literature such as *A Sketch of
Chili* [*sic*], *Expressly Prepared for the Use of Emigrants
from the United States and Europe*, which outlined the
country's appeal for foreigners. Learning that a sizable
British population already resided in Valparaíso, he may
have calculated opportunities for patronage.[7] Many
years later, however, the artist himself claimed that he

went to assist the Chileans and Peruvians in their strug-
gle against the Spaniards. All his life Whistler felt
bound to the principles of his West Point education.
His lack of participation in the American Civil War
may have been a tremendous psychological burden,
especially because his brother William had distin-
guished himself as a surgeon in the Confederate army.
His desire to become involved in this political dispute,
therefore, may represent an effort to redeem himself in
another American struggle. And finally, the possibility
exists that the artist's growing interest in things oriental
may have contributed to his desire to travel to the
Pacific coast of South America, which offered geo-
graphic access to the East.

By lifting the Valparaíso pictures out of the context
of Anglo-French art, within which they are usually
viewed, and examining them instead in relation to the
experiences of this trip, they take on new meaning.
Assumptions have been made, for example, about
Whistler's lack of involvement in the war, but a closer
look at the military events in Chile helps to clarify
aspects of the artist's actions and paintings. We also dis-
cover that he was not alone in conceiving the Tropics in
terms of oriental prototypes, for there was historic pre-
cedent for the conflation of Eastern and South Ameri-
can motifs. And we realize as well that in his choice of
the nocturnal illumination, he followed an impulse to
which a number of artist-travelers succumbed in their
Latin American pictures. The fact that we can detect
these tendencies in the work of his fellow artists
increases rather than diminishes our appreciation of
Whistler, in whose hands they were given unique form.

The Bombardment of Valparaíso

In preparation for the trip, Whistler made a will in
favor of Jo Hiffernan and gave her the power to manage
his affairs while he was away. On 2 February he left
England on the ship *Seine*, bound for South America.
At that time there were two ways to reach Chile from

England: sail down around Cape Horn, at the southern tip of the continent, and then north along its Pacific coast; or sail the Atlantic to Panama, cross the Isthmus by land, and pick up a second ship at the Pacific terminal for the final leg of the sea voyage. Much to Whistler's dismay, he went the Panama route: "We crossed the Isthmus, and it was all very awful—earthquakes and things—and I vowed, once I got home, nothing would ever bring me back again."[8] Having crossed Panama by land, he caught the steamer *Solent*, which took him southward along the Pacific coast of the continent, stopping at Callao, Peru, and elsewhere before dropping anchor on 12 March in the harbor of Valparaíso.[9] They arrived in time to witness the Spanish fleet's bombardment of the city, the safety and freedom of which the artist had come to defend.

Spain, at that moment, was in dire financial straits and determined to regain its former territories, Chile and Peru, as a means of building up its ailing economy. Open hostilities began with the arrival of the Spanish fleet in 1863 and continued through 1864, when it seized the guano-rich Chincha Islands off Peru (fig. 24). The actions of the Spaniards outraged the rest of the world, and ships from many nations sailed to the aid of the South Americans. But neither their presence nor further negotiations resolved the conflict. The Spanish squadron then threatened bombardment of the city, a threat carried out on the morning of 31 March 1866, two weeks after Whistler arrived, and much as he described it:

> There, just at the entrance of the bay, was the Spanish fleet, and, in between, the English fleet and the French fleet and the American fleet and the Russian fleet, and all the other fleets. And when the morning came, with great circles and sweeps, they sailed out into the open sea, until the Spanish fleet alone remained. It drew up right in front of the town, and bang went a shell, and the bombardment began.[10]

Whistler's recollections continued with a mention of his own role in the events:

The Chileans didn't pretend to defend themselves. The people all got out of the way, and I and the officials rode to the opposite hill where we could look on. The Spaniards conducted the performance in the most gentlemanly fashion; they just set fire to a few of the houses and once, with some sense of fun, sent a shell whizzing over toward our hills. And then, I knew what a panic was. I and the officials turned and rode as hard as we could, anyhow, anywhere. The riding was splendid, and I, as a West Point man, was head of the procession. By noon the performance was over. The Spanish fleet sailed again into position. The other fleets sailed in, sailors landed to help put out the fires, and I and the officials rode back to Valparaíso. . . . then we breakfasted, and that was the end of it.[11]

Though his account sounds rather glib, it does conform in its essential details to other contemporary reports. Advanced notice of the bombardment had been given. The evening before the attack, the foreign vessels put to sea, leaving the harbor to the Spaniards. A warning was sounded at eight A.M., an hour later the first shots were fired, and about noon the flag was raised announcing the end of the attack. The entire bombardment lasted a total of three hours. The Chileans chose to appear defenseless in the face of Spanish aggression.[12] Thus, although commentators have noted a certain lack of initiative on the part of the West Point man in these proceedings, there was little he could have done. We can imagine him among the crowd of onlookers depicted in a contemporary print, *The Bombardment of Valparaíso by the Spanish Squadron* (fig. 85), seemingly undisturbed by the bombs and fires that destroyed a good part of the city.

Following the bombardment, the Spanish squadron remained in the vicinity of Valparaíso for two weeks. During this period the Chileans feared a repeat attack, but no further assault occurred, and on 14 April the warships departed. The blockade of the port, which had lasted only fourteen days, was raised; Whistler and the others were free to leave. Yet he remained in Valparaíso until early September. During these six months he kept

85. Unidentified artist, The Bombardment of Valparaíso by the Spanish Squadron, *c. 1866, print. Private collection.*

a diary in which he made a few sketches, a crude map of South America indicating his travel route, and frustratingly brief references to food, expenditures, and developments in the war the Spaniards continued to wage further north in Peru. He made little mention of the activities that occupied him in Valparaíso or the capital city of Santiago, a short distance inland, where he visited several times. "But," as he later confided to the Pennells, "I made good use of the time, I painted the three Valparaíso pictures that are known—and the two others that have disappeared."[13]

It is too little emphasized how radical and extensive was his removal from the art world of Paris and London to this remote land. An air of romance pervades the entire adventure, an impression that the artist encouraged with the explanation he offered the Pennells for his departure:

> It was a time when many of the adventurers of the [Civil] war had made of many Southerners were knocking about London, hunting for something to do, and, I hardly know how, but the something resolved itself into an expedition to go out and help the Chileans, and, I

cannot say why, the Peruvians too. Anyhow, there were South Americans to be helped against the Spanish. Some of these people came to me as a West Point man, and asked me to join, and it was done in an afternoon.[14]

With accounts circulating about Spain's aggression against its former colonies, it is not surprising that Whistler went to their aid. Throughout his life, he took what seemed to others an exaggerated interest in military affairs. In the late 1890s and early 1900s he frequently arrived at the Pennell's for a dinner engagement, his pockets bulging with newspaper clippings, to discourse for a good part of the evening on the Boer War (1899–1902) and related news of British maneuvers in South Africa. And in spite of the insouciant air he adopted in describing the event, Spain's war against Peru and Chile was an instance of political injustice that aroused his deepest convictions.[15] In the months before Whistler's departure, Chilean statesman Benjamin Vicuña-Mackenna traveled to various nations to rally support for his country's cause. "There never was in the history of nations a war so groundless and ridiculous as this is on the part of Spain,"[16] he told his listeners, explaining that although Peru and Chile had won their independence in 1824, Spain had refused to recognize that fact. In an address before the Travellers Club in New York he called the opening of the war "a day of sad record for America, both North and South" and appealed to the love of liberty and sense of justice of his American audience:

> You were once only a small nation, and had not a defender among the great peoples of the globe, until you, young and inexperienced, but full of daring with the righteousness of your cause, went to war with England in 1812. You came great and powerful out of that struggle, and so we expect to come out of ours, against our fast-decaying mother country. . . . What we want is merely justice, the full appreciation of our dignity and our rights, so that it may not be said that we entered into this war through contemptible notions of pride and vanity, but for the sake of our present existence, our future

destinies as a nation, commanding the respect and the sympathies of the civilized world. [17]

Hearing or reading similar words in London, Whistler, the West Point man, heeded the call. [18]

His adventures recall Byron's efforts to assist the Greeks in their struggle for liberty. The interest Latin America held for the romantics was closely linked to its struggle for national liberty, and similar struggles in Greece, Poland, and Hungary had attracted their share of Byronic adventurers. The battles these underdog countries waged to overthrow the control of their despotic oppressors touched a sympathetic cord and led to a deep imaginative engagement with the locale. The situation of Peru and Chile in the 1860s possessed the same level of appeal: young nations trying to extricate themselves from the stranglehold of Spanish rule for good. Whistler's response to the South Americans, like his later outrage over developments in the Boer War, was part of his fascination with those lands, and it was reflected in his art.

Color and Light on the Pacific

Crepuscule in Flesh Colour and Green: Valparaíso (fig. 86), signed and dated in the artist's early manner— "Whistler / Valparaiso, 66"—shows his fascination with the spectacle of up to one hundred ships of diverse nations holding vigil in the elliptical confines of the harbor. Taking a vantage point from above and looking down and to the right, Whistler depicts the sweep of bay that serves to lock the forms of the vessels in place. But unlike a contemporary photograph (fig. 87), Whistler's picture takes as its subject neither the complex pattern established by the sails and riggings of the ships nor the harbor terrain. "The painter's theme was rather the greyish green of twilight sinking on the sea, and ships becalmed, at anchor, or gently moving," as a contemporary reviewer remarked. [19]

This and the rest of the small group of paintings resulting from the trip indicate that a transition was

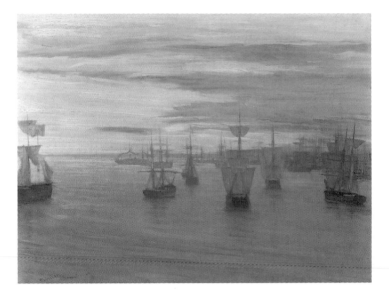

86. *James Whistler,* Crepuscule in Flesh Colour and Green: Valparaíso, *1866, 23 × 29¾ in. (58.4 × 75.6 cm). Tate Gallery, London.

coming about in Whistler's art, particularly in his treatment of color and paint. The differences between the seascapes done just before his departure and those conceived in the Chilean port demonstrate the changes his travels helped precipitate. *Harmony in Blue and Silver: Trouville* (fig. 88) is one of several seascapes painted along the coast of France in the company of Courbet in October and November 1865. These works are essentially exercises in the Frenchman's style; the paint has been applied rapidly, so that the sky appears streaky, and the creamy pigment imparts a characteristic touch to the sails of the ships. In *Crepuscule*, by contrast, the paint surface itself has become richer, more harmonious, rendering light and atmosphere more subtly than his previous work.

The unique atmosphere of Valparaíso, perched near the southern tip of South America on the shores of the Pacific Ocean, acted as a catalyst in this change. Located on a long, narrow belt of land between the ocean and the Andes, Chile feels the effects of the cold

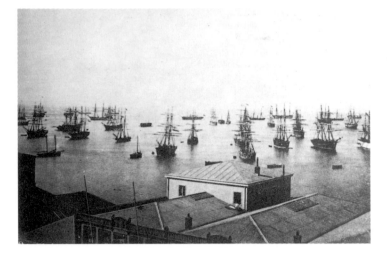

87. Photograph of Valparaíso Harbor, 1866. Private collection.

Peru (Humboldt) Current on the warm waters of the Pacific. As a result, the region is often covered in thick clouds and sea mist, not unlike an English fog.[20] But the light of the Tropics renders the atmosphere clearer, more translucent. The bowlike shape of Valparaíso further enhances its peculiar weather patterns. Clouds and fog roll into the arms of the harbor, where it seems they will linger forever, completely obstructing visibility; then suddenly they move on as quickly as they came, leaving the sky blue and clear. *Crepuscule* had its sources in the direct observation of these effects of nature, as emphasized by Arthur Jerome Eddy, who enjoyed Whistler's confidence in his later years. Studying this strange locale under the transforming influence of the fog, the artist must have been struck in a way that he would not have been in more familiar surroundings and resolved to capture its fleeting effects. He painted the canvas "at a single sitting, having prepared his colors in advance of the chosen hour," Eddy explained. "He could paint with the greatest rapidity when out-of-doors and it was important to catch certain effects of light and color."[21]

Symphony in Grey and Green: The Ocean (fig. 89), the largest canvas of the group, continues this study of atmospheric color, now more restricted and refined. It depicts a gray blue sky extending above a sea that is greenish gray in the foreground, darkening to greenish blue on the horizon. The picture is best approached through an early photograph of it (fig. 90), which shows neither the bamboo shoot nor the signature cartouche presently visible in the right foreground. These were added some time between 1866 and 1872, when the picture was exhibited at the Dudley Gallery, London.[22] As *The Ocean* was originally conceived, therefore, the lower-right quadrant and indeed the entire right half was given over entirely to the effects of color and atmosphere—weighted only by the cut-off pier and the group of ships on the left. In contrast to the darker palette of *Crepuscule*, ranging from purple to blue, this canvas exhibits a lighter color harmony. The paint has been applied over the surface in a rich, thin paste; and in the original, its effectiveness depended entirely on the delicate gradations of tone and light contrasts of color.

Nocturne: The Solent (fig. 91), although not one of the pictures whose location was known to Whistler in the 1890s, suggests identification with the Valparaíso experience and *The Ocean* in several significant ways. During his passage from Panama to Chile on the steamship *Solent*, which undoubtedly gave him the title for the painting, Whistler would have had ample time to study the effects of sea and atmosphere that constitute the subject of this work. Eddy quoted Whistler as saying, "I went out in a slow sailing-ship, the only passenger. During the voyage I made quite a number of sketches and painted one or two sea-views—pretty good things I thought at the time. Arriving in port, I gave them to the purser to take back to England for me. On my return . . . I did not find the package, and made enquiries of the purser. He changed ships and disappeared." It is conceivable, then, that *The Solent* is one of the sea views to which the artist referred.[23] As in *The Ocean*, his approach here is increasingly hesitant and subtle; the heavier treatment of pigments in his earlier works has given way to a thinner and more fluid appli-

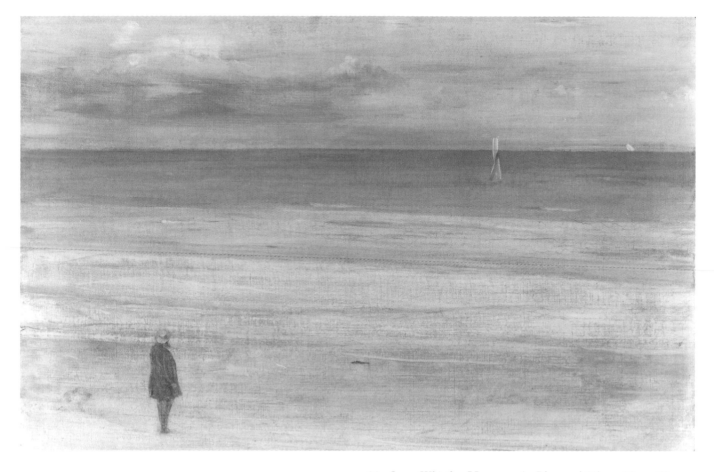

88. *James Whistler,* Harmony in Blue and Silver: Trouville, *1865, oil on canvas, 19¹/₂ × 29³/₄ in. (49.5 × 75.6 cm). Isabella Stewart Gardner Museum, Boston.*

cation of paint. His continued efforts to reduce his work to a minimum number of decisive brushstrokes is apparent, for example, in his handling of the ships on the horizon, which are suggested with a few touches of pigment that seem about to dissolve into the surrounding mist. Similarly, this work presents a nearly barren rectangle; the boats at the upper left and an indistinct shoreline at the right provide the minimal design elements. Barely interrupted by the horizon line, the sea and sky form a nearly monochromatic field of bluish green.

This study of light and atmosphere was also conducted in a closely related subgroup of vertical pictures: *Nocturne in Blue and Gold: Valparaíso* (pl. 7); *Sketch for*

Nocturne in Blue and Gold, Valparaíso Bay (fig. 92); and *The Morning after the Revolution, Valparaíso* (fig. 93). All three depict the same elements—a protruding pier, ships, and the far shore of Valparaíso harbor—under the changing effects of light after the Spanish bombardment. Here again, the particular configuration of Valparaíso likely contributed to the uniqueness of the scene. For within its amphitheaterlike structure, the smoke left in the aftermath of the attack may well have lingered for some time, conferring an eerie cast to the immediate surroundings. Some idea of the scene that confronted Whistler and other witnesses to the

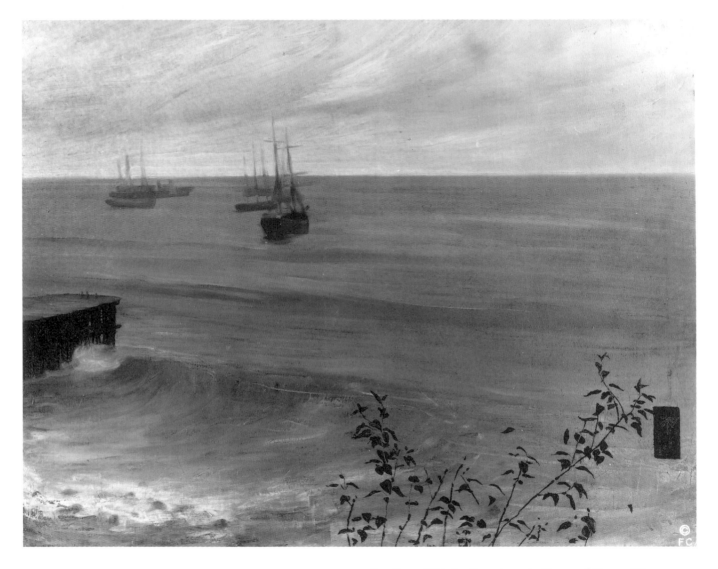

attack can be inferred from British travel writer Maria Graham's observations of a military salute to Lord Cochrane that had taken place in Valparaíso during her residence there in 1822:

> To-day, as I was standing on the hill behind my house admiring the beautiful landscape before me, and the shadows over the sea as the clouds rolled swiftly along, and sometimes concealed and sometimes displayed the cliffs of Valparaíso, the scene was rendered more grand by the firing a salute from the Aurora, the smoke from which, after creeping fleecy whiteness along the water, gradually dilated into volumes of grey cloud, and mixed with the vapours that lay on the bosoms of the hills.[24]

The appearance of the bay some four decades later, following three hours of bombardment by the entire Spanish squadron, must have been a far more incredible

90. Photograph after James Whistler, Symphony in Grey and Green: The Ocean. *George Lucas Collection, Baltimore Art Institute, on permanent loan to the Baltimore Museum of Art.*

sight. Through the thick layer of smoke that hung about the harbor all afternoon and into the night, Whistler could have glimpsed the flickering flames and glowing ruins of the burning city on the opposite shore, much as he depicted it in *Nocturne in Blue and Gold*. It anticipated by about eight years his fascination with the fireworks display at Cremorne Gardens, which gave rise to *Nocturne in Black and Gold: The Falling Rockets* (Detroit Institute of Arts), made famous by the Ruskin-Whistler trial.

Although there is little evidence to document the precise order in which Whistler created these canvases, they logically seem to fall into a sequence from night to the next morning. The bombardment ended around noon; presuming Whistler and the others were in a state of excitement and waited a bit to be sure that the Spaniards did not resume their attack, he probably did not begin to paint until nightfall. Viewed in this way, *Nocturne in Blue and Gold* is the first image, done in the evening as the smoke settled and the fires flickered

across the bay. *The Morning after the Revolution,* as it has always been known, must have followed, for it outlines the contours of the harbor against a bright blue sea as things returned to normal in the clear light of day. Although it has been called *Sketch for Nocturne in Blue and Gold,* it appears to be an independent work that belongs at the midpoint in the sequence.[25] Its treatment of sky, with the dawning light and wisps of clouds, identifies it as an early morning view. And the white banner, not visible in the night view, appears in both of the other canvases. Perhaps the flag that signaled the termination of the attack, it is a visual link between these two works. Whistler rarely worked in a series of this type. The fact that he did so here must be related to the specifics of Valparaíso: his close scrutiny of the changing face of the harbor following the bombardment and his varying treatment of color and atmosphere in its aftermath.

The Nocturnal View of the Tropics

Like Mignot, Whistler favored the coastline, rendered at sunset or by night, when topographical detail was all but suppressed. Color and atmosphere effectively became the subject of his works, as a contemporary reviewer acknowledged when he noted that *Crepuscule in Flesh Colour and Green* (fig. 86) shows "dusk in a harbour of the great ocean, probably the pool of Valparaíso, although there is not enough of land represented to enable one to identify the locality."[26] This tendency to downplay geographical specifics is carried still further in *Nocturne in Blue and Gold* (pl. 7), in which the unfamiliar outline of the harbor is barely visible against the night sky. But to what end were color and atmosphere elevated at the expense of the identity of place?

Moonlight is of course a traditional romantic element, enhancing the impression of the scene beheld; the Tropics were no exception to this, as Warren suggested:

But beautiful as the scenery of the tropics appears by day, it seems far more beautiful at night, when every

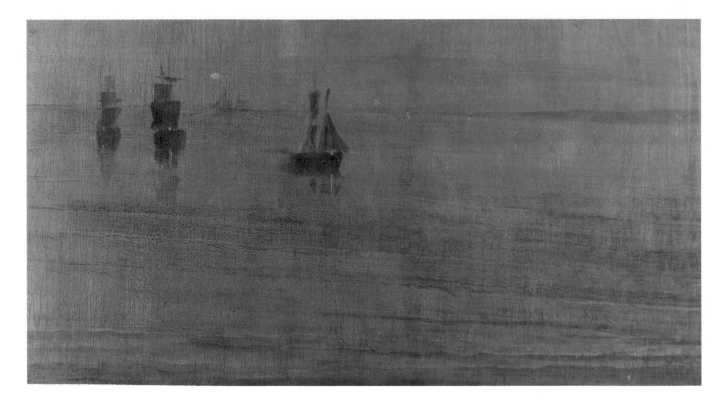

91. James Whistler, Nocturne: The Solent, *c. 1866, oil on canvas, 19³/₄ × 36 in. (50.2 × 91.4 cm). Gilcrease Institute of American History and Art, Tulsa.*

leaf and tree and flower is bathing as it were in the liquid of the moon. . . . tall palms raise themselves above the mass of surrounding foliage while their graceful branches, silvered by the moonlight, fluttered gently in the midnight breeze; the melodious song of a southern nightingale is perchance the only sound which steals upon his sense; all save this strain of bewitching music is hushed in silence, sacred and profound.[27]

It is significant that while this author and others sung the praises of the moonlit charms of the Tropics beginning in the 1840s, not until the 1860s and 1870s did landscapists take up the theme.[28] This delayed response suggests that their nocturnal views were motivated not only by a generalized romanticism but also by a more specific cause. In the post-Civil War period it seemed most appropriate to record their impressions of the southern continent by night. Taken together, these works represent another manifestation of the romance of

the Tropics, which reaches its culmination in Whistler's nocturnes of the harbor at Valparaíso.

Church must have had numerous opportunities to view the Andean landscape by night, and on at least one occasion—probably on his first trip—he sketched a view of a mountain peak inscribed "splendid moonlight / El Altar." Yet in the twenty years after his return he rarely transferred such effects to his finished canvases. It was not until 1874 that he painted *Tropical Scene at Night* (fig. 94) for his friend William Osborn, who owned a growing collection of his work. It depicts an overgrown riverbank illuminated by the light of the moon. The artist's letter to his patron hints at the difficulties he experienced with it:

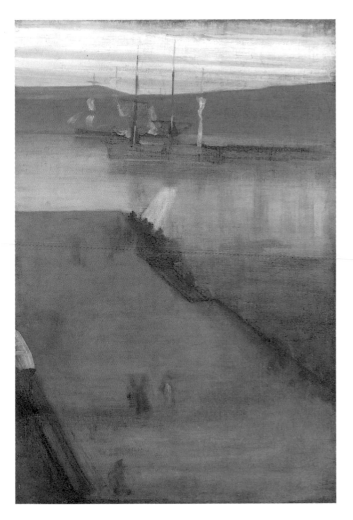

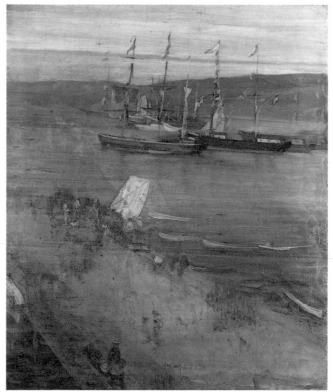

93 . James Whistler, The Morning after the Revolution, Valparaíso, *1866, oil on canvas, 29³/₄ × 24⁷/₈ in. (75.5 × 63.3 cm). Hunterian Gallery, University of Galsgow, gift of Birnie Philip.*

92 . James Whistler, Sketch for Nocturne in Blue and Gold, Valparaíso Bay, *1866, oil on canvas, 30¹/₄ × 20¹/₈ in. (76.8 × 51.1 cm). National Museum of American Art, Smithsonian Institution, Washington, D.C., gift of John Gellatly.*

I send to-day the Moonlight. I worked on it to the last minute on Saturday and if it were to remain longer would probably find several days more work. I am not yet satisfied with the foreground—but some day—in town—I should like to go at it with a fresh eye and hand.[29]

His dissatisfaction with the foreground, to judge from the painting in its present state, must have stemmed from his inability to relinquish the details of the leaves and bush to the mystical lunar light. But not as important here as the relative success of the picture is the fact that he waited until this late date to paint a night view of the Tropics.

Heade, who rarely painted nocturnal scenes, created at least one such view, *Tropical Harbor: Moonlight* (1868 [?]; private collection).[30] A small picture, it is nonetheless well composed and signed by the artist, suggesting that he considered it a finished product. Taking a view from above, he looked down over the darkened foliage to the waters of the harbor. The boats moored there are more ethereal than the white-sailed skiffs that

94. *Frederic Church*, Tropical Scene at Night, *1874*, *oil on canvas, 31 × 25 in. (78.7 × 63.5 cm). Collection of Earl Osborn. Photograph courtesy of the Fine Arts Museums of San Francisco.*

dot his daylight scenes. And the locale—which could be Rio de Janeiro, San Juan de Nicaragua, or Panama harbor—was left deliberately ambiguous. The details necessary for proper identification have been withheld, as the viewer revels with the artist in the mysterious and silvery stillness.

Mignot made his contribution to tropical moonlight iconography with works such as *Moonlight in the Tropics* and *Eruption of Cotopaxi by Night*. Although many of these paintings remain unlocated, *Moonlight over a Marsh in Ecuador* (fig. 95) gives some idea of

the artist's handling of nocturnal effects. In it the moon, illuminating the scene from behind the colonnade of palm trees, infuses the whole with a dreamlike quality.[31] The work of Mignot, like that of Church, Heade, and others, recalls a comment Whistler made. When painting his nocturnes he waited until "the evening mist clothes the riverside with poetry, as with a veil, and the poor buildings lose themselves in the dim sky, and the tall chimneys become campanili, and the warehouses are palaces in the night, and the whole city hangs in the heavens, and fairy-land is before us."[32] By

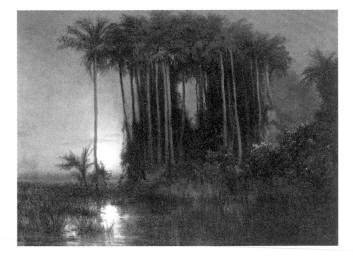

95. *Louis Mignot,* Moonlight over a Marsh in Ecuador, *1869, oil on canvas, 9⁵/₈ × 12⁷/₈ in. (24.4 × 32.7 cm). Photograph courtesy of Christie's, New York.*

1865 moonlight was the optimal illumination by which to view the landscape of South America, just as it had been for the previous generation in the Italian countryside. The impulse to paint a nocturnal view of the Tropics is directly related to the North American artist's Latin American quest: as the accumulated knowledge about the region increased, the source of its attraction proportionately decreased. The darkened canvases fairly resonate with longing, with nostalgia. Like their predecessors in Italy, these moonlit scenes were motivated on some level by the desire to suppress certain disturbing details, and therefore to maintain their myths and illusions. Moonlight, gentle and unobtrusive, was the light most conducive to preserving the last remnant of their ideal of a tropical paradise.

The Valparaíso Canvases and Oriental Design

Whistler incorporated oriental compositional devices into the actual structure of his pictures for the first time in his views of Valparaíso. In the earlier work, *Har-mony in Blue and Silver: Trouville* (fig. 88), bands of sand, sea, and sky—although striking in their reductiveness—conform to the precepts of traditional Renaissance perspective. The strip of beach establishes a plane parallel to the picture surface and relates to the horizontals before and after it in space. Like a true classicist, Whistler allocates a proper foreground plane and leads the viewer's eye from it back into space in a step-wise fashion, its progress marked by the outcroppings of rocks, the sailboats, and finally the horizon itself. Painted in a loose, free brushstroke, it blends sand, water, and sky into one harmonious whole.

By contrast, *Nocturne in Blue and Gold* (pl. 7), the related *Sketch for Nocturne in Blue and Gold* (fig. 92), and *Morning after the Revolution* (fig. 93) reveal a new spatial sensibility. The harbor's landmarks appear in an asymmetrical pattern: the pier, occupying the lower-left quadrant of the picture, cuts through the composition at an oblique angle and exists in an uneasy tension with the shoreline beyond. The foreground, it gradually becomes apparent, is tilted up sharply, leaving only a narrow band of sky visible at the top of the visual field. In addition, *Nocturne in Blue and Gold* depicts the scene against a darkening sky, rather than by the clear daylight that illuminated the beach at Trouville; in this way the artist further obscures the conventional spatial reference points. The nocturnal effects blur the details of the harbor topography and thus encourage the viewer to interpret the canvas as an arrangement of abstract shapes, in a manner quite distinct from that of the year before.

Including *Crepuscule, The Ocean,* and *The Solent,* this group of six seascapes, done in the vicinity of Valparaíso in 1866, represents Whistler's first successful attempt to order his compositions according to the principles of oriental design. Adopting a high horizon line, asymmetrical arrangement, and a thin, fluid application of paint, he created subtle, reductive compositions that mark a break from his earlier work. To appreciate fully their achievement it is necessary to review briefly the artist's study of Eastern art to the time of his departure.

By 1864 he was, along with many other artists, a regular customer at the Porte Chinoise in Paris, where he acquired prints and objets d'art. Undoubtedly he had discovered such prints as early as 1862–63, and at least one scholar suggests that his introduction to them occurred in 1858 in Auguste Delâtre's workshop in Paris, where the "French Set" was printed.[33] His fascination with these works is reflected in several figure paintings of the early 1860s: *La Princesse du pays de la porcelaine* (1863–64; Freer Gallery of Art); *Purple and Rose: Lange Lijzen of the Six Marks* (1864; Philadelphia Museum of Art); and *Caprice in Purple and Gold: The Golden Screen* (1864; Freer Gallery of Art). In each a woman is surrounded with oriental prints and porcelains, fans and screens, to create an image of feminine beauty contrasted with a profusion of fashionable treasures.[34] The Eastern artworks function, in other words, as ancillary props within an old-age Western theme, still handled in a traditional Western manner. In 1866, however, he was able to integrate Eastern principles into his views of Valparaíso. His earlier work acted as a conditioning factor, to be sure. But the successful synthesis of theory and practice occurred partly because Valparaíso itself embodied certain physical and psychological parallels with the Orient, evident first in the topography of the site itself.

Valparaíso occupies the shores of a semicircular bay and the sharply ascending crescent of hills beyond. Seen from the ocean, the city presents a magnificent panorama: a great circle of hills surrounded by the snow-capped peaks of the Andes. Making one's way to the top of those hills and looking down on the water from above (today *ascensores*, or funicular railways, carry people from the lower to the upper city) presents a no less spectacular sight. At sunset, and especially after dark, the sloping sides of the far outstretching bay are covered with flickering lights that are reflected in the water below. Thus, Valparaíso's physical configuration encouraged a rethinking of space and pictorial design. The artist, we know, spent many hours gazing out the window of the English club in Valparaíso, and from the

heights of the city he could see "the beautiful bay with its curving shores, the town of Valparaíso on one side, on the other the long line of hills."[35] Taking a bird's-eye view from the summit of this natural amphitheater, the observer beholds the sharp descent to the water, docks, and ships. So nearly vertical is the plunge, in fact, that the piers and harbor architecture seem to protrude out of nowhere.

These physical details of the place had a profound effect on the paintings Whistler did there. And the vista confronting him in Valparaíso was one that, in all its essential features, conformed to the complex spatial relations of the oriental print. The plunging perspective, indistinct detail, and asymmetrical arrangement of forms are all characteristics of the Japanese print approximated by the peculiar situation of the Chilean port. This fusion of art and reality served as the starting point for one of the most important of Whistler's pictorial innovations.

Exoticism and Romanticism

Chile possessed a character that seemed to fuse several separate cultural traditions: a combination that proved especially alluring to the romantic artist. This observation raises the issue of exoticism as a constituent phenomenon of western European romanticism. As Henry Remak observed,

> Exoticism . . . is not only the discovery of a peculiarly profiled foreign civilization, it is a state of mind. The state or rather fermentation of mind will not terminate with the exploration of a particular culture: it will look for additional satisfaction of these expectations in somewhat analogous but not identical cultures elsewhere.[36]

Chile, normally as removed from Whistler's affairs as the other side of the moon, would have been conceived as "strange" and "exotic" for its geographical remoteness alone. But it took on added allure for the associations it shared with the Orient. For "it is in the Orient," pro-

claimed Friedrich von Schlegel, "that we must seek the highest Romanticism." "The East," confirmed Wilhelm Heinrich Wachenroder, "is the home of everything wonderful."[37]

Whistler's interest in oriental objects acted as a conditioning factor, or at least a symptomatic factor, in his subsequent interest in South America. In his mind one exotic locale, the East, merged with another, the Pacific coast of South America, giving rise to images of the harbor at Valparaíso that drew on precepts of oriental perspective and composition. In effect, a place came to stand for a particular concept, which was in turn discovered to exist elsewhere. Such a merging depended upon the internal factors peculiar to the romantic imagination, but the particular recombinants of the western coast of South America and the Orient depended upon external factors as well.

A sufficient number of other artist-travelers drew on Eastern analogies in their evocations of South America to suggest that this syncretism of oriental and tropical exoticism constituted an ongoing tradition to which Whistler was on some level responding. Stirred by his own study of oriental prints, Vincent van Gogh became enamored of Japan. Unable to travel there, he came to view the southern Tropics as the equivalent of the unattainable East. Moving as far south as Arles, in southern France, van Gogh cherished the notion that its topography and light were similar to the oriental landscape he had come to love. Bestowing the highest possible praise upon it, he wrote to his brother Theo that the South was "absolute Japan."[38] Even closer parallels can be cited in the pictorial images of North American travelers. Visual affinities can be detected, for example, between *View of Valparaíso* (fig. 96), by an anonymous American artist, and Chinese export paintings. Martin Heade (fig. 42) and Frederic Church (fig. 36) both created images of South American volcanoes that bear direct comparison to Hokusai's *Views of Mount Fuji*—similarities that (especially when considered in this context) demand explanation beyond the pictorial requirements of composing a landscape around a conical form. The Ameri-

can Tropics spiritually and physically suggested an Eastern locale, an observation confirmed repeatedly in the verbal and visual descriptions of the period. Heade's *Passion Flowers and Hummingbirds* (pl. 6) has a decided oriental feel, inviting comparison with the work of the twelfth-century Song painters. The visual similarity might be dismissed at that had many writers not made direct analogies to the East in their descriptions of South American nature.

This syncretism of South and East, which was attaining full-blown proportions by the mid-nineteenth century, took several forms in the literature on Latin America. At times it amounted to little more than vague parallels. In 1863, Edward Dunbar drew on one of its most familiar manifestations when he referred to "the India to the South of us." In the hands of others, specific places and monuments became disassociated from their original Eastern context and fused to Latin American locales. A provocative example of this phenomenon occurred in the writing of Ephraim George Squier. Traveling in Nicaragua with Austen Layard's *Discoveries in the Ruins of Ninevah and Babylon* (1851), he had a vision of Central American and Near Eastern motifs merging as he drifted off to sleep:

> I went back to my quarters, and lying down in my hammock, suspended beneath the corridor of the house, where the fresh breeze circulated freely, rustling the orange leaves, took up Layard's Ninevah, which had been published a day or two before I left the States. I read of winged bulls, priestly processions, and Arab bands, and in a state of half-consciousness was trying hard to make out something about the Yezidis, who would, nevertheless, mix themselves up with the marineros of the lake, and the Naides of San Migueleto, when the discharge of a cannon, and the simultaneous clang of every bell in the city, startled me to my feet.

Although Squier's vision may have been more erudite than most, continual cross-references were made to architecture as well as landscape.

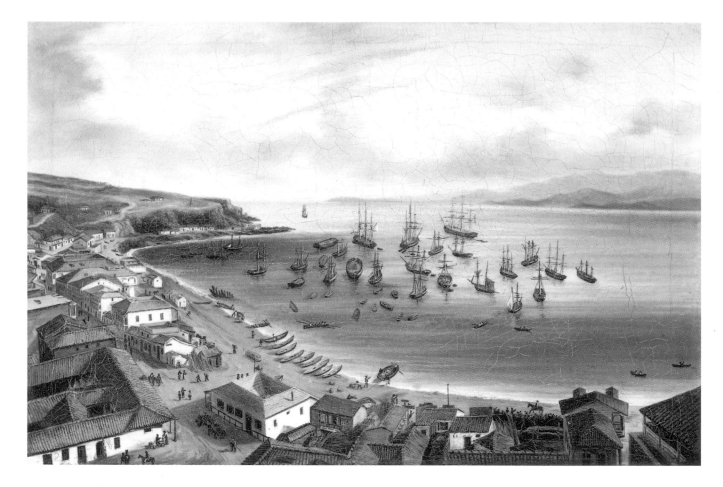

96. *Unidentified artist,* View of Valparaíso *(one of two), oil on canvas, 20 × 23 in. (50.8 × 58.4 cm). U.S. Naval Academy Museum, Annapolis, Maryland.*

Everywhere in Latin America the signs of an Eastern presence can be felt. The mix of East and West was inherent in the Spanish culture that dominated its metropolitan centers. A visitor to Bogotá, Lima, or Santiago de Chile was surrounded by remnants of Spanish culture that, as Washington Irving observed, was a "mixture of the Saracenic with the Gothic, remaining from the time of the Moors."[39] Spanish art and architecture, which had all but extinguished the pre-Columbian motifs of the indigenous peoples, exhibited a distinct Moorish influence. Thus the sight of a colonial church, often built in the mudejar or Moorish style, negated all associations with the Christian West; instead, its bold stripes and allover surface ornamenta-

tion recalled the richness of an oriental carpet and reinforced the traveler's notion of having been transported to the mysterious East. Like Irving in Spain, the visitor to Latin America must have been "more than once struck with the incidents and scenes in the streets, that brought to mind passages in the *Arabian Nights*."[40]

Similarly, the landscape conjured up parallels to Eastern scenery. One author linked the lowlands of Central America to a fantastically eroded Chinese landscape. Elizabeth Agassiz, finding herself in a garden in Rio de Janeiro, noted that "there were cocoanut and banana trees in fruit, passion vines climbing over the

house, with here and there a dark crimson flower gleaming between the leaves." The overall effect was "half Southern, half Oriental."[41] Church's self-designed villa overlooking the Hudson River, Olana, can also be seen in this light: a merging of South American and Near Eastern motifs that for decades provided the stimulus for his life and art.

Other artists made this conceptual link between Latin America and the Orient in various ways. One of the most obvious is in the travel patterns that can be detected over the course of their careers. Many followed their South American expeditions with excursions to the East and not, as is often mistakenly assumed, to the American West. Catherwood, Church, and Ferguson all frequently rendered both Latin America and Eastern subjects, but they rarely depicted the European scenery with which they were familiar and showed no interest whatsoever in heading west. Mignot, who planned to follow up his trip to Ecuador with another to India (although he was unable to go) might be added to the list, along with Humboldt, Squier, Stephens, and Heine.[42] In 1852, soon after he returned from Nicaragua with Squier, Heine departed with Commodore Perry as an official artist on his expedition to Japan. He therefore can be credited with important early renderings of Japan as well as Central America; they must have made a curious sight in the spring of 1857 hanging side by side in his studio. His career therefore epitomizes the links between Latin America and the East that he and his fellow artists sensed.[43]

The Orientalizing of the New World

On 12 October 1492 Columbus arrived at a small island he believed to be one of a group in the neighborhood of Japan. This event, as we now interpret it, resulted in the discovery of America. It was also the first important step in what might be called the orientalizing of the New World: the process whereby its lands, inhabitants, and pre-Columbian monuments were viewed and described according to Eastern models. When Columbus sailed from Palos, as every schoolchild knows, he was bound for Cathay, the land of fabulous wealth and spices. His expectations of the lands he would find were based on the reports of the many Europeans who had preceded him to the kingdom of the Great Khan. His voyage differed from theirs in only one critical respect: he headed west to reach the East, and in so doing stumbled upon what came to be known as the West Indies and America.

Columbus's mental image of the lands he was headed for derived primarily from accounts of the Orient by Marco Polo and Sir John Mandeville. As his writings reveal, he was always attentive to the similarities between the places he came upon and those mentioned particularly by Marco Polo. His descriptions of the realities of American peoples and nature are inevitably couched, therefore, in terms of Eastern prototypes. In referring to the natives, for example, he wrote on 12 November 1492, "I repeat then what I have said on several occasions, that the Caniba is no other thing than the people of the Grand Khan who must indeed be near to this place."[44] Indians, gold, flora, and fauna were all viewed through the lenses of Marco Polo's antecedent authority.

Following Columbus, the Spanish conquistadores who pushed their way into Mexico and Peru sent back reports of Aztec and Inca civilization rife with analogies to Islam. Cortés referred to Aztec temples as "mosques," and Bernal Díaz, a soldier in his service, described the Mexican palaces and gardens in terms of Moslem splendor. These analogies to the East were perpetuated in the nineteenth century by writers such as Irving and Prescott, whose *History of the Conquest of Mexico* insistently repeats this theme: "The Aztec . . . races were advanced in civilization very far beyond the wandering tribes of North America. . . . In [that] respect . . . they may have been better compared with the Egyptians." Prescott particularly cited their pyramidal temples (fig. 45) as evidence of "stronger points of resemblance to that ancient people." Observing that

"the Aztec princes . . . lived in barbaric pomp, truly Oriental," he pinpointed an essential ingredient of his age's fascination with the native inhabitants of Latin America. And of course the very name *Indian* forever reflects Columbus's mistaken notion that he had reached the East Indies. Thereafter the physical appearance, customs, architecture, and ultimately the racial origins of the New World inhabitants were traced back to the venerated tradition of the East. Lord Kingsborough had attempted to identify the South American Indians as the long-lost tribes of Israel, and the notion that the inhabitants of America had, at some far anterior time, migrated from the East was maintained until late in the century. Parallels were frequently drawn between the temple pyramids of the Mayas and the great monuments of Egypt, just as their system of hieroglyphic writing was likened to its Egyptian counterpart. This belief even led artists to distort the appearance of the South American Indians, giving them the physiognomy of an Oriental or Mongoloid. Catlin, who had devoted more than fourteen years of his life to portraying the appearance and manners of the Indians of both North and South America, protested against this not infrequent practice:

> Some travellers through South America, as if to aid the theory of Asiatic emigration, have represented the tribes of the Upper Amazon with "bridled" eyes, like the Chinese, and even characterized the Chinese obliquity, and put these more than Chinese peculiarities forward as "types." But I have seen most of the tribes on the Amazon and its affluents, and . . . they exhibit nothing of the Mongol general character of face, nor Mongol obliquity of eye.[45]

Thus, the nineteenth-century image of South America—of its landscape, people, architecture, and even its ultimate origins—was historically tied to that of the Orient. The revival of the canal project provided another, physical link in this chain of associations, for a waterway would provide direct access through Latin America to the East. Characterizing Central America as the "key to the continent, destined to unlock the riches

of two hemispheres," Squier spoke for the many who saw the entire region as the legendary passage to the Indies:

> To us is given, in this modern time, the ability . . . of acquiring the rule of the East, . . . of transferring into our unarmed hands that passage for which Columbus strove in vain, . . . that vast and incalculable trade upon which is mainly based the maritime power of England. . . . Our trim built fairies of the deep . . . sweep in the trade of Europe on one hand, and on the other bring to the mouth of the Sacramento the treasures of the Oriental world.[46]

The nexus of associations between Latin America and the East was drawn even tighter in 1852—the year Squier wrote these words—when Commodore Perry departed in his "black ships" for Japan. From 1640 until the 1850s the Japanese archipelago was almost entirely isolated from the outside world, and only the Chinese and the Dutch were permitted to conduct limited trade. This restriction was closely maintained until 1854 when, as a result of Perry's visit, a treaty opened up Japan to the United States; and in 1858 permission was extended to Britain and France. By 1865 trade had begun to flow more freely, and with the abdication of the Shogun in 1867, Japan's political and social relations with the West entered a new phase. It is not without significance, therefore, that Whistler strategically situated himself in the South Pacific at the very moment when the dream of travel to the East was finally becoming a reality; he might even have contemplated continuing on from Chile to Japan. Located on the Pacific coast of South America, Valparaíso was the perfect jumping-off place for transport and commerce to and from the East. Certainly the nocturnes he created there depend upon a leitmotif that threaded its way down through history: the fundamental symbolic theme of the Americas as the meeting place of East and West, which brings us around full circle to Columbus and the geographical myths that began this study.

Biographies and Itineraries of Artist-Travelers

BOGGS, WILLIAM BRENTON (1809–1875)

Born 1809 in New Brunswick, New Jersey, into a family with a strong military tradition. In 1839 began exhibiting landscape paintings at the National Academy of Design and elsewhere, and continued to do so occasionally throughout career. He became a civilian clerk in the Department of the Navy in 1842. Commissioned in 1852, he served as purser and artist on various tours of duty: 1852–56 on USS *Vincennes* on Pacific Survey Expedition; 1856–59 with USS *Plymouth*; 1859–61 on USS *Wyoming* with Pacific Squadron; 1862 with Bureau of Provisions; 1862–64 with Mississippi Squadron, Western Flotilla. Boggs made pencil and watercolor drawings of places visited, including South America. While on the Pacific Survey Expedition he became friends with fellow artist E. M. Kern, who

gave him many of his drawings. In 1864–73 stationed in Washington, D.C., where he died 1875.[1]

BURKHARDT, JACQUES (1808–1867)

Born 1808 in Hasle-bei-Burgdorf, Switzerland, Burkhardt studied painting and drawing in Munich and Rome. In 1839–45 he was among twelve scientific draftsmen working under the young Louis Agassiz at Neuchâtel. He then joined a Belgian expedition to Guatemala and, when that quickly failed, was dismissed in New York. Moved to Boston, where he was earning a meager living as an illustrator when in winter 1846–47 Agassiz coincidentally arrived. Accepted invitation to work for him, doing natural history illustrations for his lectures and publications, and remained in his employ

until his death. Became permanent member of his household, even after Agassiz's marriage to Elizabeth Cary in 1850, spending winters in Cambridge and summers in Nahant. In 1861–62 made trip to Europe, delivering specimens for Agassiz and drawing and painting objects in European collections. In 1865–66 Agassiz's official artist on Thayer Expedition to Brazil, where he made hundreds of drawings of fish specimens and many landscape views. In Brazil he fell ill and had to return prematurely to Cambridge, where he died February 1867. Burkhardt's drawings from the expedition, in the archives of the Museum of Comparative Zoology, remain largely unpublished.

ITINERARY. (Note: The expedition often divided into several exploring parties and followed different routes; details provided here apply to Burkhardt, who remained in Agassiz's party.) On 1 April 1865 departed New York harbor for Brazil in the position of Agassiz's artist on the Thayer Expedition. On 22 April arrived in Rio de Janeiro, where the party remained for approximately three months, preparing for their exploration of the Amazon. On 25 July, on the steamer *Cruzeiro do Sul*, sailed up the coast, stopping on 28 July at Bahia (Salvador) and on 31 July at Pernambuco (Recife) before arriving on 11 August at Pará (Belém), at the mouth of the Amazon. On 20 August began the ascent of the Amazon on the steamer *Icamiaba*. 26 August at Santarém, at mouth of the Tapajós River. On 5 September passed through Manaus on the way to Tabatinga, a frontier town between Brazil and Peru, which they reached 20 September. By 25 September in Tefé, where they spent about one month. On 23 October back in Manaus, their base, from which they made short excursions. On 27 December departed Manaus to ascend the Rio Negro as far as Pedreira, and then returned. On 15 January began descent of river to the coast; 4 February arrive at Pará. It must have been around this time that Burkhardt left the expedition due to illness to return to Boston; Agassiz's *Journey in Brazil* makes no mention of his departure, but Theodore Lyman recorded seeing him 9 March in Cambridge. The rest of the expedition made their way back slowly to Rio de Janeiro, from which they sailed for the United States on 2 July; arrived 6 August 1866.[2]

BUSH, NORTON (1834–1894)

Born 1834 in Rochester, New York, Bush studied art with local painter James Harris. In 1850 he moved to New York City and worked under Jasper Cropsey 1851–52. He maintained a studio in the city until 1872, when he settled permanently in San Francisco. Bush traveled to Latin America on three occasions during his career. In 1853 he set off for California, as tradition has it, by way of Vanderbilt's route through Nicaragua. In 1868, on a commission from San Francisco banker and art patron William C. Ralston, he painted scenes related to Ralston's business interests in Central America; he may have traveled to South America as well. In 1875 he made a third and final trip, to Peru, where he painted scenes of the railway Henry Meiggs had recently constructed high in the Andes; he also apparently visited Ecuador. Bush's later career in California included activities in the San Francisco Art Association and the Bric-a-Brac Club of that city. He became known as California's premier painter of the Tropics. He died in 1894.[3]

CARLETON, GEORGE WASHINGTON (1832–1901)

Carleton was a caricaturist and publisher. Born in New York in 1832, as a young man he worked as a clerk for Burnham, Plumb, and Co., an import and commission house. At the same time he began to do caricatures for periodicals such as *The Lantern* and *The Picayune*. In 1857 he became a partner in the publishing firm of Rudd and Carleton, which by 1861 became G. W. Carleton and Co. His house printed a wide selection of titles but specialized in humorous books, sometimes illustrated by Carleton. Trips made during the winter months provided the subjects for collections of witty

sketches, published with short commentaries. He visited Cuba and Peru (mainly Lima), and subsequently published *Our Artist in Cuba. Fifty Drawings on Wood: Leaves from the Sketch-Book of a Traveller, during the Winter of 1864–5* (1865) and *Our Artist in Peru: Leaves from the Sketch-Book of a Traveller, during the Winter of 1865–6* (1866). He always made his mark with the sign of a bird. He died in 1901.

ITINERARY. Winter 1865–66 sailed from New York to Panama on the steamship *Henry Chauncey*; crossed the Isthmus by Panama Railroad; sailed from Taboga (island off Panama) by the English steamship *Chile* to Callao. Stayed in the vicinity of Lima; returned home presumably by the same route.[4]

CATHERWOOD, FREDERICK (1799–1854)

Born 1799 in London, Catherwood was apprenticed 1815–20 to architect Michael Meredith. In 1820 attended free art classes at the Royal Academy, where Sir John Soane lectured on architecture and introduced him to the work of Piranesi. In 1821–25 traveled to Rome, Sicily, and Greece, and up the Nile. In 1825–28 again in London, practicing architecture. In 1828 with Robert Hay's expedition in Egypt to investigate and map ruined sites. In 1835 in London, trained by Robert Burford as a panoramist; worked with Burford on a panorama of Jerusalem, followed by murals of Thebes, Karnak, and the ruins of Baalbek. In 1836 met John Lloyd Stephens and went to New York, where he formed a partnership with architect Frederick Diaper. Completed his own rotunda for panoramas at Broadway and Mercer Street, the first and only permanent one in New York. In 1839–45 exhibited frequently at the National Academy of Design. In 1839 he and Stephens went to Yucatán and Central America to seek out Maya ruins. Illustrated Stephens's *Incidents of Travel in Central America, Chiapas, and Yucatán* (1841). In 1841 to Yucatán with Stephens, a trip that resulted in a second illustrated account, *Incidents of Travel in Yucatán*

(1843). In 1844 published *Views of Ancient Monuments in Central America, Chiapas, and Yucatán*, which contained twenty-five folio hand-colored lithographs, with a brief essay by Catherwood. Went to South America to make a railway survey. In 1850 moved to California; 1852 to London. On his return from London to New York in 1854 his ship the SS *Arctic* sank, and Catherwood drowned.

ITINERARY. First trip: 1839–41 (traveling companion, John Lloyd Stephens). On 3 October 1839 Catherwood and Stephens sailed from New York on the British brig *Mary Ann*; landed in Belize. After a short stay headed for Guatemala City on the vessel *Vera Paz* via Rio Dulce and Lake Isabel. By mule they ascended the Mico Mountains; followed Rio Motagua, passing through Gualán, Zacapa, Chiquimula, and Comatán (where they were detained in prison briefly). On 17 November 1839 began their archaeological work at Copán. On 30 November Stephens departed Copán to perform diplomatic duties while Catherwood stayed behind. In April 1840 Stephens had rejoined Catherwood, and they set off to Palenque (state of Chiapas, Mexico). By 14 April at Lake Atitlán; headed northwest across Guatemala by mule; at Huehuetenango they met the American Henry Pawling, who joined them for the remainder of their expedition. On 30 April crossed border into Comitán, a frontier town of Chiapas; in early May, having crossed an excruciatingly difficult stretch of terrain, they arrived at Palenque. On 1 June they quit the ruins at Palenque; traveling north, descended Usumacinta River to the coast; went by sea to Sisal. They then headed for Uxmal, where Catherwood was only able to make a few sketches before he collapsed from an attack of malaria. On 24 June Catherwood and Stephens aboard the Spanish brig *Alexandre*, bound for Havana, when they were intercepted by a ship bound for New York. End of July 1840 arrived in New York.

Second trip: 1841–42 (traveling companions John Lloyd Stephens and Dr. Samuel Cabot). On 9 October 1841 they secured passage on the *Tennessee*, bound for Sisal in Yucatán; brought extensive daguerreotype

equipment. Spent a brief time in Mérida before leaving for Uxmal. There they worked incessantly recording the ruins until each one in turn succumbed to fever; Catherwood was the last, and he worked furiously until 1 January 1842. Next they explored Kabah and a series of other sites as they rode southward toward the Campeche border; then they went east, and at Macobá turned north toward Chichén Itzá, where they worked from 11–29 March 1842. Departed Sisal for Havana and sailed from there on 4 June for New York.[5]

CATLIN, GEORGE (1796–1872)

Born 1796 in Wilkes-Barre, Pennsylvania, Catlin studied law before setting up his studio as a portraitist in Philadelphia. He worked there until 1825, when he moved on to New York State. In 1830–36 he traveled in the American West, where he began his life's work of portraying the American Indians. In 1839 he took his collection of Indian paintings to Europe, where he remained, except for his years in South America, until 1870. In 1845 in Paris he met Alexander von Humboldt and other European scientists and explorers, who must have excited his interest in tropical exploration. In 1852 he decided to go to South America after the loss of his Indian Gallery due to mounting debts. He traveled across much of the continent until 1857, with a short return trip to Europe about 1855. His tropical works were "cartoons," or sketches, which never had the widespread public exposure his earlier images of the American West enjoyed. In 1870 he returned to the United States, where he briefly exhibited his collection in New York and Washington, D.C. He died in 1872.

ITINERARY. First expedition, c. 1852–55. In c. 1852 sailed from Le Havre to Havana, where he apparently took into his employ a black slave, Caesar Bolla, who traveled with him. From Havana to Caracas, Venezuela; descended the Orinoco River, and then took a steamer to Georgetown, Guiana, where he surveyed the surrounding area. Joined in Georgetown by an Englishman, Smyth, who traveled with him as far as Belém. Claimed that because of border disputes between Guiana and Brazil, had to travel under an (unknown) assumed name; later reverted to George Catlin. Had intended to ascend the Essequibo River to the base of the Acarai (or Crystal) Mountains in Brazil, but left the river below the great cataract and passed by mule across the mountains. Then followed the Trombetas River and descended to the Amazon, passing through Santarém and Belém (Pará), its great port. Possibly made a side trip up the Tocantins and Xingu rivers, two southern tributaries of the Amazon. Then took a river steamer to Manaus and Tabatinga, on the frontier border with Peru and Colombia. This was his jumping-off point for an extended tour of the Pampa del Sacramento (or western Mato Grosso), where he arrived sometime in 1853. From there he reported that he went to Nauta, Peru, by boat along the Amazon and Ucayali rivers, then crossed the Andes to Lima. He sailed from Lima to British Columbia and traveled through the western areas of North America. In 1855 he caught a ship at Matamoros, Mexico (just on the Texas border), which made a stop at Sisal, on the Yucatán peninsula, before he returned to Europe. He apparently consulted with Humboldt in July 1855.

Second Expedition, 1856–57. (For a useful comparison with Catlin's travels in Argentina and Paraguay see the expedition report of Thomas Page, who was in this region 1853–56 and may have met him there.) After consulting with Humboldt and attending to a few other matters, sailed from Le Havre to Rio de Janeiro and Buenos Aires. By June 1856 he left Buenos Aires in search of the Indians of the Pampas and Gran Chaco. Initially he traveled on the Paraná River to Corrientes, from which he ascended to Candelaria (near present-day Posadas). After crossing the mountains into Uruguay he arrived at Concepción, then descended the River Uruguay; met Aimé Bonpland, Humboldt's South American traveling companion, who lived there. Continued along the river as far as the mouth of the Rio Negro, then on to Buenos Aires, having made a complete circle. An invitation took him to an estancia on the

97. *Frederic Church*, Morning in the Tropics, *1858*, oil on canvas, *8¹⁄₄ × 14 in. (21 × 35.6 cm). Walters Art Gallery, Baltimore (37.147)*.

Salado River in the Auca country. But the threat of war between the Argentine government and the Patagon Indians cut short his visit; he sailed from Buenos Aires through the Strait of Magellan, which allowed him to stop in Patagonia; he eventually reached Panama and crossed the Isthmus by rail. In Venezuela stopped at Caracas and Maracaibo; also visited Santa Marta, on the coast of Colombia, before returning to Europe.[6]

CHURCH, FREDERIC EDWIN (1826–1900)

Born 4 May 1826 in Hartford, Connecticut, the son of a wealthy businessman. Received training from local artists Benjamin A. Coe and Alexander H. Emmons. In 1844–46 studied with Thomas Cole, Catskill, New York. In 1850 first trip to Mount Desert Island, Maine. In 1853 to Colombia and Ecuador. In 1857

Niagara established his reputation. In 1857 to Ecuador. In 1859, in pursuit of icebergs, traveled to Newfoundland and Labrador with Louis Noble. In 1865 to Jamaica with Horace Walcott Robbins, Jr. In 1867–69 made an extensive tour of Europe and the Near East with his family. In 1869 began designing Olana, his villa of oriental design, in Hudson, New York. In later years, inflicted with inflammatory rheumatism, his painting activity declined. Spent winters in Mexico, summers alternating between Maine and Olana. Died 7 April 1900 in New York City.

ITINERARY. First trip: 1853 (traveling companion, Cyrus Field). On 8 April set sail from New York; 28 April arrive Barranquilla, Colombia, where they waited until 10 May for a river steamer to take them up

the Rio Magdalena. On 2 May began to keep journal in Spanish; 10–23 May ascended Magdalena by steamer to Conejo, the terminal of steam navigation, making the following stops: 11 May, Remolino; 12 May, Mompós; 17 May, Nares; 21 May, Conejo, where they waited two days for smaller river craft, which took them to Honda. From 23 to 31 May at Honda, waiting for baggage to catch up with them; 31 May–4 June mule trip from Honda to Bogotá; 4 June–8 July in Bogotá, except for two trips to Tequendama Falls (20–25 June and 29 June–1 July); 9–22 July by mule from Bogotá to Cartago, by way of Fusagasugá (where the Spanish journal ends on 9 July), Pandi, Melgar, Ibagué, and the Quindío Pass; 22–25 July in Cartago, on Rio Cauca; 25–30 July from Cartago they proceed up the Cauca Valley through Obando, Buga, and Palmira to Cali; 31? July–8 August from Cali to Popayán; 8 August attempted to ascend Puracé; 9–20 August from Popayán through the valley of the Rio Patiá to Pasto; 21?–24 August from Pasto by way of Túquerres to the border of Ecuador; 24 August began diary in English. On 25 August crossed river separating Colombia from Ecuador; 25–30 August to Quito by way of Ibarra and Otavalo; 30 August–8 September in Quito; 9–14 September from Quito to Riobamba, passing through Machachi, Latacunga, and Ambato; 15–21 September traveled through Riobamba, San Juan, Guaranda to Rio Guayas; 22–29 September after two days on the Rio Guayas reached port city of Guayaquil, where they remained six days; 30 September–5 October traveled on steamer *Bogotá* from Guayaquil to Panama; 5–18 October in Panama, passed time waiting for steamer; 18–29 October at sea on steamer *Ohio*, which returned them to New York harbor six months and twenty-one days after their departure.

Second trip: 1857 (traveling companion, Louis Mignot). On 15 May left Panama Bay for Ecuador; 23 May at Guayaquil; 29 May on the Guayas River and then proceeded to San Miguel (2 June) and Guaranda, in the vicinity of Mount Chimborazo; 3–14 June in Guaranda and Guanajo; 15–17 June Mocha and Machachi, sketching Chimborazo; 23 June (or before)–2 or 3 July in Quito, from which they made excursions to the surrounding mountains; 26–27 June at Pichincha and Cayambe; 2 or 3–9 July from Quito to Riobamba, where they spent two days preparing for excursion to Sangay; 9–13 July excursion to Sangay volcano, during which he kept an extensive journal; 13–21 July Riobamba and Guaranda. Huntington gives: 23 July "near Jorge," on the descent to the coast; 24 July on Rio Guayas, the last inscription to appear in his sketchbook. By the end of the month they were undoubtedly making their way to Panama, and on to New York.[7]

DREXEL, FRANCIS MARTIN (1792–1863)

Born 1792 in Dornbirn, Austria; sent to Italy for his education, which was interrupted by the Napoleonic Wars. In 1809, in an effort to avoid conscription into the army, Drexel fled to Switzerland, and he remained away more than five years. In 1817 sailed for the United States; in Philadelphia worked as a portraitist and drawing instructor. As a result of a protracted libel suit, his portrait commissions began to drop off. In 1826 he departed for South America, where he planned to sell portrait prints and paintings of Simón Bolívar. Landed in Guayaquil, Ecuador, and traveled in Peru, Bolivia, and Chile. On 10 January 1830 sailed for Philadelphia. In 1835 made painting excursion to Mexico. In 1837, after his return, he began what became a successful career in finance and gave up painting. The house of Drexel & Co. became one of the most important banking concerns in the country before his death in 1863 in Philadelphia.

ITINERARY. Departed 15 May 1826 on brig *Navarre*; in Guayaquil, Ecuador, by mid-September. On 21 December landed in Callao, then on to Lima, where he remained the next seven months. On 7 July 1827 sailed to Valparaíso; worked there and in Santiago until the following spring. Then began to work his way

98. Henry Ferguson, Chili, c. 1873, oil on canvas, 16 × 12 in. (40.6 × 30.5 cm). Collection of Lucille and Walter Rubin.

back north, landing at the Chilean port of Coquimbo on 10 April 1828 and at Arica on 26 July. Decided to make an expedition to the interior; crossed the Andes via pass at Cumba, arriving 20 September at La Paz. There were few commissions to be had there, however, and he headed back to the coast via Tiahuanaco and Puno, on Lake Titicaca. On 31 October at Arequipa, Peru, where he resided for eight months. By now sick of the difficulties of travel, he resolved to leave South America. On 14 July 1829 he returned to Valparaíso, where he continued to seek commissions until 10 Janu-

ary 1830, when he set sail for home by way of Cape Horn, and on 8 April dropped anchor at Baltimore.[8]

FERGUSON, HENRY AUGUSTUS (1842–1911)

Ferguson was born 1842 in Glens Falls, New York. In 1860 he moved to Albany to join an older brother in the wood engraving business, and there had his first training in art from Homer Dodge Martin. About 1862 he moved to New York, and in 1867 began to exhibit at the National Academy of Design. Inspired by the work of Church, Ferguson explored South America c. 1870–73. He was known to exhibit and sell his work in Chile and elsewhere in South America. He seems to have returned home by way of Europe, where he worked mainly in Venice for three years. Before returning to the United States in 1879, he also made a stop in Egypt. In 1881 Ferguson traveled to Mexico, and in 1884 returned to Europe. He was elected an associate of the National Academy of Design in 1884. Nearly fifty of his works were included in an exhibition of American landscape painting by members of the Century Association in 1911, the year of his death.

ITINERARY. Departed for South America 1870 and remained there until about 1873, visiting Ecuador, Peru, and Chile; few precise details are known. He was in Riobamba on 24 August 1872.[9]

FLAGG, HENRY COLLINS (1811–1862)

The brother of George W. and Jared B. (Washington Allston's biographer), Henry was born in 1811 in New Haven and spent part of his childhood in South Carolina. In 1827 he entered the U.S. Navy; 1832 he returned to New Haven and took up painting, but later resumed his naval career. He often exhibited pictures at the Boston Athenaeum and the National Academy of Design (NAD), which were derived from sketches

99. *Martin Heade,* South American River, *1868, oil on canvas, 26 × 22¹/₂ in. (66 × 57.1 cm). Museum of Fine Arts, Boston, M. and M. Karolik Collection.*

made on his tours of duty, including *Peruvians, with a View near Lima* (unlocated; NAD 1837). He died in 1862 in Jamestown, New York, just after receiving the rank of commander.¹⁰

HEADE, MARTIN JOHNSON (1819–1904)

Born 1819 in Lumberville, Pennsylvania, the son of a prosperous farmer and lumber mill proprietor. In 1838 he worked briefly with local primitive painter Edward Hicks and possibly also with his nephew, Thomas Hicks, a portraitist, before leaving for Europe. Spent two years in Rome and visited England and France. In

1848 returned to Rome and probably Paris. From 1838 to 1855 he led a peripatetic life, living in St. Louis, Chicago, Trenton, Providence, Newport, Boston, and New York. Earliest dated landscape 1855; 1859 moved to New York, where he began lifelong friendship with Church. In the 1860s began painting marsh scenes, first in Newburyport, Massachusetts, and later in New Jersey. In 1863–64 traveled to Brazil, especially Rio de Janeiro, where he painted his first hummingbird paintings. By June 1865 he was living in London, where he hoped to publish an illustrated volume of hummingbirds, *The Gems of Brazil*; this project was never completed. In June 1866 made the preparations for his trip to Nicaragua and Colombia. In 1870 made his third Latin American expedition, traveling to Colombia, Panama, and Jamaica; by May back in New York. In 1871 painted his first dated orchid and hummingbird images. In 1875 to California. In 1880 began to publish in *Forest and Stream*, eventually contributing more than one hundred letters to the editor. In 1883 married Elizabeth Smith and in 1884 moved permanently to St. Augustine, Florida. In the 1890s created his series of reclining flowers, the culmination of his work in floral still life begun in the 1860s. Died 1904 in St. Augustine.

ITINERARY. First trip: 1863–64. By late 1863 in Brazil; on 30 March 1864 awarded the Order of the Rose by Emperor Dom Pedro II. Exhibited a group of paintings (*Landscape; Flowers and Fruit; Sunset;* and *Gems of Brazil*) at the academy in Rio de Janeiro and then at the Salon of Fine Arts there. By June 1865 was in London.

Second Trip: 1866–67. By June planning a trip to Nicaragua and Colombia; exact date of his departure undetermined. About February returned to New York, where he exhibited scenes from Nicaragua.

Third trip: 1870. By January at Ciénaga, Colombia; also visited Barranquilla. Then headed for Jamaica; arrived at Kingston 24 February. In early March at Colón, Panama; by 26 May back in New York. (Since Heade made a trip to California from

March through June 1875, the possibility also exists that he passed across the Isthmus on his outward or return trip; to date this remains speculation.)[11]

HEINE, PETER BERNARD WILHELM (1827–1885)

Born 1827 in Dresden, Germany, Heine studied at the Dresden Academy and subsequently worked as an architectural and scene painter for the court theater of his native city. In 1849 he emigrated to the United States as a result of political turmoil in Europe, aided by Alexander von Humboldt. In 1851, soon after arriving in New York, he met Ephraim George Squier and traveled with him as draftsman to Nicaragua. Sent back letters and drawings describing the pre-Columbian antiquities to the American Art-Union, which published them in their bulletin. In 1852–55 accompanied Matthew Perry as principal artist on the expedition to Japan. Subsequently published illustrated accounts of the expedition in English and German. Also illustrated travel accounts by other authors. In 1850–59 exhibited views of the Alps, Nicaragua, Japan, China, and North America at the American Art-Union, the National Academy of Design, Washington Art Association, and elsewhere. May 1855 became a U.S. citizen. In 1856 he exhibited a panorama of China and Japan in New York. In 1859 he returned to Europe, stopping in Dresden on his way to join the Prussian expedition to East Asia, where he traveled in 1860–61. With the outbreak of the Civil War he returned to the United States and joined the Union army; 1868 he was promoted to the rank of general. In 1866 he was appointed consular clerk of the United States and served at consulates in Paris, Florence, and Liverpool until August 1871. Died 1885 in Loessnitz, near Dresden.[12]

HITCHCOCK, DEWITT CLINTON (ACTIVE 1847–79)

Draftsman, working 1847–50 in Boston, 1850–51 in Cincinnati, and 1852 again in Boston. In 1853 traveled with Squier to Central America; made a number of landscape views, which he lithographed for Squier's *Notes on Central America* (1855). Subsequently lived in New York and worked for *Harper's*, *Illustrated American News*, and other periodicals.

ITINERARY. February 1853 sailed from New York; by April began field operations in Nicaragua, especially San Salvador and Honduras, with Squier and the other members of his expedition: Lt. W. N. Jeffers and Dr. S. W. Woodhouse. Returned approximately a year later to New York.[13]

MCDONOUGH, JAMES (C. 1820–1903)

A landscape painter, illustrator, and bank-note engraver, McDonough traveled with Squier to Nicaragua in 1849–50. Upon his return he exhibited paintings of the region but apparently had little success with them. He presumably continued to live in New York and to work as a bank-note engraver. In 1879 he exhibited a view of Peru, where he may have visited in the interim, at the National Academy of Design; and in 1888 he exhibited a scene in Central America. He served as president of the American Bank Note Co. from 1887 to 1896 and died in 1903.

ITINERARY. (Squier provided the following itinerary in *Nicaragua*; it is presumed that McDonough traveled with him.) On 11 May 1849 departed New York bound for San Juan de Nicaragua on the brig *Francis*; having landed on the Atlantic coast, traveled inland by river to San Carlos, near the shore of Lake Nicaragua; eventually reached Granada, at the northern end of the lake; pushed on to Managua and then León, on the Pacific. Also visited San Salvador and Honduras before bidding farewell to Central America on 26 June 1850.[14]

MIGNOT, LOUIS REMY (1831–1870)

Mignot was born in 1831 in Charleston, South Carolina, of Huguenot extraction. Although his family background still remains something of a mystery (at

100. Louis Mignot, Tropical River Landscape, *1857, oil on canvas, 21 × 39 in. (53.3 × 99 cm). Private collection.*

least one early biographer identifies him as a Creole), he was probably the son and namesake of a confectioner of that city. His boyhood, during which he demonstrated a precocious artistic talent, seems to have been spent in his grandfather's home, near Charleston. In 1851 he left for Holland and studied for four years with Andreas Schelfhout at the Hague. He also traveled around Europe before he returned to the United States to settle in New York, where he received the praise and support of numerous critics, patrons, and fellow artists. In the summer of 1857 he accompanied Church to Ecuador and there he found the scenery that provided a major subject of his subsequent work. Shortly after the outbreak of the Civil War, with anti-Confederate feelings prevailing in the Northeast, Mignot held a sale of his paintings and on 26 June 1862 departed aboard the *Great Eastern* for England. A resident of London for the remainder of his life, he exhibited regularly at the Royal Academy and elsewhere. Trips in 1868 and 1869

to Switzerland resulted in a number of Alpine scenes. In 1870 on a trip to Paris he contracted smallpox and died in 1870 in Brighton, England. An important exhibition of his collected works, organized by his widow, was held in London and Brighton in 1876.

ITINERARY. See Church, 1857.[15]

MONTALANT, JULIUS O. (C. 1823–1878)

Montalant was born in Virginia, probably Norfolk, about 1823. Attached to the USS *St. Louis*, East India Squadron, c. 1844–45; sketched ports-of-call, including nine drawings of Brazil, Chile, New Zealand, Australia, and China now in the Museum of the U.S. Naval Academy. Navy records indicate his rank as "C.

Clerk," which may have been a civilian position; earlier he had served on the brig *Perry*. From about 1850 to 1858 he lived in Philadelphia. In 1851–61 exhibited at the Philadelphia Art Union and the Pennsylvania Academy of the Fine Arts landscapes of North America, Greece, China, France, Italy, and South America (the tropical scenes were apparently based on sketches done on board the USS *St. Louis*). October 1858 applied for a passport and soon thereafter departed for Rome. In a catalogue of 1864 Montalant was listed as a pupil of J. B. Durand-Brager. He made Rome his headquarters until his death in 1878.

ITINERARY. On 22 February 1845, Sydney, Australia; 3 March, Bay of Islands; 24 March, Auckland, New Zealand; between April and June, Valparaíso; 23 July, Rio de Janeiro.[16]

NAHL, CHARLES CHRISTIAN (1818–1878)

Born in Germany in 1818, Nahl received early artistic training in his homeland, and in Paris under Horace Vernet. Like Heine, Nahl came to the United States about 1849. He arrived in New York with his family and by 1851 had moved to San Francisco, traveling by way of the Isthmus of Panama. He kept a pictorial diary of the journey, including their boat trip along the Chagres River. In San Francisco he painted tropical scenes and views of pioneer life in California. Around 1876 he did a number of hummingbird pictures, including the one now in the Stanford University Art Museum; presumably they reflect the influence of Heade's visit to California in 1875. Also he and his younger brother Arthur made drawings for wood engravings reproduced in books and periodicals. An article by Julius Pratt published in *Century Magazine* in 1891 was illustrated with Nahl's Panama sketches, engraved by Gilbert Gaul. He died in 1878.

ITINERARY. In c. 1851 traveled from New York to San Francisco via the Chagres route across the Isthmus of Panama; few details are known.[17]

PEALE, TITIAN RAMSAY (1799–1885)

Born 1799, Titian was the youngest son of Charles Willson Peale, patriarch of the well-known family of artists in Philadelphia. At age seventeen elected a member of the newly formed Academy of Natural Sciences. His interest in insects brought him to the attention of John Say, renowned entomologist, who included some of Peale's work in his *American Entomology*. In 1817 joined Say on a collecting trip to Florida and in 1819 was chosen assistant naturalist to accompany the government-sponsored survey of Stephen Harriman Long to the Rocky Mountains. In 1830–32 he continued his exploring activities with William McGuigan on a privately sponsored expedition to South America. In 1838–42 Peale circumnavigated the globe as the official zoologist of the U.S. Exploring Expedition, headed by Charles Wilkes. Disputes between Peale and Wilkes marred the trip; in 1848 Peale was discharged from the scientific corps and his zoological report was repressed due to the dissatisfaction of Wilkes with its contents. His report was later replaced with ornithologist John Cassin's interpretation of Peale's data. Many of the drawings and oil sketches he made in South America and elsewhere were consequently omitted from the official publications of the expedition. Peale never regained his former standing among colleagues. In 1849 he joined the Patent Office, Washington, D.C., where he worked as an examiner for the next twenty-five years. He died in 1885.

ITINERARY. Departed in 1830 for South America; explored mainly Colombia, although they probably also made stops in Surinam and northern Brazil. In Colombia they apparently followed Humboldt's footsteps, visiting Turbaco, Bogotá, and the nearby Tequen-

dama Falls. They also made an excursion on the Magdalena River and recorded a delay in Buenavista. Returned to Philadelphia in 1832; 1839 in South American waters with the Wilkes Expedition, making stops in major ports, including Rio de Janeiro.[18]

PERKINS, GRANVILLE (1830–1895)

Born in Baltimore in 1830, Perkins studied in Philadelphia at an early age with drawing master William E. Smith. At age fifteen he became a theatrical scene painter; he soon began work with the Ravel family, whose stage productions (*Mazulua*, *The Green Monster*, *Jacko or the Brazilian Ape*) required elaborate stage sets. About 1851 made a five-year trip with the Ravels through Cuba, Jamaica, Yucatán, and Central America. By 1856 he had returned to Philadelphia and resumed art studies with James Hamilton. In the 1860s began to gain some reputation with his coastal and tropical views. Worked as an illustrator for Frank Leslie and later for *Harper's*. About 1870 moved to California, apparently traveling through South America on his way to the West Coast. Before 1870 his tropical pictures were mainly of Cuba; during the 1870s and 1880s they were predominantly of South American scenery (these observations are based on titles and descriptions from nineteenth-century exhibition catalogues and reviews; many of his works remain unlocated). Perkins painted in watercolors as well as in oils. By 1882 he was back in New York. Little is known of his later years. He died in 1895.

ITINERARY. C. 1851–55 traveled through Cuba, Jamaica, Yucatán, and Central America; c. 1870 may have traveled from New York to California via South America.[19]

ROBINSON, CHARLES DORMAN (1847–1933)

Born 1847 in Monmouth, Maine, Robinson moved in 1850 to San Francisco, where his father was a theatrical entrepreneur. At a young age, he began to paint panoramas and dioramas of scenic wonders. In 1861 he traveled to the East Coast, where he was reported to have received instruction from a variety of artists. In 1873 he headed west, eventually reaching San Francisco. Upon his return he painted tropical scenes that included pre-Columbian antiquities. In the San Francisco fire of 1906 Robinson's studio burned, and with it many of his paintings. He produced several views of the city in ruins after the fire. Robinson died in 1933.

ITINERARY. In 1861 and 1873–75 traveled between the East and West coasts, possibly by way of Latin America; few details are known.[20]

ROCKWELL, CLEVELAND (1837–1907)

Born 1837, Rockwell was a topographical draftsman who worked and traveled with the United States Coast Survey beginning in 1857. He first joined the USCS as an aide, working on a survey of New York harbor, and later was assigned to do an extensive study of the Columbia River in Oregon. Of particular interest to this study is his work on the Magdalena River Survey, 1865–66, done at the request of the Colombian government, represented by General Salgar. During this period he produced a number of drawings and watercolors. He resigned from the USCS in 1892 and died in 1907.

ITINERARY. On 11 December 1865 Rockwell joined a party headed by Col. S. A. Gilbert and Capt. P. F. C. West and departed New York for Colombia. January 1866 began work on the survey of the Magdalena River; survey extended from the mouth of the river to the head of navigation, some four hundred miles. Rockwell and his party arrived back in New York on 9 June 1866.[21]

SMITH, EDMOND REUEL (1829–1911)

Smith was born in 1829 and attended Georgetown College (now University) before being appointed captain's clerk in the U.S. Navy. In that capacity in 1849 he

sailed for Valparaíso, Chile, to work with Lt. James Gilliss on the U.S. Astronomical Expedition to the Southern Hemisphere. Between 1849 and 1852 he was stationed in Santiago, where he assisted with astronomical measurements and, whenever time permitted, collected natural history specimens in the area. Upon the completion of the work of the expedition he headed south for the land of the Araucanian Indians. The observations he made were subsequently recorded in his illustrated travel account, *The Araucanians; or, Notes of a Tour among the Indian Tribes of Southern Chili* [*sic*] (1855). While in Chile he made many sketches, some of which were done with the camera lucida, which served as the basis for illustrations both in his own book and in the Gilliss report. In 1859 he exhibited three paintings at the National Academy of Design, one a scene of Düsseldorf, where he is thought to have traveled and painted following his return from Chile. In 1895 and 1896 he lived on Clinton Street, New York. He died in 1911.

ITINERARY. On 11 July 1849 sailed from Baltimore around Cape Horn, bound for Valparaíso; traveled inland to Santiago, where he remained attached to the Gilliss Expedition until December 1852. On 4 January 1853 he departed from Concepción for the land of the Araucanians, where he traveled for about a year. Traveled along the River Bío-Bío to Los Angeles by way of Yumbel and the Falls of Laja. From there headed for the province of La Araucania, where he observed Indian life and volcanoes, including Llaima. Returned to Concepción; then on to Valparaíso, where he caught a British boat to Panama, and finally home.[22]

SPOONER, CHARLES H. (1836–1901)

Spooner was born in 1836 in Philadelphia. Between 1863 and 1867 he exhibited at the Pennsylvania Academy of the Fine Arts and the Philadelphia Sketch Club views of Nicaragua and Costa Rica, which suggests that he must have traveled to Central America in the early 1860s. He died in Philadelphia in 1901.

ITINERARY. Presumably traveled to Central America in the early 1860s; few details are known.[23]

STANTON, PHINEAS, JR. (1817–1867)

Born 1817, probably in Wyoming, New York, Stanton started out as a portrait and miniature painter. He worked in Charleston, New Orleans, and upstate New York as well as in New York City. After his marriage to Emily Ingham in 1847 he became vice-chancellor of Ingham University. In 1867 he accompanied naturalist James Orton as scientific draftsman on the Andean expedition sponsored by Williams College and the Smithsonian Institution. Soon after the party landed in Guayaquil, all but Orton became stricken with fever. Although they departed as quickly as possible for the healthier climate of the highlands, Stanton died soon after their arrival in Quito. He was therefore able to do little or nothing in the way of scientific illustration on the expedition.

ITINERARY. Arrived Guayaquil, Ecuador, on 19 July 1867; proceeded to Quito, where he died on 5 September 1867.[24]

WALKE, HENRY (1809–1896)

Born 1809 at Ferry Plantation, Princess Anne County, Virginia, Walke was a naval officer who combined his duties at sea with drawing and painting. In 1811 his family moved to Ohio, in 1812 to Norfolk, Virginia, and in 1820 back to Ohio, where they built a family home at Chillicothe. In 1827 he was appointed midshipman and began a life of travel, which brought him in contact with many different places and artistic influences, including oriental art. In 1836 he was attached to the USS *North Carolina*; he made sketches in Brazil and elsewhere later elaborated them into oil paintings. In 1840 he reported to the USS *Boston*, and in 1844 he was attached to the USS *Bainbridge* on the Brazil

Squadron. In 1847 he participated in the Mexican War and was present for the surrender at Veracruz, Tuxpan, and Tabasco. In 1861–65 he was involved in the Civil War, and in 1871 he retired. In 1877 he published his *Naval Scenes and Reminiscences of the Civil War*. He died in 1896 in Brooklyn, New York.[25]

WARD, JACOB C. (1809–1891)

A landscapist and pioneer daguerreotypist, Ward was born in 1809 in Bloomfield, New Jersey. He was the son of Caleb Ward, an artist, and the brother of Charles V. Ward, with whom he traveled to South America. In 1829 he exhibited for the first time at the National Academy of Design, where he continued to show his work sporadically. In the 1830s he drew illustrations for the medical texts of David Hosack, and in about 1836 traveled west with a friend who had inherited property in Iowa. On that trip he saw the headwaters of the Mississippi and made portrait sketches of Indians. *The New York Mirror* reproduced his *Soaking Mountain on the Upper Mississippi*, one of the most successful pictures resulting from that trip. He was recommended for a place on the Wilkes Expedition, but for personal reasons remained at home. In 1845–48 he made a trip to South America that had two objectives: to obtain a series of sketches for paintings of the South American landscape and to join his brother Charles in Chile, where he had started a daguerreotype business. In 1852 he exhibited at the National Academy with a London address, but nothing is known of a trip to England. He spent much of his time in a studio building he erected near his home in Bloomfield, where he died in 1891.

ITINERARY. Probably some time in 1845 sailed from Boston on the ship *Coquimbo* around Cape Horn to put in at Valparaíso after ninety-four days at sea. He spent 1845–47 (approximately) in the vicinity of Santiago and Valparaíso, making daguerreotypes and landscape sketches. Traveling north from Santiago, he arrived at La Serena, Chile, in March 1847. Continu-

ing north, he and his brother were reported to have worked in La Paz, Bolivia, before settling in Lima. En route they must have stopped in Arequipa, Peru, a view of which he exhibited at the National Academy in 1849. On 31 July 1847 they announced the opening of their photographic studio, Ward & Co., in Lima. There they produced mainly portraits until at least 8 November 1847. Between 25 November and 6 December Ward & Co. moved to Callao; by 18 March 1848 had returned to their old Lima quarters; and after 15 April ceased to advertise in the Lima press. Their return journey took them across the Andes by mule to Panama, the scenery of which also provided inspiration for a later painting. From Panama they traveled by steamer to Jamaica and on to Havana, Cuba, where they stayed for a week in November. They arrived back in New York after an absence of about three years.[26]

WHISTLER, JAMES MCNEILL (1834–1903)

Born 1834 in Lowell, Massachusetts, the third son of George Washington Whistler, civil engineer, and eldest son of his second wife, Anna Matilda McNeill. In 1843 began his expatriate life with a move to Russia, where his father was working on the railroad from St. Petersburg to Moscow. In 1845 attended first drawing lessons at the Imperial Academy of Fine Arts in St. Petersburg. He spent the summers of 1847 and 1848 in England, where he remained while his family returned to Russia. In 1849, after the death of his father, the family went to live in the United States. In 1851–54 Whistler attended the U.S. Military Academy at West Point, where he studied drawing with Robert Weir. In 1854 he was appointed to the U.S. Coast and Geodetic Survey, to a post in topography and mapmaking he retained until February 1855. Later that year painted his first oil portraits and departed for Paris, where he intended to study art, stopping in London en route. From 1856 to 1859 he was mostly in Paris, where he entered the studio of Charles Gleyre. During these years he met Gustave Courbet, Ignace

Fantin-Latour, and Félix Bracquemond. At the Salon des Refusés of 1863 exhibited *Symphony in White No. 1: The White Girl*, the most controversial of his early works. In 1865 stayed with Courbet at Trouville. In 1866 made a ten-month trip to Chile. Upon his return parted amicably from his mistress, Jo Hiffernan, and took up residence at 2 Lindsey Row, where he lived for the next eleven years. About 1869 began to sign his work with the mark of a butterfly. In 1878 Whistler-Ruskin trial; May 1879 auctioned his paintings and possessions and declared bankruptcy. In 1879–80 he stayed in Venice and in 1884 traveled to Holland. In 1885 he delivered the "Ten O'Clock" lectures in Princess Hall and traveled with William M. Chase to Holland and Belgium, where he returned in 1887. In 1888 to Paris, where he met Mallarmé. In 1890 published *The Gentle Art of Making Enemies*; met Charles Lang Freer. He died in 1903.

ITINERARY. On 31 January 1866 Whistler made a will in favor of Jo Hiffernan, giving her power of attorney to manage his affairs during his absence in South America and on 2 February departed South-ampton on board the *Seine*. On 18 February stopped at St. Thomas, Jamaica; 21 February at Colón. Crossed the Isthmus by land and on 24 February departed from Panama City on the *Solent* for the journey southward along the Pacific coast of the continent. On 28 February stopped in what Whistler called Paytoa (probably the port of Paita), Peru; 3–5 March ship docked in the harbor of Callao, which allowed him to make a short visit on 4 March to Lima; 8 March in Arica, Chile; 9 March at Cohij (?); 10 March at Caldera; and on 12 March arrived in Valparaíso, after a journey of six weeks. On 2 April witnessed the bombardment of Valparaíso harbor by the Spanish fleet. On 24 July ship *Henriquetta* arrived in Valparaíso. Whistler reported much later that he gave two paintings to the ship's purser to bring home; he claimed that the purser kept them and brought them back on a return trip to South America, when the ship, purser, and paintings were swallowed up by a tidal wave. Last consecutive entry in Whistler's South American journal on 3 September; shortly thereafter departed for England, presumably by way of Cape Horn. The exact date of his return remains undetermined, but sources seem to agree he was back in England by November.[27]

Historical Table

Science and Politics

1838–
42 U.S. Exploring Expedition headed by Charles Wilkes sailed around the world; explored South America, 1839–40, the first major government-sponsored expedition to do so.

1839 Publication of Charles Darwin's *Voyage of the Beagle* (based on expedition of 1831–36).

1840 Beginning of Peru's Age of Guano, which continued until the late 1870s.
American Ethnological Society founded.

1843–
44 Lt. Isaac Strain commanded Brazilian Expedition, sponsored by the Academy of Natural Sciences, Philadelphia.

1845 Publication of volume one of Humboldt's *Kosmos;* subsequent four volumes appeared 1845–62.
Term *Manifest Destiny* coined.
United States annexed Texas.

1846 Smithsonian Institution founded.
U.S. treaty with Colombia guaranteed free transit over the Isthmus of Panama.
United States at war with Mexico.
Louis Agassiz arrived in America from Switzerland; settled in Cambridge, Massachusetts, where he remained until his death in 1873.

1848 United States acquired California, New Mexico, Colorado, Arizona, and Nevada, according to Treaty of Guadalupe Hidalgo.

1849 Gold rush brought many travelers by land across Isthmus of Panama or by sea around Cape Horn to reach California.

1849–
52 U.S. Astronomical Expedition headed by Lt. James Gilliss made Santiago, Chile, its base of operations.

1850 Clayton-Bulwer Treaty (between the United States and Great Britain) guaranteed neutrality of an interoceanic canal.

1851 American Geographical Society founded.

1851–52 Herndon-Gibbon Expedition to the Amazon sponsored by the U.S. Navy.

1852 With the end of dictatorship of Juan Manuel Rosas Argentina opened up to foreigners.

1852–53 John P. Kennedy served as secretary of the navy; coincided with crest of U.S. government-sponsored exploration of Latin America.
Gadsden Treaty added forty-five thousand square miles of Mexican territory to the United States for ten million dollars.
New York Exhibition of the Industry of all Nations (dubbed New York Crystal Palace) opened, heralding the moment when science and technology became a major force in the United States.

1853–56 Page Expedition to Rio de la Plata, sponsored by the U.S. Navy.

1854–56 U.S. Exploring Expedition to Darien headed by Lieutenant Strain.

1855 Panama Railway opened.

1855–60 Filibusters by Walker and others in Central America.

1859 John Brown attacked Harpers Ferry (although few at the time realized it was the prelude to the Civil War).
6 May, death of Alexander von Humboldt.
Publication of Darwin's *Origin of Species*.
Construction commenced on Agassiz's Museum of Comparative Zoology, Harvard University.

1860–70 Gabriel García Morena's dictatorship of Ecuador; time of increased power of the Catholic Church.

1861–65 American Civil War.

1861–66 Friedrich Hassaurek (from Cincinnati) served as U.S. minister to Ecuador; wrote *Four Years* among Spanish Americans (1867).

1862–66 Spanish Scientific Expedition to South America; coincided with Spanish military intervention in Chile and Peru.

1865–66 Louis Agassiz led Thayer Expedition to Brazil; published *A Journey in Brazil* (1868).
At the request of the Colombian government, a party from the U.S. Coast Survey explored four hundred miles of the Magdalena River.

1867 James Orton led Smithsonian-sponsored expedition to the Andes; returned twice in the subsequent decade.
Brazil opened its rivers to free navigation for the first time.

1869 Agassiz organized Humboldt Centennial in Boston; other cities followed.
Opening of the Suez Canal.
Completion of the Transcontinental Railroad.

1870 U.S. State Department made one of the first systematic efforts to inform itself about conditions of hemispheric trade.

1870–74 Departure of first of four parties to Darien to survey interoceanic canal sites, under Thomas Selfridge, U.S. Navy.

1871–72 Agassiz led USS *Hassler* Expedition on circumnavigation of South America.

1873 Financial crash in the United States followed by the depression.

1875–76 C. F. Hartt, member of *Thayer* party, led expedition under auspices of Brazilian Geological Commission on the first of many return trips to Brazil.

1878 Selfridge surveyed the Amazon and Madeira rivers.

1879 Bureau of Ethnology founded.
International Canal Congress convened in Paris. The choice of site in Panama caused numerous problems; the canal was not completed until 1914.

1879–83 War of the Pacific. Chile emerged victorious over Peru and Bolivia.

Arts and Letters

1838–40 Peale and draftsmen Alfred Agate and Joseph Drayton accompanied Wilkes Expedition.

1839 Official announcement of the invention of photography by L. J. M. Daguerre.
Stephens and Catherwood to Belize, Mexico, and Yucatán; published *Incidents of Travel in Central America, Chiapas, and Yucatán* (1841). Catlin packed his Indian Gallery and sailed for England; he returned to the United States some thirty-two years later.

1841 Austrian Baron Emanuel von Friedrichsthal departed from Boston for Yucatán, where he took the first daguerreotypes of pre-Columbian ruins.
Catherwood and Stephens departed with Dr. Samuel Cabot on second trip to Yucatán; published *Incidents of Travel in Yucatán* (1843).

1843 Prescott's *History of the Conquest of Mexico* published.

1843–45 Charles DeForest Fredericks traveling as an itinerant daguerreotypist in Cuba and South America.

1844 Catherwood's folio volume *Views of Ancient Monuments in Central America, Chiapas, and Yucatán* published.

1845 Thomas Ewbank to Brazil; published *Life in Brazil* (1856).
Agassiz's artist Jacques Burkhardt joined Belgian expedition to Guatemala; they were turned back and landed in New York.

1845–48 Jacob Ward in South America, making daguerreotype portraits and landscape paintings in Bolivia, Chile, Peru, Panama, Jamaica, and Cuba.

1847 Prescott's *History of the Conquest of Peru* published.

1849–50 Squier, appointed chargé d'affaires in Central America, investigated antiquities with artist James McDonough.

1850 Venezuelan leader Antonio Páez and his son Ramón, travel writer and geographer, arrived in New York to live in exile.

1850–59 Comisión Corográfica, under Colonel Codazzi, surveyed the topography and people of Colombia. Included three artists, whose work initiated landscape painting in Colombia.

1851 Squier returned to Central America with artist Wilhelm Heine; published *Nicaragua; Its People, Scenery, Monuments* (1852).

1851–56 Granville Perkins traveled through Latin America with Ravel theatrical family.

1852 Catlin left Paris for South America.
Poughkeepsie-born photographer Benjamin Franklin Pease arrived in Lima to become its most important photographer.
Albertis del Oriente Browere sailed around Cape Horn on his way to California.

1852–54 French artist Camille Pissarro and Danish artist Fritz Georg Melbye traveled to Venezuela.

1853 Frederic Church and Cyrus Field departed in April for six months in Colombia and Ecuador.
Norton Bush to Central America.
Draftsman DeWitt C. Hitchcock goes to Central America with Squier.
E. R. Smith, detached from the Gilliss Expedition, set out to observe Araucanian Indians of southern Chile.

1853–54 Theodore Winthrop volunteered for Strain's expedition to Darien.

1854 Herman Melville published "The Encantadas," based on his experiences in the Galápagos Islands off Ecuador.

1855 First meeting of the Travellers Club, New York.

1856 John Ruskin's *Modern Painters*, vols. 3 and 4 (on mountains), published.

1857 Church and Louis Mignot to Ecuador.
Publication of *Brazil and the Brazilians* by Fletcher and Kidder.

1858 Albertis del Oriente Browere traveled across the Isthmus via the Chagres River route.

1859 Church completed and exhibited *The Heart of the Andes*.
Deaths of Prescott and Washington Irving.
Photographers Henry DeWitt Moulton and Villroy L. Richards arrived in Lima, where they remained until about 1863–65. Moulton's photographs published by Alexander Gardner in *Rays of Sunlight from South America* (1865).

1861–70 Melbye living in New York, where he exhibited his and Pissarro's tropical scenes.

1863 Martin Heade departed for Brazil, where he painted his first hummingbird pictures.
Squier in Peru; published *Peru: Incidents of Travel and Exploration in the Land of the Incas* (1877).

1864 Heade exhibited hummingbird paintings at the Art Academy in Rio de Janeiro; awarded Order of the Rose by the emperor.

1865 Church journeyed to Jamaica.

1865–66 Burkhardt served as draftsman on Agassiz's expedition to Brazil.
Artist Cleveland Rockwell painted scenes while on the Magdalena River Survey.
George Washington Carleton in Peru; published *Our Artist in Peru* (1866).

1866 Whistler arrived in Valparaíso to assist Chileans in Spanish siege; painted his first nocturnes.
Andrew Warren traveled to Nicaragua; exhibited *Nicaraguan Doorway* at the National Academy of Design in 1867.
Heade made a trip to Nicaragua and Colombia.

1868 Bush to Panama under the sponsorship of San Francisco art patron and banker William C. Ralston.

1870 By January Heade in Ciénaga, Colombia; also visited Panama and Jamaica before returning to New York by 26 May.
Timothy O'Sullivan appointed photographer on Darien Expedition, led by Selfridge.
Andrew Melrose painted *Morning in the Andes*.
Pease photographed the southern line of the Peruvian Railroad built by Henry Meiggs.

1870–73 Henry Ferguson traveled and painted in Ecuador, Peru, and Chile; in 1872 his work was shown in Santiago.

1871 John Moran appointed photographer on second reconnaissance of Selfridge's expedition to Darien.
Catlin installed his Cartoon Collection and La Salle paintings in Somerville Gallery, New York, and issued a catalogue of 603 entries.

1875 On commission from Meiggs, Bush traveled to Peru to paint views of his newly constructed railroad lines and mining operations.
Eadweard Muybridge traveled to Central America and Mexico; subsequently published a volume of photographs.

1876 Centennial Exhibition in Philadelphia. Dom Pedro II helped open the exposition, which included art and produce from Brazil, Mexico, and Argentina.

1879 Founding of the Society of American Artists.

1879–80 Photographers begin switching from wet to dry plates, which opened a new age in travel photography.

Notes

Introduction

1. Photographers who went to Latin America are not included here, for the issues they present require a separate study.

2. See, for example, Martin Hintz, *Living in the Tropics: A Cultural Geography* (New York: Franklin Watts, 1987).

3. Such proprietary remarks were repeated in various contexts throughout the period, as suggested by the following excerpts. William Edwards in *A Voyage up the River Amazon, Including a Residence at Pará* (New York: D. Appleton and Co., 1847), p. 11, observed, "It has been a matter of surprise to me, that those who live upon the excitement of seeing and telling some new thing, have so seldom betaken themselves to our Southern continent." In "The Easy Chair," *Harper's Monthly* 19 (1859): 271, the editor wrote, "*The Heart of the Andes* . . . is the name of Mr. Church's last picture of the scenery with which he is familiar, and which, as an artist, he has made his own." And as late as 1875 another critic reminded his readers, "It was Mr. Church's pencil which first drew attention to the impressive character of our tropical scenery" ("Mr. Church's New Painting," *Art Journal* 1 [1875]: 179).

4. The use of the inscribed signature to establish the artist's presence within the image has been discussed in relation to northern art, where it dates back to the celebrated example of Jan van Eyck's *Arnolfini Wedding* (1435; National Gallery, London). See, for example, Svetlana Alpers, *The Art of Describing* (Chicago: University of Chicago Press, 1983), pp. 176–80. Its parallel importance could be argued for American art, including *Max Schmidt in a Single Scull* (1871; Metropolitan Museum of Art), in which Thomas Eakins in essence establishes himself as an internal witness to the event depicted by introducing his self-portrait in the distant scull labeled "Eakins / 1871" on the stern. For Church, similarly, the signature had the potential for conveying meaning beyond identifying him as the maker of the work of art. To this end he manipulated its position and form and even made it—at least in letters—the object of a visual pun, replacing it with a drawing of a church. Deliberately calling our attention to it in *The Heart of the Andes*, where a stray sunbeam spotlights the inscription carved into the tree, Church alerts us to its special significance. By locating himself in this way within the scene he subtly suggests that he was not the creator but only the witness to the pictured landscape, one that existed before the arrival of the North American traveler and one that would continue to exist—now in a slightly altered state—after his departure.

Chapter 1

1. Charles Darwin, *The Voyage of the Beagle* (1839; repr., Garden City, N.Y.: Doubleday & Co., 1962), p. 500.

2. Alistair Hennessy, *The Frontier in Latin American History* (Albuquerque: University of New Mexico Press, 1978), pp. 32–34, discusses the geographical myths.

3. John Esaias Warren, "The Romance of the Tropics," *Knickerbocker Magazine* 33 (June 1849): 499–500.

4. George Catlin, *Life amongst the Indians* (London: Sampson, Low, Son & Co., 1861) and *Last Rambles amongst the Indians of the Rocky Mountains and the Andes* (New York: D. Appleton and Co., 1867).

5. William Truettner, *The Natural Man Observed: A Study of Catlin's Indian Gallery* (Washington, D.C.: Smithsonian Institution Press, 1979), pp. 61–80.

6. Quoted in Ramón Páez, *Travels and Adventures in South and Central America* (New York: Charles Scribner & Co., 1868), p. 425. For a comparative discussion of the terms *myth* and *symbol* see Henry Nash Smith, *Virgin Land: The American West as Symbol and Myth* (Cambridge, Mass., and London: Harvard University Press, 1982), p. xi.

7. For biographical information on Winthrop see Eugene T. Woolf, *Theodore Winthrop: Portrait of an American Author* (Washington, D.C.: University Press of America, 1981).

8. Theodore Winthrop, *A Companion to "The Heart of the Andes"* (New York: D. Appleton and Co., 1859), pp. 21–22.

9. Ibid., p. 17.

10. A. V. S. Anthony, "Scraps from an Artist's Notebook: The Carib Settlement," *Harper's Monthly* 15 (July 1857): 150.

11. "An Artist," "Three Weeks in Cuba," *Harper's Monthly* 6 (January 1853): 161.

12. Catlin, *Last Rambles*, p. 71.

13. Emir Rodríguez Monegal, ed., *The Borzoi Anthology of Latin American Literature* (New York: Alfred A. Knopf, 1977), 1:6. Columbus's letter of 15 February 1493 was written to King Ferdinand and Queen Isabella of Spain. For a fuller collection of the writings of Columbus in English translation see C. Colón, *Journals and Other Documents* (New York: Heritage Press, 1963) and *Select Documents Illustrating the Four Voyages of Columbus* (London: Hakluyt Society, 1930).

14. Washington Irving, *The Life and Voyages of Christopher Columbus* (1828; London: John Murray, 1849), 3:398–406, quotation p. 398.

15. See chapter 2, where these ideas are elaborated more fully in relation to the historical context of the mid-nineteenth century.

16. Alexander von Humboldt, *Personal Narrative of Travels to the Equinoctial Regions of America, during the Years 1799–1804* (London: Bohn, 1852), 1:215–16.

17. John Lloyd Stephens, *Incidents of Travel in Central America, Chiapas, and Yucatán* (1841; repr., New York: Dover, 1969), 1:34.

18. Humboldt, *Personal Narrative* 1:157.

19. Alfred Russel Wallace, *Palm Trees of the Amazon* (London: John van Voorst, 1853), pp. iii–iv.

20. S. G. W. Benjamin, "Fifty Years of American Art, 1828–1878," *Harper's Monthly* 59 (1879): 256; and *Our American Artists* (New York, 1879).

21. Quoted in E. J. H. Conner, *The Natural History of Palms* (Berkeley and Los Angeles: University of California Press, 1966), p. 24.

22. John Prest, *The Garden of Eden: The Botanic Garden and the Re-Creation of Paradise* (New Haven and London: Yale University Press, 1981), p. 11.

23. John Milton, *Paradise Lost* (New York: New American Library, 1961), bk. 4, lines 138, 216–63, 689–90.

24. J. Bard McNulty, ed., *The Correspondence of Thomas Cole and Daniel Wadsworth* (Hartford: Connecticut Historical Society, 1983), p. 20.

25. Louis Legrand Noble, *The Life and Works of Thomas Cole* (1853; repr., Cambridge, Mass.: Belknap Press, 1964), p. 8.

26. Alpha (Thomas Cole), "Emma Moreton: A West Indian Tale," *Saturday Evening Post*, 14 May 1825, pp. 1–2; reprinted in Marshall Tymn, ed., *Thomas Cole: The Collected Essays and Prose Sketches* (St. Paul: John Colet Press, 1980), pp. 77–90. Published prints by John Martin, including *The Temptation*, provided visual sources for Cole's conception of the Garden of Eden. Martin's painting, *Plains of Heaven* (1853; National Gallery, London), probably also provided prototypes for subsequent painters.

27. Barbara Novak, *Nature and Culture: American Landscape and Painting 1825–1875* (New York: Oxford University Press, 1980), pp. 3–17, summarizes these ideas.

28. Quoted in Earl A. Powell III, "Thomas Cole and the American Landscape Tradition: Associationism," *Arts* 52 (April 1978): 113.

29. *Cosmopolitan Art Journal* 3 (September 1859): 183, quoted in Novak, *Nature and Culture*, p. 139.

30. James Fenimore Cooper, *The Pioneers*, quoted in Novak, *Nature and Culture*, p. 156.

31. Other contenders for an edenic landscape include especially Italy and the American West.

32. Alexander von Humboldt, *Cosmos: A Sketch of a Physical Description of the Universe* (New York: Harper & Bros., 1850), 2:94.

33. Church's on-the-spot drawings and oil sketches have survived in far greater numbers than those of any other American artist-traveler of his day. From among the few such extant works by Heade, the palm similarly emerges as a key tropical subject. See, for example, *Two Cocoanut Palms*, a drawing in the Karolik Collection (1973.314) and a page from a small sketchbook from Colombia,

both in the Museum of Fine Arts, Boston.

34. The drawing is inscribed "Recollection of a view from a hill / near Cartago July 1853." Elaine Dee, *To Embrace the Universe: The Drawings of Frederic Edwin Church* (exhibition catalogue; Yonkers, N.Y.: Hudson River Museum, 1984), p. 34. The majority of Church's drawings and oil sketches are now housed in the Cooper-Hewitt Museum and Olana State Historic Site, Hudson, New York, the artist's former home.

35. Information supplied by palm expert Harold E. Moore, reported in a letter from Timothy Plowman to Betty Blum, 7 May 1979, curatorial files, Art Institute of Chicago.

36. Frederic Church to Ramón Páez, 11 September 1866, Archives of American Art, Smithsonian Institution, Washington, D.C.

37. Winthrop, *Companion*, p. 38.

38. Louis and Elizabeth Agassiz, *A Journey in Brazil* (Boston: Ticknor and Fields, 1868), pp. 109–10.

39. James Somerville, *F. E. Church's Painting "The Heart of the Andes"* (Philadelphia, c. 1859), p. 11.

40. Walter Montgomery, ed., *American Art and American Art Collections* (Boston: E. W. Walker, c. 1889), p. 774.

41. Henry T. Tuckerman, *Book of the Artists* (New York: George P. Putnam, 1867), p. 563.

42. *Catalogue of the Mignot Pictures with Sketch of the Artist's Life by Tom Taylor, Esq., and Opinions of the Press* (London and Brighton, 1876).

43. Milton, *Paradise Lost*, bk. 4, lines 194–95.

44. T. Addison Richards, "The Landscape of the South," *Harper's Monthly* 6 (May 1853): 721.

45. Warren, "Romance," p. 497.

46. Johann Baptist von Spix and Karl Friedrich Philipp von Martius, *Travels in Brazil in the Years 1817–1820*, trans. H. E. Lloyd (London: Longman, Hurst, Rees, Orme, Brown, and Green, 1824), 1:117.

47. Herman Melville, "The Encantadas or Enchanted Isles," in *Great Short Works of Herman Melville* (1854; repr., New York: Harper and Row, 1969), p. 99.

48. Alexander von Humboldt, *Aspects of Nature* (London: Bohn, 1849), 2:21.

49. Warren, "Romance," p. 504. For a discussion of the role of the edenic quest in the discovery and colonization of Brazil see Sergio Buarque de Holanda, *Visão de Paraíso* (São Paulo: Companhia Editora Nacional, 1960).

50. Quoted in Bruce Chatwin, *In Patagonia* (New York: Summit Books, 1977), p. 17.

51. Edmond Reuel Smith, *The Araucanians; or, Notes of a Tour among the Indian Tribes of Southern Chili* [sic] (New York: Harper & Bros., 1855). This particular image was elaborated by John Mix

52. "The Amazons of South America," *Putnam's Monthly Magazine* 6 (September 1855): 252–61.

53. Catlin, *Last Rambles*, p. 249.

54. William H. Prescott, *History of the Conquest of Mexico* (1843; London: George Bell and Sons, 1901) and *History of the Conquest of Peru* (New York: Harper & Bros., 1847).

55. Church's library at Olana included copies of Prescott's histories in 1843 and 1848 editions, respectively. *Sale of the Library of James Suydam November 22 and 23, 1865* (auction catalogue; New York: Bang & Irwin, 1865), nos. 77–79, documents contemporary artist Suydam's possession of Prescott's volumes. On Leutze see Barbara Groseclose, *Emanuel Leutze, 1816–1868: Freedom Is the Only King* (catalogue raisonné; Washington, D.C.: National Collection of Fine Arts, 1976), pp. 78–79. By 1869, when *Storming of the Teocalli* appeared in the winter exhibition of the National Academy of Design as one of a group of works by the recently deceased Leutze, a critic observed, "It is hardly fair to Leutze's memory to give the absurd composition called *Storming Teocalli* a prominent place" ("Fine Arts: The Winter Exhibition," *Putnam's Monthly* 3 [January 1869]: 121).

56. Prescott, *Conquest of Peru* 1:432–40.

57. The history of the legend is summarized in Robert Schomburgk's introduction to Sir Walter Raleigh, *The Discovery of the Large, Rich, and Beautiful Empire of Guiana* (New York: Burt Franklin, 1964). The first edited version of Raleigh's original text of 1596 appeared in 1848.

58. Alexander von Humboldt, *Researches Concerning the Institutions and Monuments of the Ancient Inhabitants of America with Descriptions and Views of Some of the Most Striking Scenes in the Cordilleras!* (London: Longman, Hurst, Rees, Orme & Brown, J. Murray & H. Colburn, 1814), 2:207. This book went by the name *Picturesque Atlas* in the nineteenth century; it is the English translation of his *Vues des Cordilleres*.

59. Details of Raleigh's biography are provided by Schomburgk's introduction to Raleigh's *Discovery*.

60. Milton, *Paradise Lost*, bk. 11, lines 409–11.

61. Probably the draft of a lecture to be delivered at the Concord Lyceum or of an article for *The Dial*, Thoreau's essay was written in about 1842 but not published in his lifetime. It was found and published posthumously. See Henry David Thoreau, *Sir Walter Raleigh* (Boston: Bibliophile Society, 1905), pp. 17, 25.

62. Thoreau, *Sir Walter Raleigh*, pp. 41, 35–37.

63. Ibid, p. xiv.

64. Raleigh, *Discovery*. For the artist's reference to Schomburgk see,

Stanley from a daguerreotype taken by Smith and illustrated in James M. Gilliss, *The U.S. Naval Astronomical Expedition to the Southern Hemisphere during the Years 1849–50–51–52*, 33d Congress, 1st session, ex. doc. no. 121 (Washington, D.C.: A. O. P. Nicholson, printer, 1855–56), opposite 1:68.

for example, Catlin, *Last Rambles*, p. 54.

65. Truettner, *Natural Man Observed*, p. 53. The Indian Gallery was Catlin's original collection of about six hundred paintings of the North American Indians, composed mainly of the works he completed on the Great Plains between 1830 and 1836, with some additions made between 1840 and 1848. See Truettner, p. 131.

66. Catlin, *Last Rambles*, pp. 52–53, 76.

67. V. S. Naipaul, *The Loss of El Dorado* (New York: Penguin Books, 1981), p. 31. Compare Raleigh's description of the region (original spelling retained throughout): "I neuer saw a more beawtifull country, nor more liuely prospects, hils so raised heere and there ouer the vallies, the riuer winding into diuers branches, . . . and euery stone that we stooped to take vp promised eythere golde or siluer by his complexion. . . . they promised to bring me to a mountaine, that had of them verye large peeces growing Diamond wise; whether it be Christall of the mountaine, *Bristoll Diamond*, or *Saphire* I doe not yet knowe, but I hope the best, sure I am that the place is as likely as those from whence all the rich stones are brought, and in the same height or very neare" (Raleigh, *Discovery*, pp. 82–84).

68. Catlin, *Last Rambles*, p. 53.

69. Rev. D. P. Kidder and Rev. J. C. Fletcher, *Brazil and the Brazilians* (Philadelphia: Childs and Peterson, 1857), p. 3.

70. On Greenwood's painting see John Wilmerding, *American Art* (New York: Penquin Books, 1976), pp. 34–35. Additional information was kindly supplied by the staff of the St. Louis Art Museum from the accession records. The diary and notebook Greenwood kept during his stay in Surinam (December 1752 to April 1758), in which he wrote of local events and the portraits he painted there, is in the manuscript collection of the New-York Historical Society.

71. Bayard Taylor to George Boker, 1 May 1851, New York, in Marie Hansen-Taylor and Horace E. Scudder, eds., *Life and Letters of Bayard Taylor* (Boston: Houghton, Mifflin and Co., 1884), 1:209.

72. Darwin, *Voyage of the Beagle*, p. 283.

73. Frederic Church to William Osborn, 29 September 1868, Church-Osborn correspondence, typescript, Olana State Historic Site, Hudson, New York. See also Hennessy, *Frontier*, for a comparative analysis of Latin American and Anglo-American perceptions of the frontier.

74. Henry H. Remak has identified the negative as well as the positive escapism involved in travel in "Exoticism in Romanticism," *Comparative Literature Studies* 15 (March 1978): 53–65.

75. George Gordon Noel Byron, "Childe Harold," in *The Poetical Works of Lord Byron* (London: Oxford University Press, 1960), p. 211, quoted in Remak, "Exoticism," p. 56.

76. As quoted in Remak, "Exoticism," p. 57. Writing in 1880, S. G. W. Benjamin made a direct comparison between "Childe Harold" and American artists: "What 'Childe Harold' did for the scenery of the Old World, the art of Church has done for that of the New" (*Art in America: A Critical and Historical Sketch* [New York: Harper & Bros., 1880], p. 81.

77. Chatwin, *In Patagonia*, pp. 44–50.

78. Author's conversation with William Truettner, January 1982.

79. *Francis Martin Drexel, 1792–1863: An Artist Turned Banker* (exhibition catalogue; Philadelphia: Drexel Museum Collection, Drexel University, 1976), pp. 10–18. My thanks to the staff of the Drexel Museum Collection for providing me with information on Drexel.

80. Gordon Hendricks, *Eadweard Muybridge: The Father of the Motion Picture* (New York: Grossman Publishers, 1975), pp. 81–91.

81. Robert Leroy Parker to Mrs. Davis, 10 August 1902, manuscript, Utah State Historical Society, quoted in Chatwin, *In Patagonia*, pp. 42–43.

82. Gabriel García Márquez, "Latin America's Impossible Reality," *Harper's* 270 (January 1985): 14.

83. Quoted in George Woodcock, *Henry Walter Bates: Naturalist of the Amazon* (New York: Barnes and Noble, 1969), pp. 118–19. Bates regularly uses the term *Amazons* rather than the more customary *Amazon*. This form dates from the time when geographers still thought of two rivers, the Lower Amazon and the Upper Amazon, or the Solimoens.

84. Frederic Church to Mrs. Church, 28 April 1853, New Granada, Joseph Downs Manuscript Collection, Henry Francis du Pont Winterthur Museum, Wilmington, Delaware.

85. Wayne Franklin, "Speaking and Touching: The Problem of Inexpressibility in American Travel Books," in *America: Exploration and Travel*, ed. Steven E. Kagle (Bowling Green, Ohio: Bowling Green State University Popular Press, 1979), pp. 18–20.

86. Catlin, *Last Rambles*, p. 276.

87. Alexander von Humboldt, *Views of Nature* (New York: Harper & Bros., 1849), p. 191.

88. This idea is discussed in Robert van Dusen, *The Literary Ambitions and Achievements of Alexander von Humboldt* (Bern, Switzerland: Herbert Lang, 1971), p. 36.

89. Humboldt, *Views of Nature*, p. 223. It is interesting to note Church's perception of the situation in nearly reverse terms. Encouraging Bayard Taylor to undertake his own proposed tropical expedition, Church hoped that Taylor would describe verbally that which he had seen but could not adequately express: "I am anxious to hear more about your intentions relative to a South American trip—I want you to describe ten thousand things which I saw—but alas— not holding the pen of a ready writer I can only think and occasionally talk about them. It is a rich field for your wealthy play of thought and I hope that you will not fail to give us a good thick book" (Church to Bayard Taylor, 13 June 1859, Bayard Taylor Papers, Department of Manuscripts and University Archives, Cornell University Library, Ithaca, New York).

90. On Hodges see Bernard Smith, *European Vision and the South Pacific* (London: Oxford University Press, 1960) and Isabel Combs Stuebe, *The Life and Works of William Hodges* (New York: Garland Publishing, 1979). Humboldt, *Cosmos* 2:371–72.

91. Humboldt, *Cosmos* 2:90–91. On Post see Joaquim de Sousa-Leão, *Frans Post, 1612–1680* (Amsterdam: A. L. Van Gendt & Co., 1973).

92. Quoted in Bernard Smith, "William Hodges and English *Plein-Air* Painting," *Art History* 6 (June 1983): 147.

93. William Hodges, *Travels in India during the Years 1780, 1781, 1782, and 1783* (London, 1783).

94. For the most complete survey of these artists see *Deutsche Künstler in Latein Amerika. Maler und Naturforscher des 19 Jahrhunderts illustrieren einen Kontinent* (exhibition catalogue; Berlin: Ibero-Amerikanisches Institut, 1978). Humboldt, *Personal Narrative* 2:92–93.

95. *Catalogue of the First Annual Exhibition of Paintings at the Louisville Museum and Gallery of Fine Arts*, May 1834, nos. 38 and 40.

96. Church's copy, Olana State Historic Site. Tuckerman, *Book of the Artists*, p. 563, mentions Mignot's trip to India, which was never realized.

97. Bayard Taylor, *At Home and Abroad* (1859; New York: George P. Putnam, 1886), p. 353, mentions that on a visit to Humboldt in Berlin all the details of the study were immediately familiar to him from the colored lithograph after Hildebrandt's *Portrait of Humboldt in His Study*, which "had been so long hanging in my own room at home."

98. Humboldt, *Cosmos* 2:93.

Chapter 2

1. By the end of 1859 the picture was already one of the most popular American paintings of the century, having been shown to vast audiences in New York (29 April–23 May), London (4 July–about 14 August), and again in New York (10 October–5 December). In the succeeding 2½ years the fame of the painting spread still wider through the engraving and its expanded tour, which included stops in Boston, Philadelphia, Baltimore, Cincinnati, Chicago, St. Louis, and Brooklyn (7 April–1 May). See Gerald Carr, "American Art in Great Britain: The National Gallery Watercolor of *The Heart of the Andes*," *Studies in the History of Art* 12 (1982): 83–84. Kevin J. Avery, "*The Heart of the Andes* Exhibited: Frederic E. Church's Window on the Equatorial World," *American Art Journal* 18 (Winter 1986): 52–72, provides new insights into the appearance of the painting's original frame and its manner of exhibition.

2. *Recollections of John Ferguson Weir*, ed. Theodore Sizer, reprinted with additions from the *New-York Historical Society Quarterly* (April, July, October 1957), p. 45.

3. "Heart of the Andes," *Littell's Living Age* 62 (1859): 64.

4. Ephraim George Squier, *Waikna; or Adventures on the Mosquito Shore* (New York: Harper & Bros., 1855), pp. 17–18. This book was one of a number of Latin American travel accounts narrated by an artist in this period. Others included "Three Weeks in Cuba," by "An Artist," and "Scraps from an Artist's Notebook," by the engraver A. V. S. Anthony.

5. *Art Journal* (September 1865), quoted in Halina Nelken, *Alexander von Humboldt. His Portraits and Their Artists: A Documentary Iconography* (Berlin: Dietrich Reimer Verlag, 1980), p. 86.

6. Henri Focillon, *The Year One Thousand*, trans. Fred D. Wieck (New York: Frederick Ungar Publishing Co., 1969), p. 1.

7. Novak, *Nature and Culture*, and Edmunds V. Bunksé, "Humboldt and an Aesthetic Tradition in Geography," *Geographical Review* 71 (April 1981): 127–46, are two of a number of landscape studies to draw upon this coincidence of events.

8. Rev. J. C. Fletcher, "Review of Thomas Page's *La Plata*," *North American Review* 88 (April 1859): 431.

9. *Harper's Monthly* 19 (1859): 271.

10. Richard Henry Stoddard, *The Life, Travels, and Books of Alexander von Humboldt* (New York: Rudd & Carleton, 1859), pp. 326–27.

11. Thomas Jefferson to Alexander von Humboldt, 6 December 1813, quoted in Laura Bornholdt, "The Abbé de Pradt and the Monroe Doctrine," *Hispanic American Historical Review* 24 (1944): 220.

12. Gordon Connell-Smith, *The United States and Latin America: An Historical Perspective* (New York: John Wiley & Sons, 1974), pp. 54–55. Other Latin American states were recognized as they established their sovereignty. Haiti, although the first to gain independence, went unacknowledged by the United States until 1862 because of the opposition of the slave-holding states. Recognition of the Dominican Republic occurred in 1866.

13. For Clay's role see Connell-Smith, *United States and Latin America*, pp. 52–54.

14. Quoted in James D. Richardson, comp., *A Compilation of the Messages and Papers of the Presidents, 1789–1904* (Washington, D.C.: Bureau of National Literature and Art, 1904), 2:218–19.

15. Jared Sparks, "South America: Government of the Spanish Colonies," *North American Review* 19 (July 1824): 164–65. Throughout the 1820s, under the leadership of Sparks and Caleb Cushing, this journal continued to disseminate information about Latin America and to promote feelings of New World unity. Reviewing Giuseppe Compagnoni's *America*, for example, Cushing found its greatest merit to be "its general subject matter, being the history of the whole continent of America." See *North American Review* 27 (July 1828): 30.

16. John Vanderlyn to Mr. Cambreling, 1 February 1826, Gratz Collection, Pennsylvania Historical Society.

17. Kenneth C. Lindsay, *The Works of John Vanderlyn* (Binghampton, N.Y.: University Art Gallery, State University of New York, 1970), p. 143.

18. Quoted in *Francis Martin Drexel*, p. 14. The portrait prints of Bolívar were presumably engraved by Drexel and published by I. B. Longacre in 1826.

19. Nelken, *Alexander von Humboldt*, pp. 58–61, 78–80.

20. A watercolor inscribed "King vulture (vultur papa) from life, Turbaco, New Grenada T. R. P. 1830" (American Philosophical Society) documents their stop there.

21. A wash drawing of the steamer *Libertador* shows their side-wheeler, which was, according to the inscription, "stranded near Buenavista below Honda, the head of navigation of the Magdalena River." Jessie Poesch, *Titian Ramsay Peale and His Journals of the Wilkes Expedition* (Philadelphia: American Philosophical Society, 1961), pp. 53–54, details this excursion.

22. Church made at least five drawings of these falls and the vicinity. In the collection of the Cooper-Hewitt Museum, including nos. 1917-4-65, -260, -261, -262, and -264.

23. Geoffrey Crayon (Washington Irving), "National Nomenclature," *Knickerbocker* 14 (August 1839): 161.

24. Washington Irving, *Astoria; or Anecdotes of an Enterprise beyond the Rocky Mountains*, rev. ed. (1836; New York: George P. Putnam, 1860), p. 103. The book was based on John Jacob Astor's fur trading activities in the Pacific Northwest.

25. *North American Review* 61 (1845): 98.

26. Darwin, *Voyage of the Beagle*.

27. Victor Wolfgang Von Hagen, *Maya Explorer: John Lloyd Stephens and the Lost Cities of Central America and Yucatán* (Norman: University of Oklahoma Press, 1947) provides background on their achievement.

28. No comprehensive study exists on the role of photography in the exploration of Latin America. For a comparative discussion of its importance in the expeditions to the American West see Weston J. Naef and James N. Wood, *Era of Exploration: The Rise of Photography in the American West, 1860–1885* (New York: Metropolitan Museum of Art, 1975).

29. Humboldt, *Cosmos* 2:90.

30. For background on ships and shipping lines see Vincent Ponko, *Ships, Seas, and Scientists: U.S. Naval Exploration and Discovery in the Nineteenth Century* (Annapolis, Md.: Naval Institute Press, 1974), pp. 4ff., and Duncan Haws, *Ships and the Sea: A Chronological Review* (New York: Thomas Crowell, 1975).

31. John Wilmerding, *Fitz Hugh Lane* (New York: Praeger, 1971), p. 43.

32. Audrey G. Wright, "Henry Walke, 1809–1896: Romantic Painter, and Naval Hero" (Master's thesis, George Washington University, 1971). "Paintings of the *North Carolina* by Walke," *Old Print Shop Portfolio* 13 (1954): 218–21, points out that this was a pendant to a view of the ship at Gosport (Norfolk), from which they set sail 12 January 1837, fifty days before arriving at Rio.

33. For identification of Burrows as Peale's patron see Poesch, *Titian Ramsay Peale*, p. 53, n. 48. On the packet lines of Burrows see John H. Kemble, *The Panama Route 1848–1864* (New York: Da Capo Press, 1972), p. 2.

34. Boies Penrose, "The Early Life of F. M. Drexel, 1792–1863," *Pennsylvania Journal of History* (October 1936): 347.

35. Arthur C. Wardle, *Steam Conquers the Pacific: A Record of Maritime Achievement 1840–1940* (London: Hodder & Stoughton, 1940).

36. Ward's *Eagle Rock* (c. 1860; New Jersey Historical Society) is similar in conception to the *Muleteers*, with the foreground platform view into the lower valley. Measuring 45³/₄ × 88 in., it depicts a well-known landmark in his native Bloomfield, New Jersey; it is unfortunately badly deteriorated.

37. Darwin, *Voyage of the Beagle*, p. 293.

38. "Our New Atlantis," *Putnam's Magazine* 5 (April 1855): 378.

39. See Ponko, *Ships, Seas, and Scientists*, chapter 4, for a summary of Perry's expedition.

40. Ephraim George Squier, "San Juan de Nicaragua," *Harper's Monthly* 10 (December 1854): 50.

41. J. T. Headley, "Vasco Núñez de Balboa," *Harper's Monthly* 18 (1859): 467.

42. William Truettner, "The Art of History: American Exploration and Discovery Scenes," *American Art Journal* 14 (Winter 1982): 14–15, discusses the phenomenon of legitimizing expansionism through the examples of history, primarily in the context of the West. Headley, "Vasco Núñez de Balboa," was one such attempt to justify expansionist designs in Latin America by calling upon the great explorer's precedent.

43. Alexander von Humboldt, *Political Essay on the Kingdom of New Spain*, ed. Mary Maples Dunn (1811; repr., New York: Alfred A. Knopf, 1972), 1: 18–45.

44. U.S. interest in the Tehuantepec route during the Mexican War is discussed in Frederick Merk, *Manifest Destiny and Mission in American History: A Reinterpretation* (New York: Alfred A. Knopf, 1963), pp. 128–29.

45. David McCullough, *The Path between the Seas: The Creation of the Panama Canal, 1870–1914* (New York: Simon and Schuster, 1977), provides an overview of the subject.

46. J. T. Headley, "Darien Exploring Expedition under Command of Lieut. Isaac C. [*sic*] Strain," *Harper's Monthly* 10 (March, April, May 1855): 433–58, 600–615, 745–64. The account was compiled from private journals kept by the expedition members, which Strain turned over to Headley along with "the book of sketches made by the draftsman"; the fate of the original manuscripts and sketches is unknown.

47. Quoted in Ponko, *Ships, Seas, and Scientists*, p. 169.

48. The division of the spheres of influence of the two companies was realized in 1851. In 1847 Law had formed the U.S. Mail Steamship Company to provide biweekly service between New York and Chagres. Opposition developed when Aspinwall's Pacific Mail Steamship Company set up a rival line. This provoked Law, in turn, to secure ships to compete with Aspinwall's Pacific traffic. By 1851 they arrived at a compromise whereby Law confined himself to the Atlantic and Aspinwall to the Pacific. See *Dictionary of American Biography* 6:39–40 for entry on Law and the details of the competition.

49. Kemble, *Panama Route*, pp. 31–57.

50. Letter from John Sing to his mother, 10 November 1849, Panama, John Sing Collection, New-York Historical Society.

51. Frederic Church, 1853 South American diaries, entries for 5–17 October, manuscript, Olana State Historic Site.

52. On Aspinwall see *Dictionary of American Biography* 1:396.

53. For a contemporary account of the railroad see Oran, "Tropical Journeyings: Panama Railroad," *Harper's Monthly* 18 (January 1859): 145–69.

54. Karl Berman, *Under the Big Stick: Nicaragua and the United States since 1848* (Boston: South End Press, 1986), pp. 31–33. On Vanderbilt see also *Dictionary of American Biography* 10:169–73.

55. Berman, *Under the Big Stick*, pp. 29–31, quotation p. 29.

56. See, for example, Stephens, *Incidents of Travel in Central America* 1:406–20, where he included the information on the proposed canal he was able to assemble while pursuing his consular and archaeological duties. The long-term interest of the United States in this question is indicated by the fact that as early as 30 June 1785 Thomas Jefferson secured and presented to the American Philosophical Society a study entitled *Mémoire sur la possibilité, les avantages, et les moyens d'ouvrir un canal dans l'Amerique septentrionale, pour communiquer de la mer Atlantique, ou du Nord, à mer Pacifique, ou du Sud*, written by Martin de la Bastide in about 1785. Information found in the Archives of the American Philosophical Society.

57. "Domestic Art Gossip," *The Crayon* 4 (1857): 90. A further report, *The Crayon* 4 (1857): 221, mentioned the exhibition of Heine's work at the National Academy of Design: "In the Landscape department, Mr. Heine has six pictures. Nos. 4 and 18 are views in Nicaragua. These pictures are unpretending representations of their respective scenes, both being evidently faithfully drawn."

58. Many of Hitchcock's images were lithographed in Squier's *Notes on Central America; Particularly the States of Honduras and San Salvador* (New York: Harper & Bros., 1855), which gave special emphasis to the author's pet project of the moment, the Honduran Interoceanic Railroad.

59. For two partial compendia of Aspinwall's collection see *Catalogue of the Aspinwall Gallery of Oil Paintings by the Old and Modern Masters* (New York: Chickering Hall, 1886) and *The Remarkable*

Private Collection of Art Treasures from the Mount Mansion, the Estate of the Late William H. Aspinwall, Bristol, Rhode Island: Magnificent Paintings by Famous European Masters (Boston: Leonard & Co., 1899). Winthrop's role as advisor to the art purchasing of the Aspinwall family is indicated by two letters to his mother among the Winthrop Papers, Manuscript Division, New York Public Library—29 April 1852, no. 70, in which he reported, "Bought *entirely at my own discretion* $300 of pictures for John Aspinwall, including one of Cole's"; and 2 January 1853, no. 95, in which he wrote, "I observe in the N.Y. papers that Cleopatra has bought the landscape or sea-scape of Church's the "Mount Desert Beacon" which I admired very much and recommended to him." Cleopatra was apparently his nickname for William Aspinwall; the painting subsequently appeared in the 1886 sale of his collection as *The Beacon on Mount Desert Island, Coast of Maine*, no. 7.

60. Although the artist of the painting has not been securely identified, its provenance does suggest association with Aspinwall, for it came down through the descendants of Franklin Hughes Delano (1813–1893), who had been a neighbor of Aspinwall's. It has therefore been speculated that Delano at some point acquired it from Aspinwall (author's conversation with the present owner, Ramón Osuna).

61. Theodore Winthrop to Frederic Church, 25 April 1857, manuscript, Olana State Historic Site.

62. Quoted in Albert K. Weinberg, *Manifest Destiny: A Study of Nationalist Expansionism in American History* (Chicago: Quadrangle Books, 1963). In the late 1850s, in the aftermath of the filibuster wars, a number of articles on the subject appeared in the popular press. *Harper's Monthly*, for one, recounted past attempts at filibusters, implying justification for contemporary deeds. See, for example, an account of the French adventurer Lussan in the Caribbean in 1684, "An Old Filibuster," *Harper's Monthly* 18 (December 1858): 18–31.

63. *Hints to Farmers on the Nature of Guano*, 1st American ed. of 3d London ed., 1843, A. J. Duffield, *The Prospects of Peru: The End of the Guano Age and a Description Thereof* (London: Newman & Co., 1881), p. 66.

64. Alexander Gardner, *Rays of Sunlight from South America* (Washington, D.C.: Philip & Solomons, 1865). The photographs were all taken by Moulton but were published under Gardner's name, as indicated by the identifying text below each print in the album: "Negatives by H. Moulton; positives by A. Gardner." For background see Keith McElroy, "Henry DeWitt Moulton: Rays of Sunlight from South America," *History of Photography* 8 (1984): 7–21. My thanks to the author for providing me with an advanced copy of the manuscript.

65. Inca (Matthew Fontaine Maury), *The Amazon, and the Atlantic Slopes of South America*, a series of letters first published in the *National Intelligencer* and *Union* newspapers (Washington, D.C.: Franck Taylor, 1853), p. 48.

66. Merk, *Manifest Destiny*, p. 210.

67. Naval War Records Library, "Officers Letters, March 1850, No. 161," quoted in Whitfield J. Bell, "The Relation of Herndon and Gibbon's Exploration of the Amazon to North American Slavery, 1850–1855," *Hispanic American Historical Review* 19 (1939): 495, where the excerpt from the letter to Ann Maury, dated 30 June 1850, also appears.

68. Although the expedition report stimulated interest in Brazil, neither it nor Maury's articles could be said to have precipitated a widespread relocation of southern plantations there. The publicity that Brazil received as a result of his efforts, however, undoubtedly contributed to the emigration of several thousand self-exiled Confederates after the Civil War.

69. For a discussion of the commercial and political components of these expeditions see John P. Harrison, "Science and Politics: Origins and Objectives of Mid-Nineteenth Century Expeditions to Latin America," *Hispanic American Historical Review* 35 (1955): 175–202.

70. From a report of the special committee of the American Philosophical Society, 7 January 1848, which appears in Ponko, *Ships, Seas, and Scientists*, p. 95.

71. Gilliss, *U.S. Naval Astronomical Expedition*, copy, Olana State Historic Site.

72. Van Wyck Brooks, *The Times of Melville and Whitman* (New York: E. P. Dutton, 1947), p. 195. See Hamilton Basso's introduction to Lewis William Herndon and Lardner Gibbon, *Exploration of the Valley of the Amazon, Made under the Direction of the Navy Department* (1854; repr., New York: McGraw-Hill, 1952), pp. i–xxvii for discussion of Mark Twain's interest in this volume.

73. Thomas Jefferson Page, *La Plata: The Argentine Confederacy and Paraguay* (New York: Harper & Bros., 1859). Among many adventures, he described an encounter with Humboldt's old companion Aimé Bonpland, who had made a home in Paraguay. They invited the eighty-two-year-old explorer to join them, but he was unable to do so. See Herndon and Gibbon, *Exploration*, pp. 295–98.

74. Fletcher, "Page's La Plata," p. 431.

75. Ibid. An invaluable listing of travel literature can be found in Bernard Naylor, *Accounts of Nineteenth-Century South America: An Annotated Checklist of Works by British and United States Observers* (London: Athlone Press, 1969).

76. Letter from Theodore Winthrop to his mother, 2 January 1853, Panama, Theodore Winthrop Papers, Manuscript Division, New York Public Library.

77. Theodore Winthrop, *The Canoe and the Saddle: Adventures among the Northwestern Rivers and Forests and Isthmiana* (posthumous publication of previously unpublished manuscript; New York: Dodd, Mead, and Co., 190[?]), p. 315.

78. Although the evolution of the image can be traced, the circumstances behind the creation of it and other watercolor drawings from the expedition remain mysterious. The watercolors, now housed in the Gilcrease Institute of American History and Art in Tulsa, Oklahoma, were painted by the western artist Edward Kern, who was not known to be a member of Page's party. It is likely that Kern worked up the watercolors in Washington from field sketches made by some amateur draftsman among the crew or possibly from daguerreotypes. Page had with him "photographic apparatus with all the appliances which ingenuity had lent to modern geographic research," although the fate of any images that might have been taken remains unknown. On Kern see Robert V. Hine, *Edward Kern and American Expansion* (New Haven: Yale University Press, 1962), p. 126. Additional information on the watercolors was kindly supplied to me by the staff of the Gilcrease Institute. On Page's photographic apparatus see John Kirtland Wright, *Geography in the Making: The American Geographical Society, 1851–1951* (New York: American Geographical Society, 1952), p. 23. Page, *La Plata*, p. 232, mentions "the loss of our daguerreotype instruments" but fails to indicate when it occurred.

79. In making these changes, the engraver may have been inspired by the description that appeared in Page, *La Plata*, p. 145: "Five miles above Arracife, while running close to the right bank, we saw a host of mounted Indians in the distance. They came dashing at a full gallop over the plain, looking like Centaurs, as they gracefully guided their horses through the windings of a dense palm forest, and undeviatingly directed their course to the river, without for an instant checking speed. On they came, men and women, in all their nudity; no garments of any description, except a piece of stuff about the loins; neither paint nor ornaments, neither saddles nor bridles. . . . We gazed with interest upon these savages, for the warlike Chaco tribes have alone, amid the degradation and extirpation of the nations of their race upon the American continent, defied, for more than three centuries, the power of the white man."

80. The illustration appears in Alfred Demersay, "Fragments d'un voyage au Paraguay," *La Tour du Monde* 4 (1861): 96–112, where its source in Page's expedition report is credited.

81. The same hill had previously been climbed by Darwin, who wrote in *Voyage of the Beagle*, p. 264, "A never-failing source of pleasure was to ascend the little hillock of rock (St. Lucia) which projects in the middle of the city. The scenery certainly is most striking." It was, and remains, a traditional viewing spot overlooking the city. But the details of the foreground and other aspects of Smith's drawing were repeated in subsequent images, suggesting that it offered a pictorial prototype.

82. Joseph D. Ketner II, "Robert S. Duncanson (1821–1872): The Late Literary Landscape Paintings," *American Art Journal* 15 (1983): 39. Duncanson's dependence on Church suggests that an interesting reversal has occured, for the South American landscape, which was guided by the image of the biblical Eden, became in turn the point of departure for the imaginary Arcadian picture.

83. Patricia Trenton and Peter H. Hassrick, *The Rocky Mountains: A Vision for Artists in the Nineteenth Century* (Norman: University of Oklahoma Press, 1983), pp. 10–13, 195.

84. A painting has been discovered recently in a private collection

in Quito, Ecuador, that bears a striking resemblance to Church's picture in overall composition (photograph unavailable). It has been assumed, traditionally, to have been painted by a native artist.

85. "Sketchings," *The Crayon* 1 (1855): 140. Walter Montgomery, ed., *American Art and American Art Collections* (Boston: E. W. Walker, c. 1889), p. 774.

86. Asher B. Durand, "Letters on Landscape Painting," *The Crayon* 1 (1855): 34–35.

87. John I. H. Baur, ed., *The Autobiography of Worthington Whittredge, 1820–1910* (1905; repr. New York: Arno Press, 1969), p. 28.

88. David Huntington, *The Landscapes of Frederic Edwin Church: Vision of an American Era* (New York: George Braziller, 1966), p. 16.

89. "Sketchings," *The Crayon* 3 (1856): 116. The article, although anonymous, was perhaps authored by William Stillman, editor of *The Crayon* and one-time pupil of Church.

90. For the tour of *Niagara* see Carr, "American Art in Great Britain," p. 86.

91. John Durand, *The Life and Times of A. B. Durand* (New York: Scribner's, 1894), p. 60.

92. By the time *Heart of the Andes* returned home from its tour, a *Crayon* reviewer claimed that its success had heightened the appreciation of American art abroad: "The picture, during its exhibition in England, received unusual attention from the press. American Art, through it, has risen many degrees in the scale of appreciation in England, and Mr. Church is fully entitled to ackowledgements for it" ("Exhibitions," *The Crayon* 6 [December 1859]: 382).

93. *Literary Gazette*, quoted in *The Crayon* 6 (1859): 281.

94. William Clark Griggs, *The Elusive Eden: Frank McMullan's Confederate Colony in Brazil* (Austin: University of Texas Press, 1987), pp. viii–ix, provides an overview of these various emigration efforts; the body of the text is devoted to McMullan's colony.

95. William Davis, *The Last Conquistadores: The Spanish Intervention in Peru and Chile, 1863–1866* (Athens: University of Georgia Press, 1950). The details and implications of Whistler's travels in Chile are discussed in chapter 7.

96. Nathan Reingold, ed., *Science in Nineteenth-Century America: A Documentary History* (New York: Hill and Wang, 1964), especially pp. 251–53.

97. Quoted in Joseph Smith, *Illusions of Conflict: Anglo-American Diplomacy toward Latin America, 1865–1896* (University of Pittsburgh, 1979), p. 81.

98. McCullough, *Path between the Seas*, p. 610.

99. Ephraim George Squier, *Nicaragua; Its People, Scenery, Monuments, Resources, Condition, and Proposed Canal* (New York: Harper & Bros., 1852), p. 89.

100. Other images by Bush that likely represent Lake Nicaragua include *Tropical Landscape*, illustrated in *American Paintings, Drawings, and Sculpture of the Eighteenth, Nineteenth, and Twentieth Centuries* (auction catalogue; Christie, Manson & Woods, 1981); and *Volcano and Lake*, in a private collection (photograph is on file at the Inventory of American Paintings Executed before 1914, Office of Research Support, National Museum of American Art, Smithsonian Institution, no. B9.07 LC 10/4). The only painting Bush sent to the annual exhibition of the National Academy of Design between 1852 and his death was *Lake Nicaragua*, which he showed in 1871 (no. 52, for sale), indicating his belief in the subject's potential market value.

101. Heade's drawings in the Karolik Collection, Museum of Fine Arts, Boston, include *Virgin Bay, Nicaragua* (no. 1973.315); *Granada, Nicaragua* (no. 60.1011); *Fort on the San Juan River, Nicaragua* (no. 1973.312); and *Nicaraguan Hut and Studies of Bamboo* (no. 1973.316). *Lagoon in Nicaragua* was shown at the National Academy of Design in 1867 (no. 231, for sale). No documentation has so far come to light to explicate the motivation behind Heade's trip, but given his association with mutual friend John R. Bartlett, it is likely that he was acquainted with Squier and his artists, and was well aware of the canal issue. In Heade's case, however, one must bear in mind his mania for hummingbirds, of which Nicaragua was known to have a rich population. See, for example, Thomas Belt, *The Naturalist in Nicaragua* (London: John Murray, 1874), pp. 137–40, one of many references of the day to praise the country's many species of hummingbirds.

102. Joel Snyder, *American Frontiers: The Photographs of Timothy O'Sullivan, 1867–1874* (Philadelphia Museum of Art, 1981), p. 26. The photographs from the Selfridge Expedition are in the National Archives, Still Pictures Branch, Washington, D.C. Some confusion has arisen in the literature over the work of O'Sullivan, who accompanied the expedition on its 1870 reconnaissance, and John Moran, who followed in 1871—a confusion that can be resolved by identifying the location of the photographs, for the two men worked in two different regions of Darien.

103. Duffield, *Prospects of Peru*, p. 88.

104. William S. Auchincloss, *Ninety Days in the Tropics, or Letters from Brazil* (Wilmington, Delaware, 1874), p. 38.

105. Ibid.

106. Benjamin Pease documented the southern line of the Peruvian railroad from Mollendo (on the coast) to Arequipa (about sixty miles into the mountainous interior) in a set of views taken in May 1870 as work neared completion. A list of the photographs he took survives, although the photographs themselves remain unlocated. Like the work of Bush, this project was at least partially sponsored by Meiggs. See Keith McElroy, "The History of Photography in Peru in the Nineteenth Century, 1839–1876" (Ph.D diss., University of New Mexico, 1977), pp. 182, 622.

107. Compared to the railways of North America, those of South America played a limited role in opening the frontiers. It might be said that Latin America missed the railway age. Those lines that

were built were the by-product of base metal mining, and as late as the 1870s transportation badly needed improving. See Hennessy, *Frontier*, pp. 81–82, 142–143. For a study that deals with one country see J. Fred Rippy, "The Dawn of the Railway Era in Colombia," *Hispanic American Historical Review* 23 (1943): 650–63.

108. Mary W. Williams, *Dom Pedro the Magnanimous: Second Emperor of Brazil* (Chapel Hill: University of North Carolina Press, 1937), pp. 86–111; and *The Empire of Brazil at the Universal Exhibition of 1876 in Philadelphia* (Rio de Janeiro, 1876).

109. "The International Exhibition No. 31: Brazil in Agricultural Hall," *The Nation* 23 (9 November 1876): 282.

110. John Ferguson Weir, "Paintings and Sculpture at the Centennial Exhibiton—I," *American Architect and Building News* 3 (26 January 1878): 28.

111. Gilberto Ferrez and Weston J. Naef, *Pioneer Photographers of Brazil* (New York: Center for Inter-American Relations, 1976), pp. 31, 89, 114, 116.

112. The Lamborn Collection, now in the Philadelphia Museum of Art, is one such collection of Latin American art formed in this period and given to the museum at the turn of the century. See Robert Henry Lamborn, *Mexican Painting and Painters* (New York and Philadelphia, 1891).

113. *Art Journal* (American ed.) 1 (1875): 179.

Chapter 3

1. *Cotopaxi. Painted by Frederic E. Church. From Studies Made in the Summer of 1857* (pamphlet; New York: Goupil's Gallery, c. 1863).

2. "Church's *Cotopaxi*," *New York Times*, 17 March 1863.

3. *Catalogue of the Mignot Pictures* lists a number of geologically related subjects, including *Cotopaxi* (no. 72). George Catlin, *The Lifted and Subsided Rocks of America* (London: Truebner & Co., 1870).

4. Humboldt, *Researches* 1:120, 118.

5. "Church's *Cotopaxi*." For a more extensive discussion of the ten paintings in the series and the related drawings and oil sketches see Katherine Manthorne, *Creation & Renewal: Views of Cotopaxi by Frederic Edwin Church* (exhibition catalogue; Washington, D.C.: National Museum of American Art, 1985).

6. Benedict Nicolson, *Joseph Wright of Derby: Painter of Light* (London and New York: Pantheon Books, 1968).

7. George Kubler, *The Shape of Time: Remarks on the History of Things* (New Haven and London: Yale University Press, 1962), p. 45.

8. "From Our Own Correspondent," newspaper clipping, 7 April 1863, New York Public Library scrapbook on Church.

9. James Fenimore Cooper, *The Crater; or, Vulcan's Peak* (1847;

repr., Cambridge, Mass.: Harvard University Press, 1962).

10. Catlin, *Lifted and Subsided Rocks*, p. 139.

11. Winthrop, *Companion*, p. 19.

12. Humboldt, *Cosmos* 1:228–29, 238.

13. For discussion and illustrations see Manthorne, *Creation & Renewal*, pp. 80–81.

14. Frederic Church to Charlotte Church, 8 August 1853, Henry Francis du Pont Winterthur Museum, Joseph Downs Manuscript Collection, Wilmington, Delaware, no. 57 × 18.39.

15. Quoted in Franklin W. Kelly, "Myth, Allegory, and Science: Thomas Cole's Paintings of Mount Etna," *Arts in Virginia* 23 (1983): 3.

16. Frederic Church to Charlotte Church, 8 August 1853.

17. Humboldt, *Researches* 1:124.

18. Ibid., 1:122–23. *View of Cotopaxi*, featuring the Head of the Inca, appeared as the frontispiece to the book.

19. Katherine Manthorne, "Benjamin Silliman and American Art: A Study in the Relations between Geology and Landscape Painting in the Pre-Darwinian Era" (research paper, Columbia University, 1978).

20. Isabella Field Judson, ed., *Cyrus W. Field: His Life and Work (1819–1892)* (New York: Harper & Bros., 1896), pp. 39–41. Quotation from letter of James Hall to Cyrus Mason dated 8 September 1846 in the Cyrus Field Papers, Rare Book and Manuscript Division, New York Public Library.

21. "Eruption of Mauna Loa, Hawaii," *Harper's Weekly* 3 (16 April 1859): 249. Ephraim George Squier, "The Volcanoes of Central America," *Harper's Monthly* 19 (November 1859): 739–62. James Nasmyth, "Volcanic Action," *The Crayon* 1 (27 June 1855): 409.

22. On the related *South American Landscape* see Manthorne, *Creation & Renewal*, fig. 19, cat. no. 5.

23. John Ruskin, "Of Mountain Beauty," *Modern Painters* 4 (1856; repr., New York: John Wiley & Sons, 1882), 139.

24. "Do Mountains Grow?" *Harper's Monthly* 15 (1857): 43.

25. Charles Wilkes, *Narrative of the United States Exploring Expedition during the Years 1838, 1839, 1840, 1841, and 1842* (Philadelphia: Lea & Blanchard, 1845), 4:125.

26. Frederic Church, essay on Tequendama Falls, 1853, manuscript, Olana State Historic Site.

27. Frederic Church, Sangay diary, July 1857, manuscript, Olana State Historic Site.

28. Huntington, *Landscapes of Church*, p. 45.

29. On his study with Werner see Douglas Botting, *Humboldt and the Cosmos* (New York: Harper & Row, 1973), pp. 22–23. These changes in outlook can be perceived in the course of Humboldt's

207

30. James Orton, *The Andes and the Amazon; or, Across the Continent of South America* (New York: Harper & Bros., 1876), p. 151. Between 1867 and 1877 Orton headed three scientific expeditions to South America. The first edition of his book (New York and London, 1870) covered only the first expedition; the revised 1876 edition included the second. For background see Robert Ryal Miller, "James Orton: A Yankee Naturalist in South America, 1867–1877," *Proceedings of the American Philosophical Society* 126 (1982): 11–25.

31. Frederic Church to Aaron C. Goodman, 24 July 1857, manuscript, Olana State Historic Site.

32. Novak, *Nature and Culture*, pp. 35–36, perceptively analyzes the diaries in terms of their aural emphasis.

33. Winthrop, *Companion*, pp. 34, 23.

34. Louis L. Noble, *Church's Painting: "The Heart of the Andes"* (New York: D. Appleton and Co., 1859), p. 3.

35. "Cotopaxi," Goupil's, c. 1863.

36. *A Catalogue of Paintings, Engravings, & C. at the Picture Gallery of the Maryland Historical Society*, Sixth Annual Exhibition (Baltimore, 1858), nos. 113, 121. The fact that these works were done in 1858 precludes the possibility that Mignot was trying to capitalize on the fame of Church's canvas.

37. Quoted in *Catalogue of the Mignot Pictures*.

38. Although currently known as *Lagoon of the Guayaquil River, Ecuador,* this canvas clearly represents not the coastal lowlands, but rather a broad sweep of the Cordilleras, better described by its former title, *Morning in the Andes*. See Manthorne entry on the painting in *American Paradise: The World of the Hudson River School* (exhibition catalogue; New York: Metropolitan Museum of Art, 1987), pp. 298–301.

39. Frederic Church to Martin Heade, 7 March 1870, Church-Heade correspondence, Archives of American Art, Smithsonian Institution, Washington, D.C.

40. Stephens, *Incidents of Travel in Central America* 1:405.

41. "Report from Nicaragua," *Smithsonian Annual Report* (1867).

42. Winthrop, *Companion*, p. 3.

43. Humboldt, *Cosmos* 5:262, 264.

44. Squier, "Volcanoes of Central America," p. 739.

45. These observations could be extended to include artistic interest in the geological forms in the American West, such as Paul Kane's image of Mount St. Helens, Sanford Gifford's of Mount Rainier, and Timothy O'Sullivan's photographs of Pyramid Lake. "The peculiar rock formations, from which this lake derives its name, are remarkable even among the 'Rockies,'" O'Sullivan's companion explained. "The principal pyramid towers above the lake to a height of more than 500 feet, presenting in its general outline a remarkably perfect pyramidal form." See "Photographs from the High Rockies," *Harper's Monthly* 39 (September 1869): 465–75. In con-

trast to these dormant formations in the West, however, the active volcanoes of the Andes seemed one step closer to their goal.

46. For a discussion of Cézanne's remarks see Theodore Reff, "Painting and Theory in the Final Decade," in *Cézanne: The Late Work*, ed. William Rubin (New York: Museum of Modern Art, 1977), pp. 47–48. Turner is quoted in Lawrence Gowing, *Turner: Imagination and Reality* (exhibition catalogue; New York: Museum of Modern Art, 1966), p. 27.

47. *Study of Cotopaxi Erupting* (c. 1857–62; Cooper-Hewitt Museum, no. 1917-4-786), illustrated in Manthorne, *Creation & Renewal*, fig. 28, cat. no. 20.

48. Squier, *Nicaragua*, p. 507.

49. Mary Sayre Haverstock, "Round Trip to Paradise," *Art in America* 54 (1966): 65–71, discussed Catlin's South American explorations together with those of Church and Heade; otherwise, scholars have concentrated almost exclusively on his western oeuvre.

50. "Anecdotes of Catlin," *The Crayon* 1 (1855): 252.

51. "The Almanac: Catlin's Lithographs Showing Colt Firearms," *Antiques* 37 (1940): 35. Truettner, *Natural Man Observed*, p. 56.

52. Catlin, *Life amongst the Indians*, quoted in George Catlin, *Episodes from Life among the Indians and Last Rambles*, ed. Marvin Ross (Norman: University of Oklahoma Press, 1979), p. 24.

53. See the mineral chart he fashioned from "a variety of specimens of steatite from the Red Pipe Stone Quarry, on the Coteau des Prairies, near the sources of the St. Peters [Minnesota] River." Catlin Papers, Archives of American Art, Smithsonian Institution, Washington, D.C.

54. Truettner, *Natural Man Observed*, cat. no. 366, p. 245.

55. Catlin, *Lifted and Subsided Rocks*, p. 157.

56. Catlin, *Last Rambles*, p. 53. Although he vividly conjures up Cotopaxi, Chimborazo, and other peaks in Ecuador, he seems not to have traveled there.

57. Humboldt to Catlin, 12 September 1855, quoted in Catlin, *Last Rambles*, pp. 331–32. The topic of the distribution of races, of interest to Catlin and his contemporaries, is explored extensively in chapter 4.

58. Darwin, *Voyage of the Beagle*, p. 260.

59. Catlin, *Lifted and Subsided Rocks*, p. 160.

60. Truettner, *Natural Man Observed*, pp. 61–68, discusses Catlin's background in Philadelphia science. On Bonpland see Catlin, *Lifted and Subsided Rocks*, pp. 220–21. On Schomburgk see Catlin, *Last Rambles*, p. 54. The names of Roderick Murchison and Charles Lyell appear along with those of Humboldt, John Herschel, Carl Ritter, Leopold von Buch, William Beaumont, Agassiz, James Dana, William B. Rogers, Dr. Jackson, Benjamin Silliman, Edward Hitchcock, Joseph Jukes, T. Sterry Hunt, John Phillips, Henry Thomas De LaBeche, James Hall, William Logan, and other men of science throughout the pages of *Lifted and Subsided*

Rocks, where he argues the positive and negative aspects of their individual theories.

61. Catlin, *Lifted and Subsided Rocks,* p. 204.

62. Ibid., pp. 156–57.

63. Ibid., p. 149.

64. Catlin, *Last Rambles,* pp. 213–14.

Chapter 4

1. Catlin, *Last Rambles,* pp. 304–34.

2. Thomas Jefferson, *Notes on the State of Virginia,* quoted in Curtis M. Hinsley, Jr., *Savages and Scientists: The Smithsonian Institution and the Development of American Anthropology, 1846–1910* (Washington, D.C.: Smithsonian Institution Press, 1981), p. 21, where Hinsley discusses the importance of this question for American anthropology.

3. Parallels between Gauguin and Catlin (and other artists in this study) might be further explored. Gauguin referred to himself as "Indian," "Savage," "Peruvian," and "Inca," and he traced his ancestry through his mother to Peru, where he lived until the age of nine. Later he traveled to Central America, where he worked as a laborer on the Panama Canal. For a discussion of one aspect of this issue see Barbara Braun, "Paul Gauguin's Indian Identity: How Ancient Peruvian Pottery Inspired His Art," *Art History* 9 (March 1986): 36–54.

4. Warren, "Romance," p. 500. He was one of many travelers to express this sentiment.

5. From Frederick Catherwood's introduction to his *Views of Ancient Monuments in Central America, Chiapas, and Yucatán,* published in 1844 and reprinted in Victor Wolfgang Von Hagen, *Frederick Catherwood, Archt.* (New York: Oxford University Press, 1950), pp. 119–44, quotation p. 137. For a Spanish reprint of the text with full-page color illustrations of Catherwood's lithographs see *Vision del mundo Mayo—1844* (Mexico: Cartón y Papel de México, S.A., 1978).

6. The ruins of Palenque had been studied earlier by Jean-Frédéric Maxmilien, Count de Waldeck. His *Voyage pittoresque et archéologique dans la province d'Yucatán* (Paris, 1838) had stimulated the interest of Stephens to go there. But, as Von Hagen argues, the fact that his images of the ruins were romanticized and inaccurate disqualifies him as the rediscoverer of the Maya. See Von Hagen, *Maya Explorer,* pp. 152–55.

7. Friedrichsthal's explorations were reported in the Boston *Daily Evening Transcript,* 7 September 1841. My thanks to Col. Merl M. Moore, Jr., for providing me with this reference.

8. B. M. Norman, *Rambles in Yucatán; or, Notes of Travel through the Peninsula, Including a Visit to the Remarkable Ruins of Chi-Chen, Kaban, Zayi, and Uxmal* (New York: Langley, 1843).

9. The phrase "archaeological epidemic" appears in Samuel Foster Haven, *Address from the Proceedings of the American Antiquarian Society for 22 October 1877* (Worcester, Mass.), p. 8.

10. Richard Hofstadter has argued most vigorously for an interpretation of U.S. history in terms of space. For a discussion of the time-space matrix of Latin America see Hennessy, *Frontier,* p. 3.

11. Don Juan de Velasco, *Historia del Reino de Quito* (Quito: Imprenta del Gobierno, 1844), a source to which Prescott and others frequently refer, is still in Church's library at Olana. In a diary entry for 7 September 1853 (manuscript, Olana State Historic Site) the artist proudly mentions his acquisition of a nineteenth-century limited edition of this eighteenth-century text: "Obtained a copy of El history of the Kingdom of Quito written by a monk named Velasco, 200 copies were published for subscribers only." He also owned Johann J. von Tschudi's *Travels in Peru* (New York: George P. Putnam, 1853).

12. Although Prescott's histories concentrated on the actions of the heroes Cortés and Pizarro, respectively, the narratives were prefaced by luminous accounts of Aztec and Inca life. See *Conquest of Mexico,* bk. 1, "Introduction to the Aztec Civilization," and *Conquest of Peru,* bk. 1, "Introduction—View of the Civilization of the Incas."

13. Quoted in Von Hagen, *Frederick Catherwood,* p. 127. It is interesting to note that although Prescott explained at some length the intellectual, social, and economic achievements of Aztec life, it was his evocation of priests, sacrifices, and cannibal feasts that made the most lasting impression on his readers. The excerpt quoted by Catherwood epitomized Prescott's dramatic treatment on the Aztecs; but even in *Conquest of Peru,* where the more peaceful Incas proved a less spectacular subject, the author emphasized their enormous wealth and "barbaric splendor."

14. Thomas Cole, "Essay on American Scenery" (1835), quoted in *American Art, 1700–1960,* ed. John McCoubrey, Sources and Documents in the History of Art Series (Englewood Cliffs, N.J.; Prentice-Hall, 1965), p. 108.

15. For a discussion of Prescott's approach see David Levin, *History as Romantic Art: Bancroft, Prescott, Motley, and Parkman* (Stanford: Stanford University Press, 1959).

16. Bernadino de Sahagún's *Historia general de los cosas de Nueva España* was printed for the first time in 1829–30.

17. Prescott to Humboldt, 23 December 1843, quoted in Ignacio Bernal, *A History of Mexican Archaeology: The Vanished Civilizations of Middle America* (London and New York: Thames and Hudson, 1980), p. 100; see pp. 112–19 for a discussion of Prescott's position on the question of origins.

18. Prescott, *Conquest of Peru* 1:37. His reluctance to speak on the subject was praised by several contemporaries; see, for example, *Littell's Living Age* 15:497. Others, however, did not find Prescott's attitudes so congenial; for a critical review see Theodore Parker, "Prescott's Conquest of Mexico," in *The American Scholar,* ed. George Willis Cooke (Boston: American Unitarian Association,

1907), pp. 220–67.

19. Albert Gallatin, "Notes on the Semi-Civilized Nations of Mexico, Yucatán, and Central America," *Transactions of the American Ethnological Society* 1 (1845): 1–352. An overview of the negative, ambivalent, and positive attitudes toward Meso-American culture can be found in Benjamin Keen, *The Aztec Image in Western Thought* (New Brunswick, N.J.: Rutgers University Press, 1971), pp. 349–50.

20. Lord Kingsborough's efforts to seek out and publish Mexican manuscripts and artifacts in support of his argument resulted in the appearance of nine of the projected volumes of *Antiquities of Mexico* (London: A. Aglio, 1830–48), which provided a useful source of visual imagery. For a discussion of his work see Elizabeth Carmichael, *The British and the Maya* (exhibition catalogue; London: Trustees of the British Museum, 1973), p. 13.

21. Stephens, *Incidents of Travel in Central America* 2:442.

22. On the inflammatory state of the debate see Robert E. Bieder and Thomas G. Tax, "From Ethnologist to Anthropologist: A Brief History of the American Ethnological Society," in *American Anthropology: The Early Years*, ed. John V. Murra, 1974 Proceedings of the American Ethnological Society (St. Paul: West Publishing, 1976), p. 17.

23. Quoted in Hinsley, *Savages and Scientists*, p. 25, where a summary of the debate of the monogenesists and the polygenesists can be found.

24. Norman, *Rambles*, p. 251. Elsewhere in the book he suggested the possibility that there existed earlier American races that had since become extinct: "There are reasons for believing that the American continent has witnessed the growth and extinction of more than one race of men which had advanced to a high degree of civilization." Ibid., p. 172.

25. Catlin, *Last Rambles*, pp. 306–7. In his earlier discussions of the North American Indians Catlin wrote of the theory of the long-lost tribes of Israel invoked by the monogenesists; see *Letters and Notes on the Manners, Customs, and Conditions of the North American Indians* (London, 1841).

26. John Lloyd Stephens, *Incidents of Travel in Yucatán* (1843; repr., New York: Dover, 1963), 2:281.

27. Stephens, *Incidents of Travel in Central America* 1:9–10.

28. A large group of Catherwood's Egyptian drawings is included in the Robert Hay Volumes, British Museum.

29. While Stephens's accounts of Yucatán and Central American contain much antiquarian information, his earlier narrative on the Near East is chatty and anecdotal. The author himself stated in his preface that he had not "gone into much detail in regard to ruins." See John Lloyd Stephens, *Incidents of Travel in Egypt, Arabia Petraea, and the Holy Land* (1837; New York: Harper & Bros., 1867), p. v. The evidence suggests that his work with Catherwood in the interim had helped to engender a new archaeological awareness.

30. According to the records of the National Academy of Design for 1845, Catherwood exhibited the following Mayan subjects: 257. *Palace of Palenque, in the State of Chiapas;* 258. *Ancient Arched Gateway in Yucatán;* 259. *Uxmal in Yucatán;* 261. *Well of Bolonchen, in Yucatán;* 263. *Building in Uxmal, Yucatán, Erected by the Indians;* 267. *Casa de las Monjas, Uxmal, in Yucatán;* 278. *Ancient Pyramidal Structure at Copán, in Central America;* 282. *Ancient Building at Palenque, in the State of Chiapas;* 287. *Fragment of an Ancient Building in Yucatán.* According to the Records of the American Art-Union, in 1847 he showed 236. *Views in Central America (Portfolio).* See *Boston Semi-Weekly Advertiser,* 3 June 1843, where it was announced that fifteen "specimen drawings" were shown at the bookstore of Tappan and Dennet.

31. This is the original drawing for the lithograph, which appeared as plate 10 in *Views of Ancient Monuments.*

32. Victor Carlson, *Hubert Robert: Drawings and Watercolors* (exhibition catalogue; Washington, D.C.: National Gallery of Art, 1978). David Roberts (1796–1864), a contemporary of Catherwoods, offers interesting parallels. He was numbered among the foremost artist-topographers of his day, well known for his work on Spain and later Egypt and the Holy Land, which resulted from his trip of 1838–39. See Helen Guiterman and Briony Llewellyn, comps., *David Roberts* (London: Phaidon Press and Barbican Art Gallery, 1986).

33. Von Hagen, *Frederick Catherwood*, pp. 12, 62–63, first suggested this connection between Catherwood and Piranesi.

34. For an extensive discussion of this issue see John Wilton-Ely, *The Mind and Art of Giovanni Battista Piranesi* (London: Thames and Hudson, 1978).

35. Keith F. Davis, *Désiré Charnay: Expeditionary Photographer* (Albuquerque: University of New Mexico Press, 1981) provides an overview of his career; see pp. 102–4 for Catherwood's influence.

36. There is no comprehensive study of Squier's career. On his Central American interests see Charles Lee Stansifer, "The Central American Career of Ephraim George Squier" (Ph.D. diss., Tulane University, 1959). For his work in Peru see Mariana Mould de Pease, "Ephraim George Squier y su visión del Perú" (Master's thesis, Pontificia Universidad Católica del Perú, Lima, 1981); and Keith McElroy, "Ephraim George Squier: Photography and the Illustration of Peruvian Antiquities," manuscript kindly supplied to me by the author.

37. These investigations were reported in Ephraim George Squier, *Ancient Monuments of the Mississippi Valley* (Washington, D.C.: Smithsonian Institution Contributions to Knowledge, 1848) and in his *Antiquities of the State of New York* (Buffalo: G. H. Derby, 1851).

38. The names of Stephens and Catherwood appear frequently in Squier's writings. He also owned at least nine of Catherwood's original drawings; see John Sabin, *Catalogue of the Books, Manuscripts, Maps, Drawings, and Engravings Principally Related to Central America, and Peru, American Antiquities, etc. Belonging to Mr. E. G.*

Squier (New York: C. C. Shelley, 1876).

39. The primary objective of Squier's expedition of 1853 was to survey Honduras and San Salvador for the proposed Honduran Interoceanic Railroad; in consequence the illustrations by Hitchcock that appear in his *Notes on Central America* are landscape views and maps of strategic sites. Whether or not Hitchcock made drawings of the antiquities is uncertain.

40. *The Painter and the New World* (exhibition catalogue; Montreal: Museum of Fine Arts, 1976). Thomas Tax, "The Development of American Archaeology, 1800–1879" (Ph.D. diss., University of Chicago, 1973), p. 112. Neither Stansifer, "Career of Ephraim George Squier," nor McElroy, "Ephraim George Squier," both specialized studies, makes any mention of Heine or McDonough.

41. Letter from Bartlett to Squier, 10 September 1846, Squier Papers, Library of Congress, Washington, D.C. Squier's complaint is quoted in McElroy, "Ephraim George Squier," p. 12.

42. His *Castle of Grenada—A Scene on the Shore of Nicaragua* (unlocated), for example, was exhibited as no. 291 at the National Academy of Design in 1851.

43. Don C. Seitz, ed., *Letters from Francis Parkman to E. G. Squier* (Cedar Rapids, Iowa: Torch Press, 1911), letter dated 6 September 1850.

44. Ibid., letter dated 12 September 1851.

45. Squier, *Waikna*, pp. 9–10.

46. Wilhelm Heine, "Correspondence of the Bulletin," *Bulletin of the American Art-Union* (1851): 125–26. My thanks to Col. Merl M. Moore, Jr., for providing me with this reference. His analogy to Palenque suggests familiarity with the work of Waldeck; in addition, he and Squier undoubtedly studied carefully the volumes of Catherwood and Stephens. Squier, for example, compared sculptures he came upon to "those which have become familiarized to us by the pencil of Catherwood"; see Squier, *Waikna*, p. 259.

47. The paintings are presently unlocated and known through exhibition records of the National Academy of Design, nos. 4, 18, and 407. For review see "Domestic Art Gossip," *The Crayon* 4 (1857): 90, 221. The same titles were also listed in *Catalogue of Works of Art Comprising the First Annual Exhibition of the Washington Art Association, 1857* as nos. 42–44.

48. Squier, *Nicaragua* 2:335.

49. Quoted in Stansifer, "Career of Ephraim George Squier," p. 20.

50. Smith, *Araucanians*, p. vi.

51. Stephens, *Incidents of Travel in Central America* 1:98–99. In 1847 Stephens made a pilgrimage to Germany to meet Humboldt and afterward published "An Hour with Humboldt," *Littell's Living Age* 15 (1847): 151ff.

52. Bayard Taylor, "Introduction," in Stoddard, *Life, Travels, and Books*, p. xiii.

53. Given the prevailing neoclassical attitudes, which generally precluded appreciation of pre-Columbian civilizations, Humboldt's receptivity toward them was remarkable. It was likely due in large measure to the influence of Johann Gottfried von Herder's *Outlines of a Philosophical History of Man* (1784; repr., New York: Alfred A. Knopf, 1966), pp. 155–61, which provided a theoretical framework for evaluating the Amerindian and other primitive cultures according to their own intrinsic merit. Humboldt's introduction to Herder's ideas, especially his rejection of the eighteenth-century disdain for works of "savages" or "barbarians," assisted his own appreciation of the architecture and sculpture he found in Mexico and the Andes—objects that he may otherwise have instinctively ignored or dismissed. Keen, *Aztec Image*, pp. 328–30, discusses the relation between Humboldt and Herder.

54. Humboldt, *Researches* 1:1.

55. Ibid., p. 40.

56. *Catalogue of the Paintings in the Robert L. Stuart Collection* (New York: New York Public Library, 1898), no. 135.

57. Humboldt, *Researches* 2:100.

58. Review of Church's *Heart of the Andes*, signed J. M. S., *North American and U.S. Gazette* (Philadelphia), 27 February 1860; photocopy of Church's scrapbook, Olana State Historic Site. Whether or not Church actually saw a ruin at this precise location, or transposed it from elsewhere, is not certain. Its presence is not indicated in the drawings of Cayambe now in the Cooper-Hewitt Museum, including nos. 1917-4-738 (dated 1857), 1917-4-772A, and 1917-4-772B (both dated 1853).

59. Humboldt, *Researches* 2:100. Stuart reported the specifics of its location in his description of his painting; see *Robert L. Stuart Collection*, no. 135.

60. Letter from Church to Warren, 29 June 1857, Quito, Gratz Collection, Pennsylvania Historical Society; microfilm, Archives of American Art.

61. For illustrations of these colonial carvings see, for example, José de Mesa and Teresa Gisbert, *Monumentos de Bolivia* (La Paz: Gisbert y Cía, 1978), cover illustration. I am grateful to Louisette and Thomas Zuidema, Department of Anthroplogy, University of Illinois, for suggestions on the identification of this ruin.

62. Russell Osborne and Edward Aiken, eds., *Catalogue of the Library of Robert L. Stuart* (New York: J. J. Little, 1884), p. ix.

63. Humboldt, *Researches* 1:40–41.

64. Warren, "Romance," p. 501.

65. Peale's pencil, ink, and wash study inscribed "From Amancaes [*sic*] 1839" is in the collection of the American Philosophical Society. Wilkes, *Narrative* 1:244–45.

66. For Jefferson's directive see "Circular Letter," *Transactions of the American Philosophical Society* 4 (1799): xxxvii, quoted in Tax, *American Archaeology*, pp. 55–56. For Peale's involvement see Brooke Hindle, Lillian B. Miller, and Edgar P. Richardson, *Charles Willson Peale and His World* (New York: Metropolitan

Museum of Art, 1982), p. 86.

67. Quoted in Arthur P. Whitaker, ed., *Latin America and the Enlightenment* (Ithaca and London: Cornell University Press, 1961), p. 62.

68. Pachacamac, about nineteen miles from Lima, is described by Wilkes, *Narrative* 1:278–81. On the Ohio Mounds see Tax, *American Archaeology*, pp. 63–75.

69. Majorie Arkelian, *Tropical: Tropical Scenery by the Nineteenth-Century Painters of California* (exhibition catalogue; Oakland: Oakland Museum, 1971), p. 45.

70. Haven, *Address*, p. 8. The ruin in this painting is identifiable with Maya monuments of the type illustrated by Catherwood; see fig. 46.

71. Stephens, *Incidents of Travel in Central America* 1:115. He also arranged to have plaster casts of the sculpture at Palenque made, but they were destroyed before they could be removed from the site. See Von Hagen, *Maya Explorer*, pp. 175–76.

72. Squier, *Nicaragua*, pp. 283–301, for example, reports his efforts to remove the stones from Momotombita Island and send them to the Smithsonian.

73. Letter from Parkman to Squier, 2 April 1850, in Seitz, *Letters*, p. 28. My efforts to securely identify Squier's sculptures with works now in the Smithsonian have so far proved unsuccessful. In a letter of 18 November 1850 Parkman reported, "I was in New York the other day when I saw at the Historical Society's rooms, a number of boxes of antiquities marked with your name and apparently sent there by Mr. Cotheal" (ibid.).

74. Letter from Church to Heade, 14 September 1892, Church-Heade correspondence, Archives of American Art, Smithsonian Institution, Washington, D.C.

75. Letters from Church to Luigi DiCesnola, 10 July 1893 and 5 September 1893, Archives, Metropolitan Museum of Art, New York. The reliefs were included in the exhibition *Before Cortés: Sculpture of Middle America* (New York: Metropolitan Museum of Art, 1970), no. 253, and are now on permanent exhibition in the Rockefeller Wing of Primitive Art. My thanks to Diana Fane for pointing out these references to me.

76. The neoclassical taste for correctness and severity had precluded full aesthetic appreciation of pre-Columbian sculpture by Humboldt, who established historic and psychological parameters as alternative criteria by which it could be judged; see *Researches* 1:36–38. Perhaps in America, where the ideas of Winckelmann and others had less influence, there was a greater possibility of looking at these objects with an unprejudiced eye. In 1857 *The Crayon* noticed Winckelmann's *History of Art*, which, according to the reviewer, had appeared for the first time in an English translation only the year before. In fact, there had been an eighteenth-century English edition, with which he (and his readers) were apparently unfamiliar; see "Histories of Art," *The Crayon* 4 (1857): 212–31. The question of American interest in non-Western art deserves a separate study,

but few, it seems, were as adventurous in their taste as Stephens and Catherwood.

77. Stephens, *Incidents of Travel in Central America* 1:151. Letter from Parkman to Squier, 2 April 1850, quoted in Seitz, *Letters*. Stephens admittedly had the advantage of observing Maya sculpture of the high or classical style, with its slender forms and elegant lines; but few viewers were so unreserved in their praise.

78. George Kubler, *Art and Architecture of Ancient America* (Harmondsworth, England: Penquin Books, 1975), p. 14, discusses issues of verisimilitude.

79. Initially he wrote that they "represent according to Dr. Leopold Batres an eagle devouring a sun disc—the Aztec idea of an Eclipse." Later he reported, "The subject is 'The Eagle swallowing a Comet'—But some of our own Archaeologists may interpret it with more certainty and fulness [sic]." His confidence that this configuration, today identified as eagles devouring hearts, could be interpreted against Western standards is a typical response. Church to DiCesnola, 10 July and 5 September 1893.

80. Humboldt, *Views of Nature*, p. 393.

81. Prescott, *Conquest of Peru* 1:59.

82. Tschudi, *Travels in Peru*, pp. 225–26.

83. Humboldt, *Views of Nature*, pp. 393–94. Compare these works with John Gadsby Chapman's numerous renderings of the Via Appia (see, for example, one version in the Brooklyn Museum), produced for an eager American tourist market, or similar subjects by other artists that appear in Edgar P. Richardson and Otto Wittman, Jr., *Travelers in Arcadia* (exhibition catalogue; Detroit: Detroit Institute of Arts, 1951).

84. *A Collection of Paintings by the Late Henry A. Ferguson, A.N.A.* (auction catalogue; New York: Anderson Galleries, 1918), no. 36, 8 × 13 in.

85. On Martínez see Hernán Crespo Toral, . . . *Y al fin, aparece el paisaje* (exhibition catalogue; Quito: Museum Camilo Egas, Banco Central del Ecuador, 1981), fig. 12.

86. Humboldt, *Researches* 2:72ff, gives an account of the rope bridge at Penipe, illustrated in his plate 33. Church's pencil drawings include *Rope Bridge over the Puanambo River August 1853*," no. 1917-4-1342; *A Bamboo Bridge at Buga, Colombia*, no. 1917-4-53; and *A Bridge over the River Combeima at Ibaque 16 July 1853*, no. 1917-4-44, all in the collection of the Cooper-Hewitt Museum, Smithsonian Institution, New York.

87. Ephraim George Squier, *Peru: Incidents of Travel and Exploration in the Land of the Incas* (New York: Harper & Bros., 1877). Thornton Wilder, *The Bridge of San Luis Rey* (1927; repr., New York: Avon Books, 1976).

88. Humboldt, *Researches* 2:73.

89. Thomas Ewbank, "Indian Antiquities," in Gilliss, *U.S. Naval Astronomical Expedition* 2:122. Curiously, the antiquities discussed by Ewbank were from Peru and seemed to have little to do with

Gilliss's expedition in Chile.

90. Mariano Edward Rivero and Johann Jacob von Tschudi, *Peruvian Antiquities* (New York: A. S. Barnes, 1854), pp. 344, 285.

91. Humboldt, *Researches* 1:161. On Aztec writing see Harry Waldman, ed., *Encyclopedia of Indians of the Americas* (St. Clair Shores, Mich.: Scholarly Press, 1974–81), 3:54–55.

92. Michael Coe, *The Maya* (London: Thames and Hudson, 1980), pp. 161–68 for writing system.

93. Prescott, *Conquest of Mexico* 3:393.

94. The publications of their findings also appeared nearly simultaneously. See *Description de l'Égypte, ou recueil des observations et des recherches qui ont été faites en Égypte pendant l'expédition de l'armée française, publié par les ordres de sa majesté l'empereur Napoléon le grand*, 23 vols. (Paris: Imprimerie impériale, 1809–28) and Humboldt's *Voyage aux regions equinoxiales du Nouveau Continent*, 35 vols. (Paris, 1805–34). For others, the fascination with Maya hieroglyphics may have been inspired by a general interest in cryptographic writing; see, for example, Edgar Allan Poe, "A Few Words on Secret Writing," *Graham's American Monthly Magazine* 19 (1841): 33–38.

95. The stone was discovered in 1799, but the findings were not published until the 1820s; quotation from "The Rosetta Stone," *The Crayon* 6 (1859): 186. For its importance on these writers see John Irwin, *American Hieroglyphics: The Symbol of the Egyptian Hieroglyphics in the American Renaissance* (Baltimore: Johns Hopkins University Press, 1983).

96. Stephens, *Incidents of Travel in Central America* 1:159–60. The more dubious Prescott wrote, "It is not likely that another Rosetta Stone will be found, with its trilingual inscription, to supply the means of comparison, and to guide the American Champollion in the path of discovery" (*Conquest of Mexico* 3:394).

97. Sylvanus G. Morley, *The Ancient Maya*, ed. and rev. George W. Brainerd (Stanford: Stanford University Press, 1956), chapter 12.

98. Stephens, *Incidents of Travel in Central America* 1:158. Carmichael, *The British and the Maya*, p. 20, testifies to the accuracy of Catherwood's renderings.

99. Squier, *Nicaragua*, pp. 405–6.

100. Catlin, *Last Rambles*, p. 311. In *Catalogue Descriptive and Instructive of Catlin's Indian Cartoons* (New York: Baker and Godwin, 1871) he reported his visit to the land of the Maya: "In 1855, from Matamoros, I sailed for Sisal, in Yucatán—visited the ruins of Uxmal, painted Indians, Mayas; sailed from Sisal to Havre, went to Paris, and to Berlin."

101. Stephens, *Incidents of Travel in Central America* 1:158.

Chapter 5

1. On the positivists and the creationists see Neal C. Gillespie, *Charles Darwin and the Problem of Creation* (Chicago and London: University of Chicago Press, 1979), pp. 3–21.

2. Novak, *Nature and Culture*, pp. 47–77.

3. For American attitudes toward Darwin in 1845 see W. B. O. Peabody, "Review of Darwin's Researches in Geology," *North American Review* 61 (July 1845): 181–99. Church owned *Voyage of the Beagle* in an 1852 edition; copy, Olana State Historic Site. For Orton's dedication see the frontispiece to his *Andes and the Amazon*.

4. Charles Darwin, *The Origins of Species by Means of Natural Selection or the Preservation of Favoured Races in the Struggle for Life* (1859; repr., New York: New American Library, 1958), p. 27.

5. Quoted in "Louis Agassiz," *Harper's Monthly* 25 (1862): 201.

6. Ibid., pp. 194–95.

7. Quoted in David McCullough, "The American Adventure of Louis Agassiz," *Audubon* 79 (January 1977): 13. For background on Gray's position see Gillespie, *Charles Darwin*, pp. 111–17; for background on Agassiz's position see pp. 51–53.

8. Asa Gray, "Natural Selection Not Inconsistent with Natural Theology," originally appeared as "Darwin on the Origin of Species" and "Darwin and His Reviewers," *Atlantic Monthly* 6 (1860): 109–16, 229–39, 406–25. Louis Agassiz, "On the Origin of Species," *American Journal of Science and Art*, 2d series, 30, no. 88 (July 1860): 142–54.

9. Agassiz's account of his Munich days appears in Elizabeth Cary Agassiz, ed., *Louis Agassiz: His Life and Correspondence* (Boston and New York: Houghton, Mifflin and Co., 1885), p. 79ff.

10. Agassiz and Agassiz, *Journey in Brazil*, p. v.

11. Edward Lurie, *Louis Agassiz: A Life in Science* (Chicago: University of Chicago Press, 1960), pp. 78–94, discusses the importance of *Recherches sur les poissons fossiles*.

12. On the Hassler Expedition see Edward Lurie, *Nature and the American Mind: Louis Agassiz and the Culture of Science* (New York: Science History Publications, 1974), especially pp. 105–17. The scrapbook of J. Henry Blake, Archives of the Museum of Comparative Zoology, Harvard University, also contains many references to it.

13. Agassiz and Agassiz, *Journey in Brazil*, p. 33. Lurie, *Louis Agassiz*, pp. 345–48, provides a brief background of the expedition.

14. Quoted in McCullough, "American Adventure," p. 17.

15. Nathaniel Thayer was the wealthiest sponsor Agassiz had acquired to date; a partner in the firm that eventually became Kidder, Peabody, he had "one of the largest fortunes acquired by any New Englander of his day." He eschewed the Harvard education of his father and grandfather in favor of business and became one of the university's great benefactors. See Louise Hall Tharp, *Adventurous Alliance: The Story of the Agassiz Family of Boston* (Boston: Little, Brown and Co., 1959), p. 161. For the partial contents of Thayer's art collection see *British Portraits. Barbizon Landscapes. Early Dutch Works*, property of the estate of the late Nathaniel Thayer of Boston, Massachusetts (New York: American Art Association and Anderson Galleries, 1935).

16. William James, *Louis Agassiz: Words Spoken by Professor William James at the Reception of the American Society of Naturalists . . . on December 30, 1896* (Cambridge, Mass.: Printed for Harvard University, 1897), p. 3.

17. Samuel G. Ward was described as a "banker and a lover of art of high intelligence, the friend of poets and painters, and to me, in later years, one of the kindest and wisest of advisers and friends" by William James Stillman in *Autobiography of a Journalist* (Boston and New York: Houghton, Mifflin and Co., 1901), p. 224.

18. Remarks on the expedition party quoted in Tharp, *Adventurous Alliance*, pp. 160–75.

19. For a roster of the expedition staff see Agassiz and Agassiz, *Journey in Brazil*, p. vii. In a letter to his mother dated 22 March 1865 Agassiz explained the logic behind the choice of paid scientists. See E. Agassiz, *Louis Agassiz*, p. 628.

20. Ernest Wadsworth Longfellow, *Random Memories* (Boston: Houghton Mifflin Co., 1922), quoted in Tharp, *Adventurous Alliance*, p. 161.

21. Agassiz and Agassiz, *Journey in Brazil*, p. 406.

22. James to his mother, 30 (?) March 1865, *The Letters of William James*, ed. Henry James (1920; repr., New York: Kraus Reprint Co., 1969), p. 56.

23. Agassiz and Agassiz, *Journey in Brazil*, p. 16.

24. Agassiz to his mother, 7 July 1866, in E. Agassiz, *Louis Agassiz*, p. 639.

25. Lurie, *Louis Agassiz*, p. 355; Lyell is quoted on p. 354.

26. These issues are addressed in depth in chapter 3.

27. David Huntington, "Church and Luminism: Light for America's Elect," in John Wilmerding, *American Light: The Luminist Movement, 1850–1875* (exhibition catalogue; Washington, D.C.: National Gallery of Art, 1980), pp. 179–87.

28. This sketch and others appear in his Brazilian diary, William James Papers, Houghton Library, Harvard University; illustrated in Lurie, *Louis Agassiz*.

29. Louis Agassiz, *Essay on Classification*, ed. Edward Lurie (1857; repr., Cambridge, Mass.: Harvard University Press, 1962), p. 38.

30. Agassiz and Agassiz, *Journey in Brazil*, p. 8.

31. Ibid.

32. Theodore E. Stebbins, Jr., *The Life and Works of Martin Johnson Heade* (New Haven: Yale University Press, 1975), pp. 126–54, provides an overview of the hummingbird and orchid pictures.

33. Johann Baptist von Spix, *Avium species novae, quas in itinere per Brazilian annis 1817–1820* (Monachii, 1824–25).

34. Following Clement and Hutton, Heade's early biographer McIntyre reported that Heade accompanied Fletcher to Brazil; see Robert G. McIntyre, *Martin Johnson Heade, 1819–1904* (New York: Pantheon Press, 1948), pp. 11–12. For the corrected informa-

tion see Stebbins, *Martin Johnson Heade*, pp. 84–85, 126–27.

35. Agassiz acknowledged, "Several years before my own journey on the Amazons, I had been indebted to the Rev. Mr. Fletcher for a valuable collection of fishes from . . . Amazonian localities." See Agassiz and Agassiz, *Journey in Brazil*, p. 184, note.

36. Tuckerman, *Book of the Artists*, p. 543. These remarks are probably the origin of a statement made by McIntyre—"Agassiz' praise of Heade's hummingbirds is proof of the scientific worth of his paintings"—and repeated elsewhere. A careful reading of Tuckerman's statement does not lead to that conclusion. See McIntryre, *Martin Johnson Heade*, p. 13.

37. Didymus (Martin Heade), "Taming Hummingbirds," *Forest and Stream*, 14 April 1892, p. 348.

38. For the interests of the society in Latin America see "List of Articles Relating to Hispanic America Published in the Periodicals of the American Geographical Society, 1852–1933 Inclusive," *Hispanic American Historical Review* 14 (1934): 114–30.

39. Wright, *Geography in the Making*, pp. 92–93, 245–46. On Dom Pedro's activities in the United States see Ronald Genini, "Dom Pedro in California," *Journal of the West* 12 (1973): 576–88.

40. Quoted in Williams, *Dom Pedro*, p. 212.

41. Heade was one of the few North American artist-travelers in this period to participate in local Latin American exhibitions and to receive official awards. In this respect he was fortunate in having visited Brazil, where support of the arts was due largely to the enlightened rulership of Dom Pedro II and his father before him. Brazil was unusual in having established an art academy and regular exhibitions early in the century. Henry Ferguson, traveling in Chile in the following decade, was able to show his work in one of the earliest officially sponsored exhibitions, held in Santiago in 1872. See *Exposición Nacional de Artes e Industria en Santiago de Chile* (Santiago: Emprenta de la Librería del Mercurio, 1872), nos. 154–55. At least one other North American artist received an award from Dom Pedro II: he gave the Order of the Rose to Hiram Powers on his visit to the sculptor's studio on Florence in 1871; see Williams, *Dom Pedro*, p. 160.

42. On Bates, Wallace, and the history of Amazonian exploration see the introduction to Woodcock, *Henry Walter Bates*. Edwards, *Voyage up the River Amazon*, reviewed in *Literary World* 1 (June 1847): 438–40.

43. Other accounts by North Americans included Thomas Ewbank's *Life in Brazil; or, a Journal of a Visit to the Land of Cocoa and the Palm* (1856; repr., Detroit: Blaine Ethridge Books, 1971) and Rev. D. P. Kidder and Rev. J. C. Fletcher, *Brazil and the Brazilians* (Philadelphia: Childs & Peterson, 1857).

44. Ann Blum and Sarah Landry, "In Loving Detail," *Harvard Magazine*, May–June 1977, pp. 48–49. My thanks to Ms. Blum for assistance in locating references on Burkhardt, which include materials in the Archives of the Museum of Comparative Zoology, Harvard University; and the Theodore Lyman Papers, Massa-

chusetts Historical Society.

45. On the Danish artist Eckhout see Hugh Honour, *The New Golden Land: European Images of America from the Discoveries to the Present Time* (New York: Pantheon Books, 1975), pp. 48–51, 78–83.

46. Agassiz and Agassiz, *Journey in Brazil*, pp. 59; 220, note; 264; 264, note. No definitive compendium of these drawings was made, and Agassiz's reports of his accomplishments varied. In a letter to Sir Philip de Grey Egerton of 26 March 1867, he stated, "I have eleven hundred colored drawings of the species of Brazil made from life by my old friend Burkhardt" (E. Agassiz, *Louis Agassiz*, p. 647).

47. For Burkhardt's death see Agassiz and Agassiz, *Journey in Brazil*, p. viii, note.

48. The descriptions appear in Spix and Martius, *Travels in Brazil* 1:283–90.

49. Burkhardt's pencil drawing is also in the Museum of Comparative Zoology. The changes he made from drawing to watercolor parallel the geometric alterations that occur from drawing to painting in Fitz Hugh Lane's best work. On Lane see Katherine Manthorne, "Fitz Hugh Lane's Drawings: Study in the Sources of a Style" (Master's thesis, Columbia University, 1979).

50. Agassiz and Agassiz, *Journey in Brazil*, p. 60. On p. 529, appendix 5, "Permanence of Characteristics in Different Human Species," Agassiz explained that Hunnewell's photographs of the Amazonian natives were intended to assist him in the study of human races and of the effects of interracial breeding: "During a protracted residence in Manaos, Mr. Hunnewell made a great many characteristic photographs of Indians and Negroes, and half-breeds between both these races and the Whites. All these portraits represent the individuals selected in three normal positions, in full face, in perfect profile, and from behind. I hope sooner or later to have an opportunity of publishing these illustrations, as well as those of pure negroes made for me in Rio by Messrs. Stahl and Wahnschaffe." Two engravings after photographs by Stahl and Wahnschaffe appear in *Journey in Brazil*, pp. 83–84.

51. Ibid., p. 102, note; illustration appears on opposite page.

52. Ibid., p. 63, note. See also George Leuzinger, *Oficina fotográfica de G. Leuzinger . . . 337 fotográficas diversas* (Rio de Janeiro, c. 1865). Some of Leuzinger's Brazilian photographs are housed in the George Eastman House, Rochester, New York.

53. On Marc Ferrez see Ferrez and Naef, *Pioneer Photographers of Brazil*, pp. 114–16. Charles Frederick Hartt, *Geology and Physical Geography of Brazil* (1870; repr., New York, 1975), where the illustration—entitled *The Sugar Loaf, Corcovado and Gavia, from São Domingo*—appears on p. 10.

54. Theodore E. Stebbins, Jr., in *A New World: Masterpieces of American Painting, 1760–1910* (exhibition catalogue; Boston: Museum of Fine Arts, 1983), p. 281, provides a brief synopsis of the interpretations of these images offered to date, several of which

are discussed in more detail below.

55. Heade, "Taming Hummingbirds," p. 348.

56. James Orton, "On the Condors and Humming Birds of the Equatorial Andes," *Proceedings of the American Association for the Advancement of Science* 19 (August 1870): 260–67. William H. Hudson, *Idle Days in Patagonia* (London: Chapman and Hall, 1893) and *The Naturalist in La Plata* (London: Chapman and Hall, 1892).

57. Introduction to Robert V. Hine, *Bartlett's West: Drawing the Mexican Boundary* (New Haven: Yale University Press, 1968). Stebbins, *Martin Johnson Heade*, pp. 17–18, for portrait commissions; p. 136 for letter. The John Russell Bartlett Papers are in the John Carter Brown Library, Brown University, Providence, Rhode Island. See, for example, William Swainson, *A Selection of the Birds of Brazil and Mexico* (London: H. G. Bohn, 1841) or John Gould, *A Monograph of the "Trochilidae," or Family of Hummingbirds* (London: John Gould, 1861).

58. Belt, *Naturalist in Nicaragua*, p. 138.

59. The sixteen paintings intended for *The Gems of Brazil*, purchased by Sir Morton Peto in 1865 and sold in the 1980s through Hirschl and Adler Galleries, include *Bird Drinking Nectar, Ruby Throat, United States, Snow Caps, Pelas Aphard, Two Birds Alighting, Mango, Hooded Ivior Bearoe, EGL Huxon Chieger, Stripe Bellied Star Throat, Bird on Its Back and Bird in Nest, Loddyes Plover Crest, Amethyst, Coquette, Frilled Coquette Maril, Brariliau Ruby*, and *Butterfly*. My thanks to Mrs. M. P. Naud for assistance with these references.

60. Martin Heade, "Introduction," *The Gems of Brazil*, Martin J. Heade Papers and Notes, Archives of American Art, Smithsonian Institution, Washington, D.C. See Mrs. Henry Cust, *Wanderers: Episodes from the Lady Emmeline Stuart-Wortley and Her Daughter Victoria, 1849–1855* (London: Jonathan Cape, 1928) for a compendium of her travel accounts, from which Heade quoted.

61. Agassiz and Agassiz, *Journey in Brazil*, p. 13.

62. Didymus (Martin Heade), "Hummingbirds," *Forest and Stream*, 25 August 1892, p. 158.

63. Belt, *Naturalist in Nicaragua*, p. 112.

64. Belt, *Naturalist in Nicaragua*, p. 140, estimates the hummingbird population in Nicaragua. For a discussion of these paintings see Stebbins, *Martin Johnson Heade*, cat. nos. 100 and 80, respectively. The fact that Heade observed Omotepe and other active volcanoes in Nicaragua further links *Hummingbirds near a Volcano* with that trip.

65. Ella M. Foshay, "Nineteenth-Century American Flower Painting and the Botanical Sciences" (Ph.D. diss., Columbia University, 1979), p. 310. Whereas Foshay interprets these pictures as flower compositions in which birds have been incorporated (see, for example, her statement on pp. 307–8: "The incorporation of hummingbirds in all of Heade's orchid compositions more directly and clearly seem to reflect Darwin's view of nature."), I view the hummingbird pictures as a series that began in 1864, into which orchids were later

introduced. The difference is more than merely semantic, for in my opinion Heade's primary interest was always in hummingbirds, his understanding of which grew both through observation over the course of his three expeditions to Latin America and through his exposure to Darwin's ideas. This qualification, however, in no way diminishes Foshay's perceptive analysis of these works.

66. Tuckerman, *Book of the Artists*, p. 542.

67. Heade, "Taming Hummingbirds," p. 348.

68. R. C. Padden, *The Hummingbird and the Hawk: Conquest and Sovereignty in the Valley of Mexico* (Columbus: Ohio State University Press, 1967), pp. 6–7. For the role of Huitzilopochtli in Aztec belief see "Aztecs" in Waldman, *Encyclopedia of Indians of the Americas* 3:43–44.

69. Virginia C. Holmgren, "To Know a Hummingbird," *Américas* 30 (June–July 1978): 14, discusses torpidity; Heade, "Taming Hummingbirds," p. 348. We can assume also that Heade was familiar with this characteristic from his reading of Wilson, Gould, Audubon, and others.

70. Jules Marcou, *Life, Letters, and Works of Louis Agassiz* (New York: Macmillan, 1896), pp. 153–54.

71. Emerson to Agassiz, 23 February 1868, Agassiz Papers, Harvard University, quoted in Lurie, *Louis Agassiz*, p. 357.

72. Letter from Agassiz to Karl Gegenbauer, July 1872, quoted in Lurie, *Nature and the American Mind*, p. 112.

73. Agassiz's participation in the Hassler Expedition did, however, alleviate the embarrassing situation that had arisen from his declarations on Amazonian glaciation. Circumnavigating South America gave him the opportunity to study the glacial phenomenon in the most southerly portion of the continent, previously described by Darwin. A study in his short publications, his wife's letters in the *Atlantic Monthly*, and his personal correspondence reveals that he confirmed Darwin's observations, namely, that during the Pleistocene, glaciers extended from the Strait of Magellan to as far north as thirty-seven degrees south latitude in a pattern essentially symmetrical with the ice sheet of the northern hemisphere. He avoided any formal retraction of his earlier statements but simply never mentioned the subject again. See Albert V. Carozzi's introduction to the reprint edition of Hartt, *Geology*, p. 15.

74. Quoted in Lurie, *Nature and the American Mind*, p. 112.

75. Louis Agassiz, "Evolution and Permanence of Type," *Atlantic Monthly* 33 (1874): 101.

Chapter 6

1. Gradually observers began to realize, however, that this mode of vision had omitted some intangible but necessary elements. Church, its major practitioner, came in for particular criticism: "Some of Church's pictures, if reduced, would make capital illustrations for Humboldt's *Cosmos*, or any other similar textbook of natural science,—for Agassiz's work on Brazil, for instance. They are faithful and beautiful but they are not so rich as they might be in poetry, the aroma of art" (Montgomery, *American Art*, p. 774).

2. Warren, "Romance," p. 500; emphasis added.

3. "Pictures by the Late L. R. Mignot," *The Builder* 34 (24 June 1876): 607.

4. *Catalogue of the Mignot Pictures*, p. 3, paintings nos. 50, 101–3.

5. While I do not intend to sound an overly pathetic note in this discussion of Mignot, these circumstances—as I hope to demonstrate—had a direct impact on his art. In his case these feelings of loneliness and disengagement may have been exacerbated by the circumstances of his birth and upbringing, which remain somewhat mysterious. His date of birth, for example, has yet to be determined with certainty: a situation somewhat unusual for Charleston, where precise record keeping was established early on and perpetuated by the southern penchant for genealogy. The question of the identity of his parents is similarly unresolved. Dumas Malone, ed., *Dictionary of American Biography* 12 (1933), pp. 609–10, notes that Remy Mignot was "probably" the father of Louis and made no mention of his mother, while *Bryan's Dictionary of Painters and Engravers* 3 (1904), p. 339, states that Mignot "was a creole." On the basis of this information Jean O'Leary, "Louis Remy Mignot: Nineteenth-Century American Landscapist" (research paper, Columbia University, 1978), p. 16, speculates that the artist was the issue of a casual liaison between Remy Mignot and a mulatto or quadroon woman. His boyhood, as reported by Downes, was "spent in the home of his wealthy grandfather near his birthplace," implying that his grandfather and not his parents raised him. If accurate, these accounts suggest that he lacked a normal home life and experienced possible uncertainty and even shame about his own background and identity—factors that would have contributed to his own feelings of anxiety and alienation. We might detect, too, an element of romantic tragedy in his death at the age of thirty-nine, when he was at the height of his powers and reputation.

6. Denys Sutton, *James McNeill Whistler: Paintings, Etchings, Pastels, and Watercolors* (London: Phaidon, 1966), pp. 5–7, for example, emphasizes this aspect of the artist's biography.

7. McIntyre, *Martin Johnson Heade*, p. 21.

8. Thomas McFarland, *Romanticism and the Forms of Ruin: Wordsworth, Coleridge, and the Modalities of Fragmentation* (Princeton, N.J.: Princeton University Press, 1981), pp. 7–8, discusses the various manifestations of this longing.

9. Quoted in Michael Davitt Bell, *The Development of American Romance: The Sacrifice of Relation* (Chicago: University of Chicago Press, 1980), p. 15.

10. Nathaniel Hawthorne, *The Scarlet Letter* (1850; repr., New York: New American Library, 1981), p. 45.

11. The drawings are all in the Cooper-Hewitt Museum. Nos. 1917-4-882 and -804 provide the endpoints of their stay in Guayaquil; others done in port and along the river include -193, -194,

216

-196, -200, -805, -810, -811, -823, -884, and -885.

12. *Cosmopolitan Art Journal* 3 (December 1859): 233.

13. Drew Faust, *A Sacred Circle: The Dilemma of the Intellectual in the Old South, 1840–1860* (Baltimore: Johns Hopkins University Press, 1977), especially pp. 17–24.

14. Titles of the paintings are taken from *Catalogue: Special Sale of Fine Oil Paintings Including the Collection of the Well-Known American Artist, Mr. L. R. Mignot, Now in London, Comprising Some of His Latest and Best Works* (New York: Leeds and Miner, 1868), where they appear with the following catalogue numbers: *A Ship-Wrecked Sailor Waiting for a Sail* (21), *The Glories of the Broad Belt of the World* (41), *St. Agnes Eve* (2), *Incense-Breathing Morn* (43), *A Painted Sea upon a Painted Ocean (15)*, and *Childe Harold's Pilgimage* (1).

15. Tuckerman, *Book of the Artists*, p. 563.

16. Richards, "Landscape of the South," p. 721.

17. Church's South American journal, Guayaquil, 24–29 September 1853.

18. Exactly how Mignot came to seek training at the Hague is uncertain. According to Tom Taylor, his family, once resigned to his choice of career, arranged for his study: "As means for the training of a painter were hardly to be procured in his native town, young Mignot was dispatched to the care of friends in Holland, where he was placed in the studio of Schelfhout for instruction" (*Catalogue of the Mignot Pictures*, pp. 1–2).

19. Letter from Johnson to the American Art-Union, 20 November 1851, quoted in Patricia Hills, *Eastman Johnson* (New York: Whitney Museum of American Art, 1972), p. 12. For background on the Hague and the training to be obtained there see Roland de Leeuw, John Sillevis, and Charles Dumas, eds., *The Hague School: Dutch Masters of the Nineteenth Century* (exhibition catalogue; The Hague: Haags Gemeentemuseum, 1983).

20. Humboldt, *Cosmos* 2:90. For background on the Dutch expedition see E. van den Boogaart, ed., *Johann Maurits van Nassau-Siegen, 1604–1679: A Humanist Prince in Brazil* (The Hague: Johann Maurits van Nassau Stichting, 1979).

21. *Morning Post* (July 1876), quoted in *Catalogue of the Mignot Pictures*.

22. Smith, *European Vision*, pp. 149–50, discusses this term in respect to the European's increasing interest in the South Seas.

23. A painting entitled *Gathering Plantains—Guayaquil River* is no. 35 in *Catalogue: Special Sale*.

24. Friedrich Hassaurek, *Four Years among Spanish-Americans* (New York: Hurd and Houghton, 1868), p. 5.

25. Similarly, the canvas in a private collection (fig. 67) is known as *On the Orinoco, Venezuela*. In the absence of documentation of the trip from Mignot's hand, it has been assumed that he remained for its duration in the company of Church, who did not visit Venezuela or the Orinoco. These paintings more likely represent the Guayas

River, upon which Mignot and Church traveled in Ecuador.

26. *The Crayon* 7 (March 1860): 83.

27. Hassaurek, *Four Years*, p. 3.

28. See, for example, Cooper-Hewitt drawings no. 1917-4-884 and -888.

29. See, for instance, the illustration "Laundress in the City of Rio de Janeiro" in his *Voyage pittoresque et historique du Brésil*.

30. Auchincloss, *Ninety Days*, pp. 27–28.

31. Catlin, *Last Rambles*, p. 172 of Ross ed.

32. Herman Melville, *White Jacket, or the World in a Man of War* (1850; repr., Evanston and Chicago: Northwestern University Press and the Newberry Library, 1970), p. 210.

33. He exhibited an oil painting entitled *Bay of Rio de Janeiro* at the Philadelphia Art Union, cat. no. 111, for sale, March–August 1851.

34. The canvas was completed and exhibited in 1864 at the Academie, Rio de Janeiro. The wood engraving after it was published as the frontispiece to "Brazil, Its Emperor and Its People," *Frank Leslie's Popular Monthly* (April 1876). See Stebbins, *Martin Johnson Heade*, pp. 87–89, 228.

35. Illustrated in Isaac F. Holton, *New Granada: Twenty Months in the Andes* (New York: Harper & Bros., 1857), p. 506, where the author described it as "a faithful delineation, kindly furnished me by the artist-traveler, Mr. Church."

36. Smith, *Araucanians*, p. 108.

37. Winthrop, *Companion*, p. 31.

38. Catlin, *Last Rambles*, p. 11.

39. *Dictionary*, s.v. "Downes," 6:465–66.

40. Quoted in Levin, *History as Romantic Art*, p. 125.

41. Gilliss, *U.S. Naval Astronomical Expedition* 1:457.

42. A smaller work (6 × 12 in.), known by the title *Lake Scene in Ecuador*, 1860, probably served as a study for these two works. See *Recent Acquisitions in American Painting* (exhibition catalogue; New York: Kenneth Lux Gallery, 1981), no. 22.

43. Tuckerman, *Book of the Artists*, p. 564. His choice of vocabulary suggests that the painting might be identified with a work exhibited at the Brooklyn Art Association in 1862 as *Ave Maria* (no. 73, for sale). The painting appears not to depict an actual church, but rather an imaginative evocation of that style of architecture. Certain details were deliberately distorted for expressive intent. The oversized figures of the Madonna and Child placed conspicuously over the entranceway, for instance, seem to have no precise counterparts in existing churches of this type.

44. "The National Academy Pictures Canvassed," *Harper's Weekly Magazine* (30 May 1857): 339.

45. Church to Heade, 9 October 1868, Church-Heade correspon-

dence, Archives of American Art.

46. Tuckerman, *Book of the Artists*, p. 564.

47. *The Crayon* 7 (1860): 83, 140.

48. Humboldt, *Personal Narrative* 1:437. My observations on this point have been confirmed against accounts of numerous travelers, past and present, including Kent Mathewson, a geographer of Ecuador, in personal correspondence.

49. We might consider in this regard, as a proof by contrapositive, the conspicuous lack of twilight effects in Church's tropical oeuvre. For while he repeatedly essayed the theme in a series of North American scenes culminating in the great *Twilight in the Wilderness* (1860; Cleveland Museum of Art), he studiously avoided sunsets in the South American paintings on which he worked simultaneously. This observation suggests that the more realistically minded Church did not include chromatic sunset effects in his Ecuadorian works because, from a naturalistic standpoint, they did not belong there. One notable exception is *Cross in the Wilderness* of 1858, in which the twilight sky could carry deliberate elegiac associations. See Manthorne entry in Barbara Novak, ed., *The Thyssen-Bornemisza Collection: Nineteenth-Century American Paintings* (London: Sotheby's, 1986), pp. 94–95.

50. *Brooklyn Eagle*, 21 March 1862.

51. For an interesting discussion of these issues as they relate to the twilight theme in literature see James Doolittle, "Four Elements in Romantic Writing: Mountain, Blue, Twilight, I," *Symposium* 23 (Fall-Winter 1969): 220.

52. *Morning Post* (July 1876), quoted in *Catalogue of the Mignot Pictures*, p. 20.

53. Tuckerman, *Book of the Artists*, p. 563.

54. Darwin, *Voyage*, pp. 500–501.

55. Hudson, *Idle Days in Patagonia*, pp. 222, 225.

Chapter 7

1. Andrew McLaren Young, Margaret MacDonald, Robin Spencer, and Hamish Miles, *The Paintings of James McNeill Whistler* (New Haven and London: Yale University Press, 1980) summarizes the literature on each of these pictures: *Symphony in Grey and Green: The Ocean* (Frick Collection), no. 72, p. 42; *Crepuscule in Flesh Colour and Green: Valparaíso* (Tate Gallery), no. 73, pp. 42–43; the so-called *Sketch for the Nocturne in Blue and Gold, Valparaíso Bay* (National Museum of American Art), no. 74, pp. 43–44; *The Morning after the Revolution, Valparaíso* (Hunterian Museum and Art Gallery, University of Glasgow), no. 75, p. 44; *Nocturne in Blue and Gold: Valparaíso* (Freer Gallery of Art), no. 76, pp. 44–45; *Nocturne: The Solent* (Gilcrease Institute), no. 71, p. 41. It is possible that when Whistler mentioned five Valparaíso pictures, he referred to the works depicting the port harbor specifically; this does not preclude the possibility that *The Solent* was done on the voyage between Panama and Chile, but because it was not painted in Valparaíso, it was not counted as part of the group. It is also possible that when the artist recalled the number of works that he did some thirty years before, and no longer in his possession, he may have made an error.

2. Quoted in Gordon Fleming, *The Young Whistler* (London: George Allen & Unwin, 1978), p. 229.

3. Nikolaus Pevsner, "Whistler's *Valparaíso Harbor* at the Tate Gallery," *Burlington Magazine* 79 (October 1941): 115–16, 121, discusses the events of that trip as they relate to *Crepuscule*. Donna Stein, "James McNeill Whistler's Voyage to South America in 1866" (research paper, New York, c. 1966) provides an overview of the year's activities.

4. Elizabeth Pennell, "Whistler Makes a Will," *The Colyphon* (1934), quoted in Fleming, *Young Whistler*, p. 227.

5. Elizabeth Robins Pennell and Joseph Pennell, *The Whistler Journal* (Philadelphia: Lippincott, 1921), pp. 41–43, covers the Valparaíso period; for Mrs. Whistler's opinion, see p. 253.

6. In a letter of February 1864 to Thomas Armstrong, George du Maurier mentioned the tension in Whistler's household; the letter is referred to in Horace Gregory, *The World of James McNeill Whistler* (New York: Thomas Nelson, 1959), pp. 101–3, where it is assumed that the trip was an attempt to avoid a domestic crisis. Hesketh Pearson, *The Man Whistler* (New York: Harper & Row, 1952), p. 35, reaches the same conclusion.

7. Daniel J. Hunter (pseudonym for Benjamin Vicuña-Mackenna), *A Sketch of Chili [sic], Expressly Prepared for the Use of Emigrants from the United States and Europe . . . and Several Papers Relating to the Present War between That Country and Spain, and the Position Assumed by the United States Therein* (New York: Hallet, 1866) is one example of this type of literature. It is interesting to note that John Singer Sargent later printed a number of portraits of Chilean patrons he met in Europe.

8. Pennell and Pennell, *Whistler Journal*, p. 42.

9. Details appear in the unpublished diary Whistler kept on the trip. See "Valparaíso Journal," R. Birnie Philip Bequest, Hunterian Museum, Glasgow.

10. Whistler's observations recorded in Pennell and Pennell, *Whistler Journal*, pp. 42–44, on the ships in the harbor, are substantiated by the military records, which indicate the presence of men-of-war from various nations including the United States, Great Britain, France, Sweden, and Russia. Spanish vessels, of course, were also present. See Davis, *The Last Conquistadores*, p. 295, note.

11. Pennell and Pennell, *Whistler Journal*, pp. 42–43.

12. For a complete account of this war see Davis, *The Last Conquistadores*; on the bombardment of Valparaíso, pp. 291–310.

13. The last consecutive entry in his journal was made 3 September. Pennell and Pennell, *Whistler Journal*, p. 43.

14. Ibid., p. 42.

15. The example of his brother's distinguished record of service as a surgeon in the Civil War, as various authors have mentioned, may have led him to regret his own lack of participation. Taking an overactive interest in subsequent political struggles may have been at least partially in the way of compensation.

16. Vicuña-Mackenna, *Sketch of Chili*, p. 25, where a lecture delivered before the Travellers Club of New York on 2 December 1865 appears.

17. Ibid., p. 29.

18. Because Whistler was involved with a group of American southerners while he was in London (see below), he may very well have heard a similar appeal there. In any case, in Great Britain a great deal of attention was paid to the circumstances in Chile for purely economic reasons. The port of Valparaíso played a substantial role in British shipping and commerce. According to statistics reported by Vicuña-Mackenna, England was Chile's largest foreign importer and accounted for 43 percent of all goods imported in 1864 (compared to the United States, for example, which only accounted for 5 percent). There was also a large resident British population in Valparaíso. Vicuña-Mackenna, *Sketch of Chili*, p. 24.

19. *Athenaeum*, 5 January 1867, pp. 22–23, quoted in Young et al., *Paintings of Whistler*, p. 42, where a summary of the literature on the painting can be found.

20. On the Peru Current see *Encyclopedia Americana* (Danbury, Conn.: Grolier, 1988), 21:785.

21. Arthur Jerome Eddy, *Recollections and Impressions of James A. McNeill Whistler* (Philadelphia: Lippincott, 1903), p. 23.

22. Young et al., *Paintings of Whistler*, p. 42.

23. Quoted in Young et al., *Paintings of Whistler*, p. 41, where the possibility is raised that this could be one of the missing pictures.

24. Maria Graham, Lady Callcott, *Journal of a Residence in Chile during the Year 1822 and a Voyage from Chile to Brazil in 1823* (London: Longman, Hurst, Rees, Orme, Brown, and Green, 1824), p. 172, entry dated 2 July 1822. It is highly likely that Whistler had read the work of the well-known Mrs. Graham.

25. The fact that all three pictures are of the same dimensions further negates the suggestion that one of them is a study for another in the series; so far as I have been able to determine, there is no known instance in which Whistler did a study in preparation for a finished work on a canvas in this manner.

26. *Athenaeum*, pp. 22–23.

27. Warren, "Romance," p. 497.

28. The exceptions to this observation are images of ruins, in which the moonlight carried implications of the romance and mystery that surrounded their origins; see chapter 4.

29. Letter from Church to Osborn, 7 September 1874, typescript, Olana State Historic Site.

30. Stebbins, *Martin Johnson Heade*, p. 75, points out that *Point*

Judith, Moonlit Calm is one of his few night scenes; *Tropical Harbor* is illustrated on p. 235.

31. Mignot's nocturnal scenes may reflect the influence of the seventeenth-century landscapist Aert van der Neer, whose work the American artist would have had the opportunity to study during his years in Holland. In subject as well as in mood van der Neer would have provided an apposite model, for he varied the recurrent Dutch theme of local waterways by rendering them at night. In a work such as *River Scene by Moonlight* (Rijksmuseum, Amsterdam) Mignot could have observed the splendidly silhouetted forms and silvery surfaces that are successfully repeated in his own nocturnal view.

32. James Abbott McNeill Whistler, *The Gentle Art of Making Enemies* (1890; repr., New York: Dover, 1967), p. 144.

33. Jacques Dufwa, *Winds from the East: A Study in the Art of Manet, Degas, Monet, and Whistler, 1856–86* (Stockholm: Almquist & Wiksell International, 1981), pp. 155–78.

34. A number of scholars have discussed various aspects of Whistler's Japonisme; for a useful, up-to-date summary see David Park Curry, *James McNeill Whistler at the Freer Gallery of Art* (Washington, D.C.: Freer Gallery of Art, 1984), pp. 17–18, 104–6.

35. Whistler's description of the bay appears in Pennell and Pennell, *Whistler Journal*, p. 42. The Pennells also report, "Mr. McQueen, a young Oxford undergraduate when we knew him, told us that his father was in Valparaiso when Whistler was there, that he put Whistler up at his Club, and that it was from the Club windows that the beautiful upright Valparaiso was painted" (ibid., p. 48).

36. Remak, "Exoticism," p. 56.

37. Quoted in McFarland, *Romanticism*, p. 8.

38. Vincent van Gogh, *The Complete Letters of Vincent van Gogh* (Greenwich, Conn.: New York Graphic Society, 1958), 3:56. Van Gogh's sentence reads in full, "The weather here remains fine, and if it was always like this, it would be better that the painters' paradise, it would be absolute Japan."

39. Squier, *Nicaragua*, p. 174. Washington Irving, *The Alhambra* (Philadelphia: Carey and Lea, 1832), 1:iii.

40. Irving, *Alhambra* 1:16.

41. Agassiz and Agassiz, *Journey in Brazil*, p. 49.

42. Humboldt had long held a desire to visit Egypt and the Orient but was unable for political reasons to do so; Squier was sufficiently intrigued by the Orient to author a book entitled *The Chinese as They Are* (1843); and Stephens had preceded his book on the Maya with one on Egypt and the Middle East.

43. Heine's images reached the public in a variety of ways. For a description of the panorama elaborated from Heine's sketches of Japan see *The Crayon* 3 (1856): 60. The sketches were published by Napoleon Sarony in a portfolio entitled *Graphic Scenes of the Japan Expedition*, and in Heine's own account, *Reise um die Erde nach Japan* (Leipzig: H. Costenoble, 1856). *The Crayon* 4 (March 1857): 90 mentions the paintings on view in Heine's studio, likely

the same ones he exhibited later that spring at the National Academy of Design; see chapter 2, n. 57.

44. Quoted in Tzvetan Todorov, *The Conquest of America: The Question of the Other*, trans. Richard Howard (New York: Harper and Row, c. 1984), p. 31.

45. Catlin, *Last Rambles*, p. 316.

46. Squier, *Nicaragua* 2:7–8.

Appendix 1

1. George C. Groce and David H. Wallace, *The New-York Historical Society's Dictionary of Artists in America, 1564–1860* (New Haven and London: Yale University Press, 1957), pp. 60–61. *M. and M. Karolik Collection of American Watercolors and Drawings, 1800–1875* (Boston: Museum of Fine Arts, 1962), pp. 84–85.

2. Archives of the Museum of Comparative Zoology, Harvard University. Blum and Landry, "In Loving Detail." Lyman Family Papers, Massachusetts Historical Society. Itinerary from Agassiz and Agassiz, *Journey in Brazil*.

3. Arkelian, *Tropical*, pp. 29–30. Jean Hanowell, "Norton Bush" (paper from the files of the Crocker Art Museum, 1980). Dwight Miller, *California Landscape Painting, 1860–1885 : Artists around Keith and Hill* (Stanford: Stanford Art Gallery, 1975), pp. 37–46.

4. Madeleine Stern, "G. W. Carleton, His Mark," in *Imprints in History: Book Publishers and American Frontiers* (Bloomington: Indiana University Press, 1956), pp. 191–205.

5. Von Hagen, *Maya Explorer*.

6. These itineraries are based on Catlin's own contradictory accounts and will undoubtedly be modified as corroborating evidence is found. In *Life amongst the Indians* he mentions three separate voyages, but the details are vague and the evidence suggests that he made only two visits to South America (if he did make a third trip, it was likely only to the Antilles). In *Life amongst the Indians* he gives his departure date as 1852 and in *Catalogue Descriptive and Instructive* as 1853. Harold McCracken, *George Catlin and the Old Frontier* (New York, 1959), p. 204, locates Catlin in Paris on 23 January 1853, writing a letter to Sir Thomas Phillipps, but other data substantiates an 1852 departure. All sources are in agreement that he left Mexico for Europe in 1855. The evidence for a third trip, presumably 1857–59 (the dates are nowhere spelled out), is far less substantial. Truettner, *Natural Man Observed*, states that he traveled in South America for a total of seven years; he places him in Brussels in 1857 and implies he went back to South America and then returned to Brussels three years later. McCracken does not mention it at all and puts the three trips within the time frame 1853–58. Catlin, *Last Rambles*, referred ambiguously to "my last rambles of three years."

7. Frederic Church correspondence from South America, 1853, Henry Francis Du Pont Winterthur Museum. Frederic Church, South American letters and diaries, Olana State Historic Site. David Huntington, "Landscape and Diaries: The South American Trips of F. E. Church," *Brooklyn Museum Annual* 5 (1963–64): 65–98. Huntington, *Landscapes of Frederic Edwin Church*.

8. *Francis Martin Drexel*. Joaquin H. Ugarte y Ugarte, *El pintor Austriaco Francis Martin Drexel (1792–1863) en la iconografía Bolivariana* (Lima, 1973). Penrose, "Early Life," pp. 345–57.

9. *Paintings by the Late Henry A. Ferguson, A.N.A.* (auction catalogue; New York: Anderson Galleries, 1918). *Paintings by Henry A. Ferguson, 1842–1911* (exhibition checklist; New York: Gallery of Cornelius J. Sullivan, 1936). *The National Cyclopedia of American Biography* (New York, 1936), 25:184.

10. Groce and Wallace, *Dictionary*, p. 230; exhibition records.

11. Stebbins, *Martin Johnson Heade*.

12. Col. Merl Moore, Jr., "More About the Events Surrounding the Suppression of *Harper's Weekly*," *American Art Journal* 12 (Winter 1980): 82–85. *M. and M. Karolik Collection*, p. 184.

13. Groce and Wallace, *Dictionary*, p. 319. Squier, *Notes on Central America*.

14. Groce and Wallace, *Dictionary*, p. 412; exhibition records. Squier, *Nicaragua*. American Art-Union Letters. Seitz, *Letters*.

15. Katherine Manthorne, "Louis Remy Mignot's *Sources of the Susquehanna*," in *Next to Nature: Landscape Paintings from the National Academy of Design*, ed. Barbara Novak (exhibition catalogue; New York: National Academy of Design, 1980).

16. Census for 1840, Norfolk. Census for 1850, Philadelphia. Records of the Custom House, Philadelphia, 1858. Records of the General Accounting Office, National Archives (RG 217). Exhibition records, biographical references compiled by Col. Merl M. Moore, Jr. Itinerary from dated drawings, Museum of the U.S. Naval Academy.

17. Arkelian, *Tropical*, p. 41. Joseph Armstrong Baird, Jr., "Charles Christian Nahl: Artist of the Gold Rush," exhibition review, *American Art Review* 3 (September–October 1976): 56–70. Stebbins, *Martin Johnson Heade*, p. 154.

18. Peale Files, American Museum of Natural History, New York. Poesch, *Titian Ramsay Peale*.

19. *American Artists* (Boston, n.d.), 1:179–92. Arkelian, *Tropical*, p. 42; exhibition records.

20. Arkelian, *Tropical*, pp. 42, 45. Marjorie Arkelian, *The Kahn Collection of Nineteenth-Century Paintings by Artists in California* (Oakland: Oakland Museum, 1975), pp. 41–42. *California Art Research*, First Series, Abstract from WPA Project 2874, San Francisco, 1937.

21. Franz Stenzel, *Cleveland Rockwell: Scientist and Artist, 1837–1907* (Portland, 1972).

22. Gilliss, *U.S. Naval Astronomical Expedition*; exhibiton records. Groce and Wallace, *Dictionary*, p. 587. Wayne D. Rasmussen, "The

United States Astronomical Expedition to Chile, 1849–1852," *Hispanic American Historical Review* 34 (1954): 103–13. Smith, *Araucanians*.

23. Groce and Wallace, *Dictionary*, p. 597; exhibition records.

24. Groce and Wallace, *Dictionary*, p. 599. James Orton, *The Andes and the Amazon*.

25. Audrey G. Wright, "Henry Walke, 1809–1896: Romantic Painter and Naval Hero" (Master's thesis, George Washington University, 1971).

26. Joseph F. Folsom, "Jacob C. Ward—One of the Old-Time Landscape Painters," *Proceedings of the New Jersey Historical Society*, n.s. 3 (April 1918): 83–93. McElroy, "History of Photography in Peru," pp. 771–73.

27. Young et al., *Paintings of Whistler*. "Valparaíso Journal."

Select Bibliography

Manuscript Collections

Agassiz, Louis. Papers. Houghton Library, Harvard University, Cambridge, Massachusetts.

———. Archives of the Museum of Comparative Zoology, Harvard University, Cambridge, Massachusetts.

Bartlett, John Russell. Papers. John Carter Brown Library, Brown University, Providence, Rhode Island.

Blake, J. Henry. Scrapbook. Archives of the Museum of Comparative Zoology, Harvard University, Cambridge, Massachusetts.

Catlin, George. Papers. Archives of American Art, Smithsonian Institution, Washington, D.C.

Church, Frederic. Manuscripts. Archives of American Art, Smithsonian Institution, Washington, D.C. Includes Church-Heade correspondence.

———. Library, letters, diaries, and papers. Olana State Historic Site, Taconic State Park Region, Hudson, New York.

———. Correspondence from South America, 1853. Henry Francis du Pont Winterthur Museum, Joseph Downs Manuscript Collection, Wilmington, Delaware.

Field, Cyrus. Papers. New York Public Library, Rare Book and Manuscript Division, New York.

Gratz Collection. Pennsylvania Historical Society, Philadelphia, Pennsylvania.

Heade, Martin Johnson. Papers and notes. Archives of American Art, Smithsonian Institution, Washington, D.C.

James, William. Papers. Houghton Library, Harvard University, Cambridge, Massachusetts.

Lyman, Theodore. Papers. Massachusetts Historical Society, Boston, Massachusetts.

Phillipps, Sir Thomas. Papers. Correspondence with George Catlin. Thomas Gilcrease Institute of American History and Art. Tulsa, Oklahoma.

Selfridge, Thomas O. Papers. Naval Historical Foundation Collection, Library of Congress, Washington, D.C.

Squier, Ephraim George. Papers. Manuscript Division, Library of Congress, Washington, D.C.

Taylor, Bayard. Papers, accession number 14/18/1169. Department of Manuscripts and University Archives, Cornell University Library, Ithaca, New York.

Winthrop, Theodore. Papers. New York Public Library, Rare Book and Manuscript Division, New York.

Whistler, James McNeill. "Valparaíso Journal," R. Birnie Philip Bequest, Hunterian Museum, Glasgow.

Journals (nineteenth-century journals and newspapers containing exhibition reviews and miscellaneous notices about art and artists)

American Art Journal

Art Journal (London)

Boston Semi-Weekly Advertiser

Brooklyn Eagle

Cosmopolitan Art Journal

The Crayon

Daily Evening Transcript (Boston)

Frank Leslie's Popular Monthly

Harper's Monthly

Harper's Weekly

Littell's Living Age

The Nation

Putnam's Monthly

Books and Articles

Agassiz, Elizabeth Cary, ed. *Louis Agassiz: His Life and Correspondence*. Boston and New York: Houghton, Mifflin and Co., 1885.

Agassiz, Louis. *Essay on Classification*. Edited by Edward Lurie. 1857. Reprint. Cambridge, Mass.: Harvard University Press, 1962.

―――. "Evolution and Permanence of Type." *Atlantic Monthly* 33 (1874): 92–101.

―――. "On the Origin of Species." *American Journal of Science and Art*, 2d series, 30, no. 88 (July 1860): 142–54.

Agassiz, Louis, and Elizabeth Agassiz. *A Journey in Brazil*. Boston: Ticknor and Fields, 1868.

"The Amazons of South America." *Putnam's Monthly Magazine* 6 (September 1855): 252–61.

American Paradise: The World of the Hudson River School. Exhibition catalogue. New York: Metropolitan Museum of Art, 1987.

"Anecdotes of Catlin." *The Crayon* 1 (1855): 252.

Anthony, A. V. S. "Scraps from an Artist's Notebook." *Harper's Monthly* 14 (1856): 22–29; 14 (1857): 164–73; 15 (1857): 145–54.

Arkelian, Marjorie. *Tropical: Tropical Scenery by the Nineteenth-Century Painters of California*. Exhibition catalogue. Oakland: Oakland Museum, 1971.

"An Artist." "Three Weeks in Cuba." *Harper's Monthly* 6 (January 1853): 161–75.

Auchincloss, William S. *Ninety Days in the Tropics, or Letters from Brazil*. Wilmington, Delaware, 1874.

Avery, Kevin J. "*The Heart of the Andes* Exhibited: Frederic E. Church's Window on the Equatorial World." *American Art Journal* 18 (Winter 1986): 52–72.

Baur, John I. H., ed. *The Autobiography of Worthington Whittredge: 1820–1910*. 1905. Reprint. New York: Arno Press, 1969.

Before Cortés: Sculpture of Middle America. Exhibition catalogue. New York: Metropolitan Museum of Art, 1970.

Bell, Michael Davitt. *The Development of American Romance: The Sacrifice of Relation*. Chicago: University of Chicago Press, 1980.

Belt, Thomas. *The Naturalist in Nicaragua*. London: John Murray, 1874.

Benjamin, S. G. W. *Art in America: A Critical and Historical Sketch*. New York: Harper & Bros., 1880.

―――. *Our American Artists*. New York, 1879.

Berman, Karl. *Under the Big Stick: Nicaragua and the United States since 1848*. Boston: South End Press, 1986.

Bernal, Ignacio. *History of Mexican Archaeology*. London: Thames and Hudson, 1980.

Bieder, Robert E., and Thomas G. Tax. "From Ethnologist to Anthropologist: A Brief History of the American Ethnological Society." In *American Anthropology: The Early Years*, edited by John V. Murra. 1974 Proceedings of the American Ethnological Society. St. Paul: West Publishing Co., 1976.

Blum, Ann, and Sarah Landry. "In Loving Detail." *Harvard Magazine*, May–June 1977, pp. 38–51.

Boogaart, E. van den, ed. *Johann Maurits van Nassau-Siegen, 1604–1679: A Humanist Prince in Brazil*. The Hague: Johann Maurits van Nassau Stichting, 1979.

Botting, Douglas. *Humboldt and the Cosmos*. New York: Harper and Row, 1973.

Braun, Barbara. "Paul Gauguin's Indian Identity: How Ancient Peruvian Pottery Inspired His Art." *Art History* 9 (March 1986): 36–54.

British Portraits. Barbizon Landscapes. Early Dutch Works. Property of the estate of the late Nathaniel Thayer of Boston, Massachusetts. New York: American Art Association and Anderson Galleries, Inc., 1935.

Brooks, Van Wyck. *The Times of Melville and Whitman*. New York: E. P. Dutton, 1947.

Bryan's Dictionary of Painters and Engravers. Edited by George C.

Williamson. London: George Bell and Sons, 1903–5.

Buarque de Holanda, Sergio. *Visão de Paraíso: Os motivos edenicos no descobrimento e colonizacao do Brasil.* São Paulo: Companhia Editora Nacional, 1960.

Bunksé, Edmunds V. "Humboldt and an Aesthetic Tradition in Geography." *Geographical Review* 71 (April 1981): 127–46.

Carleton, George Washington. *Our Artist in Peru: Leaves from the Sketch-Book of a Traveller, during the Winter of 1865–6.* New York and London: Carleton, 1866.

Carlson, Victor. *Hubert Robert: Drawings and Watercolors.* Exhibition catalogue. Washington, D.C.: National Gallery of Art, 1978.

Carmichael, Elizabeth. *The British and the Maya.* Exhibition catalogue. London: Trustees of the British Museum, 1973.

Carr, Gerald. "American Art in Great Britain: The National Gallery Watercolor of *The Heart of the Andes.*" *Studies in the History of Art* 12 (1982): 81–97.

Catalogue of the Aspinwall Gallery of Oil Paintings by the Old and Modern Masters. New York: Chickering Hall, 1886.

Catalogue of the First Annual Exhibition of Paintings at the Louisville Museum and Gallery of Fine Arts. May 1834.

Catalogue of the Mignot Pictures with Sketch of the Artist's Life by Tom Taylor, Esq., and Opinions of the Press. London and Brighton, 1876.

Catalogue of Paintings, Engravings, & C. at the Picture Gallery of the Maryland Historical Society. Sixth Annual Exhibition. Baltimore, 1858.

Catalogue of the Paintings in the Robert L. Stuart Collection: The Gift of His Widow Mrs. Mary Stuart. New York: New York Public Library, Astor, Lenox, and Tilden Foundations, 1898.

Catalogue: Special Sale of Fine Oil Paintings Including the Collection of the Well-Known American Artist, Mr. L. R. Mignot, Now in London, Comprising Some of His Latest and Best Works. New York: Leeds and Miner, 1868.

Catalogue of Works of Art Comprising the First Annual Exhibition of the Washington Art Association. 1857.

Catherwood, Frederick. *Views of Ancient Monuments in Central America, Chiapas, and Yucatán.* London, 1844. Facsimile. *Vision del Mundo Mayo—1844.* México: Cartón y Papel de México, S.A., 1978.

Catlin, George. *Catalogue Descriptive and Instructive of Catlin's Indian Cartoons . . . and Twenty-seven Canvas Paintings of La-Salle's Discoveries.* New York: Baker and Godwin, 1871.

———. *Episodes from Life among the Indians and Last Rambles.* Edited by Marvin C. Ross. Norman: University of Oklahoma Press, 1979.

———. *Last Rambles amongst the Indians of the Rocky Mountains and the Andes.* New York: D. Appleton and Company, 1867.

———. *Letters and Notes on the Manners, Customs, and Conditions of the North American Indians.* London, 1841.

———. *Life amongst the Indians.* New York, 1857. London: Sampson, Low, Son & Co., 1861.

———. *The Lifted and Subsided Rocks of America.* London: Truebner & Co., 1870.

"Catlin's Lithographs Showing Colt Firearms." *Antiques* 37 (January 1940): 35.

Chatwin, Bruce. *In Patagonia.* New York: Summit Books, 1977.

Coe, Michael. *The Maya.* London: Thames and Hudson, 1980.

Cole, Thomas. "Essay on American Scenery." 1835. Reprinted in *American Art, 1700–1960,* edited by John McCoubrey. Englewood Cliffs, N.J.: Prentice-Hall, 1965.

——— [Alpha, pseud.]. "Emma Moreton: A West Indian Tale." *Saturday Evening Post,* 14 May 1825.

A Collection of Paintings by the Late Henry A. Ferguson, A.N.A. with an "Appreciation" by George Smillie. New York: Anderson Galleries, 1918.

Colón, C. [Christopher Columbus]. *Journals and Other Documents.* New York: Heritage Press, 1963.

———. *Select Documents Illustrating the Four Voyages of Columbus.* London: Hakluyt Society, 1930.

Connell-Smith, Gordon. *The United States and Latin America: An Historical Perspective.* New York: John Wiley & Sons, 1974.

Conner, E. J. H. *The Natural History of Palms.* Berkeley and Los Angeles: University of California Press, 1966.

Cooper, James Fenimore. *The Crater; or, Vulcan's Peak.* 1847. Reprint. Cambridge, Mass.: Harvard University Press, 1962.

Cotopaxi. Painted by Frederic E. Church. From Studies Made in the Summer of 1857. New York: Goupil's Gallery, c. 1863.

Cowdrey, Mary Bartlett, comp. *National Academy of Design Exhibition Record, 1826–1860.* New York: New-York Historical Society, 1943.

Crespo Toral, Hernán. . . . *Y al fin, aparece el paisaje.* Exhibition catalogue. Quito: Museum Camilo Egas, Banco Central del Ecuador, 1981.

Curry, David Park. *James McNeill Whistler at the Freer Gallery of Art.* Washington, D.C.: Freer Gallery of Art, 1984.

Cust, Mrs. Henry. *Wanderers: Episodes from the Lady Emmeline Stuart-Wortley and Her Daughter Victoria, 1849–1855.* London: Jonathan Cape, 1928.

Darwin, Charles. *The Origin of Species by Means of Natural Selection or the Preservation of Favoured Races in the Struggle for Life.* 1859. Reprint. New York: New American Library, 1958.

———. *The Voyage of the Beagle.* 1839. Reprint. Garden City,

N.Y.: Doubleday & Co., 1962.

Davis, Keith F. *Désiré Charnay: Expeditionary Photographer.* Albuquerque: University of New Mexico Press, 1981.

Davis, William. *The Last Conquistadores: The Spanish Intervention in Peru and Chile, 1863–1866.* Athens: University of Georgia Press, 1950.

Dee, Elaine. *To Embrace the Universe: The Drawings of Frederic Edwin Church.* Exhibition catalogue. Yonkers, N.Y.: Hudson River Museum, 1984.

Demersay, Alfred. "Fragments d'un voyage au Paraguay." *La Tour du Monde* 4 (1861): 97–112.

Description de l'Égypte, ou recueil des observations et des recherches qui ont été faites in Égypte pendant l'expédition de l'armée francaise, publié par les ordres de sa majesté l'empereur Napoléon le grand. 23 vols. Paris: Imprimerie impériale, 1809–28.

Deutsche Künstler in Latein Amerika: Maler und Naturforscher des 19 Jahrhunderts illustrieren einen Kontinent. Exhibition catalogue. Berlin: Ibero-Amerikanisches Institut, 1978.

"Do Mountains Grow?" *Harper's Monthly* 15 (1857): 43–45.

Drexel, Francis Martin. *Journal of a Trip to South America, 1826–1830.* Philadelphia, 1916.

Duffield, A. J. *The Prospects of Peru: The End of the Guano Age and a Description Thereof.* London: Newman & Co., 1881.

Dufwa, Jacques. *Winds from the East: A Study in the Art of Manet, Degas, Monet, and Whistler, 1856–86.* Stockholm: Almquist & Wiksell International, 1981.

Durand, Asher B. "Letters on Landscape Painting: Letter 2." *The Crayon* 1 (1855): 34–35.

Durand, John. *The Life and Times of A. B. Durand.* New York: Scribner's, 1894.

Dusen, Robert van. *The Literary Ambitions and Achievements of Alexander von Humboldt.* Bern, Switzerland: Herbert Lang, 1971.

Eddy, Arthur Jerome. *Recollections and Impressions of James A. McNeill Whistler.* Philadelphia: Lippincott, 1903.

Edwards, William H. *A Voyage up the River Amazon, Including a Residence at Pará.* New York: D. Appleton and Co., 1847.

The Empire of Brazil at the Universal Exhibition of 1876 in Philadelphia. Rio de Janeiro, 1876.

Ewbank, Thomas. *Life in Brazil; or, a Journal of a Visit to the Land of the Cocoa and the Palm.* New York: Harper & Bros., 1856.

Exposición Nacional de Artes e Industria en Santiago de Chile. Santiago: Emprenta de la Librería del Mercurio, 1872.

Faust, Drew. *A Sacred Circle: The Dilemma of the Intellectual in the Old South, 1840–1860.* Baltimore: Johns Hopkins University Press, 1977.

Ferrez, Gilberto, and Weston J. Naef. *Pioneer Photographers of Brazil.* New York: Center for Inter-American Relations, 1976.

Fleming, Gordon. *The Young Whistler.* London: George Allen & Unwin, 1978.

Fletcher, Rev. James C. "Review of Thomas Page's *La Plata.*" *North American Review* 88 (April 1859): 430ff.

Focillon, Henri. *The Year One Thousand.* Translated by Fred D. Wieck. New York: Frederick Ungar Publishing Co., 1969.

Folsom, Joseph F. "Jacob C. Ward—One of the Old-Time Landscape Painters." *Proceedings of the New Jersey Historical Society,* new series 3 (April 1918): 83–93.

Foshay, Ella M. "Nineteenth-Century American Flower Painting and the Botanical Sciences." Ph.D. diss., Columbia University, 1979.

Francis Martin Drexel, 1792–1863: An Artist Turned Banker. Exhibition catalogue. Philadelphia: Drexel Museum Collection, Drexel University, 1976.

Gallatin, Albert. "Notes on the Semi-Civilized Nations of Mexico, Yucatán, and Central America." *Transactions of the American Ethnological Society* 1 (1845): 1–352.

García Márquez, Gabriel. "Latin America's Impossible Reality." *Harper's* 270 (January 1985): 13–16.

——— *One Hundred Years of Solitude.* Translated by Gregory Rabassa. New York: Avon Books, 1971.

Gardner, Alexander. *Rays of Sunlight from South America.* Washington, D.C.: Philip & Solomons, 1865.

Genini, Ronald. "Dom Pedro in California." *Journal of the West* 12 (1973): 576–88.

Gillespie, Neal C. *Charles Darwin and the Problem of Creation.* Chicago and London: University of Chicago Press, 1979.

Gilliss, James M. *The U.S. Naval Astronomical Expedition to the Southern Hemisphere during the Years 1849–50–51–52.* 33d Congress, 1st session, ex. doc. no. 121. Washington, D.C.: A. O. P. Nicholson, Printer, 1855–56.

Gogh, Vincent van. *The Complete Letters of Vincent van Gogh.* Greenwich, Conn.: New York Graphic Society, 1958.

Gordon, George. *The Poetical Works of Lord Byron.* London: Oxford University Press, 1960.

Gould, John. *A Monograph of the "Trochilidae," or Family of Hummingbirds.* London: John Gould, 1861.

Graham, Maria [Lady Callcott]. *Journal of a Residence in Chile during the Year 1822 and a Voyage from Chile to Brazil in 1823.* London: Longman, Hurst, Rees, Orme, Brown, and Green, 1824.

Gray, Asa. "Darwin on the Origin of Species" and "Darwin and His Reviewers." *Atlantic Monthly* 6 (1860): 109–16, 229–39, 406–25.

Gregory, Horace. *The World of James McNeill Whistler.* New York: Thomas Nelson, 1959.

Griggs, William Clark. *The Elusive Eden: Frank McMullan's Confederate Colony in Brazil.* Austin: University of Texas Press, 1987.

Groce, George C., and David H. Wallace. *The New-York Historical Society's Dictionary of Artists in America, 1564–1860.* New Haven and London: Yale University Press, 1957.

Groseclose, Barbara. *Emanuel Leutze, 1816–1868: Freedom Is the Only King.* Catalogue raisonné. Washington, D.C.: National Collection of Fine Arts, 1976.

Guiterman, Helen, and Briony Llewellyn, comps. *David Roberts.* London: Phaidon Press and Barbican Art Gallery, 1986.

Hansen-Taylor, Marie, and Horace E. Scudder, eds. *Life and Letters of Bayard Taylor.* Boston: Houghton and Mifflin, 1884.

Harrison, John P. "Science and Politics: Origins and Objectives of Mid-Nineteenth Century Expeditions to Latin America." *Hispanic American Historical Review* 35 (1955): 175–202.

Hartt, Charles Frederick. *Geology and Physical Geography of Brazil.* 1870. Reprint. New York, 1975.

Hassaurek, Friedrich. *Four Years among Spanish-Americans.* New York: Hurd and Houghton, 1867.

Haven, Samuel Foster. *Address from the Proceedings of the American Antiquarian Society for 22 October 1877.* Worcester, Mass.

Haverstock, Mary Sayre. "Round Trip to Paradise." *Art in America* 54 (1966): 65–71.

Haws, Duncan. *Ships and the Sea: A Chronological Review.* New York: Thomas Y. Crowell, 1975.

Hawthorne, Nathaniel. *The Scarlet Letter.* 1850. Reprint. New York: New American Library, 1981.

Heade, Martin. "Introduction." In *The Gems of Brazil,* Martin J. Heade Papers and Notes, Archives of American Art, Smithsonian Institution, Washington, D.C.

———— [Didymus, pseud.]. "Taming Hummingbirds." *Forest and Stream* (14 April 1892): 348.

Headley, J. T. "Darien Exploring Expedition under Command of Lieut. Isaac C. [*sic*] Strain." *Harper's Monthly* 10 (March–April–May 1855): 433–58, 600–615, 745–64.

————. "Vasco Núñez de Balboa." *Harper's Monthly* 18 (1859): 467–84.

Heart of the Andes: Notices of the Press. Kurtz Gallery, 1859.

Heine, Wilhelm. "Correspondence of the Bulletin." *Bulletin of the American Art-Union* (1851): 125–26.

————. *Reise um die Erde nach Japan an bord der Expeditionsescadre unter Commodore M. C. Perry in den Jahren 1853, 1854, und 1855.* Leipzig: H. Costenoble, 1856.

————. *Wanderbilder aus Central-America: Skizzen eines deutschen Malers.* Leipzig: H. Costenoble, 1853.

Hendricks, Gordon. *Eadweard Muybridge: The Father of the Motion Picture.* New York: Grossman Publishers, 1975.

Hennessy, Alistair. *The Frontier in Latin American History.* Albuquerque: University of New Mexico Press, 1978.

Herder, Johann Gottfried von. *Outlines of a Philosophical History of Man.* 1784. Reprint. New York: Alfred A. Knopf, 1966.

Herndon, Lewis William, and Lardner Gibbon. *Exploration of the Valley of the Amazon, Made under the Direction of the Navy Department.* 1854. Reprint. New York: McGraw-Hill, 1952.

————. *Exploration of the Valley of the Amazon.* 33d Congress, 1st session, ex. doc. no. 53. Washington, D.C.: Robert Armstrong, Public Printer, 1854.

Hills, Patricia. *Eastman Johnson.* New York: Whitney Museum of American Art, 1972.

Hindle, Brooke, Lillian B. Miller, and Edgar P. Richardson. *Charles Willson Peale and His World.* New York: Metropolitan Museum of Art, 1982.

Hine, Robert V. *Edward Kern and American Expansion.* New Haven: Yale University Press, 1962.

Hinsley, Curtis M., Jr. *Savages and Scientists: The Smithsonian Institution and the Development of Anthropology, 1846–1910.* Washington, D.C.: Smithsonian Institution Press, 1981.

Hints to Farmers on the Nature of Guano. 1st American ed. of 3d London ed., 1843.

"Histories of Art." *The Crayon* 4 (1857): 212–13.

Hodges, William. *Travels in India during the Years 1780, 1781, 1782, and 1783.* London, 1783.

Holmgren, Virginia C. "To Know a Hummingbird." *Américas* 30 (June–July 1978): 11–15.

Holton, Isaac F. *New Granada: Twenty Months in the Andes.* New York: Harper & Bros., 1857.

Honour, Hugh. *The New Golden Land: European Images of America from the Discoveries to the Present Time.* New York: Pantheon Books, 1975.

Hudson, William H. *Idle Days in Patagonia.* London: Chapman and Hall, 1893.

————. *The Naturalist in La Plata.* London: Chapman and Hall, 1892.

Humboldt, Alexander von. *Aspects of Nature.* Translated by Mrs. Sabine. London: H. G. Bohn, 1849.

————. *Cosmos: A Sketch of a Physical Description of the Universe.* Translated by E. C. Otté. Vols. 1–2, New York: Harper & Bros., 1850. Vols. 3–4, London: H. G. Bohn, 1851. Vol. 5, London: H. G. Bohn, 1859.

————. *Personal Narrative of Travels to the Equinoctial Regions of America, during the Years 1799–1804.* Translated by Thomasina Ross. Vols. 1–2, London: H. G. Bohn, 1852. Vol. 3, London:

H. G. Bohn, 1853.

————. *Political Essay on the Kingdom of New Spain.* Edited by Mary Maples Dunn. Translated by John Black. 1811. Reprint. New York: Alfred A. Knopf, 1972.

————. *Researches Concerning the Institutions and Monuments of the Ancient Inhabitants of America with Descriptions and Views of Some of the Most Striking Scenes in the Cordilleras!* Translated by Helen Maria Williams. London: Longman, Hurst, Rees, Orme & Brown, J. Murray & H. Colburn, 1814.

————. *Voyages aux regions equinoxiales du Nouveau Continent.* 35 vols. Paris, 1805–34.

Huntington, David. *Frederic Edwin Church.* Exhibition catalogue. Washington, D.C.: National Collection of Fine Arts, 1966.

————. "Landscapes and Diaries: The South American Trips of F. E. Church." *Brooklyn Museum Annual* 5 (1963–64): 65–98.

————. *The Landscapes of Frederic Edwin Church: Vision of an American Era.* New York: George Braziller, 1966.

Irving, Washington. *Astoria; or Anecdotes of an Enterprise beyond the Rocky Mountains.* 1836. Rev. ed. New York: Putnam, 1860.

————. *The Life and Voyages of Christopher Columbus.* 1828. London: John Murray, 1849.

———— [Geoffrey Crayon, pseud.]. "National Nomenclature." *The Knickerbocker* 14 (August 1839): 158–62.

Irwin, John. *American Hieroglyphics: The Symbol of the Egyptian Hieroglyphics in the American Renaissance.* Baltimore: Johns Hopkins University Press, 1983.

James, Henry, ed. *The Letters of William James.* Boston: Atlantic Monthly Press, 1920. Reprint. New York: Kraus Reprint Co., 1969.

James, William. *Louis Agassiz: Words Spoken by Professor William James at the Reception of the American Society of Naturalists . . . on December 30, 1896.* Cambridge, Mass.: Printed for Harvard University, 1897.

Judson, Isabella Field, ed. *Cyrus W. Field: His Life and Work (1819–1892).* New York: Harper & Bros., 1896.

Kagle, Steven E., ed. *America: Exploration and Travel.* Bowling Green, Ohio: Bowling Green State University Popular Press, 1979.

Keen, Benjamin. *The Aztec Image in Western Thought.* New Brunswick, N.J.: Rutgers University Press, 1971.

Kelly, Franklin W. "Myth, Allegory, and Science: Thomas Cole's Painting of Mount Etna." *Arts in Virginia* 23 (1983): 2–15.

Kemble, John H. *The Panama Route, 1848–1864.* New York: Da Capo Press, 1972.

Ketner, Joseph D., II. "Robert S. Duncanson (1821–1872): The Late Literary Landscape Paintings." *American Art Journal* 15 (1983): 35–47.

Kidder, Rev. D. P., and Rev. J. C. Fletcher. *Brazil and the Brazilians.* Philadephia: Childs & Peterson, 1857.

Kingsborough, Lord [Edward King]. *Antiquities of Mexico; Comprising Facsimilies of Ancient Mexican Paintings and Hieroglyphics.* London: A. Aglio, 1830–48.

Kubler, George. *Art and Architecture of Ancient America.* Harmondsworth, England: Penguin Books, 1975.

————. *The Shape of Time: Remarks on the History of Things.* New Haven and London: Yale University Press, 1962.

Lamborn, Robert Henry. *Mexican Painting and Painters.* New York and Philadelphia, 1891.

Leeuw, Roland de, John Sillevis, and Charles Dumas, eds. *The Hague School: Dutch Masters of the Nineteenth Century.* Exhibition catalogue. The Hague: Haags Gemeentemuseum, 1983.

Leuzinger, George. *Oficina fotográfica de G. Leuzinger . . . 337 fotográficas diversas.* Rio de Janeiro, c. 1865.

Levin, David. *History as Romantic Art: Bancroft, Prescott, Motley, and Parkman.* Stanford: Stanford University Press, 1959.

Lindsay, Kenneth C. *The Works of John Vanderlyn.* Binghampton, N.Y.: University Art Gallery, State University of New York, 1970.

"List of Articles Relating to Hispanic America Published in the Periodicals of the American Geographical Society, 1852–1933 Inclusive." *Hispanic American Historical Review* 14 (1934): 114–30.

Longfellow, Ernest Wadsworth. *Random Memories.* Boston: Houghton Mifflin Co., 1922.

"Louis Agassiz." *Harper's Monthly* 25 (1862): 194–201.

Lurie, Edward. *Louis Agassiz: A Life in Science.* Chicago: University of Chicago Press, 1960.

————. *Nature and the American Mind: Louis Agassiz and the Culture of Science.* New York: Science History Publications, 1974.

McCracken, Harold. *George Catlin and the Old Frontier.* New York, 1959.

McCullough, David. "The American Adventure of Louis Agassiz." *Audubon* 79 (January 1977): 2–17.

————. *The Path between the Seas: The Creation of the Panama Canal, 1870–1914.* New York: Simon and Schuster, 1977.

McElroy, Keith. "Ephraim George Squier: Photography and the Illustration of Peruvian Antiquities." *History of Photography* 10 (April–June 1986): 99–129.

————. "Henry De Witt Moulton: Rays of Sunlight from South America." *History of Photography* 8 (1984): 7–21.

————. "The History of Photography in Peru in the Nineteenth Century, 1839–1876." Ph.D. diss., University of New Mexico, 1977.

McFarland, Thomas. *Romanticism and the Forms of Ruin: Wordsworth, Coleridge, and Modalities of Fragmentation.* Princeton, N.J.: Princeton University Press, 1981.

McIntyre, Robert G. *Martin Johnson Heade, 1819–1904.* New York: Pantheon Press, 1948.

McNulty, J. Bard, ed. *The Correspondence of Thomas Cole and Daniel Wadsworth.* Hartford: Connecticut Historical Society, 1983.

Malone, Dumas, ed. *Dictionary of American Biography.* 20 vols. New York: Charles Scribner's Sons, 1928–36.

M. and M. Karolik Collection of American Watercolors and Drawings, 1800–1875. Boston: Museum of Fine Arts, 1962.

Manthorne, Katherine. "Benjamin Silliman and American Art: A Study in the Relations between Geology and Landscape Painting in the Pre-Darwinian Era." Research paper, Columbia University, 1978.

—————. *Creation & Renewal: Views of Cotopaxi by Frederic Edwin Church.* Exhibition catalogue. Washington, D.C.: National Museum of American Art, 1985.

Marcou, Jules. *Life, Letters, and Works of Louis Agassiz.* New York: Macmillan, 1896.

Marlor, Clark S. *A History of the Brooklyn Art Association with an Index of Exhibitions.* New York: James F. Carr, 1970.

Maury, Matthew Fontaine [Inca, pseud.]. *The Amazon, and the Atlantic Slopes of South America.* Washington, D.C.: Franck Taylor, 1853.

Melville, Herman. "The Encantadas or Enchanted Isles." In *Great Short Works of Herman Melville.* 1854. Reprint. New York: Harper and Row, 1969.

—————. *White Jacket, or the World in a Man of War.* 1850. Reprint. Evanston and Chicago: Northwestern University Press and the Newberry Library, 1970.

Merk, Frederick. *Manifest Destiny and Mission in American History: A Reinterpretation.* New York: Alfred A. Knopf, 1963.

Mesa, José de and Teresa Gisbert. *Monumentos de Bolivia.* La Paz: Gisbert & Cía, 1978.

Miller, Robert Ryal. "James Orton: A Yankee Naturalist in South America, 1867–1877." *Proceedings of the American Philosophical Society* 126 (1982): 11–25.

Milton, John. *Paradise Lost.* New York: New American Library, 1961.

Montgomery, Walter, ed. *American Art and American Art Collections.* Boston: E. W. Walker, c. 1889.

Moore, Col. Merl, Jr. "More About the Events Surrounding the Suppression of *Harper's Weekly.*" *American Art Journal* 12 (Winter 1980): 82–85.

Morley, Sylvanus G. *The Ancient Maya.* Edited by George W. Brainerd. Stanford: Stanford University Press, 1965.

Mould de Pease, Mariana. "Ephraim George Squier y su visión del Perú." Master's thesis, Pontificia Universidad Católica del Perú, 1981.

Muybridge, Eadweard. *The Pacific Coast of Central America and Mexico; the Isthmus of Panama; Guatemala; and the Cultivation and Shipment of Coffee.* San Francisco, 1876.

Naef, Weston J., and James N. Wood. *Era of Exploration: The Rise of Photography in the American West, 1860–1885.* New York: Metropolitan Museum of Art, 1975.

Naipaul, V. S. *The Loss of El Dorado.* New York: Penguin Books, 1981.

Nasmyth, James. "Volcanic Action." *The Crayon* 1 (27 June 1855): 409.

Naylor, Bernard. *Accounts of Nineteenth-Century South America: An Annotated Checklist of Works by British and United States Observers.* London: Athlone Press, 1969.

Naylor, Maria, ed. and comp. *The National Academy of Design Exhibition Record, 1861–1900.* New York: Kennedy Galleries, 1973.

Nelken, Halina. *Alexander von Humboldt. His Portraits and Their Artists: A Documentary Iconography.* Berlin: Dietrich Reimer Verlag, 1980.

—————. *Humboldtiana at Harvard.* Cambridge, Mass.: Harvard University Press, 1976.

Noble, Louis Legrand. *Church's Painting: "The Heart of the Andes."* New York: D. Appleton and Co., 1859.

—————. *The Life and Works of Thomas Cole.* 1853. Reprint. Cambridge, Mass.: Belknap Press, 1964.

Norman, B. M. *Rambles in Yucatán; or, Notes of Travel through the Peninsula, Including a Visit to the Remarkable Ruins of Chi-Chen, Kaban, Zayi, and Uxmal.* New York: Langley; Philadelphia: Thomas, Cowperthwait & Co.; and New Orleans: Norman, Steel, & Co., 1843.

Novak, Barbara. *Nature and Culture: American Landscape and Painting, 1825–1875.* New York: Oxford University Press, 1980.

—————. *Next to Nature: Landscape Paintings from the National Academy of Design.* Exhibition catalogue. New York: National Academy of Design, 1980.

—————, ed. *The Thyssen-Bornemisza Collection: Nineteenth-Century American Paintings.* London: Sotheby's, 1986.

O'Leary, Jean. "Louis Remy Mignot: Nineteenth-Century American Landscapist." Research paper, Columbia University, 1978.

Oran. "Tropical Journeyings: Panama Railroad." *Harper's Monthly* 18 (January 1859): 145–69.

Orton, James. *The Andes and the Amazon; or, Across the Continent of South America.* New York: Harper & Bros., 1876.

—————. "On the Condors and Humming Birds of the Equatorial Andes." *Proceedings of the American Association for the Advancement*

of Science 19 (August 1870): 260–67.

Osborne, Russell, and Edward Aiken, eds. *Catalogue of the Library of Robert L. Stuart.* New York: J. J. Little & Co., 1884.

"Our New Atlantis." *Putnam's Monthly Magazine* 5 (April 1855): 378–83.

Padden, R. C. *The Hummingbird and the Hawk: Conquest and Sovereignty in the Valley of Mexico.* Columbus: Ohio State University Press, 1967.

Páez, Ramón. *Travels and Adventures in South and Central America.* New York: Charles Scribner, 1868.

Page, Thomas Jefferson. *La Plata: The Argentine Confederacy and Paraguay.* New York: Harper & Bros., 1859.

The Painter and the New World. Exhibition catalogue. Montreal: Museum of Fine Arts, 1976.

Parker, Theodore. "Prescott's Conquest of Mexico." In *The American Scholar,* edited by George Willis Cooke. Boston: American Unitarian Association, 1907.

Peabody, W. B. O. "Review of Darwin's Researches in Geology." *North American Review* 61 (July 1845): 181–99.

Pearson, Hesketh. *The Man Whistler.* New York: Harper & Row, 1952.

Pennell, Elizabeth. "Whistler Makes a Will." *The Colyphon* (1934).

Pennell, Elizabeth Robins, and Joseph Pennell. *The Whistler Journal.* Philadelphia: Lippincott, 1921.

Penrose, Boies. "The Early Life of F. M. Drexel, 1792–1863." *Pennsylvania Journal of History* (October 1936).

Pevsner, Nikolaus. "Whistler's *Valparaíso Harbor* at the Tate Gallery." *Burlington Magazine* 79 (October 1941): 115–16, 121.

"Pictures by the Late L. R. Mignot." *The Builder* 34 (24 June 1876): 607.

Poe, Edgar Allan. "A Few Words on Secret Writing." *Graham's American Monthly Magazine* 19 (1841): 33–38.

Poesch, Jessie. *Titian Ramsay Peale and His Journals of the Wilkes Expedition.* Philadelphia: American Philosophical Society, 1961.

Ponko, Vincent. *Ships, Seas, and Scientists: U.S. Naval Exploration and Discovery in the Nineteenth Century.* Annapolis, Md.: Naval Institute Press, 1974.

Prescott, William H. *History of the Conquest of Mexico.* 1843. London: George Bell and Sons, 1901.

———. *History of the Conquest of Peru.* New York: Harper & Bros., 1847.

Prest, John. *The Garden of Eden: The Botanic Garden and the Re-Creation of Paradise.* New Haven and London: Yale University Press, 1981.

Raleigh, Sir Walter. *The Discovery of the Large, Rich, and Beautiful Empire of Guiana.* The first edited version of Raleigh's original text of 1596 appeared in 1848. Reprint. New York: Burt Franklin, 1964.

Reingold, Nathan, ed. *Science in Nineteenth-Century America: A Documentary History.* New York: Hill and Wang, 1964.

Remak, Henry H. H. "Exoticism in Romanticism." *Comparative Literature Studies* 15 (March 1978): 53–65.

The Remarkable Private Collection of Art Treasures from the Mount Mansion, the Estate of the Late William H. Aspinwall, Bristol, Rhode Island: The Magnificent Paintings by Famous European Masters. Boston: Leonard & Co., 1899.

"Report from Nicaragua." *Smithsonian Annual Report.* 1867.

Richards, T. Addison. "The Landscape of the South." *Harper's Monthly* 6 (May 1853): 721–32.

Richardson, Edgar P., and Otto Wittman, Jr. *Travelers in Arcadia.* Exhibition catalogue. Detroit: Detroit Institute of Arts, 1951.

Rivero, Mariano Edward, and Johann Jacob von Tschudi. *Peruvian Antiquities.* New York: A. S. Barnes, 1854.

Rodríguez Monegal, Emir, ed. *The Borzoi Anthology of Latin American Literature.* New York: Alfred A. Knopf, 1977.

Ruskin, John. *Modern Painters.* Vol. 4. 1856. Reprint. New York: John Wiley & Sons, 1882.

Sahagún, Bernadino de. *Historia general de los cosas de Nueva España.* Edited by Claus Litterscheid. Reprint. Barcelona: Tusquets, 1985.

Seitz, Don C., ed. *Letters from Francis Parkman to E. G. Squier.* Cedar Rapids, Iowa: Torch Press, 1911.

Smith, Bernard. *European Vision and the South Pacific, 1768–1850.* London: Oxford University Press, 1960.

———. "William Hodges and English *Plein-Air* Painting." *Art History* 6 (June 1983): 143–52.

Smith, Edmond Reuel. *The Araucanians; or, Notes of a Tour among the Indian Tribes of Southern Chili [sic].* New York: Harper & Bros., 1855.

Smith, Henry Nash. *Virgin Land: The American West as Symbol and Myth.* Cambridge, Mass., and London: Harvard University Press, 1982.

Smith, Joseph. *Illusions of Conflict: Anglo-American Diplomacy toward Latin America, 1865–1896.* Pittsburgh: University of Pittsburgh, 1979.

Snyder, Joel. *American Frontiers: The Photographs of Timothy O'Sullivan, 1867–1874.* Philadelphia Museum of Art, 1981.

Somerville, James. *F. E. Church's Painting "The Heart of the Andes."* Philadelphia, c. 1859.

Sousa-Leão, Joaquim de. *Frans Post, 1612–1680.* Amsterdam: A. L. Van Gendt & Co., 1973.

Sparks, Jared. "South America: Government of the Spanish Colo-

nies." *North American Review* 19 (July 1824): 158–208.

Spix, Johann Baptist von. *Avium species novae, quas in itinere per Brazilian annis 1817–1820*. Monachii, 1824–25.

Spix, Johann Baptist von, and Karl Friedrich Philipp von Martius. *Travels in Brazil in the Years 1817–1820*. Translated by H. E. Lloyd. London: Longman, Hurst, Rees, Orme, Brown, and Green, 1824.

Squier, Ephraim George. *Ancient Monuments of the Mississippi Valley.* Washington, D.C.: Smithsonian Institution Contributions to Knowledge, 1848.

———. *Antiquities of the State of New York.* Buffalo: G. H. Derby, 1851.

———. *The Chinese as They Are.* 1843.

———. *Nicaragua; Its People, Scenery, Monuments, Resources, Condition, and Proposed Canal.* New York: Harper & Bros., 1852.

———. *Notes on Central America; Particularly the States of Honduras and San Salvador.* New York: Harper & Bros., 1855.

———. *Peru: Incidents of Travel and Exploration in the Land of the Incas.* New York: Harper & Bros., 1877.

———. "San Juan de Nicaragua." *Harper's Monthly* 10 (December 1854): 50–61.

———. "The Volcanoes of Central America." *Harper's Monthly* 19 (November 1859): 739–62.

——— [Samuel Bard, pseud.]. *Waikna; or Adventures on the Mosquito Shore.* 1855. Reprint. Gainesville: University of Florida Press, 1965.

Stansifer, Charles Lee. "The Central American Career of Ephraim George Squier." Ph.D. diss., Tulane University, 1959.

Stebbins, Theodore E., Jr. *The Life and Works of Martin Johnson Heade.* New Haven: Yale University Press, 1975.

Stebbins, Theodore E., Jr., Carol Troyen, and Trevor J. Fairbrother. *A New World: Masterpieces of American Painting, 1760–1910.* Exhibition catalogue. Boston: Museum of Fine Arts, 1983.

Stein, Donna. "James McNeill Whistler's Voyage to South America in 1866." Research paper, New York, c. 1966.

Stenzel, Franz. *Cleveland Rockwell: Scientist and Artist, 1837–1907.* Portland: Oregon Historical Society, 1972.

Stephens, John Lloyd, "An Hour with Humboldt." *Littell's Living Age* 15 (1847): 151–53.

———. *Incidents of Travel in Egypt, Arabia Petraea, and the Holy Land.* 1837. New York: Harper & Bros., 1867.

———. *Incidents of Travel in Central America, Chiapas, and Yucatán.* 1841. Reprint. New York: Dover, 1969.

———. *Incidents of Travel in Yucatán.* 1843. Reprint. New York: Dover, 1963.

Stern, Madeleine. "G. W. Carleton, His Mark." In *Imprints in History: Book Publishers and American Frontiers.* Bloomington: Indiana University Press, 1956, pp. 191–205.

Stillman, William James. *Autobiography of a Journalist.* Boston and New York: Houghton, Mifflin, and Co., 1901.

Stoddard, Richard Henry. *The Life, Travels, and Books of Alexander von Humboldt.* New York: Rudd & Carleton, 1859.

Stuebe, Isabel Combs. *The Life and Works of William Hodges.* New York: Garland Publishing, 1979.

Sutton, Denys. *James McNeill Whistler: Paintings, Etchings, Pastels, and Watercolors.* London: Phaidon, 1966.

Swainson, William. *A Selection of the Birds of Brazil and Mexico.* London: H. G. Bohn, 1841.

Tax, Thomas Gilbert. "The Development of American Archaeology, 1800–1879." Ph.D. diss., University of Chicago, 1973.

Taylor, Bayard. *At Home and Abroad.* 1859. New York: George P. Putnam, 1886.

Tharp, Louise Hall. *Adventurous Alliance: The Story of the Agassiz Family of Boston.* Boston: Little, Brown and Co., 1959.

Thoreau, Henry David. *Sir Walter Raleigh.* Boston: Bibliophile Society, 1905.

Todorov, Tzvetan. *The Conquest of America: The Question of the Other.* Translated by Richard Howard. New York: Harper and Row, 1984.

Trenton, Patricia, and Peter H. Hassrick. *The Rocky Mountains, A Vision for Artists in the Nineteenth Century.* Norman: University of Oklahoma Press, 1983.

Truettner, William. "The Art of History: American Exploration and Discovery Scenes, 1840–1860." *American Art Journal* 14 (Winter 1982): 4–31.

———. *The Natural Man Observed: A Study of Catlin's Indian Gallery.* Washington, D.C.: Smithsonian Institution Press, 1979.

Tschudi, Johann Jacob von. *Travels in Peru during the Years 1838–1842.* Translated by Thomasina Ross. New York: George P. Putnam, 1853.

Tuckerman, Henry T. *Book of the Artists.* New York: George P. Putnam, 1867.

Tymn, Marshall, ed. *Thomas Cole: The Collected Essays and Prose Sketches.* St. Paul: John Colet Press, 1980.

Velasco, Don Juan de. *Historia del Reino de Quito.* Quito: Imprenta del Gobierno, 1844.

Vicuña-Mackenna, Benjamin [Daniel J. Hunter, pseud.]. "The Republic of Chili [*sic*], Its Present Condition and Prospects: A Lecture before the Traveller's Club of New York." In *A Sketch of Chili [sic], Expressly Prepared for the Use of Emigrants from the United States and Europe to that Country, with a Map, and Several Papers Relating to the Present War between that Country and Spain, and the Position Assumed by the United States Therein.* New York:

Hallet, 1866.

Viola, Herman J., and Carolyn Margolis, eds. *Magnificent Voyagers: The U.S. Exploring Expedition, 1838–1842*. Exhibition catalogue. Washington, D.C.: Smithsonian Institution Press, 1985.

Von Hagen, Victor Wolfgang. *Frederick Catherwood, Arch*. New York: Oxford University Press, 1950.

———. *Maya Explorer: John Lloyd Stephens and the Lost Cities of Central America and Yucatán*. Norman: University of Oklahoma Press, 1947.

Waldeck, Count de [Jean-Frédéric Maxmilien]. *Voyage pittoresque et archéologique dans la Province d'Yucatán*. Paris, 1838.

Waldman, Harry, ed. *Encyclopedia of Indians of the Americas*. St. Clair Shores, Michigan: Scholarly Press, 1974–81.

Wallace, Alfred Russel. *Palm Trees of the Amazon*. London: John van Voorst, 1853.

Wardle, Arthur C. *Steam Conquers the Pacific: A Record of Maritime Achievement, 1840–1940*. London: Hodder & Stoughton, 1940.

Warren, John Esaias. "The Romance of the Tropics." *The Knickerbocker Magazine* 33 (June 1849): 496–504.

Weinberg, Albert K. *Manifest Destiny: A Study of Nationalist Expansionism in American History*. Chicago: Quadrangle Books, 1963.

Weir, John Ferguson. "Paintings and Sculpture at the Centennial Exhibition—I." *American Architect and Building News* 3 (26 January 1878).

———. *Recollections of John Ferguson Weir*. Edited by Theodore Sizer. Reprinted with additions from the *New-York Historical Society Quarterly* (April, July, October 1957).

Whistler, James Abbott McNeill. *The Gentle Art of Making Enemies*. 1890. Reprint. New York: Dover, 1967.

Whitaker, Arthur P., ed. *Latin America and the Enlightenment*.

Ithaca and London: Cornell University Press, 1961.

Wilder, Thornton. *The Bridge of San Luis Rey*. 1927. Reprint. New York: Avon Books, 1976.

Williams, Mary W. *Dom Pedro the Magnanimous: Second Emperor of Brazil*. Chapel Hill: University of North Carolina Press, 1937.

Wilmerding, John. *American Light: The Luminist Movement, 1850–1875*. Exhibition catalogue. Washington, D.C.: National Gallery of Art, 1980.

Wilton-Ely, John. *The Mind and Art of Giovanni Battista Piranesi*. London: Thames and Hudson, 1978.

Winthrop, Theodore. *A Campanion to "The Heart of the Andes."* New York: D. Appleton and Co., 1859.

———. *The Canoe and the Saddle: Adventures among the Northwestern Rivers and Forests and Isthmiana*. New York: Dodd, Mead, and Co., 190(?).

Woodcock, George. *Henry Walter Bates: Naturalist of the Amazon*. New York: Barnes and Noble, 1969.

Woolf, Eugene T. *Theodore Winthrop: Portrait of an American Author*. Washington, D.C.: University Press of America, 1981.

Wright, Audrey G. "Henry Walke, 1809–1896: Romantic Painter and Naval Hero." Master's thesis, George Washington University, 1971.

Wright, John Kirtland. *Geography in the Making: The American Geographical Sociey, 1851–1951*. New York: American Geographical Society, 1952.

Yarnall, James L., and William H. Gerdts, comps. *The National Museum of American Art's Index to Amrican Art Exhibition Catalogues from the Beginning through the 1876 Centennial Year*. Boston: G. K. Hall & Co., 1986.

Young, Andrew McLaren, Margaret MacDonald, Robin Spencer, and Hamish Miles, *The Paintings of James McNeill Whistler*. New Haven and London: Yale University Press, 1980.

Index